THE ARCHITECTURE OF NATURAL LIGHT

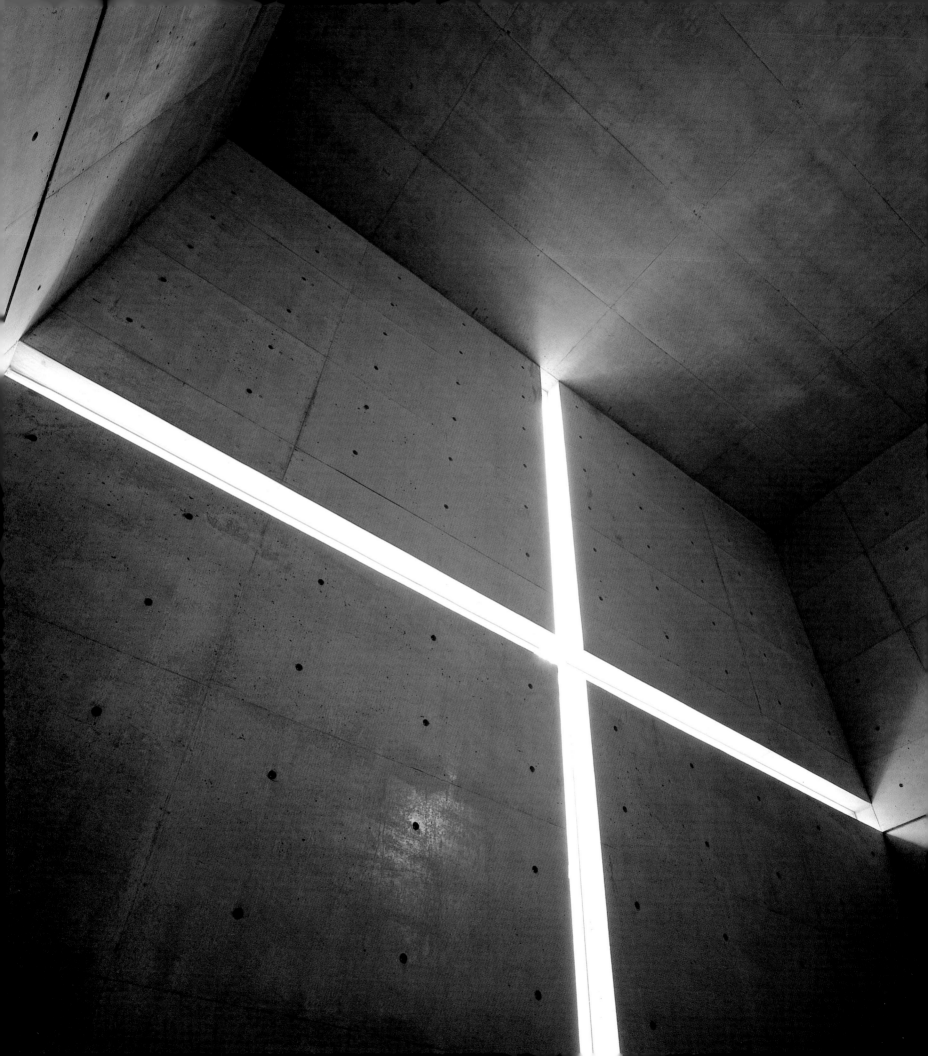

THE ARCHITECTURE OF NATURAL LIGHT

HENRY PLUMMER

The Monacelli Press

TO PATTY, WITH LOVE

All rights reserved. Published in the United States by
The Monacelli Press, a division of Random House, Inc.

First published simultaneously in 2009 in the United Kingdom by
Thames & Hudson, Ltd., London and by
The Monacelli Press, a division of Random House, Inc., New York.

The Monacelli Press and colophon are trademarks of Random House, Inc.

Library of Congress Cataloging-in-Publication Data
Plummer, Henry, 1946-
The architecture of natural light / Henry Plummer.
p. cm.
Includes bibliographical references.
ISBN 978-1-58093-240-0
1. Light in architecture. I. Title.
NA2794.P48 2009
720'.47—dc22 2009010508

Printed and bound in China

10 9 8 7 6 5 4 3 2 1

Designed by b3k / Claas Möller

www.monacellipress.com

Frontispiece: Tadao Ando, Church of Light, Japan

CONTENTS

THE OTHER ARCHITECTURE

THE OTHER ARCHITECTURE
Constructing metaphysical space

The beholding of the light
is itself a more excellent and a fairer thing than all the uses of it.
Francis Bacon (1561–1626)

The ebb and flow of light in the sky affects every part of our lives, and literally makes possible life on Earth. At its simplest, light allows us to see, to know where we are and what lies around us. Beyond exposing things to view, light models those things to enhance visual acuity and to help us negotiate the physical world. Furthermore, daylight is the source of energy that drives the growth and activity of all living things, and over millennia has waxed and waned with such intensity that our bodies and minds are now closely tuned to its cycles and spectrum. In addition to generating life, daylight is also essential to sustaining life by deterring a large number of diseases, as well as maintaining our biological rhythms and hormonal distribution. While we have invented many kinds of artificial light to supplement the light of the sun, the radiation of such man-made alternatives lacks the tempo and wavelength, nuance and tone necessary to replace our need for frequent exposure to natural light.

These practical virtues have impelled builders to open their forms to available light, within varying constraints of climate and culture. But while infusions of daylight may ensure that the lighting in buildings is adequate and comfortable, we need more from architecture than physical contentment. We expect our buildings to also be emotionally satisfying: to appear alive rather than dead; to take hold of our affections with moods that resonate with what we wish to feel inside; to keep us in touch with the flow of nature; and to empower us to make spaces our own by activating our perceptions and dreams. These extra depths of experience imply aspects of light that may have no practical benefit whatsoever, beyond satisfying the human spirit.

From the beginnings of architecture and all over the world, man's relationship with light has transcended necessity, and even the limits of objective reality. The way daylight has been handled historically by architects offers striking insights into the human ethos of each age, and often tells a tale that is different from the more rational language of form and space. The most remarkable of these constructs are religious in nature, where light was employed to arouse feelings of mysticism and to convey the sacredness of a place. Commonly identified with spiritual forces and beings due to its awing powers over life on Earth, light could manifest a divine presence for believers. But also expressed in such buildings was something simpler and more immediately graspable: an ethereal presence at the outer limits of material existence with a miraculous capacity to bring things alive at a sensory level, and to create, before one's very eyes, a sudden intensity of being.

Even the most cursory account of changing attitudes towards daylight and architecture reveals dramatic variations in the meaning and handling of light itself, and in its capacity to visualize a wide range of beliefs and values that could not be expressed with material form. Therein lay an extraordinary challenge for architects, for how could they creatively manage the sea of light found in the air when that radiation could not be grasped or worked with the hands? One cannot even see light unless it is aimed directly into the human eye, or arrives after striking a solid object or filtering through a medium, such as smoke or mist. To overcome this predicament, builders resorted to *modulation*, inventing a repertoire of light-controlling elements that behaved in

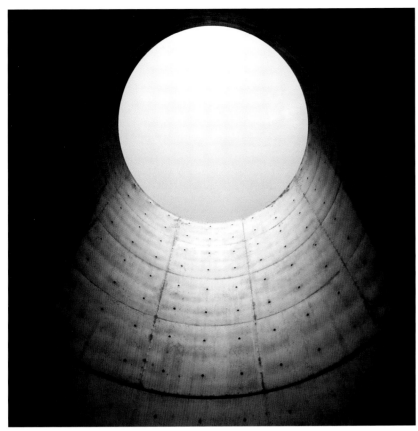
Forest of Tombs Museum by Tadao Ando.

ing monumental size in the axial tunnels of the temples of Egypt. Hypostyle halls in the great temples at Karnak (below, left) and Luxor, for instance, were aimed to points on the desert horizon where the sun rose or set on dates of profound celestial significance. It is conjectured that these shafts were devised as receptacles for a flood of light that, once a year, would dramatically penetrate the full length of the interior. Rays of sun would illuminate, but also resurrect – perceptually and symbolically – figures of deities set at the rear, piercing the dark as a cosmic energy that could restore the gods' powers and sanctify life on Earth. This year-long swing of advancing and retreating light along dim corridors invoked a metaphysical presence that may have been sheltered and calibrated by, but was essentially free of, the temple's colossal stonework.

While light was increasingly devoted to rational aims in the Classical era, a stunning exception is the Pantheon of Rome (AD 118–28), a temple dedicated to all the gods. Hidden within its bulky mass is a great bounded volume of space that is absolutely still, taking the shape of a perfect circle beneath a hemispherical dome. The experiential power of this building, however, lies neither in its mass nor in its void, but in its active dialogue with the sky. Filling the interior every day is zenithal light from a single source, a huge oculus (from the Latin, literally 'eye'), sending inside a dramatic sunbeam that constructs and shapes its own space as it sweeps around the drum, at once illuminating and revitalizing the deities enshrined there. The coffered dome was further dematerialized and linked to the Roman cosmos by a once-gilt surface whose flecks of light would catch the eye of the beholder and draw it heavenward.

In Christianity, light, including daylight at a metaphoric level, became a symbol of God himself, a divine light that 'shines in the darkness' and was incarnate in Christ, who proclaimed: 'I am the light of the world.' The soaring masses and voids of Gothic cathedrals formed a wondrous sight in medieval cities throughout Europe. But what is immediately apparent when entering one still containing its full array of stained glass, such as Chartres in France or León in Spain (below, right), is the way in which physical reality is completely upstaged by a mystical twilight in the air, with tinged shadows that pervade

ways beyond, and often distinct from, their equally valued physical properties (above). Roofs and walls, openings and finishes, screens and membranes were shaped into optical instruments that could obstruct or admit, focus or disperse, absorb or reflect the traffic of incident light they received, but also could send that light where builders wished and when they wished, and with whatever intensity or frequency they desired.

Impressive examples of mastery with light appeared throughout the ancient world, generally to establish ritual ties with a mythical sky, and reach-

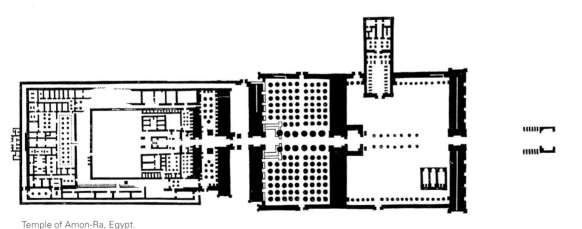
Temple of Amon-Ra, Egypt.

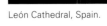

León Cathedral, Spain.

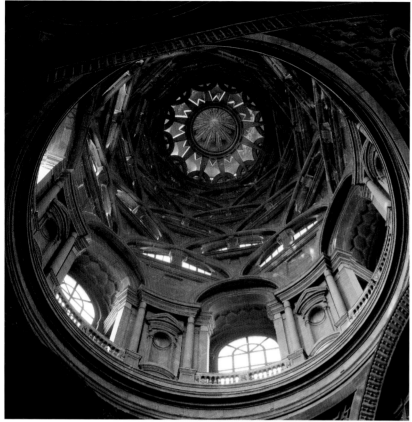
Chapel of the Holy Shroud by Guarino Guarini.

The Renaissance break with the spiritualized space of the Middle Ages led to a calm and uniform treatment of light, epitomized in the grey softness of Brunelleschi's San Lorenzo (1429), in Florence. Even where spaces were differently lit, gradations are subtle, and the aim was to articulate rather than to enthrall. The essential role of Quattrocento light was to enhance clear vision by modelling form, permitting easy and total comprehension, and by illuminating space as a concrete container devoid of mystery. Light became a discreet and neutral medium, indistinguishable from air, whose anonymity was needed to emphasize the objective aspects of architecture: precision, completeness, proportion, order, geometry.

During the Baroque age, a Counter-Reformation urge to reassert a mystical view, and excite widespread religious feeling, produced a theatrical lighting where miraculous and transcendental ideas became real to the senses. As in the sudden chiaroscuric contrasts and blinding flashes painted by Caravaggio, violently breaking up form and space, seventeenth-century Italian church architecture employed light from hidden sources to blend worldly and visionary elements into one, and to ultimately visualize and popularize religious beliefs. Towering above the Roman churches of Bernini's Sant'Andrea al Quirinale and Borromini's San Carlo alle Quattro Fontane, and especially the Turinese churches of Guarini (left), are spectacles of light that recede upward, promising a future of heavenly bliss. Calm and stable lighting is replaced by turbulent energy propelled by atmospheric perspective, where light is handled to deliberately eat away solid masses and explode space with illusory depths. These tendencies only accelerate in the deluge of light used to backlight and corrode eighteenth-century building shells, culminating in the German Rococo of Balthasar Neumann at Neresheim and Vierzehnheiligen. Related phenomena become a tool to dazzle the eye and proclaim the State's infinite power in the eighteenth-century court architecture of France and Germany. Huge mirrors and gilt stucco completely dissolve form and space at Louis XIV's Versailles, for example, or at the Amalienburg Pavilion by François de Cuvilliés (below), and surround a privileged point of space with restless, scintillating images that radiate endlessly outward.

and make a stirring presence in the stone voids. Cloaking wall and vault is a semi-darkness whose negation enhances the aerial suffusion of coloured light emitted from huge, jewel-like windows and filling the space with a tangible haze that comes and goes with time and weather. The stone carcass of this heavenly city was a means to an end, not an end in itself, and, while embodying many beliefs of the Church, failed to convey the fundamental spirit of the building – a situation analogous to the difference between body and spirit, startlingly evident at death.

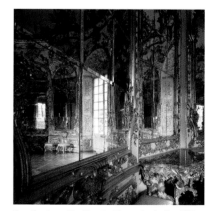
Amalienburg Pavilion by François de Cuvilliés.

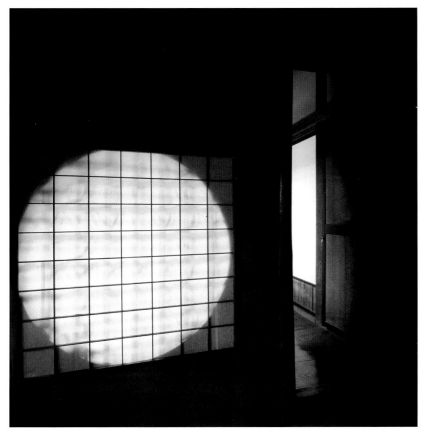

Yoshijima House, Japan.

Entirely different treatments of light developed in Eastern building cultures to communicate their own beliefs about life and existence. Illumination was deliberately withheld from the labyrinth of voids in a Buddhist or Hindu temple in order to heighten its evocation of a mountain of God, and to thrust the devout pilgrim into a symbolic death. Gloomy darkness made spiritual rebirth possible, whose journey began with a circumambulation of womb-like caves and ended in a slowly emergent glow at the centre. By contrast, the illumination of an Ottoman mosque was handled to produce a mood of calm, where emotions are reduced and tensions resolved. Coating walls and rising domes are smooth glazed tiles, which return light at a uniform angle to render surfaces quietly lustrous and rid the building of weight, a buoyancy heightened by cutting domes free with rings of windows.

More modest if equally ingenious ideas about light manipulation occur in vernacular architecture, usually originating in climatic forces and serving domestic rather than religious aims. To take only one example, the cavernous roof above porous walls in a traditional Japanese house evolved as a parasol to intercept sun and rain, and as a horizontal filter that disseminates light without obstructing breezes – a combination suited to the sultry climate. But beyond providing adequate comfort, these light-controlling elements were also refined, over centuries of experimentation, to create something appealing to the human heart rather than body – a unique blend of tranquillity and mystery that continues to resonate with the Japanese psyche. What stands out in these simple timber houses is an atmosphere shaped by frail light dying into shadows, only faintly illuminated by the dream-like glow of white paper *shoji* and flickers of gold brought alive in the darkness (left).

With the advent of industrialization in the nineteenth and twentieth centuries, combined with the mass production of steel and glass, the daylighting of buildings radically transformed in both the degree and breadth of its application. Stimulating technical advances was a growing demand for the healthful benefits of natural light in buildings where people increasingly worked and lived remote from the sun. The new-found control over natural light became applied as much to a house, office, school, library, factory or museum as to a church or seat of government. But this revolution was not solely one of quantity, for the rise of new democratic systems and their concern for human individuality brought architects an unprecedented freedom in the expression of ideas about light. Such ideas were no longer merely for dogma or propaganda, but could now offer people a range of *undetermined* experiences. In many ways, the past century's growing fascination with daylight in architecture is tied to this shifting world-view – from static and unchanging absolutes to a more liberating reality in which the only

thing believed permanent is change – a reality ideally conveyed by a medium that is the essence of change.

Paralleling these transformations was a radical shift in our understanding of the properties and significance of *light itself*, which occurred in both science and art during the early twentieth century. Among those who caused a fundamental reconceptualization of light was Albert Einstein, who in 1905 proposed the existence of light as tiny and separate 'packets' of energy called photons, commenting: 'For the rest of my life, I will reflect on what light is'. The structure of light was previously understood as corpuscular by Isaac Newton, and as an electromagnetic wave following the discoveries of physicist James Clerk Maxwell. But the arrival of quantum theory, introduced by Max Planck in 1900 and expanded upon by Einstein, gave birth to what was considered a 'new kind of light' – a 'modern' light. Light was now understood as both wave and photon, displaying a strange blend of wave- and particle-like properties. These early discoveries, followed more recently by speculations on vibrating strands of energy in string theory, have done more than create a puzzling duality in the nature of light, for they have created a new kind of physics in which matter itself is undulating with electric and magnetic forces.

The proposition that light forms a real presence in empty space, and even within physical things – its vibrant intensity stemming from a complex interaction of light with matter – was being simultaneously explored in the visual arts. Already in the mist and smoke of an Impressionist canvas by Monet or the pointillism of Seurat, we find a molecular light drifting through space to veil objects and become the very heart of the image. In paintings by Van Gogh, light rarely illuminates things at all, but appears instead as a palpable energy that pulses through the air and penetrates objects, flowing in waves that emanate from a sulphur-yellow sun, or rain down from a star or lamp. The increasing dissolution of solid form in abstract painting allowed the mood, flow, colour and shadow of light to become the dominant subject of pictures. Painters such as André Derain and Gino Severini, followed by Jackson Pollack and Richard Pousette-Dart, expanded upon a vision of light as vibrating particles and oscillations, conveyed through radiant pigments and a textured impasto laid on with brushwork. The grainy and colourful light they composed is never static, reflecting knowledge that light is like nothing else that enters our world – seeming to never come to rest and always in motion. Even in the figural pictures of Edward Hopper, we find a light free of the objects with which it mingles. Whether as a wave of sun spreading over the land, or a sunbeam piercing a dark room, Hopper made the light around the people he painted an evanescent force with which they commune, and seems to be saying that these simple encounters might help to soothe the existential loneliness of modern man.

The new-found importance and understanding of light arising in both art and science had a transformative impact on twentieth-century architecture. Pioneers such as Frank Lloyd Wright, Le Corbusier, Alvar Aalto and Louis Kahn were increasingly intrigued with the *immaterial* aspects of buildings, and the way in which solid volumes could throw attention to the flowing energy they trapped and displayed. 'More and more,' Wright asserted, 'light is the beautifier of the building', and he exploited daylight as 'the great luminary of all life' by making it 'part of the building itself'. Le Corbusier was more direct, pronouncing: 'Light is the key to well-being', and further, 'I compose with light.' Aalto made many analogies between light and acoustics, and used spreading lines, similar to those employed by physicists, to study how rays of light could be bent and guided into buildings. Most poetic was Kahn, who considered light to be a metaphysical presence, 'the source of all being', and stated: 'We were born of light. The seasons are felt through light. We only know the world as it is evoked by light, and from this comes the thought that material is spent light. To me, natural light is the only light, because it has mood – it provides a ground of common agreement for man – it puts us in touch with the eternal. Natural light is the only light that makes architecture, architecture.' Evidently these architects had started to question whether light *exists* in its own right, visible in itself and not merely a vehicle for making other things visible.

Over the past century, an intense exploration into this 'new kind of light' by our most sublime architects has begun to trace the recent chapter of an

 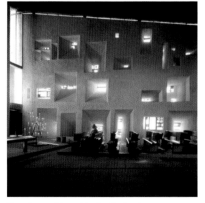

Postal Savings Bank by Otto Wagner. Ronchamp Chapel by Le Corbusier.

alternate history in the art of building. Rather than glamorizing form and gesture, these building are conceived, first and foremost, as domains of immaterial forces and energies, whose fluid events are linked to the sky but also demonstrate a way of seeing that is true to the world today. While not neglecting physical needs, which they tend to also satisfy superbly, these metaphysical works are striking in their elevation of light to a primary role in architectural expression. Among the finest contributions to this heritage are Antoni Gaudí's Casa Batlló (1906), Otto Wagner's Postal Savings Bank (1906; opposite, left), Pierre Chareau's Maison de Verre (1931), Gunnar Asplund's Göteborg Law Courts (1937), Frank Lloyd Wright's Johnson Wax Headquarters (1939; see p. 83), Le Corbusier's Ronchamp Chapel (1955; opposite, right), Alvar Aalto's Vuoksenniska Church (1959; see p. 19), Luis Barragán's Capuchin Chapel (1960), Louis Kahn's Kimbell Art Museum (1972; below, left), Jørn Utzon's Bagsværd Church (1976), and the equal mastery if lesser fame of Joseph Esherick's Cary House (1960; below, right) and Aldo van Eyck's church in The Hague (1970; right). In each instance, daylight has been manipulated to give it a unique and palpable presence, and, more significantly, to transform objective reality, while constructing in its place a more fluid reality that people are empowered to creatively engage with.

A variety of developments in neighbouring disciplines have helped to shape this expanding discourse on light. Anticipating much of the spatial freedom applied to light in contemporary architecture has been the work of artists who made 'environmental light' their basic medium. The creations of Bauhaus artist László Moholy-Nagy and his younger colleague György Kepes abound with inventions and predictions for light that is liberated from any container, such as Moholy-Nagy's 'light fresco' or Kepes's 'floating mirroring buoys'. The real construct of Moholy-Nagy's celebrated *Light-Space Machine* from the 1920s was not the mechanism itself or room it stood in, but the ephemeral patterns of light and shadow projected on the walls and made to revolve in a choreographed motion that only exists when the machine is switched on. The aim to give light a leading role in works devoid of solid concrete things was picked up in the 1960s by California artists including Robert

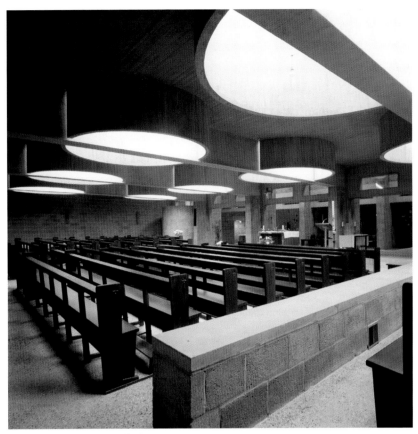

Catholic Church by Aldo van Eyck.

Irwin, James Turrell, Maria Nordman and Larry Bell, all of whom sought a serenity missing from the kinetic spectacles of their predecessors. For several decades, these artists produced essentially no objects, basing their work entirely upon evanescent constructs of sun and shadow, time and mutation, atmosphere and scrim. Their intent was to offer elusive phenomena in empty space, upon which the viewer could shape his or her own specific experience. Set free from any object were ethereal shapes of projected light, amorphous shadows and fogged images, all analogous less to painting or

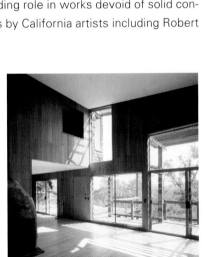

Kimbell Art Museum by Louis Kahn.

Cary House by Joseph Esherick.

sculpture than to tides of fleeting colour at dusk, the shimmer of light upon water, or the silver haze cast by moonlight. Among these artists, Turrell has been especially adept at hewing pure light, and continues to empty his work of materiality to emphasize what he calls the 'thingness of light', whose only value occurs when it is directly perceived (right). 'Light is not so much something that reveals', Turrell insists, 'as it is itself the revelation.'

The architectural as well as artistic vision of light wrought into distinct phenomena has been given a broad empirical basis by Dutch photobiologist Marcel Minnaert. By blending visual perception and the physics of light in his groundbreaking book, *The Nature of Light and Colour in the Open Air* (1954), Minnaert offers a basis for understanding how myriad phenomena are concretely produced in the ordinary world.[1] As opposed to Goethe's subjectively written *Theory of Colours* (1810), whose conjectures were based on personal examination unhampered by physics, Minnaert blends careful observations of luminous effects with analyses of how those effects are generated by physical modulations of light. His work not only helps to throw attention onto light's beauty and mystery in the daily environment, but also treats those phenomena as palpable qualities that can be consciously perceived and described, and to some extent causally understood according to how light is modified when interacting with material things.

Complementing Minnaert's observations, while offering a more radical reconsideration of experienced light, is the influence of phenomenology (the study of phenomena) as a discipline, and its insistence on *a phenomenal way of thinking and seeing*, a mode inherently different from the analytic and objective vision of science. As a branch of existential philosophy, whose aims are basically ontological, the conception of phenomenology developed during the mid-twentieth century by Edmund Husserl and his followers is based upon a 'return to things', as opposed to intellectual abstractions and constructions.[2] While not referring directly to architecture, the core of phenomenology – as *description* when one is *filled with wonder* – offers a method of examining phenomena through intensified seeing and sensing. By suspending judgment and grasping things in a kind of primal encounter, it becomes possi-

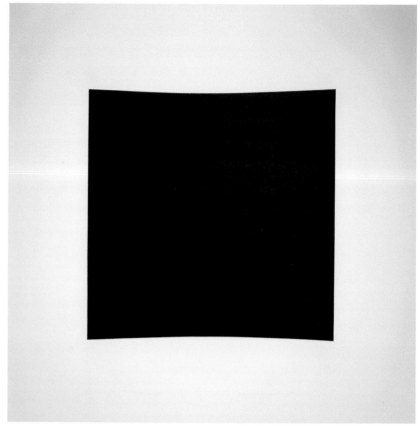

Quaker Meeting House by James Turrell.

ble to discern the most elusive and subtle aspects of buildings, including aspects of light we fail often to consciously notice.

The broad import of phenomenology for architecture, and for understanding the role of light in places we care deeply about – the 'spaces we love' – has gained a poetic dimension in the writings of French philosopher Gaston Bachelard. In his still astonishing book *The Poetics of Space* (1958), and later in *The Flame of a Candle* (1961), Bachelard introduces the concept of a 'primal image', and locates the source of its imaginative power in simple archetypal

places, ranging from 'nests' and 'corners' to 'cellars' and 'attics', and in metaphysical places such as 'the lamp that glows in the window', 'reveries of faint light', and spaces that participate in 'cosmic events'.[3] The mesmerizing allure of images where light is fighting off darkness, argues Bachelard, originates in primordial memories that are only accessible through poetic imagination, daydream and reverie – sublimations that lie below rational thought.

Over the past half century, phenomenology's capacity to transform our understanding of architecture is being broached in a more direct way by theorists from environmental disciplines. One of the first to assert that the essence of architecture lies in the senses was Danish planner and architect Steen Eiler Rasmussen, whose aptly titled *Experiencing Architecture* (1959) includes speculations on how something as capricious as natural light can be artistically controlled.[4] He concludes that this is possible because the adaptability of the human eye makes variations in the quantity of light insignificant, and it is rather the *quality* of light that is of paramount importance. Light's value is diminished by uniform illumination, becoming shadowless and dead, and is enhanced by directional illumination with textural and sculptural effects. Providing another step in our awareness of architecture as a phenomenon are the writings of Norwegian architect Christian Norberg-Schulz. Drawing on concepts formulated by Bachelard, as well as by Martin Heidegger and Maurice Merleau-Ponty, Norberg-Schulz attempts to return our focus to the poetic and qualitative realities of architecture.[5] The primary task of the art of building, he declares, is to create a 'spirit of place' whose totality consists not only of concrete things with material presence, but also intangible things – primarily light and atmosphere – which can inspirit buildings as well as landscapes.[6] The present author's own writings on similar topics are not inconsistent with these efforts to equate light with experience and the art of place, and to deepen our appreciation of light as human beings.[7]

In recent decades, several noted practitioners of architecture – in the tradition of Wright, Le Corbusier and Kahn – have revived the dual exploration of light through the complementary avenues of writing and building. Finnish architect Juhani Pallasmaa continues to expand the phenomenological basis of architecture, while avoiding the occasional bias of Norberg-Schulz towards architectural nostalgia. In his book *The Eyes of the Skin* (1996) and in buildings such as the Rovaniemi Art Museum (1986; below, left), Pallasmaa reminds us that light plays a crucial role in helping us become fully conscious of our existence in the world, and provokes interaction at an immediate, visceral and pre-cognitive level with the light we encounter.[8] A similar point of view is repeatedly confirmed in the work of American architect Steven Holl (below, right), whose constructs embody the central idea that 'the perceptual spirit and metaphysical strength of architecture are driven by the quality of light and shadow shaped by solids and voids, by opacities, transparencies and translucencies. Natural light, with its ethereal variety of change, fundamentally orchestrates the intensities of architecture.'[9] Sensations of light are also given prominent weight by Swiss architect Peter Zumthor. In *Thinking Architecture* (1998) and *Atmospheres* (2006), Zumthor recounts the influence upon him of such childhood memories as the 'soft gleam of the waxed oak staircase' in his aunt's house, and more generally acknowledges that 'daylight, the light on things, is so moving to me that I feel it almost as a spiritual quality. When the sun comes up in the morning – which I always find so marvellous, absolutely fantastic the way it comes back every morning – and casts its light on things, it doesn't feel as if it quite belongs in this world. I don't understand light. It gives me the feeling there's something beyond me, something beyond all understanding. And I am very glad, very grateful that there is such a thing.'[10] Spanish architect Alberto Campo Baeza questions: 'Finally, is light not the substance of architecture? Is the history of architecture not the search for understanding, and dominion over light?' Campo Baeza incorporates light in his pure white houses and buildings such as the Caja Granada Headquarters Bank (2001; overleaf) not to beautify, but rather 'to make men feel the rhythm marked by nature, harmonizing spaces with light, mitigating them with the passing of the sun'.[11]

All these recent tendencies indicate that a quiet change is underway in the architectural balance between absolute form and ephemeral light, as well as in the fundamental role of the architect: on the one hand as a form-giver of pre-determined (and increasingly exhibitionist) shapes, and on the other as a

Rovaniemi Art Museum by Juhani Pallasmaa.

Bellevue Art Museum by Steven Holl.

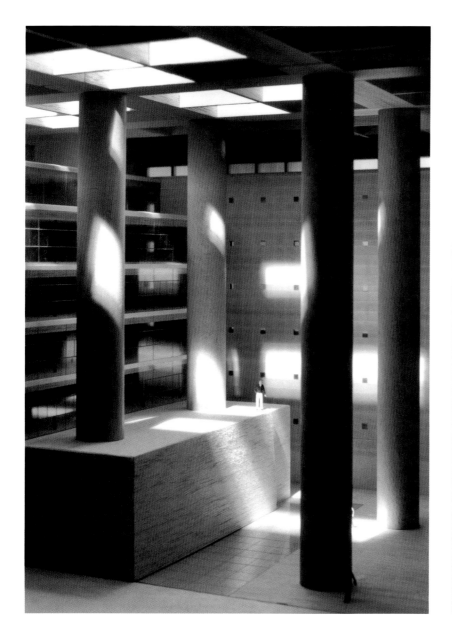

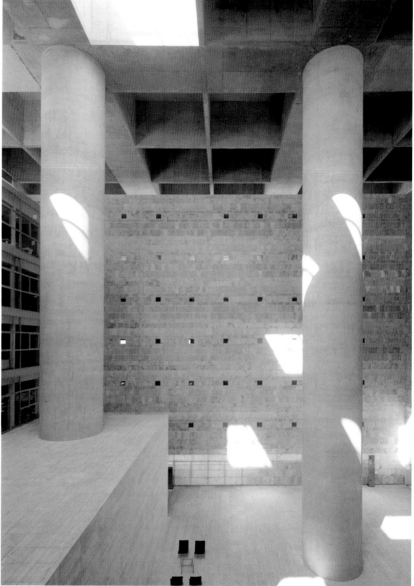

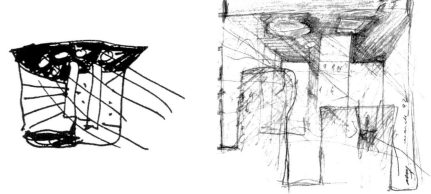

Caja Granada Headquarters Bank by Alberto Campo Baeza.
Clockwise from top left: model; finished building; sectional study; conceptual sketch.

catalyst of undefined perceptual opportunities. In the process, we are discovering a hidden magnitude in the immaterial aspects of buildings, and the 'other' plane along which architecture has evolved since its origins. The most familiar of these planes, being immediately useful and easily controlled, is the world of form. This is the realm of mass and material, solid and void, decoration and surface – permanent and stable aspects of buildings that a person can physically touch, measure and inspect, and shape for physical habitation. But equally significant, if more elusive and often unspoken as it lies largely beyond the capacity of words, is the world of light, which exists independently of the objects it clothes. This is the realm of ambience and mood, shadow and reflection, tonality and temperament – ethereal and fluid aspects of buildings that a person can apprehend and feel through circuits of perception and sensibility; as the poet might say, can touch with the soul but not with the body, nor order or measure by use of the mind. The very term 'light' implies that architecture can go *beyond* the physical level, and take on a metaphysical reality that is only possible once form is immaterialized.

For those architects now leading the way towards a *phenomenal architecture*, daylight is understood as something more than a commodity, whether for illumination or sustainability, dogma or propaganda, and material form has become a tool to shape something more important than itself. Just as the true value of a violin or piano for a musician lies in the ravishing sounds it generates, so the physical edifice for today's virtuoso architects of light serves as an instrument with which to shape marvellous phenomena out of radiation from the sky. In the course of their work, these architects envision streams of light as a primary force in the initial conception of a building, often stripping volumes bare of all but the essentials so that light itself becomes the main subject. They employ scale models to study how light currents are guided and moulded by built forms, experimenting with fluent energy in the same way that musicians rehearse to refine acoustic currents in air, and speak or write about these ineffable qualities with unprecedented clarity and passion.

A basic idea shared by architects who manage light to create places that are perceptually fluid – and thus never precisely the same from person to person, or moment to moment – is that the essence of building is experiential, defined largely by how sublime light presents itself at the *very moment* it is visually encountered. But these interactions also enable us to concretely experience aspects of existence that would otherwise remain hidden within us, presenting us with a paradox. For while it is true that nothing would be visible without light, light also makes it possible to express and show to the mind's eye things that elude the physical one. In helping redefine the relationships of people with the environment and with themselves, a world of phenomena is being created which shares an emphasis on *being* rather than *seeing*, and upon which every percipient is invited to inscribe his or her own experience – a world that is intensely human precisely because it only takes shape through a person's creative imagination.

EVANESCENCE

ORCHESTRATION OF LIGHT TO MUTATE THROUGH TIME

1 EVANESCENCE
Orchestration of light to mutate through time

While buildings may be physically static, their ability to register changes and movements of natural light allows them to perceptually transform and display signs of life: deadened volumes begin to stir when beams of light pierce into rooms or glide over walls; mute objects take on moods derived from the weather or hour of day; shadows appear as a palpable presence and thin or deepen, soften or sharpen according to how they are cast onto walls or settle in space. Spaces brighten or dim in relation to their allotment of sun, seeming to fall asleep and come awake as they respond to what flows across the sky. More than anything else, it is these quiet perturbations that allow architecture to rise above its physical limitations and mirror the rhythms of our innermost life.

Buildings shaped to reveal and celebrate the flux of energy found in the sky destabilize some of the most fundamental aspects of conventional architecture. As the finality of architecture dissolves into a state of impermanence, attention is drawn away from a traditional emphasis on form and object, the rational and the measurable. But equally intriguing is the way fluid light constructs a greater world of space, drawing the sky into rooms and painting its distant presence on walls. Terrestrial buildings are inscribed with a celestial domain, and allowed, in Bachelard's words, to 'inhabit the universe', just as the universe comes to inhabit the building.[12]

The foundations of this way of looking at architecture were laid in prehistory by builders who sought to link their forms with the power of the cosmos, often by framing the rising and setting of heavenly bodies. The moon and stars, but especially the sun, were considered deities whose emissions of energy governed all rhythms of life on Earth, and whose metamorphoses expressed a holy presence and resurrective power. The dawning flash of sun over the Heelstone at Stonehenge (below), down the shaft of an Egyptian temple, or into the apse of a medieval church marked a periodic return of the gods (or God) and a link with the revolving heavens. Through openings aimed carefully towards the horizon, light was induced to perform what historian Mircea Eliade calls a 'hierophany', in which the coming of light constitutes a numinous arrival – a divine force that is active, compelling and alive.[13] Reappearing light demonstrated also, for the believer, an emergence of spiritual energy out of the darkness, whose cyclic return and endless beginnings gave visible hope of a cosmic order.

Contemporary architecture's rediscovery of ephemeral light, which asserted itself in the 1960s and 1970s, coincided with the emergence of the new science of archaeoastronomy and its findings that the primary purpose of many ancient buildings was to expose and extol the behaviour of the universe. This period saw the detection of solstitial alignments in archaic monuments around the world, from Ireland's Newgrange to Cahokia in Illinois, as well as the appearance of several influential books – among them the republication in 1964 of Norman Lockyer's *The Dawn of Astronomy*, followed a year later by Gerald Hawkins's *Stonehenge Decoded*.[14] These archaeological discoveries and speculations raised a startling thought about architecture, namely that since prehistory one of its essential aims has been

Stonehenge, England.

to reach for and incorporate the sky, and to look to the heavens to satisfy an enduring human need for orientation and perspective.

While a mythic dimension is still present, today's architecture shows a broader fascination with the enlivening powers of energy itself. Rather than giving sole emphasis to key directions or moments within the solar course, believed in the past to mark crucial events and turning points of cosmic energy (notably the rising or setting sun at equinoxes and solstices), interest is now focused on propelling buildings into motion for lengthier periods, with a succession of images that wax and wane in emotional intensity. Fluent energy and visible motion also provide a means to express the widespread belief, perhaps defining our age, that space can no longer be understood apart from time, and that reality includes a fourth dimension, a temporal one in which light and time are one and the same.

Even where a redemptive light is introduced to twentieth-century churches, its temporal forms are far more elaborate and prolonged than in the past – no longer restricted to dawn or dusk, and defined instead by lasting progressions that contain sudden aberrations and unexpected motions. Aalto's Vuoksenniska Church (1959; right) and Le Corbusier's monastery at La Tourette (1960), for instance, are defined not by privileged moments, but by prolonged sequences of light and shadow, which arrive and disappear in various locations and ever-new forms. Similarly, the unhurried ebb and flow of energy develops in Kaija and Heikki Sirén's Student Chapel (1957) around a midday filtration of sun through timber trusses, in Reima Pietilä's Kaleva Church (1966) as radial sunbeams into a circle of concrete frames, and in Paul Rudolph's Tuskegee Chapel (1969; below, left) as parallel rays that creep down and up brick walls.

Among contemporary architects, Tadao Ando is especially adept at detonating buildings with passing sun at preordained hours of the day, and applying this flow equally to a house or office as much as to a chapel. Ando's Koshino House (1981; below, centre and overleaf) and JUN Port Island Building (1985; below, right), no less than his Mt Rokko Chapel (1986; see p. 59) and Water Temple (1991; p. 24), are formed to receive light as an elabo-

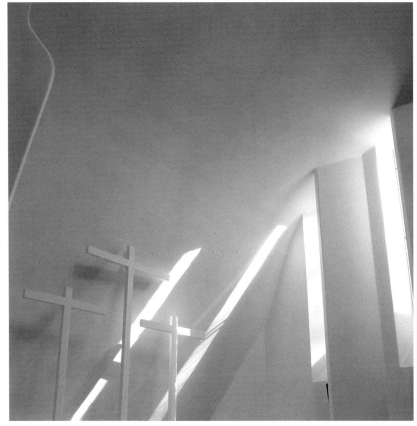

Vuoksenniska Church by Alvar Aalto.

rate unfolding of liquid shapes and shifting brightness, whose movements are dramatized as they wash over and transform the naked concrete. These phenomena strive, Ando explains, for a 'feeling of transience' and 'passing of time', in which two different modes of temporal existence become fused – 'capturing the moment while giving glimpses of eternity'. Ando's cinematic arrangements originate in Eastern thought, particularly the feeling for beauty in ephemeral nature that pervades Japanese culture – a love for the phases of moonlight, the transitional moods of autumn and spring, cherry blossoms and

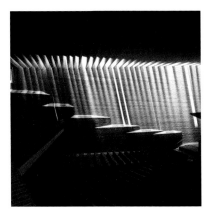

Tuskegee Chapel by Paul Rudolph.

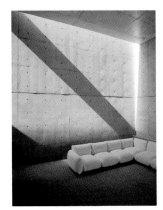

Koshino House by Tadao Ando.

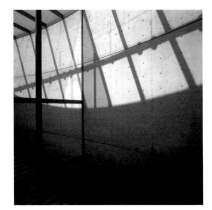

JUN Port Island Building by Tadao Ando.

morning glories, fading dusk and fleeting mist. Philosopher Daisetz Suzuki finds the roots of this 'momentaristic tendency' in Zen Buddhism, observing that, in Japan, 'changeability itself is frequently the object of admiration. For it means movement, progress, eternal youthfulness, and it is associated with the virtue of non-attachment, which is characteristically Buddhistic as well as an aspect of Japanese character.'[15]

Another Japanese architect for whom transitory light is a central concern is Shoei Yoh. In a series of small houses with evocative titles such as 'Light-Lattice' (1981; p. 28), 'Sundial' (1984; below, left) and 'Cross of Light' (1985), Yoh has reconceptualized the window into a network of cracks, turning the dwelling into 'a sundial that reveals the passing of time'. A more painterly moment develops outside on the stainless-steel skin of his Light-Lattice House, its satiny finish as sensitive to the spectrum of sky as are Kahn's stainless-steel panels at the Yale Center for British Art (1974), intended to appear on an overcast day like a 'moth' and on a sunny day like a 'butterfly'. The pearly greys of Yoh's steel cladding deepen at dusk into rich violets, outlined in yellow where tungsten light leaks through, the opposite hues strengthening one another through contrast.

Spurring the recovery of transient light in Western architecture have been similar developments in the visual arts, notably the investigations of mutating light by artists James Turrell, Maria Nordman and Susan Vogel. Turrell, in particular, has consciously exploited for expressive purposes the perception of light's speed and time span, suspending normal time and replacing it with the time traced by sun and weather (below, centre). The sole purpose of Turrell's *Skyspaces*, including his Quaker Meeting House in Houston (2000; opposite, above), is to open a window onto the sky through which people can 'engage celestial events' and experience 'a sense of standing on the planet'. The outer world is obscured from view so that the sky becomes the room's entire focus, encouraging an intense kind of contemplation on faint shifts of ethereal colour. This flow turns rapid and eventful at dawn or dusk, with dramatic mutations of brightness and hue, progressing at sunset from pale blue to a rich cobalt blue, and then dark ultramarine, only to fade into deepening

purples and finally a velvety black – whose palpable blackness is devoid of stars, due to the ceiling's foreground of light and colour.

Underlying these attempts by architects and artists to concretize time with mobile light is a framework of ideas developed in philosophy. Chief among these are concepts of 'duration' and 'real time', *la durée réelle*, developed by French philosopher Henri Bergson to distinguish between measurable time and the kind of time directly experienced by human beings. 'The duration lived by our consciousness', Bergson writes, 'is a duration with its own determined rhythm, a duration very different from the time of the physicist,' which remains homogenous and identical for everyone.[16] If the former is a subjective and qualitative time, the latter is objective and quantitative. Making experiential time possible is human memory, which 'imports the past into the present' and 'contracts into a single intuition many moments of duration'.[17]

American philosopher Susanne Langer expands on Bergson's time-concepts in her 1953 book *Feeling and Form*. Langer differentiates between 'clock time', whose monotonous ticks can be counted, and the entirely different structure of 'lived' or 'experienced time', whose underlying principle is 'passage' and constitutes 'pure duration'.[18] While the former is 'one-dimensional', the latter is 'voluminous' and filled with 'tensions', whose 'peculiar building-up, and . . . ways of breaking or diminishing or merging into longer and greater tensions, make for a vast variety of temporal forms'.[19] If one substitutes 'light' for 'music' in Langer's description of 'duration', one finds a compelling description of temporal phenomena in recent architecture: 'Light spreads out time for our direct and complete apprehension . . . It creates an image of time measured by the motion of forms that seem to give it substance, yet a substance that consists entirely of light, so it is transitoriness itself.'[20] An additional property of 'duration' is noted by Merleau-Ponty, who suggests that when transient phenomena are experienced in depth, they exhibit a 'temporal perspective' and 'double horizon'.[21] Such phenomena stretch out time, extending beyond the present moment with indications of how they are meant to turn out and finish, but also resonating with an immediate past from which they developed. Duration, therefore, contains a sense of imminence, as well as of memory.

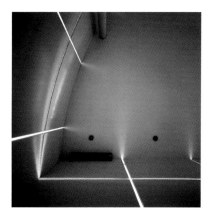

Sundial House by Shoei Yoh.

Light Reign by James Turrell.

Kirkkonummi Parish Centre by Juha Leiviskä.

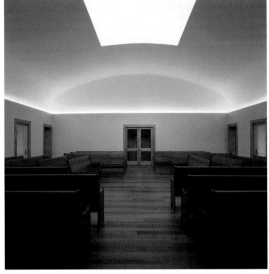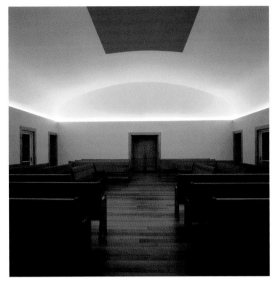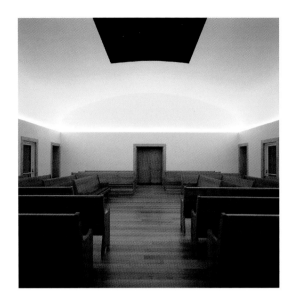

Light sequence in Quaker Meeting House by James Turrell (afternoon, twilight, night).

Many of these ideas found their earliest and most beautiful expression in Scandinavian architecture, especially that of Finland, where the art of building developed around the bewitching extremes and steady rhythms unique to northern light. From sunless winters to nightless summers, and from the haze of a summer evening to lingering winter dusk, Arctic skies undergo astonishing contrasts of intensity and atmosphere. Space and time feel indefinite, suspended in a continuous passage with intimations of decay and regeneration. The mood remains one of drowsiness and dream, inspiring thoughts of what has been and what may be. Beginning with Erik Bryggman and Alvar Aalto, Finnish architects have sought to magnify and bring inside the shifting skies that define their world. Aalto pioneered many techniques to make his buildings mutate with light, from the fanned-out wings of the Paimio Sanatorium (1933), intended to follow and trap therapeutic sunshine, to the brickwork of the Säynätsalo Town Hall (1952), laid at slight angles to catch arcing sun.

Finnish 'duration' reaches its artistic peak in the contemporary churches of Juha Leiviskä (opposite, right). Displayed is a command with mobile phenom-ena as persuasive as that found in cinema; one could well apply to Leiviskä's light the term coined by film-maker Andrey Tarkovsky to describe film direc-tion, 'sculpting in time'.[22] Leiviskä's slowest and most leisurely effects derive from ambient colours of sky and weather on bare white walls, whose tones are so subtle one can miss them, and so slow they can only be grasped over the course of a day. More accelerated are the complex arrivals of sun before noon, whose startling entry into churches such as Myyrmäki (1984; p. 30) and Männistö (1992; p. 34) is closely tied to religious ritual: 'In my churches,' Leiviskä notes, 'the sun is to enter at the end of the morning service.'[23]

The rising and falling of energy in churches by Leiviskä, also a pianist, bear close analogy with the ebb and flow of tensions in music. He compares his light to 'whispering sounds', 'polyphonic music', and the 'fugue'. Slow spurts and cascades of illumination are as finely tuned as if the building itself were a musical instrument, attained architecturally by adjusting the size of gaps between walls and extending walls to cut off the sun at particular times, thereby giving each plane its own unique optical moment and pressure within

Light sequence in living room of Koshino House by Tadao Ando.

a larger sequence. These slits are then grouped into rhythmical sections to construct an overall 'image of time', to use Langer's term. Light may travel down one plane as an opening beat, to be augmented by light wandering over neighbouring walls, with certain walls making a stronger impression according to their radiant streaks or transparent colours, often with foreground and background planes taking turns in the composition, but always leading to a climactic radiance with liturgical timing.

Scandinavia is not the only place in Europe where architects are fusing light and time. In a series of buildings reduced to austere white voids, leaving little present but drifting light whose ambient flux is surrounding and enveloping, Alberto Campo Baeza has raised questions about the nature of architecture itself. These thoughts are most strongly developed in a series of buildings near Cadíz, notably the Gasper (1992; see p. 185), Asencio (2001; p. 36) and Guerrero (2005; p. 40) houses, where the primary material is not plaster and paint, but light and shadow put into play by the intense Mediterranean skies. Rather than concentrate on selective walls, Campo Baeza employs a range of discrete openings to open up volumes to multiple points in the solar course – skylights to draw in zenithal light, clerestories to capture diagonal rays, low windows to gather horizontal light from patios – but also to open views to tonal displays on the perimeter walls. The words used to describe archaic architecture by Swiss philosopher Max Picard in his profound book *The World of Silence*, first published in 1948, could well apply to Campo Baeza's houses, within whose walls 'the heavenly spheres and the rays of the sun lived again on Earth, and in their silence one heard their movement in the sky'.[24]

A consciousness of time is raised twice each day, at sunrise and sunset, in Swiss architects Herzog & de Meuron's Dominus Winery (1998; p. 134). Conceived to cut the heat and glare of the Napa sun while admitting cooling breezes, the porous walls of caged stone allow horizontal rays of light to percolate through their network of cracks. Projecting inside are thousands of sparks that trickle over floors and splash onto glass to double the scintillation. Reminiscent of Moholy-Nagy's *Light Machine*, as well as Otto Piene's *Light Ballet* of 1964, the mobile projections do not appear tied to any location, but wash through space and fill the air to dapple every surface, including the people who walk by. At these transitional moments, a spell is cast over the interior, giving the simple stone box an optic sensation that is plainly sensuous and has the power of a trance.

Suggesting another dimension of decelerated time are the video works of American artist Bill Viola, whose principle technique is to slow down film and thereby attain what critic Walter Benjamin, referring to cinematic slow motion, calls 'an immense and unexpected field of action'.[25] In films such as *Catherine's Room* (2001), Viola incorporates what he calls 'simultaneous levels of time', where the same room, differently furnished, appears concurrently on five screens at varied hours under contrasting light.[26] In addition to the 'real time' of human action, there is, in Viola's words, the 'parallel time' of life unfolding in different rooms at the same moment, and the 'natural time' of penetrating light as it develops with the hours and seasons, 'manifesting the larger sense of Nature Time in our own bodies'.[27] Simultaneous flows of this kind have been a concern of Viennese architect Heinz Tesar, who weaves together three different temporal currents in his Donau City Church (2000; below and p. 138). While the exterior undergoes a daylong change in the hue of its dark steel skin, the interior is awakened early and late by a solitary sunbeam angling down the altar wall from either of two corner lanterns, in each case aiming a finger of light onto the room's spiritual centre. A slow and dispersed countermovement occurs in small pencils of sun from countless circles cut into the walls, whose brilliant spots glide over the floor.

Steven Holl draws on both Bergson's 'duration' and the Buddhist belief in 'continuous flux' to propose a mode of architecture where sensory phenomena continually mutate, and are imbued with both memory and future. At the heart of this notion are such phenomenological concepts as 'Speed of Shadow' and 'Pressure of Light', both tentatively broached in his unbuilt Palazzo del Cinema in Venice (1990). Inspired in part by cinema, these ideas connecting time and light include what Holl calls the 'diaphanous time' of water reflections and the 'absolute time' of a Pantheon-like sunbeam. More adventurous experiments with mobile light take centre stage in Holl's

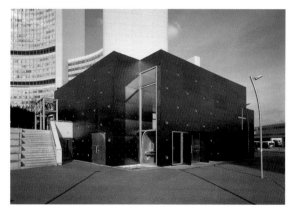
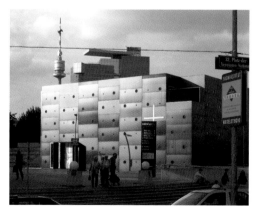

Light sequence at Donau City Church by Heinz Tesar (afternoon, sunset).

projects for a Museum of the City in Cassino and Centre for Contemporary Art in Rome (both 1996), as well as the Sun-Slice House on the Lago di Garda (2008). Models are employed and photographed to test the sun's transit from various slits, whose radiant lines bend as they wrap around angles of wall or floor. In order to visually 'score' these cinematic motions, an idea explored in the 1920s by Moholy-Nagy and more recently by Bill Viola, Holl clusters photographs, similar to a cinematic storyboard, to produce composite images of moments in time (below).

'Time, or duration, is a central theme of the interior,' Holl writes of his St Ignatius Chapel (1997; p. 44), but also present, as at Le Corbusier's mid-century Ronchamp Chapel (see p. 10) and La Tourette Monastery, are simultaneous cycles analogous to the almost imperceptible 'coexisting time states' of Viola's video panels.[28] Metaphorically expressed as 'bottles of light', the chapel's seven rooftop scoops catch assorted angles of sun and sky, and guide their fluid intensities below. These differences result from the varied orientations and diameters of the 'bottles', as well as from the mysterious double tintings of light as it passes through hidden stained-glass lenses and reflects off complementary hues painted on the rear of the baffles. Thus one gazes inside upon many different phases of light, each caught at a different moment of waxing and waning energy and colour.

Coming closest to Moholy-Nagy's disembodied 'light frescos' and 'light symphonies', envisioned over half a century ago, are the shadow play in Martínez Lapeña-Torres Arquitectos' sunscreen along Palma de Mallorca's ramparts (1992; right) and, conversely, the washes of colour cast onto walls by glass artist James Carpenter. Startling patterns of saturated hue are entirely free of any built form in Carpenter's installation at Edward Larrabee Barnes's Sweeney Chapel (1987; p. 48). When the late-morning sun strikes an egg-crate of clear glass in the east window, whose shelves contain sheets of transparent dichroic glass, complementary colours of light appear magically out of thin air, to roam about the altar space.[29]

All of these architects who are conceiving buildings to detonate and be gently perturbed by the course of the sun are endowing the environment with

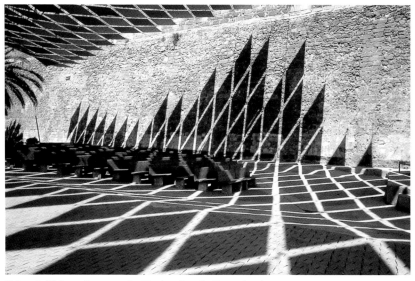

Palma de Mallorca Sunscreen by Martínez Lapeña-Torres Arquitectos.

a picture of reality that is no longer Euclidean, or in a steady state, but is continually changing. In doing so, they are moving beyond the limits of a field defined principally by physical facts, and are exploring aspects of architecture that derive more from a process than from a state. But equally important in these transient works, whose range and expression are unsurpassed in the history of architecture, is their radical and irreversible transformation of human perception. The impact is not merely visual, for their rhythms correspond to our own diurnal flow of moods and bodily cycles. Significant as well is their demand for a definite time of perception, requiring that we linger for minutes, even hours, in order to savour their metamorphoses. Visitors are required to *invest* time in order to *experience* time. We need to slow down to experience the *durée réelle* these buildings provide, and depend less upon retinal images than on a flowing blend of thought and imagination, feeling and perception. It is this rhythmical continuity that forms the basis of an inner world for all living things, and offers the architect a means – which is immediately and universally understood – of relating buildings intimately to life.

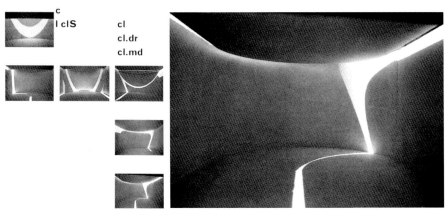

Light Score for Museum of the City by Steven Holl.

Mobile shadows on concrete wall and white pebbles.
Opposite: Light slot of staircase.

Water Temple, Japan Tadao Ando

Several kinds of transient light are exploited at this temple, built in 1991, on Japan's Awaji Island to visualize the resurrective beliefs of its Buddhist sect. Large and free-standing concrete walls, through and along which the labyrinthine approach is wound, display huge patterns of sun and shadow that slide and mutate throughout the day. One then arrives at, and symbolically descends into, the glowing sheet of a lotus pond, itself symbolic of enlightenment. This womb-like progression culminates in a dark, curving passage that leads finally into a sanctuary, which brightens dramatically at day's end as red light from the setting sun pours through a single aperture. The peripheral darkness and intensified hue of this innermost void are reborn each day as the sun goes down, its warm light further coloured as it filters through vermillion screens to saturate the holy space.

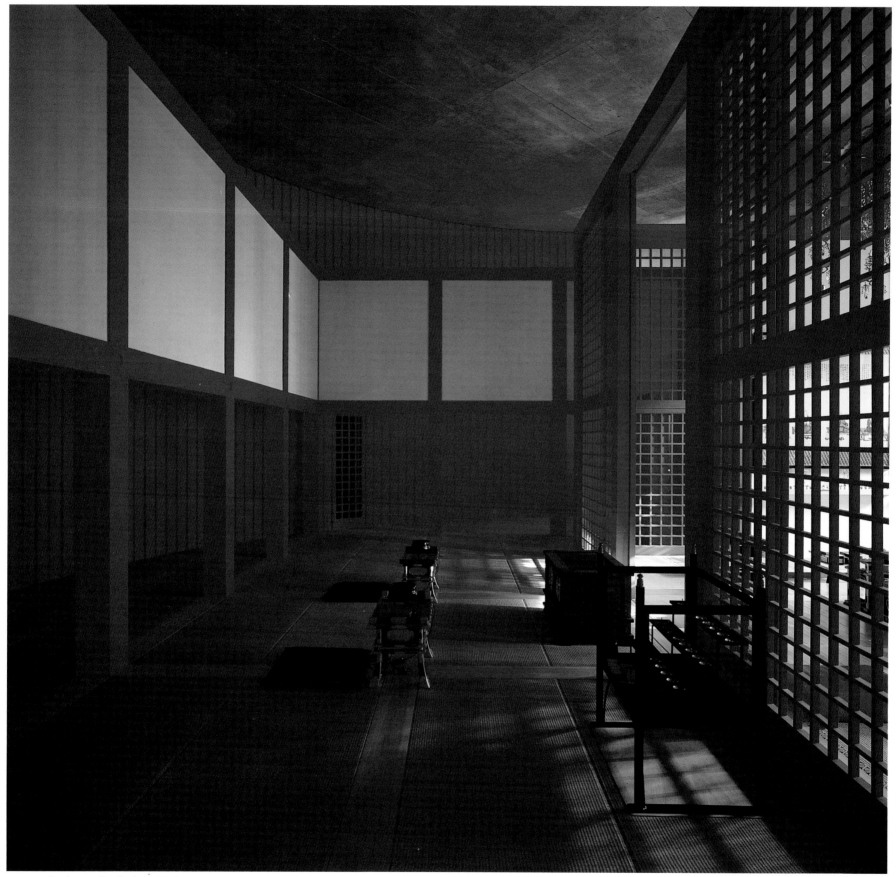

Setting sun flooding into temple.

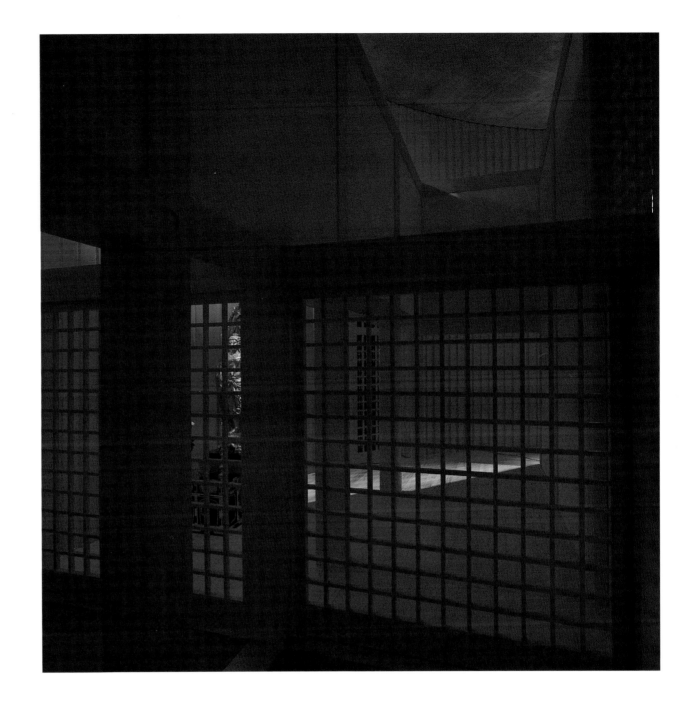

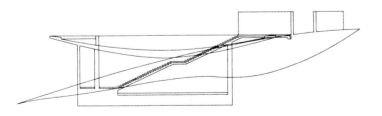 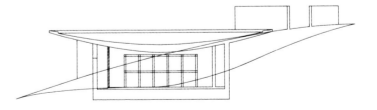

Above: Section.
Top: Saturation of red light at sunset.

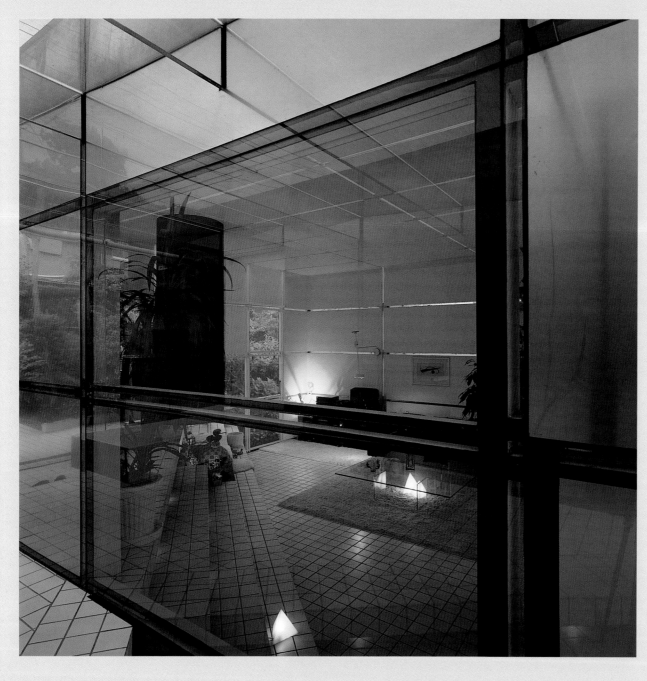

View from atrium into living room at twilight.
Opposite, clockwise from top left: Sequence of sunlight in living room (morning, noon); cutaway perspective view from above; living room at noon.

Light-Lattice House, Japan Shoei Yoh

Gyrating webs of sunshine are cast throughout the day into Shoei Yoh's small house in Nagasaki, which dates from 1981, via gaps left in a double-grid structure of steel channels. Projected patterns double the radiant lines of the envelope and glide slowly about each room. The slant of light records every new angle of sun, and turns dramatically vertical at noon when, for an instant, the distinction dissolves between luminous slits and projected energy. Revealing the sun's imperceptible pace are graph-like coordinates of wall, floor, tile and grouting, over which the solar path is traced.

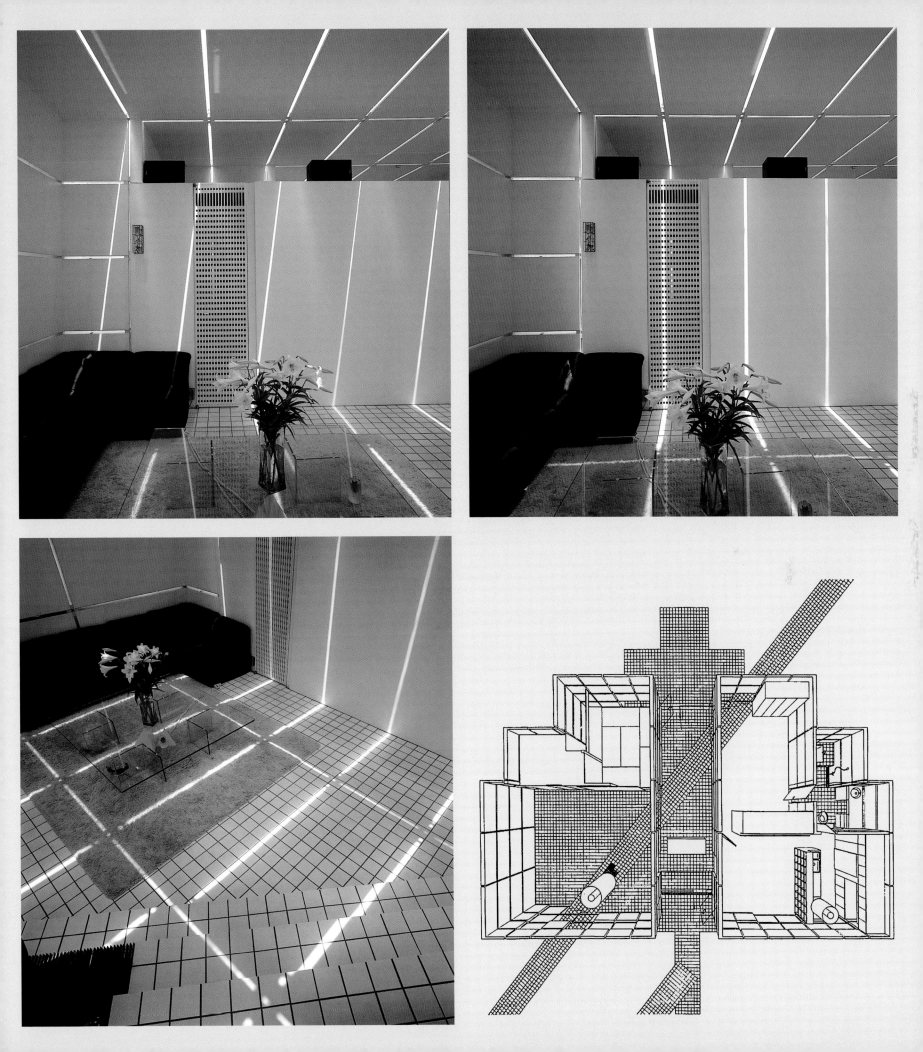

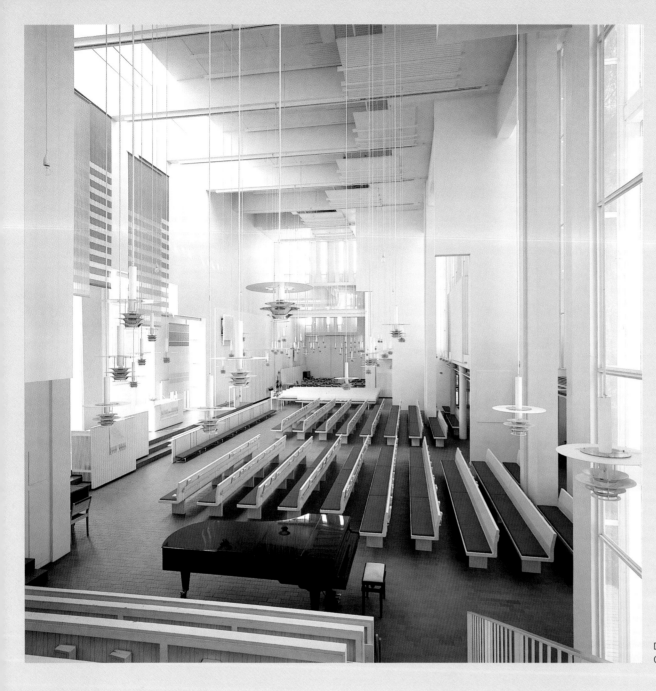

Diffuse white light of overcast day.
Opposite: Crescendo of sun on altar wall.

Myyrmäki Church, Finland Juha Leiviskä

Sunlight never enters Leiviskä's churches all at once, but unfolds in a mounting progression with its own past and future. Slots between wall planes, aimed uniformly south, are illuminated in rapid succession as sunshine enters from the side, raking the surface in a pattern whose angle varies according to the season. While the overall phases are roughly the same – sunbeams crawling down layered walls, to culminate behind the altar before disappearing – the temporal form of each church is unique. At this particular church in Vantaa, built in 1984, the south sun appears gradually from the left and inches down a foreground wall, advancing over tactile boards, smooth plaster and hanging fabrics, to fully light the entire plane facing parishioners, only to suddenly vanish and then reappear in a concentration beyond the altar.

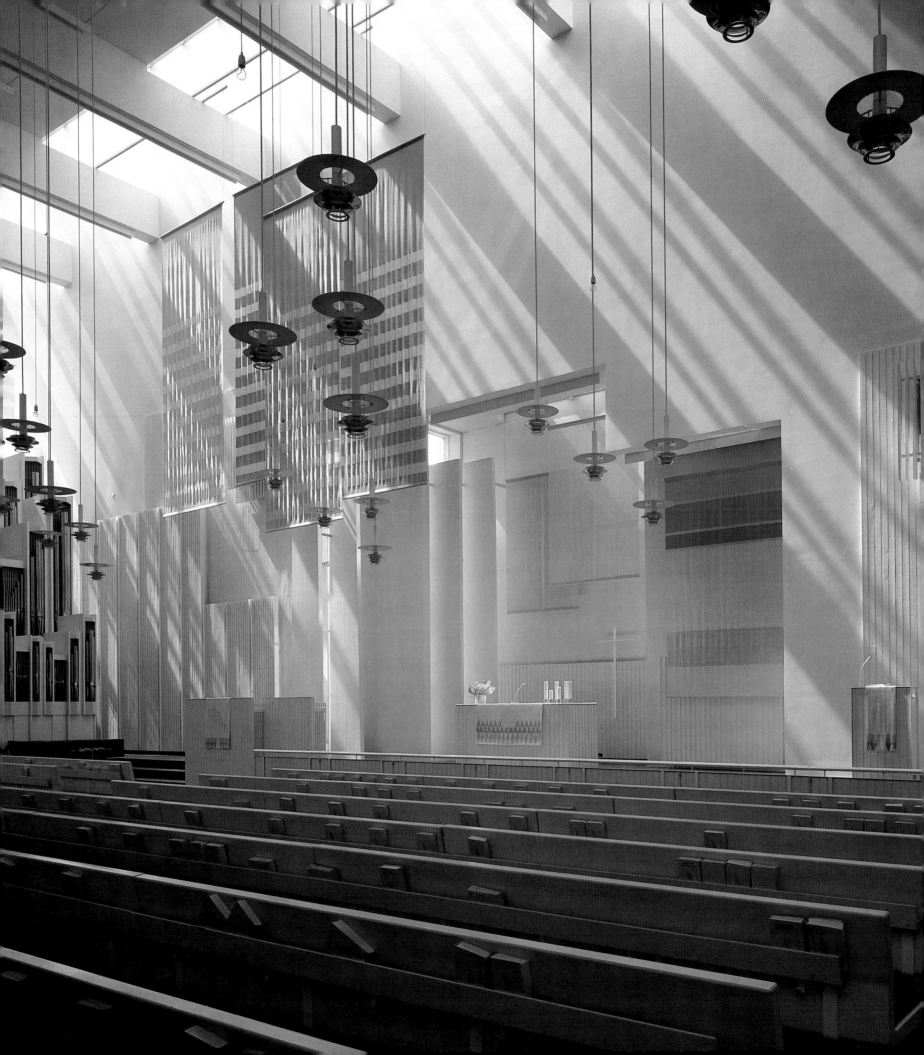

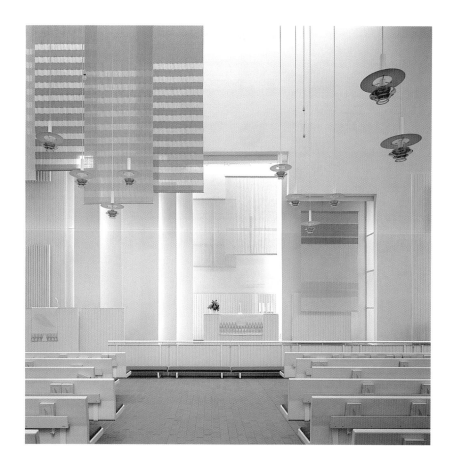
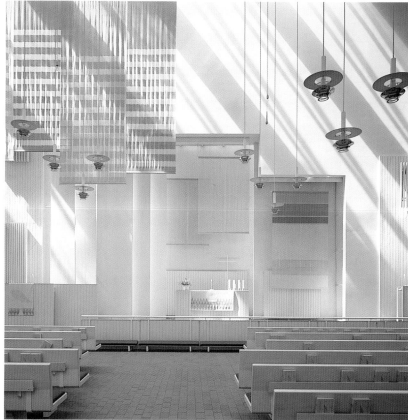
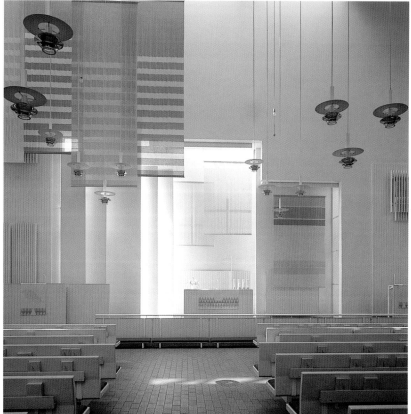
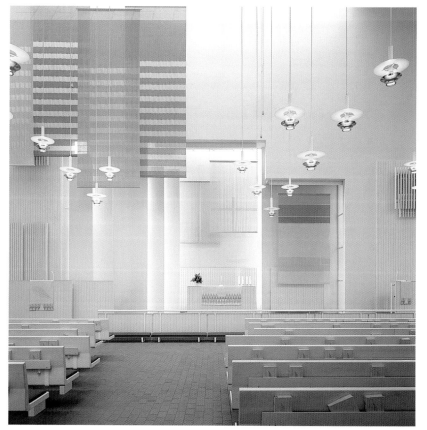

Above, left to right: Sequence of light on altar wall (midday, late afternoon).
Top, left to right: Sequence of light on altar wall (early morning, late morning).

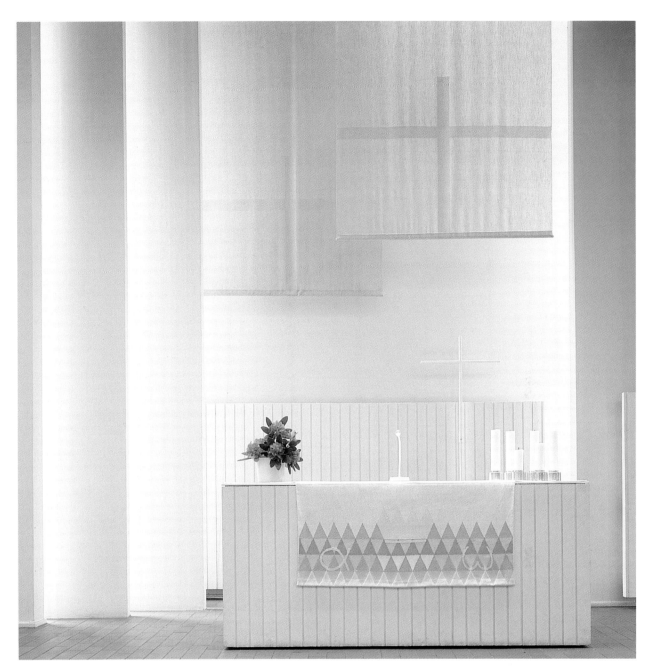

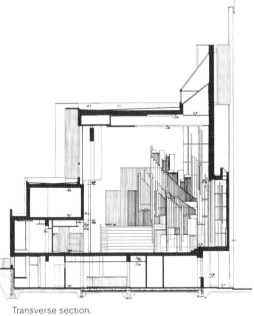

Transverse section.

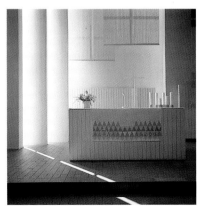

Above, left to right: Sequence of light in altar recess (late morning, afternoon).
Top: Light in altar recess (early morning).

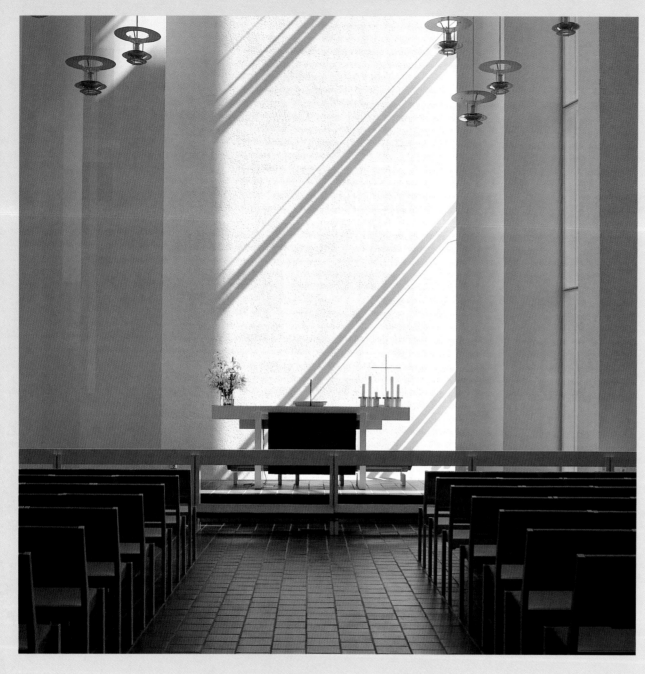

Final note of sun behind altar.
Opposite, clockwise from top left: Sequence of light on altar wall (diffuse white light, reflected colours, receding sun, raking sun).

Männistö Church, Finland Juha Leiviskä

By contrast with his Myyrmäki Church (p. 30), the altar walls at Leiviskä's Männistö Church in Kuopio from 1992 are gazed upon from the west looking east, so that sunshine enters from the right and produces a different temporal structure. The sequence begins with ghosted colours from sun reflecting off hidden paint on the rear of the baffles, followed by a sudden arrival of sunshine as the walls ignite in a great crescendo before slowly fading away one by one, leaving a single vertical plane lit behind the altar as a final notation. In both churches, the appearance and disappearance of light verifies one's own existence in time, while constituting what the Greeks called an 'epiphany' – a sudden apparition that reveals and manifests the divine.

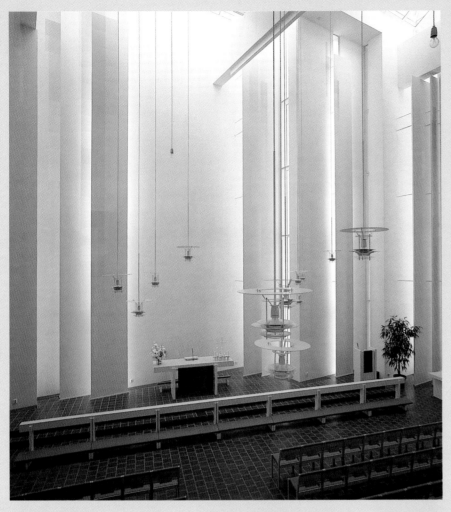
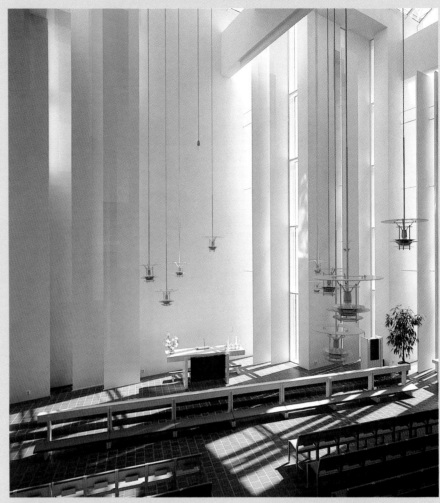
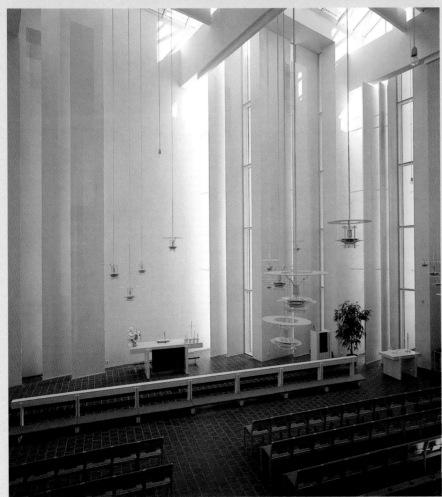
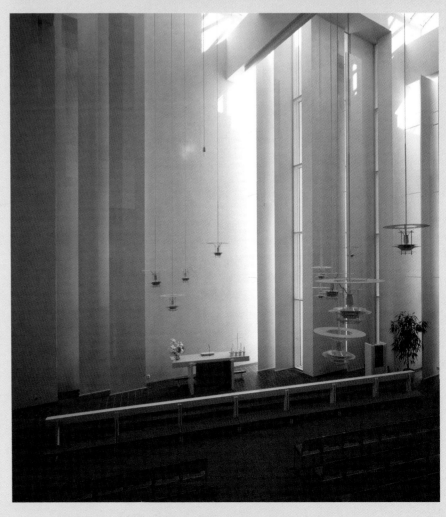

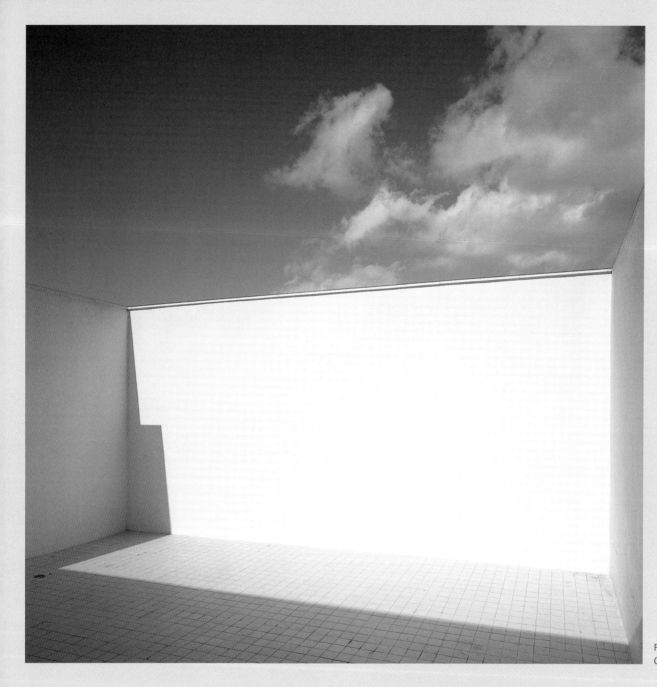

Roof terrace at midday with framed clouds.
Opposite: Coloured light on roof terrace (early afternoon).

Asencio House, Spain Alberto Campo Baeza

The painterly drama at this house in Novo Sancti Petri, dating from 2001, is triggered by the intense sun of the Costa de la Luz, whose energy, according to the architect, 'is the primary material with which the house has been made'. While three sides are closed to the prying eyes of neighbours, the west façade opens to the light through a variety of apertures. Pure white most of the day, the western walls are struck for an hour every evening by the full force of the setting sun, whose rainbow hues penetrate the length of the house through an enfilade of openings. Bluish hues of skylit rooms are combed through with stray beams of yellow-orange, while west-facing rooms pick up sunshine and bounce it around until spaces fill with a soft, gold explosion. Smudged and increasingly dense shadows cast from trees are superimposed over colours, merging impressions of earth and sky in a Hopper-esque moment.

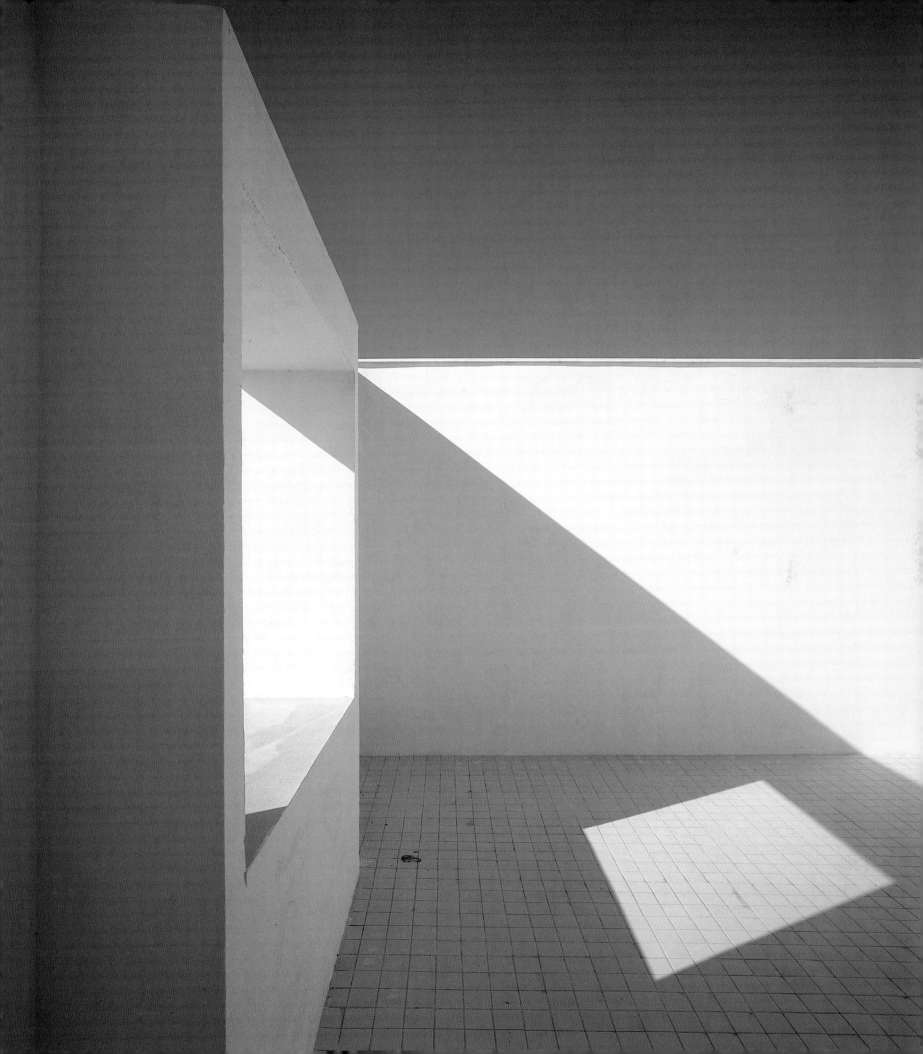

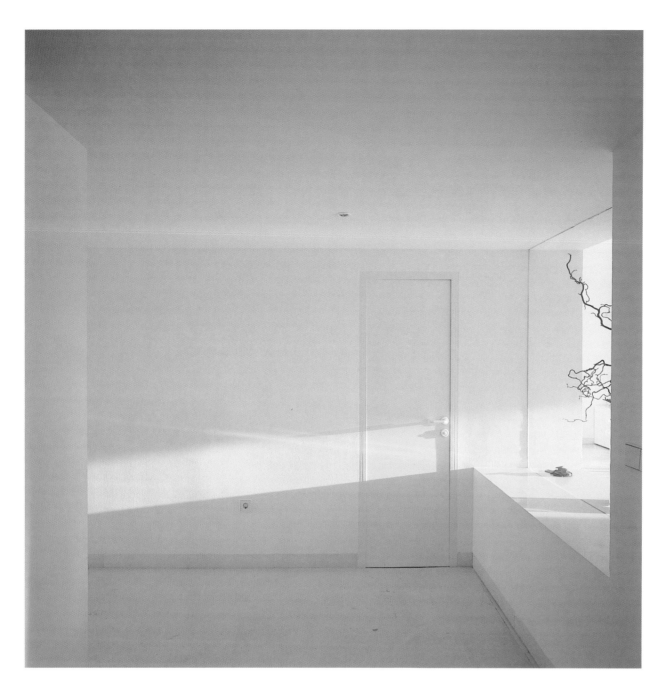

Above: Sequence of light in staircase (daytime, early sunset, late sunset).
Top: Flood of golden light at sunset into centre of house.

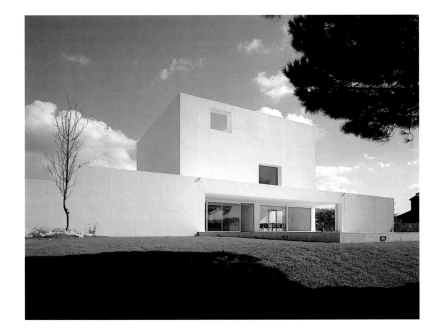
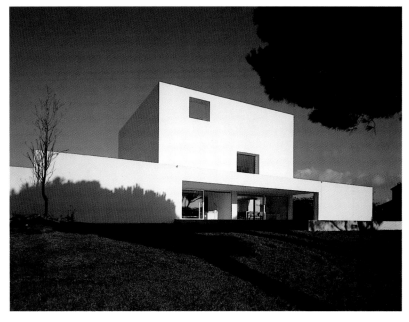
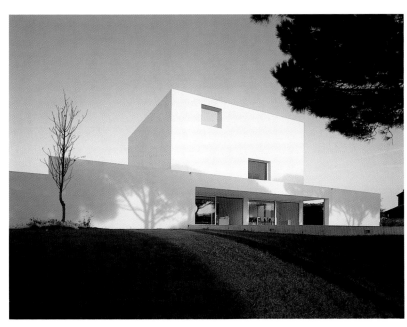
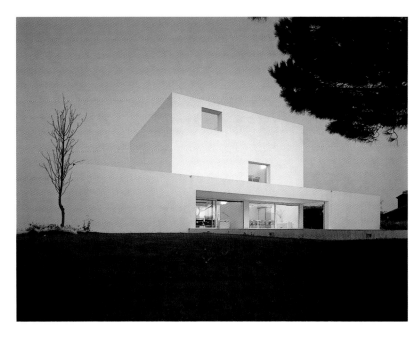
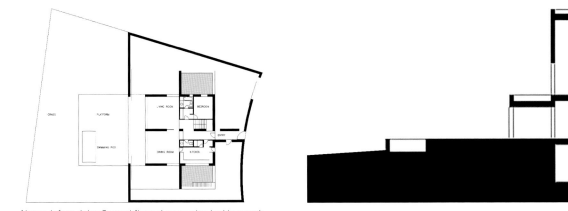

Above, left to right: Ground-floor plan; section looking north.
Top, clockwise from top left: Sequence of light on west façade (midday, early afternoon, dusk, sunset).

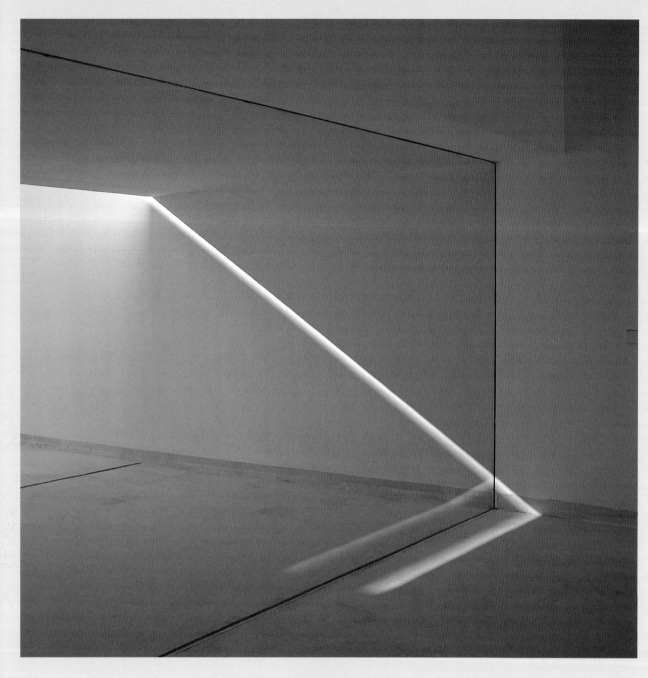

Slice of morning sun.
Opposite: Sunlight and blue shadows on white stucco.

Guerrero House, Spain Alberto Campo Baeza

Underlying the punctured boxes of Alberto Campo Baeza is what the architect calls an 'impluvium of light', pierced to receive a 'fine luminous rain' that 'splashes us with its slow sweep', but also displays the sun's shifting spectrum in 'stains of changing light projected through skylights, to dance on walls throughout the day and create a space suspended in time'. As twilight arrives in the Guerrero House in Zahora, dating from 2005 and perhaps Campo Baeza's most transient achievement, solar displays on its huge white walls slowly shift to deepening yellows, then become traced with orange above gathering blue shadows. They turn pink for a hypnotic moment before finally, ultimately, being overtaken with watery purples.

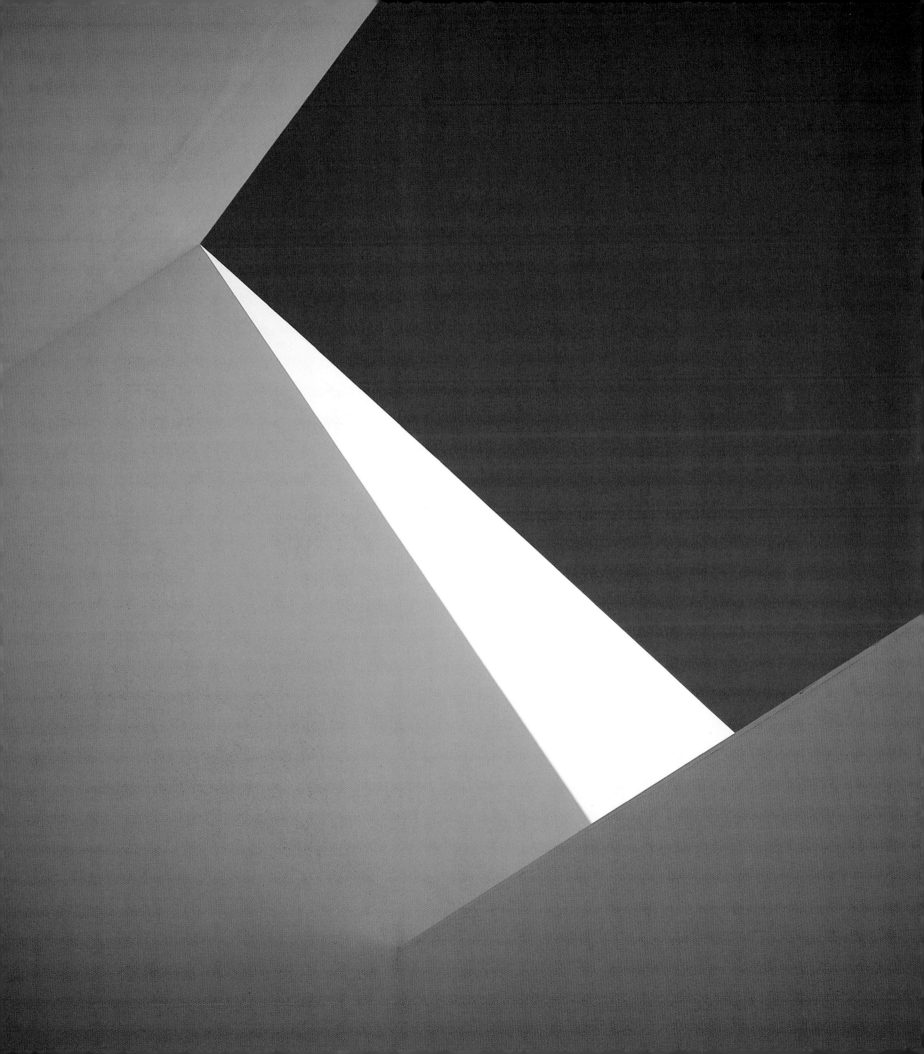

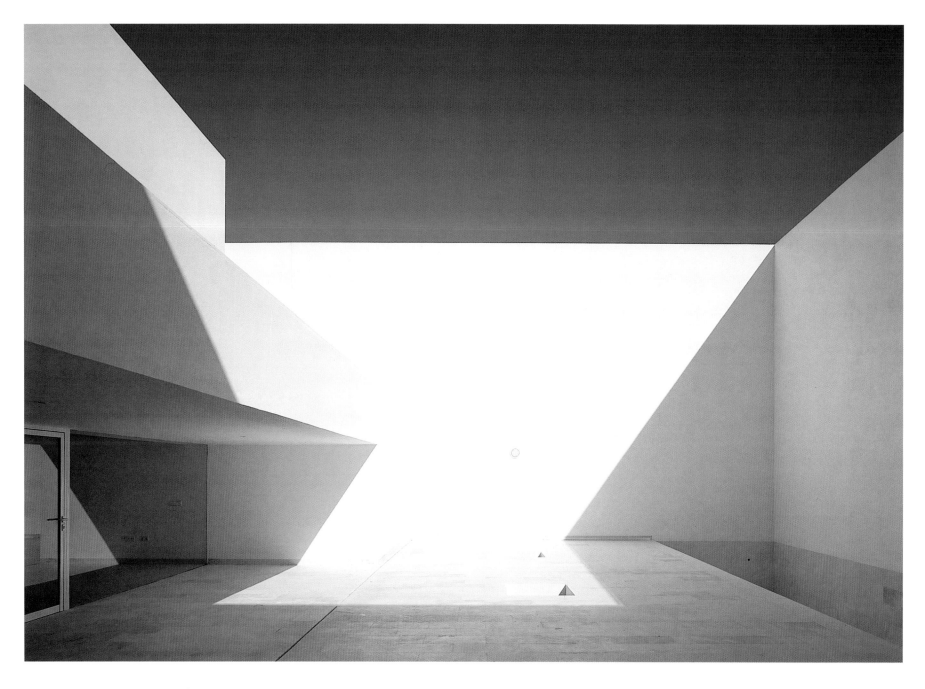

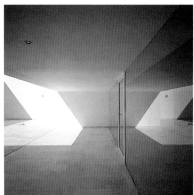 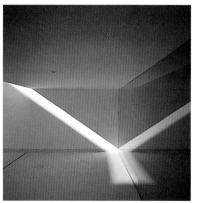 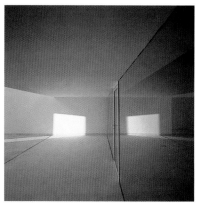 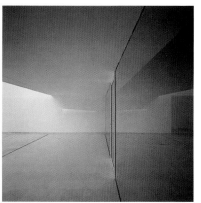

Above, left to right: Sequence of light at covered entry (midday, afternoon, sunset, dusk).
Top: Light in rear court (morning).

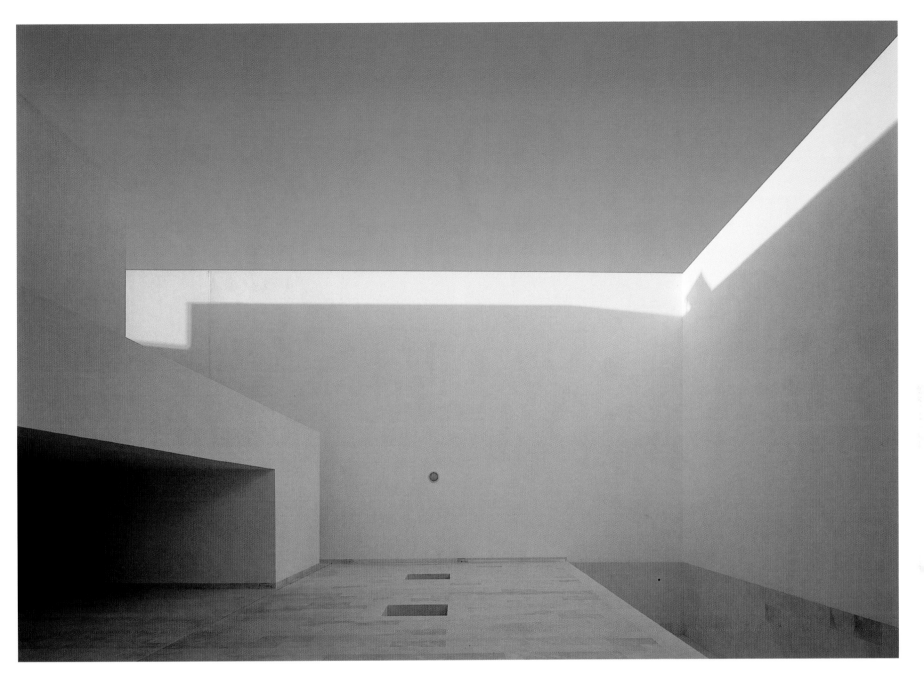

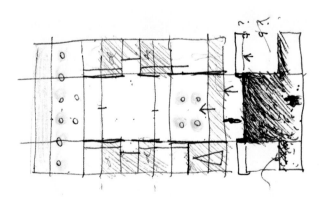

Above, left to right: Plan and transverse section; longitudinal section.
Top: Light in rear court (sunset).

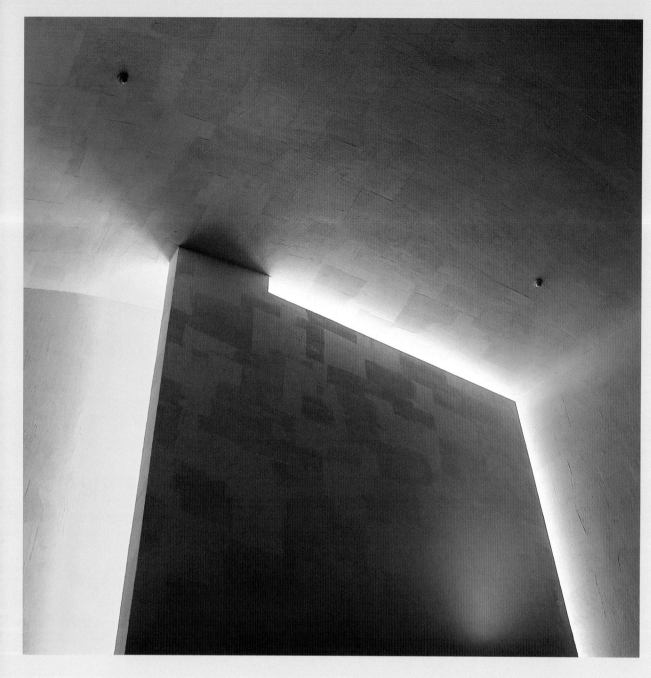

Seeping yellow light.
Opposite: Interior facing altar.

Chapel of St Ignatius, Washington, USA Steven Holl

At Steven Holl's 1997 chapel in Seattle, each 'bottle' of light behaves as a kind of periscope with its own allotment of sun, reminiscent of the directional scoops of Le Corbusier's chapel at Ronchamp (see p. 10) and the circumferential light canals of Alvar Aalto's church at Vuoksenniska (see p. 19). Colours of light wax and wane with the solar course, giving the interior a visible, visceral sense of time. Passing clouds add a further dimension, described by Holl as a 'phenomenal pulse', whose 'oscillating wave of reflected colour . . . invigorates the silent space'. Highlighting these Bergsonian passages are two events: the first occurs at noon, when a flash of sun grazes across the altar wall to spotlight a crucifix and cause the uneven plaster to palpitate; and the second, longer-lasting occurrence is the presence of an orange sunbeam that roams around the Reconciliation Chapel, heightened by its own mutating shape and the scratched plaster on which it lands. Intensifying the orange hue is a purple ambience, whose interplay repeats at finer scale as warm rays skim over plaster ridges, to be combed through with purplish light caught in the valleys.

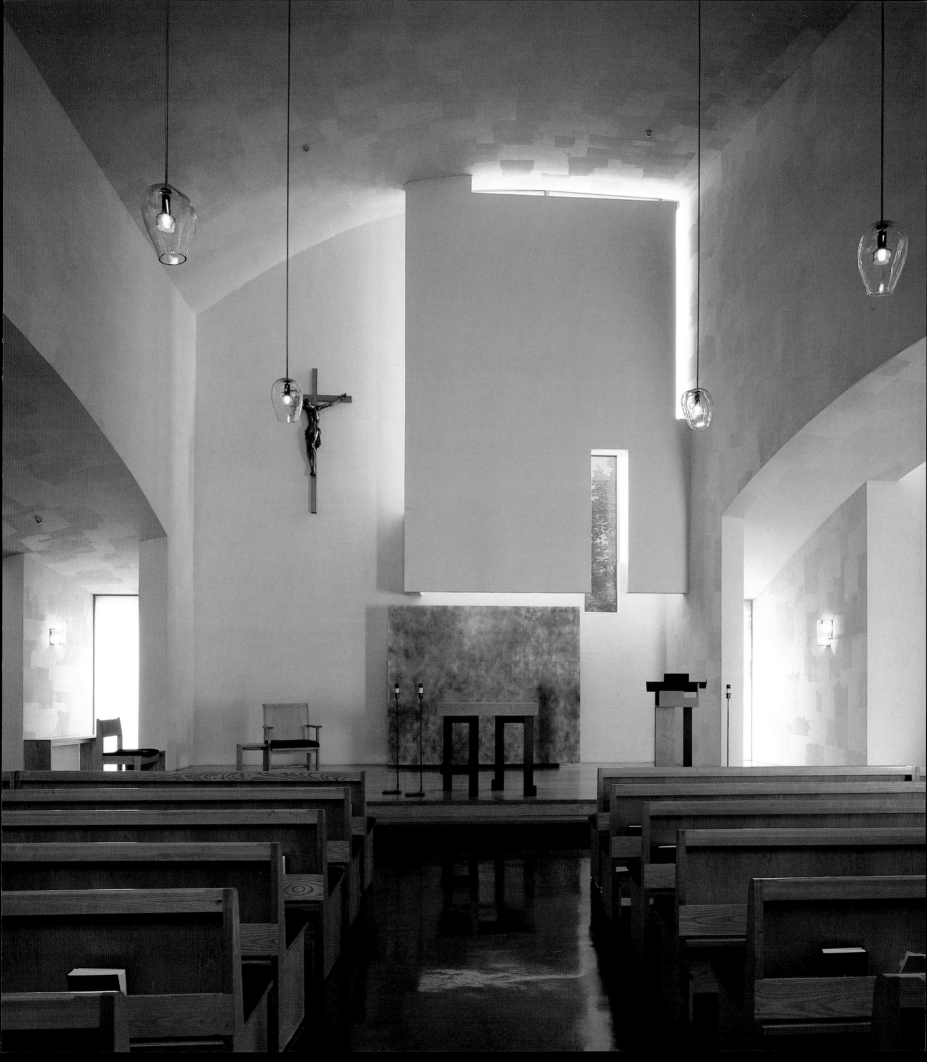

 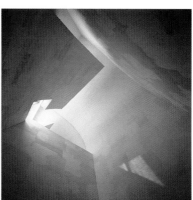 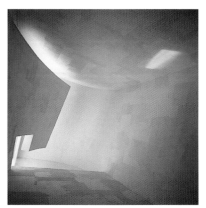

Above, left to right: Sequence of light in Reconciliation Chapel, with 'purple field' and 'orange lens' (midday, late morning, afternoon).
Top: Blessed Sacrament Chapel with 'orange field' and 'purple lens'.

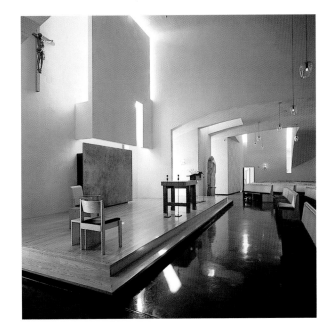
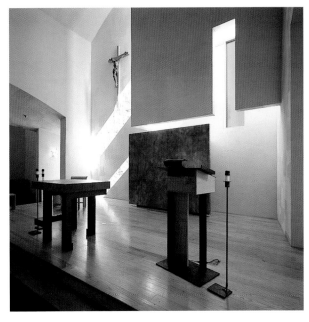
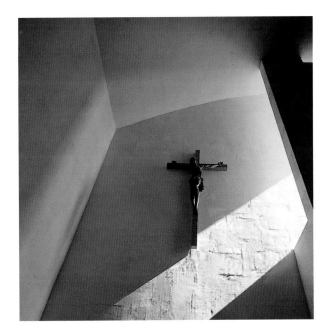
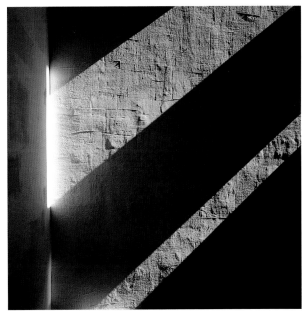
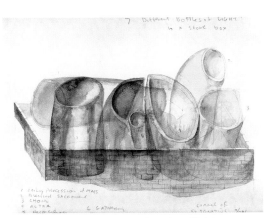
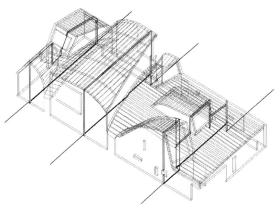

Above, left to right: Watercolour of 'bottles of light'; axonometric.
Top, clockwise from top left: Sequence of light on altar wall (morning, midday, detail of plaster at midday, detail of crucifix at midday).

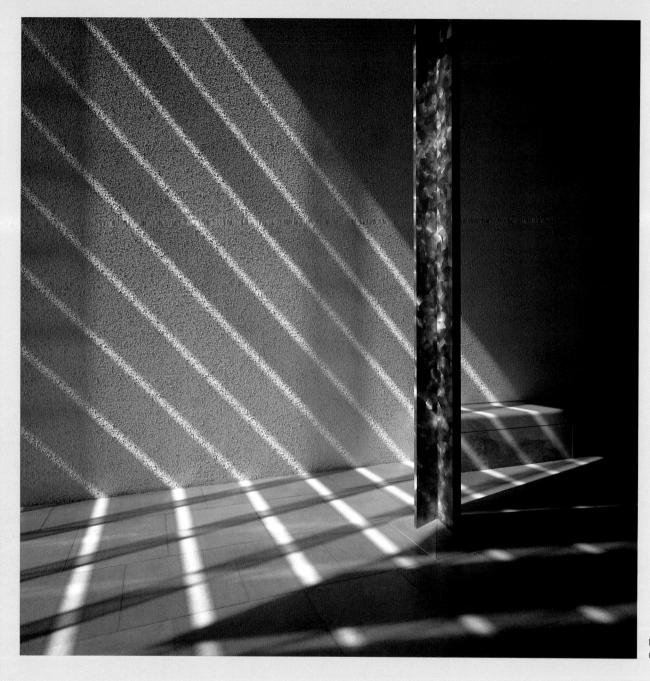

Moment of blue and white light.
Opposite: Upward view of transparent egg-crate.

Sweeney Chapel, Indiana, USA
Edward Larrabee Barnes with James Carpenter

Dichroic glass sheets at this 1987 chapel in Indianapolis, unnoticed in the window lattice of transparent glass, emit criss-crossing bands of blue-green and red-yellow light, whose complementary tones enigmatically appear and play over the altar wall, emphasizing the chapel's focal point. The ethereal images mutate continually in shape and position, angle and hue. Occasionally the colours intermix; at other times warm or cool tones predominate, while their patterns transform in slope and size as the angle of incident sun rises.

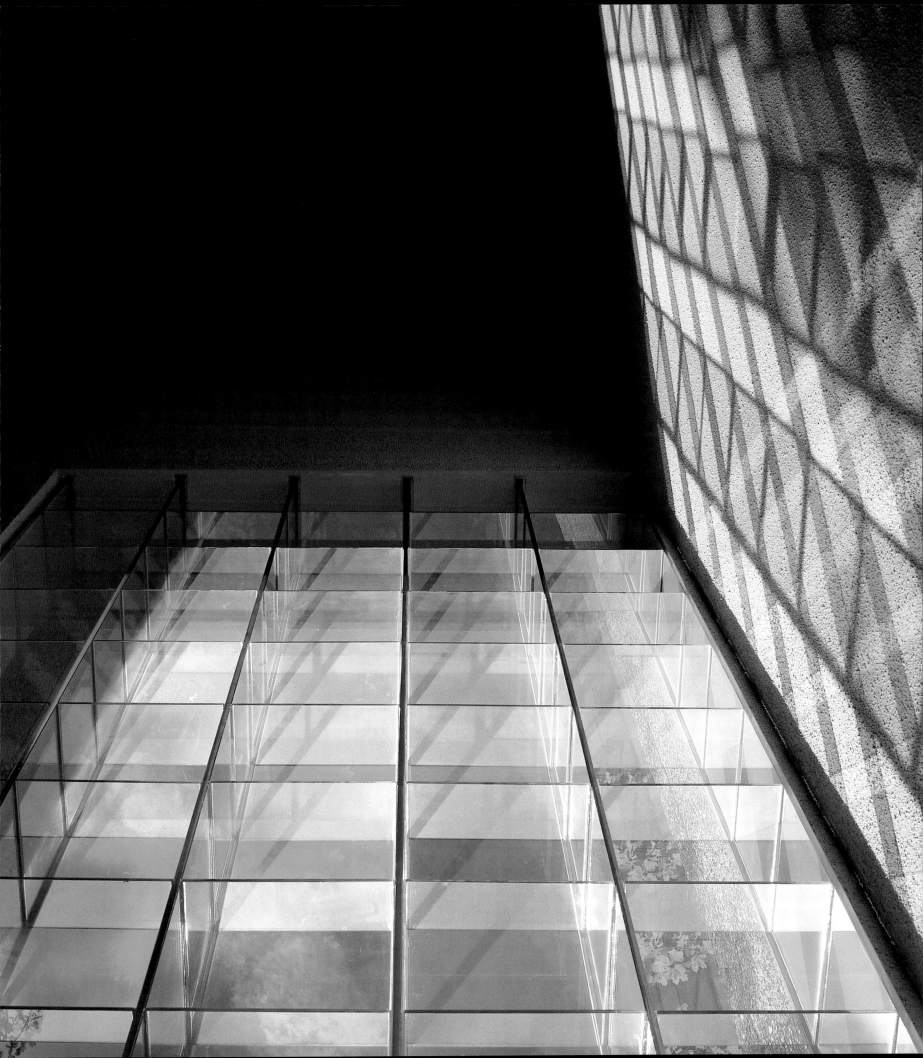

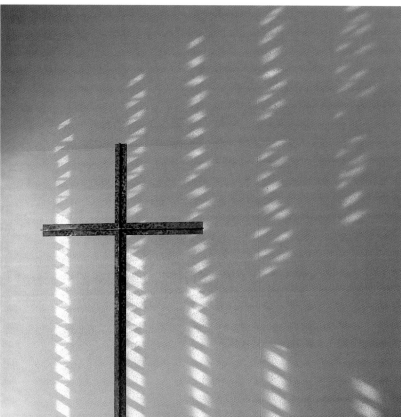
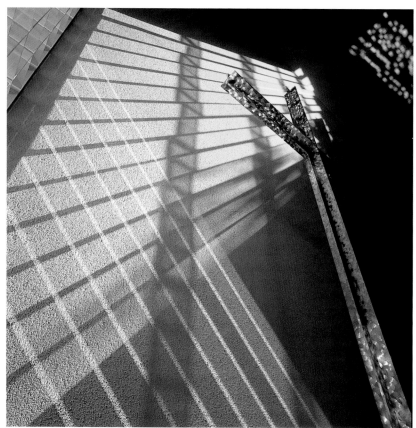

Above, left to right: Light on altar wall (early afternoon); colours projected on altar wall, cross and ceiling.
Top: Sequence of light on altar wall (late morning, midday).

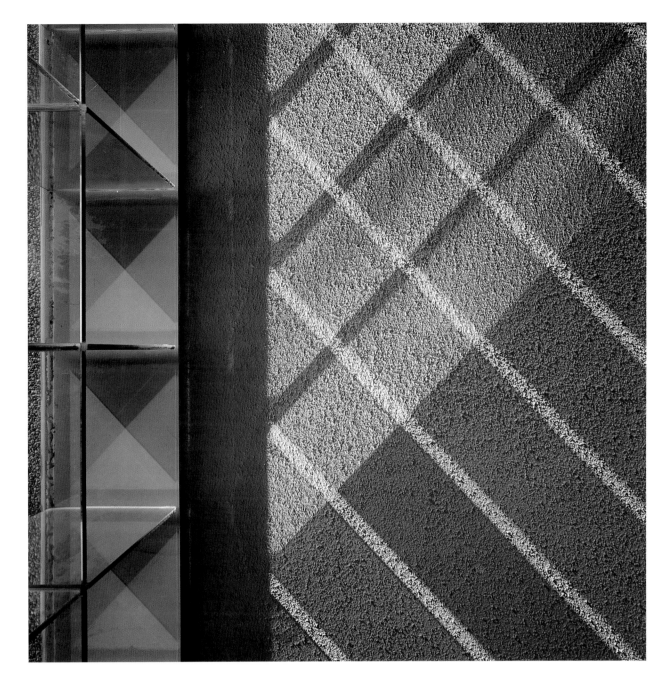

Above: Perspective of glass lattice.
Top: Colours of light on rough white plaster.

PROCESSION

CHOREOGRAPHY OF LIGHT FOR THE MOVING EYE

2 PROCESSION
Choreography of light
for the moving eye

The proverbial 'light at the end of the tunnel', or 'lamp in the window at night', both exerts a visual attraction, and electrifies space with strong perceptual and emotional forces. Underlying this charge is one of Gaston Bachelard's most entrancing 'primal images', which transcends our own immediate memory and provides what is perhaps the deepest felt encounter with light known to people: the loss and then recovery of light in darkness. This psychic condition amplifies the upward tug of a Baroque dome, the horizontal lure of a medieval apse (below), the downward draw of white sand in a Zen temple, the mesmerizing flicker of a skylit arcade or Shinto shrine, and the relief of emerging from a dim alley into a sunny Italian piazza.

Due to its power to seduce and attract, light has always played a pivotal role in successions of space that are rewarding and memorable. It is not single, isolated moments or views that are important for the moving eye, but a continuous flow of human perceptions – an experience based, argues Edmund Bacon, on the 'modular rhythm of footsteps' and the 'relationship of spaces to one another, as experienced over time'.[30] Le Corbusier applied similar ideas to his formulation of a poetics of movement, beginning with his Maison La Roche (1925; see p. 150), in Paris, writing that this house would be 'like a *promenade architecturale*', in which 'the architectural spectacle presents itself successively to the eye. The spectator follows an itinerary and the scenes unfold in a wide variety of forms. There is the play of inflowing light illuminating the walls or creating half-lights.'[31] His Villa Savoye of six years later is also based on the slow unfolding of 'constantly varied aspects,

unexpected and sometimes astonishing'. To achieve this interplay of light and movement, he arranged routes along a calculated progression of perspectives and 'points of command', instigated by stairs and ramps, and a succession of framed views that rise and fall, open and close. Le Corbusier's houses were conceived, then, not as fixed objects, but as fluidly evolving light and space that can *only* be experienced as people pass through them, encountering the before and after, as well as the present. This sequential mode of seeing entails what Gordon Cullen calls in his *Townscape* essays the 'serial vision'.[32] Unlike an accidental chain of events, connected views provide a 'tool with which human imagination can mould the environment into a coherent drama'. Anticipating the filmic methods of architects half a century later, Cullen recommends that 'serial drawings' be used to study the 'sequence of revelations' experienced with movement through a series of related spaces.

In recent decades, ideas about perceptual flow have been simultaneously broadened and loosened by the increasingly mobile images of our visual culture, stemming from media such as cinema and the Internet. One aspect of this shift is the growing interest in a kind of perspective that not only evolves with human motion, but is less prescriptive and non-linear, demanding that a visitor improvise while on the move and give final shape to his or her own experience. Expanding upon iconic works of space in motion, including Mies van der Rohe's Barcelona Pavilion (1929; opposite, below), Linz-based architects Riepl Riepl deploy light in their St Francis Church (2001; p. 234) to attract the community through an elevated beacon, and then gradually draw

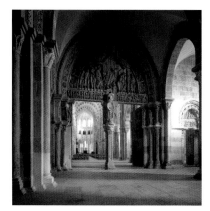

Ste-Madeleine, Vézelay, France.

visitors through the building by a series of luminous multi-axial elements. A glass-enclosed garden pulls one through the entrance, while distant glass walls lure the visitor further inside, either diagonally left by several routes into the sanctuary or to a chapel on the far right – an indirect flow that continually leaks with diversions and short cuts and culminates with an equally polyvalent main hall, whose perceptually emphatic altar wall must compete with the light seeping in around the perimeter. The luminous cues come into play at crucial junctures to demand improvisation as one negotiates an asymmetric flow of space.

Sharing similar notions but more complex is the porous maze leading into and through Peter Zumthor's Therme Vals (1996; p. 60), whose geological voids have the suspense of cave exploration. This radically unfixed choreography finds a parallel in attempts by twentieth-century artists and poets to construct a non-linear flow of images or words. Making an analogy with Cubist painting, the poet William Carlos Williams proposed the discarding of narrative sequence. Williams instead composed his poem as an unfinished structure, in which the reader could move about in a non-rigid framework, allowing the sequence to become 'a little fluid . . . like ice in March'.[33] As components shimmer and break apart, prodding and tugging the human eye that roams over them, a spontaneous kind of movement is invited that can be forking or circular, backward or forward. Related to Williams's aim is the 'projective' and 'open' verse developed by Charles Olson to construct a poem that is 'kinetic', and moves about the page free of linear authority. This kind of structure is essentially a 'process', explains Olson, requiring that 'each perception must immediately and directly lead to a further perception'.[34]

These concepts of free-flowing movement through space were repeatedly adapted to architectural routes by the late Enric Miralles and his partner, Carme Pinós. As at Zumthor's Vals, the spatial flow of their projects derives from the landscape; at their boarding school at Morella (1994; right), it develops as an erratic sequence of angular cuts that emerge from contours and twist on themselves as they spill down a hillside. Visitors wend their way through trapezoidal spaces that continually narrow or widen, split and

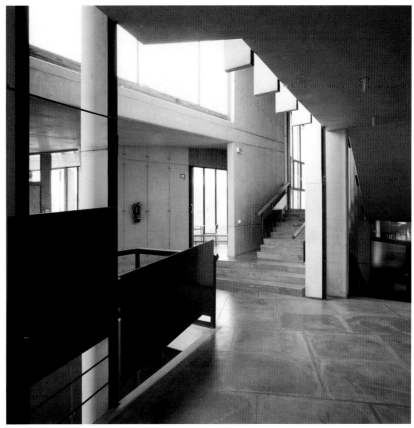

Morella Boarding School by Miralles & Pinós.

diverge, lured by the fractured glow of windows and skylights, whose radiant splinters are charged by glimpses of the landscape. Miralles has used the metaphor of an 'explosion of light-reflecting crystals' to describe this cascade of dispersive space, realized in the 'window shutters and transparencies, gathering the light and fragmenting it'. At Morella, light-cues are scattered like the dispersed and seemingly accidental volumes of American artist Michael Heizer, as if positioned not by the human mind, but by natural forces of water currents or blowing wind. About his 'Match Drop Dispersal' (1968),

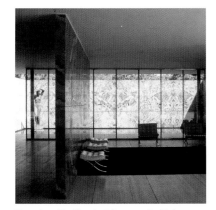

Barcelona Pavilion by Mies van der Rohe.

Heizer wrote: 'The matchsticks were employed as a dispersing device . . . dropped from two feet above a sheet of paper and taped down,' thus producing a 'disintegrative' space that also defines the flow of voids in his contemporaneous work 'Dissipate'.[35]

Offering another case study in this regard is the concatenated light of Steven Holl's subterranean addition to the Nelson-Atkins Museum in Kansas City (2007; p. 64), where movements are 'threaded' rather than linear, pulled vaguely along by what Holl calls 'sequences of shifting and overlapping perspectives'. Beckoning light draws the visitor onward step by step, and image by image, through a fragmentary rather than comprehensive narrative, an idea comparable to the 'weak ontology' and 'fragile thought' put forward by the Italian philosopher Gianni Vattimo.[36] Light neither centres nor aligns space, as in the past, but appears in the periphery as a 'vague' and 'marginal background event'.

Another medium that has strongly influenced the processional light of contemporary architecture is the art of cinema. Japanese architect Fumihiko Maki has suggested that designers operate like film directors when they organize buildings, employing, as he himself often does, different sceneries within one building. In this way, Maki has given buildings such as the Spiral in Tokyo (1985; below) and the Kyoto Museum of Modern Art (1986) a choreography similar to the films of Federico Fellini. Related concepts relevant to architecture are found in the films of Andrei Tarkovsky, for whom cinematic flow is a living rather than linear experience, achieved when the film is stretched and lengthened by human memory and by images that evoke something significant beyond what we see before us, allowing time to flow out the edges of a frame.[37] Intensifying this leakage in films such as *Nostalghia* (1983) are dream-inducing moments of atmosphere and the mesmerizing spell of rhythmic light. Another technique Tarkovsky exploits to loosen time from any rigid progression is the directorial power to endow not only the entire film, but also its segments and even separate frames, with simultaneous temporal structures that are not unlike Williams's 'ice in March' or Viola's 'parallel times'.

Cultural and Congress Centre by Jean Nouvel.

Simultaneous structures can also be formed with the cinematic tool of a window in series, as exploited by Madrid-based architects Mansilla + Tuñón in the León Municipal Auditorium (2002; p. 68), using a scatter of luminous scenes to pull visitors up a switchback ramp. Pictures in motion have long been exploited by Parisian architect Jean Nouvel, who describes his buildings as 'scenographic', with routes composed along a series of 'camera angles and apertures'. In his Culture and Congress Centre (1999; above and p. 130), in Lucerne, stairs rise up to the concert hall between metallic veils that alternately open and haze over views. When arriving at a dim grey lobby, from which all visual distractions are obliterated, and an equally dim terrace above, the visitor's attention is directed solely upon radiant scenes in a series of apertures, varied in both location and shape to engage the eye in shifting viewpoints. Carefully oriented along pre-determined sightlines to specific urban monuments and alpine features, each scene is animated both by life outside and by one's mobile eye, suggesting multiple film projections inside a dark theatre. These images recall Michelangelo Antonioni's stories 'made of

Spiral by Fumihiko Maki.
Opposite: Modern Art Museum of Fort Worth by Tadao Ando.

passages and fragments', which are 'unbalanced, like the life we live', and employed in films such as *L'avventura* (1960) or *Blow-Up* (1966).[38] In a similar manner, as soon as the visitor passes one vista, another quite different scene comes into view, producing a space–time that is episodic rather than continuous, but whose sequence can be slowed or quickened, played forward or in reverse, according to the wishes of each percipient.

Among the most impressive recent compositions based on divergent movements through light are the buildings of Spanish architect Rafael Moneo, constructed around what he calls 'processional rituals'. An early instance is his Museum of Roman Art (1986; below, left), in Mérida, whose strong central current continually branches into lateral streams. One of these routes descends along a great zig-zag ramp to the underground darkness of archaeological remains, dimly lit by vertical light shafts. Other routes slip off to the side at right angles, up stairs and along bridges, drawn through a series of galleries divided by walls resembling ruins. All these fragments of time and space are linked, but not ruled, by a mesmerizing enfilade of brick planes lit by roof slits crossing the main axis, and by the pronounced illumination of a single end wall.

Moneo's ability to endow each building with a coherent yet multivalent procession is again visible in his Davis Museum (1993; below, centre), at Wellesley College, Massachusetts. Beginning at ground level, the scissor-stair makes a slow ascent along adjacent flights of opposite direction, interrupted at landings where the stairs reconnect. Mid-point in each flight, the dim staircase opens onto toplit galleries above and below, with balcony-like views. Unifying this oscillation of darkness and brightness is another, far more powerful experience: a gradual progression from earth to sky, culminating in a sculpture gallery that is flooded with daylight from the rooftop monitors. 'The act of going to the top is like a process of purification,' says Moneo, 'in which the light comes down from the skylight, almost from heaven.' By contrast, the loosely broken paths of the Miró Foundation at Palma de Mallorca (1993; p. 72) meander down a hillside, their shape inspired by the child-like gaiety of Miró's art. Entirely different again is Moneo's Lady

Forest of Tombs Museum by Tadao Ando.

of the Angels Cathedral (2003; p. 230), in Los Angeles, where movement is relaxed by episodic and leaking paths. The desire for an east-facing apse led to an indirect route that begins with arrival at the eastern end, and then slips along a dark ambulatory skirting the nave, which it partly obscures by a series of chapels. This route is ushered to the rear of the church by a wash of light along one side from a continuous roof slit, and on the other by a repetitive glow of toplit chapels, between which are slender glances and alternate entries into the soaring, luminous nave. One's eye is drawn towards the altar

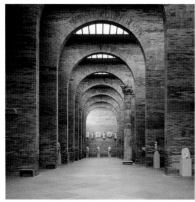

Museum of Roman Art by Rafael Moneo.

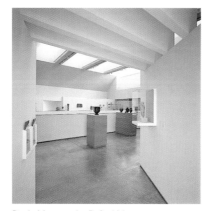

Davis Museum by Rafael Moneo.

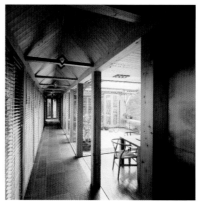

Villa Busk by Sverre Fehn.

by optical rhythms and by a hovering cross in a chute of light – a symbol that penetrates *into* the church, analogous to Christ bringing light to the world.

Against such a processional complexity stands a group of buildings by Norwegian architect Sverre Fehn, whose paths emerge from far longer journeys through the landscape. While Fehn's architecture, from small houses to museums such as the Ivar Aasen Centre (2000; p. 74), is generally arranged along a rather simple linear spine, he overlaps this route with strands that perpetually diverge and meet, cross and reunite, and fuses these with poetic images evoking travels beyond the reach of the eye. Internal paths open at both ends into nature, so as to begin and end in the light of day, and along the way are modulated by light and dark rhythms suggestive of the Nordic forest. Guiding these archetypal patterns is Fehn's notion of 'elongated architecture', in which 'the building lies like a line in the landscape' and 'traces a path writing on the surface of the world'. A magnificent illustration is his Villa Busk (1990; opposite, below right), conceived as 'a line cutting horizontally and vertically' through glacial topography, but also as a line about which Fehn 'had a feeling of it being a dream about a journey I still had not made'. This dream is, in part, inherently Norwegian, beginning with the protective rocks and trees of the forest and reaching beyond to the freedom of fjords, whose horizons open to an outer world and a beckoning future.

Contextual journeys similar to Fehn's, but coming from very different impulses, stitch buildings by Rotterdam architect Rem Koolhaas back into their city fabric. The promenade of his Dutch Embassy (2004; p. 76), in Berlin, repeatedly draws the wider city into its course and orbit. The neighbouring Klosterstraße enters the embassy along a ramp, whose path proceeds to snake through a lobby and wind up to the roof along a coil of jerky, irregular, and often spontaneous fragments. Along the way, segments of routes and transitions between them are guided by cues of natural light, including sudden illuminations and framed urban views, as well as reflections that brighten and dim on a continuous aluminium finish.

While Tadao Ando's architecture flows seamlessly out of paths in either landscape or city, light is deployed as a transitional device to calm eye and mind as it slowly withdraws from the outer world, and, conversely, to carve away critical thresholds by leaking through joints where volumes intersect. Ando describes his intent as an 'unfolding of space' with a 'sense of discovery', where components form 'sequences of architectural spaces of varying mood'. Although composed from highly abstract contemporary volumes, paths are imprinted with distinctly Japanese images, recalling the soft, diffuse light leading to a teahouse, the delayed and labyrinthine approach to a Shinto shrine or a Zen temple, and the slow hide-and-reveal technique of a stroll garden. Ando exceeds these space–time sources, however, in the complexity and suspense of his routes, as well as in the multiple fractures along the way, stretching buildings into a long series of shifting cinematic fragments.

Quite apart from its physical form, each of Ando's buildings is shaped around a unique choreography of light and movement, and is intensified psychologically by a sense of returning to our origins. There is the Mt Rokko Chapel (1986; below, left), whose translucent glass tube quiets nerves before turning through darkness to reviving light in a half-buried chapel; the Akka Gallery of two years later (below, centre), whose dangling stair along a huge, curving wall weaves in and out of shade and raining light as it climbs to the sky; and the Forest of Tombs Museum (1992; below, right and opposite, above), whose journey begins with a spiral ramp descending to dark subterranean galleries, and ends with a ramping ascent up and around toplit walls. The galleries at the Modern Art Museum of Fort Worth (2002; see p. 57), too, have winding routes that alternate shade with transcendental water reflections. These labyrinths display a Japanese genius for enlarging limited space, increasing the number and quality of perceptual events engaged along the way. The time of one's movement is thereby slowed down, infused with moments, and thickened in density. But it is the variety of levels upon which sequential light works that is most impressive in these buildings – in part to satisfy a human longing for tranquillity removed from a chaotic world, but also to create an experience similar to a spiritual voyage, all the while reminding us of the fundamental rhythms of life and comprehension of opposites that are epitomized in Zen philosophy.

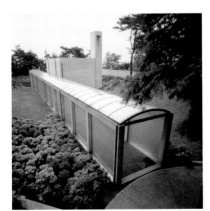
Mt Rokko Chapel by Tadao Ando.

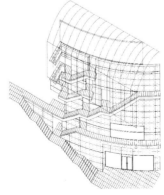
Akka Gallery by Tadao Ando.

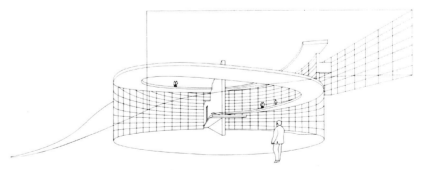
Forest of Tombs Museum by Tadao Ando.

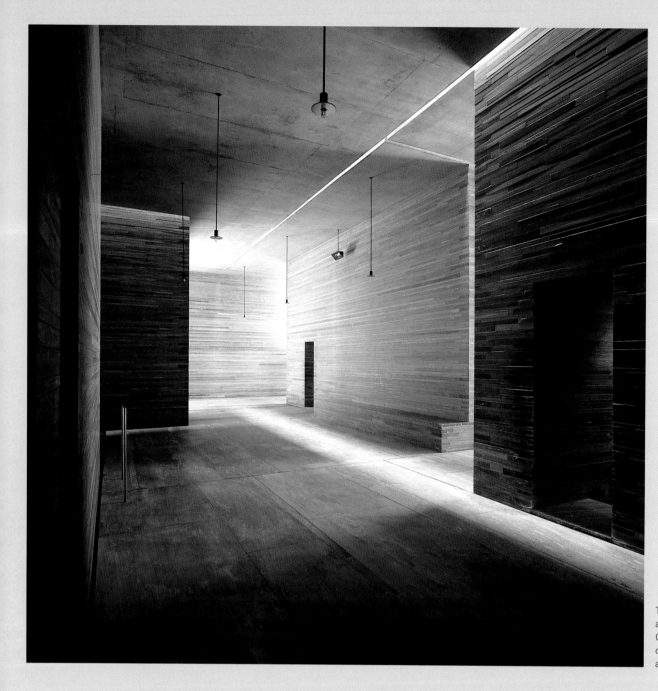

Trail of light to 'fire bath' at right and 'drinking stone' beyond. Opposite: Passage to outdoor pool in distance, past 'massage space' at left, and central bath at right.

Therme Vals, Switzerland Peter Zumthor

The ceremonial procession at these 1996 baths in the Swiss village of Vals begins with a deliberate negation: a dim subterranean tunnel followed by dark, mahogany-clad changing rooms, inducing a yearning for the light beyond. The newly naked bather descends into a gigantic cavern, with glimpses of light raining into the darkness from cracks in the roof. Helping to point the way along interconnected paths that lead to baths and showers encased in their own stone chambers are luminescent trails from distant windows, which appear around corners like the thread of Theseus to tug the visitor from space to space, and eventually up to an open-air pool. This loosely choreographed ritual movement is described by Zumthor as the 'meander', where contrasts of temperature, smell and sound are accompanied by the changing light from above. 'It was incredibly important to us to induce a sense of freedom of movement,' Zumthor recalls, 'a milieu for strolling, a mood that has less to do with directing people than seducing them.'

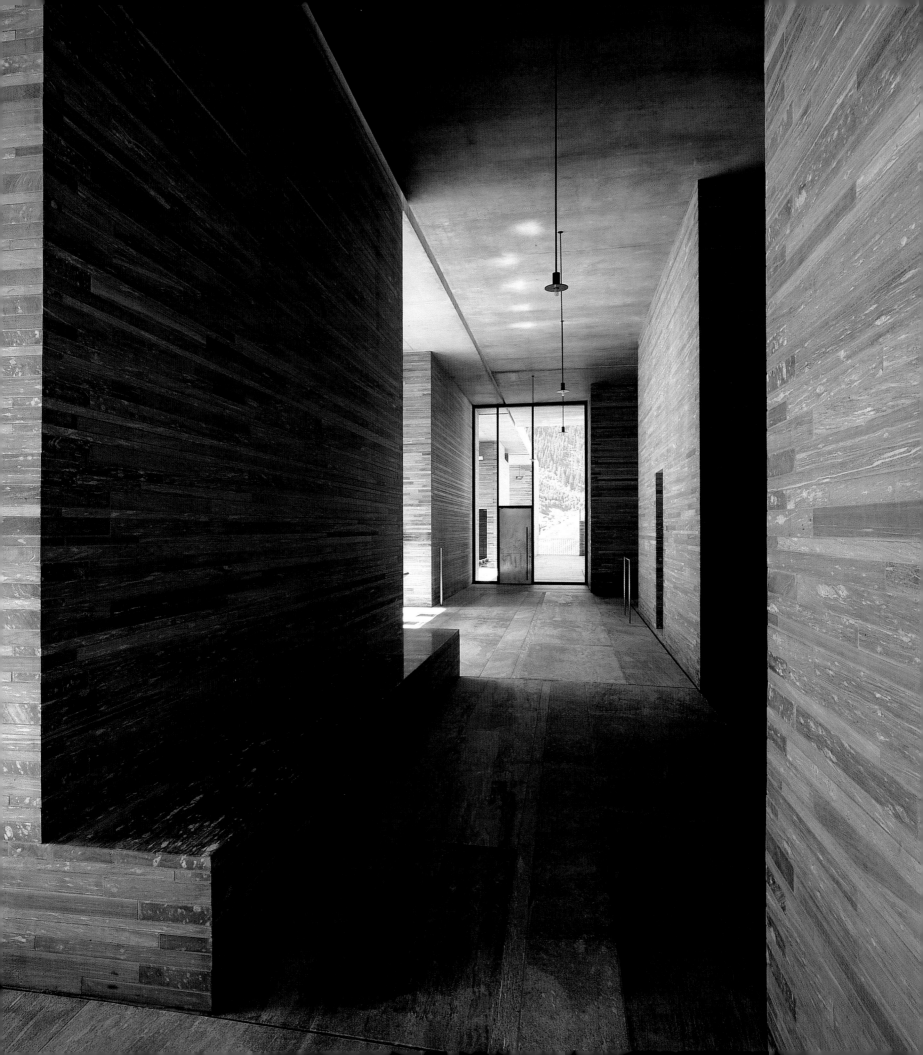

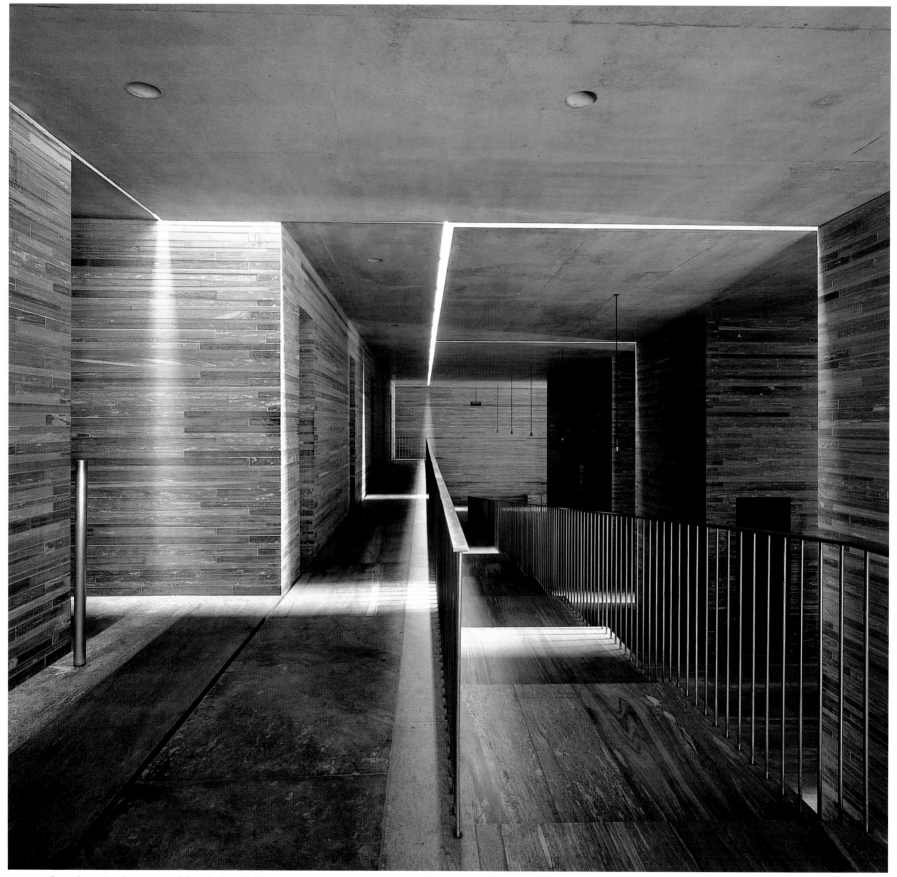

Ramp from changing rooms, at left, to baths at right.

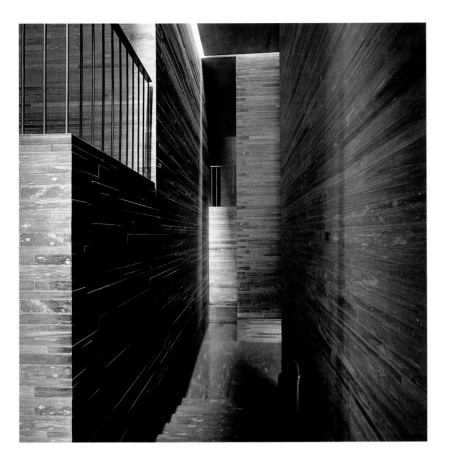
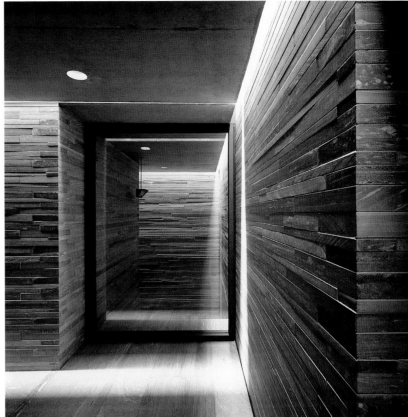
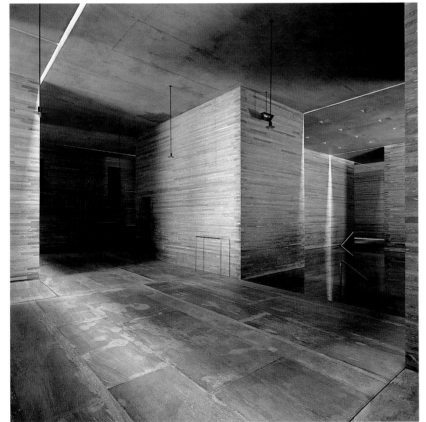
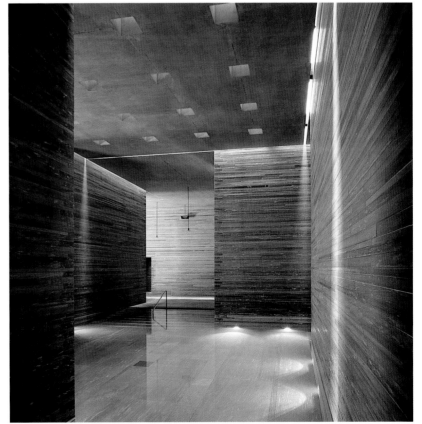

Clockwise from top left: Water and light leading, around 180º turn, to 'sound bath' at right; alternative entrance to baths; central 'indoor bath'; central bath at right, and dark arrival zone beyond at left.

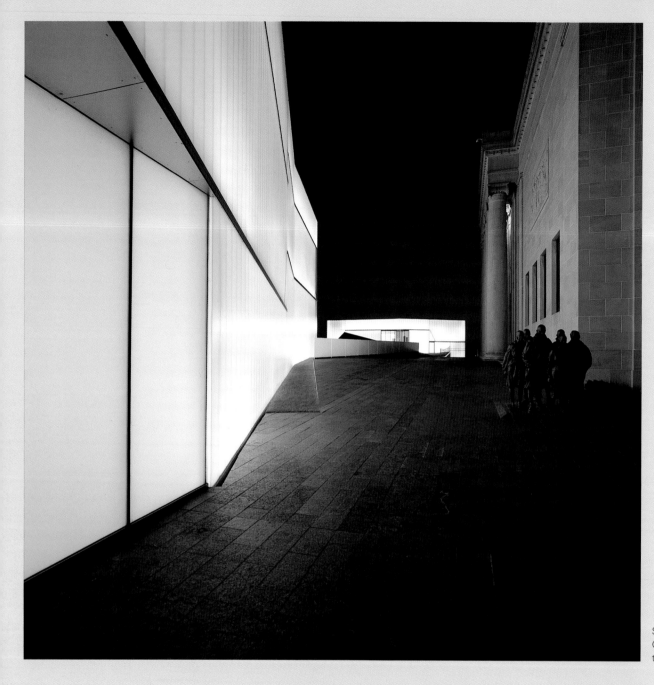

Sequence of 'glass lenses' at dusk.
Opposite: Arrival at ground level, with routes
to museum below and library above.

Bloch Building, Nelson-Atkins Museum, Missouri, USA
Steven Holl

While never deployed as hierarchic cues, the radiant zones of Steven Holl's 2007 extension for the Nelson-Atkins Museum in Kansas City – from clear glass to translucent planks, from sidelight to toplight, and the slippery reflections off polished floors and plaster walls – draw the eye in many directions, through layer upon layer of porous rooms and countless ramps and stairs, each leading to freshly emerging light. The transparency of action derives from optic events varied in both location and character, so as to beckon sporadically from above, below, or either side, while concentrated around routes skirting the envelope. In the dark of night, these luminous incidents reappear outside, with different effect, as a cascade of lanterns to lead visitors through multiple paths in a sculpture park.

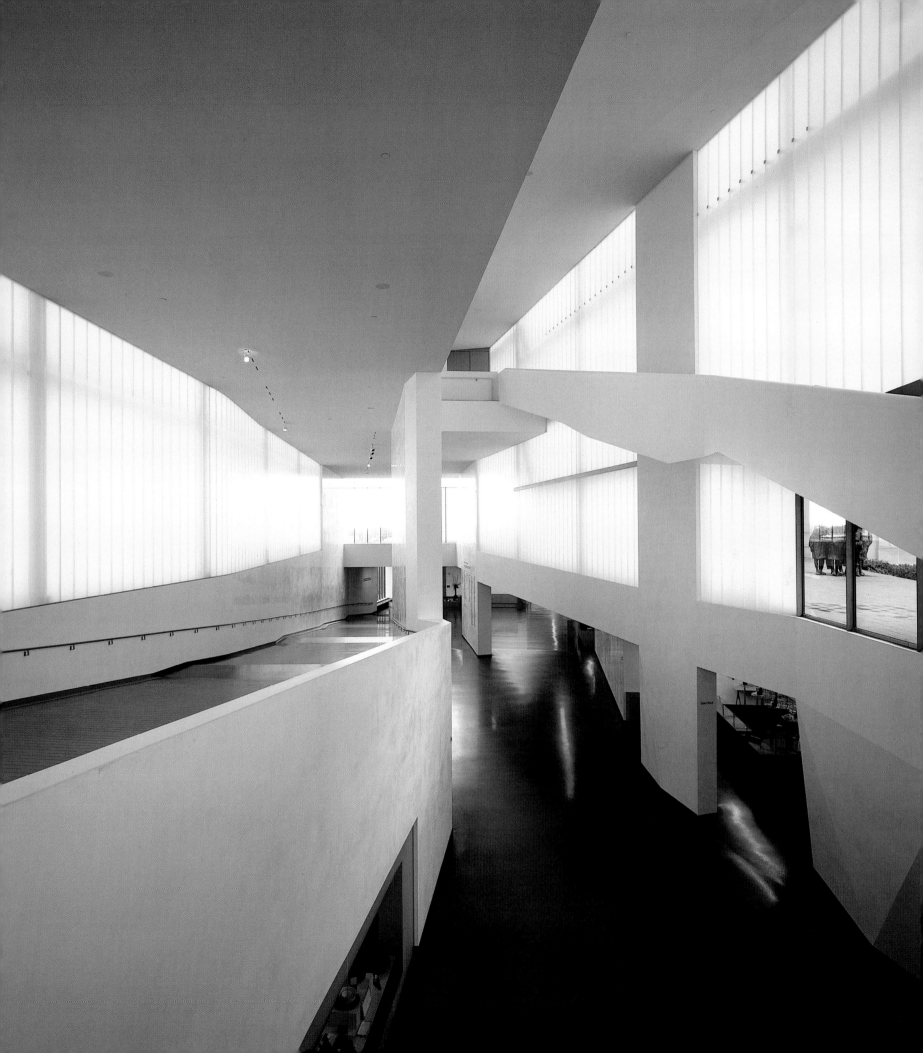

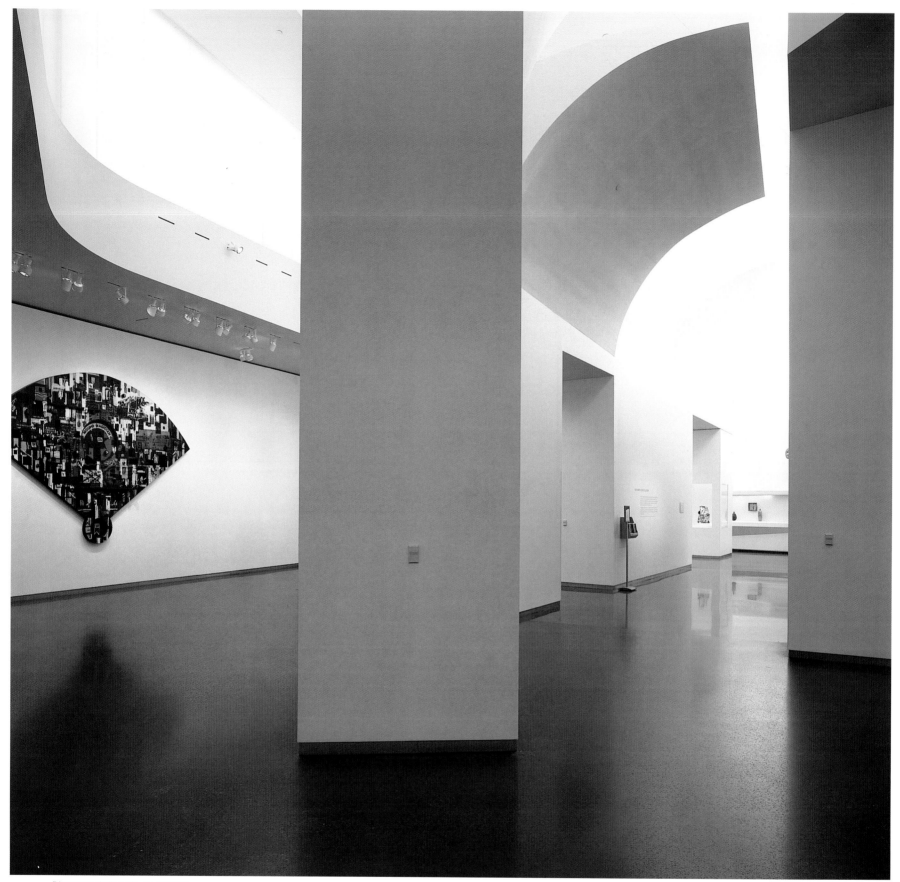

Divergent skylit paths in galleries.

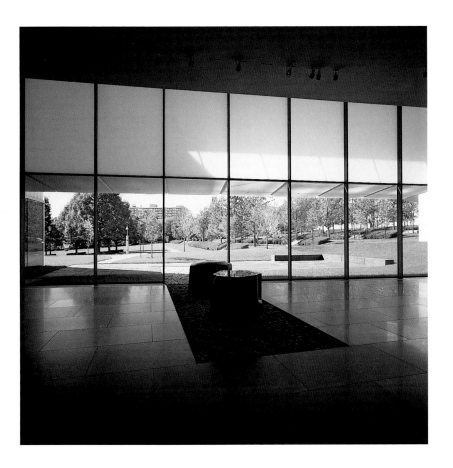
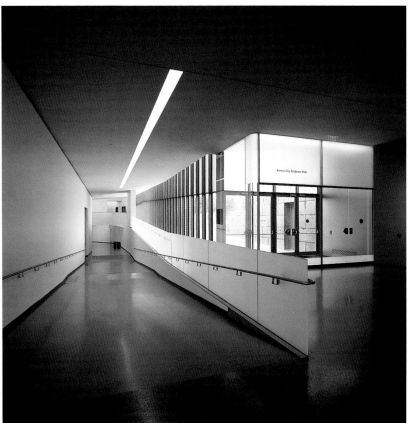

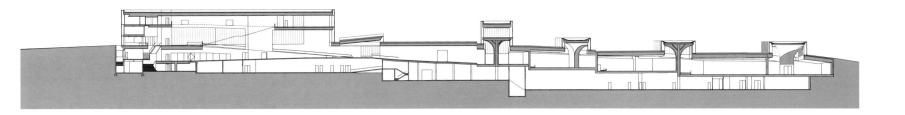

Top, left to right: Noguchi gallery at base of ramp, opening to sculpture park;
ramp to galleries, with access at right to sculpture park.
Middle: Longitudinal section.
Above: Watercolour of 'glass lenses'.

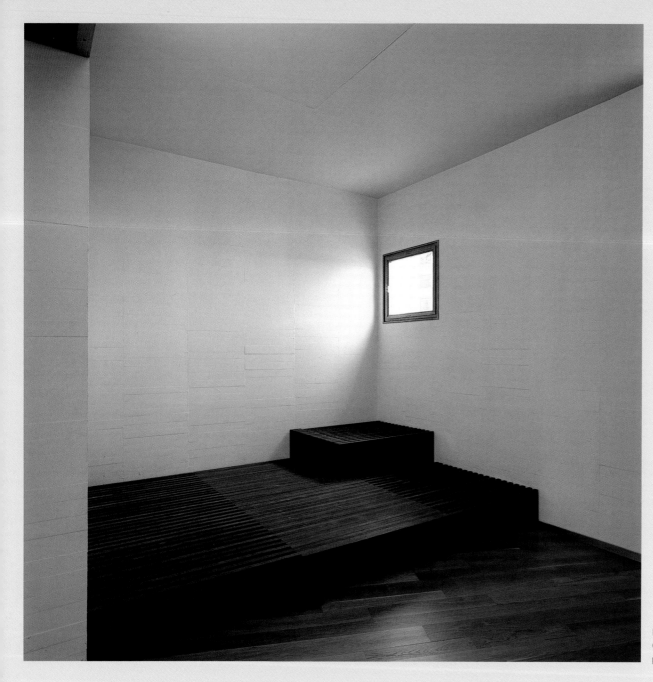

Resting stop at base of ramp to galleries.
Opposite: High windows culminating
procession at upper gallery.

León Municipal Auditorium, Spain Mansilla+Tuñón

A device called a 'stack of windows' is employed at this 2002 public space to create a procession leading to exhibition rooms on several levels. The Cubist façade of this series of ramps is hewn with embrasures, which inevitably recall the south wall at Le Corbusier's Ronchamp Chapel (see p. 10), but in this case are angled to glimpse parts of a city (León) that once marked the Way of St James – giving an extra dimension to the on-and-off light. Radiation trapped within cells, suggestive of signal lights, conducts the eye up inclines and around turns, while inducing the climber to pause and linger at each new vista, as a stop on the way. The result is a series of film clips embedded in a longer film, the former consisting of separate scenes of urban locales, and the latter a continuous flicker between ground and sky.

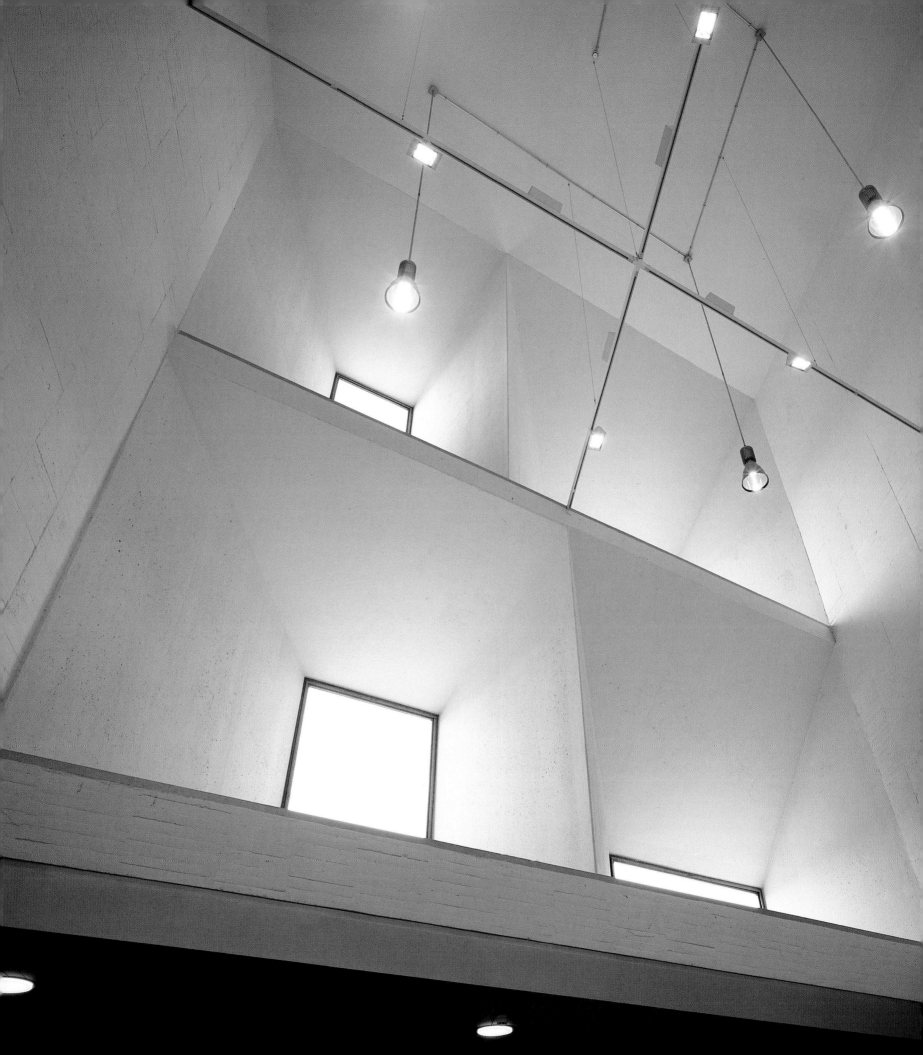

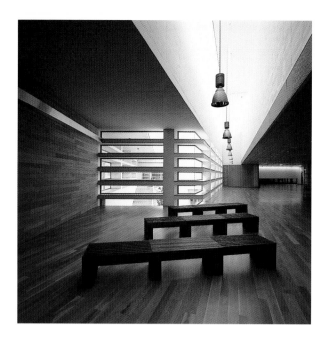
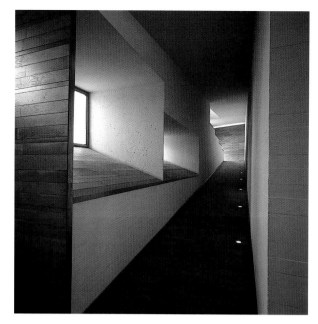
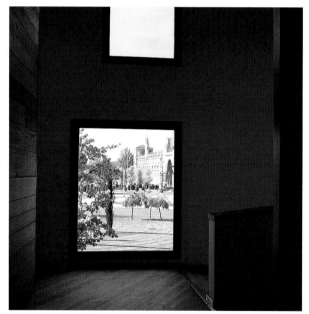
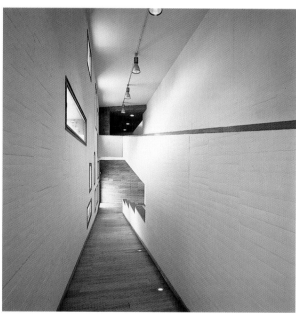

Clockwise from top left: Auditorium lobby; initial ramp with deep embrasure windows; view back down middle ramp with final ramp to upper gallery at right; framed view of historic Convent of San Marcos.

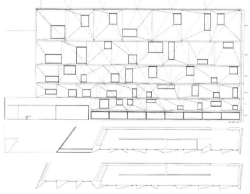

Elevation and plans of lightscreen and ramps.

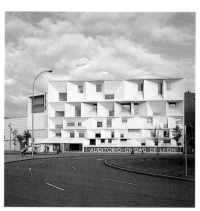

Exterior.

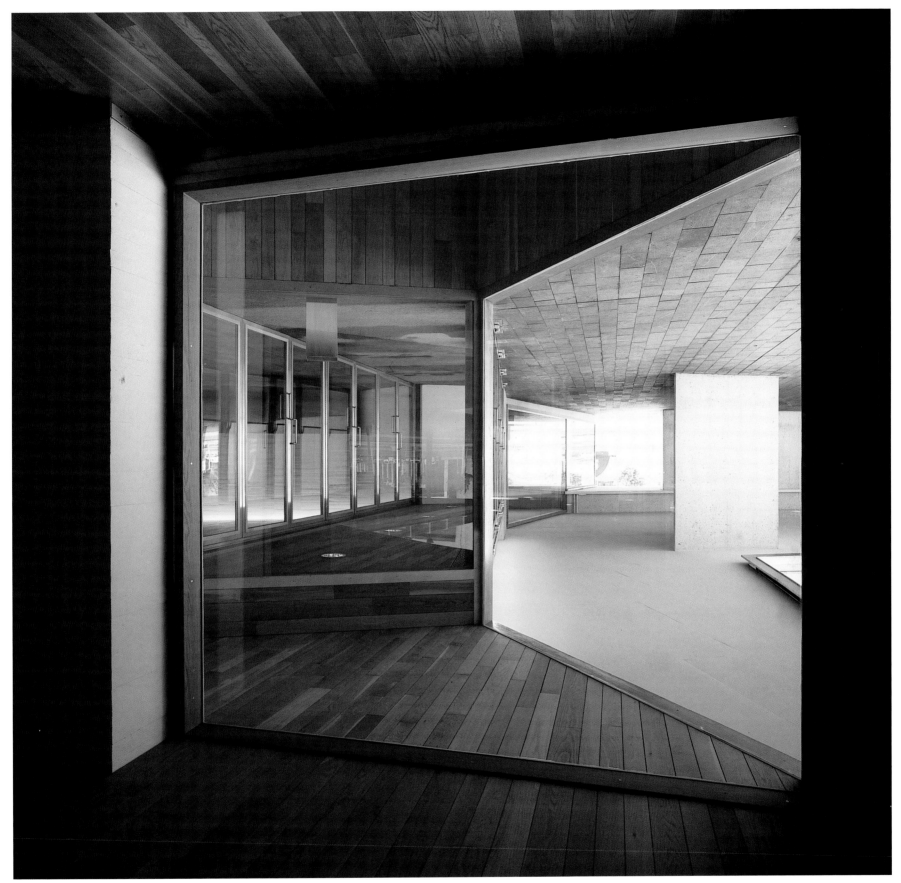

Entrance.

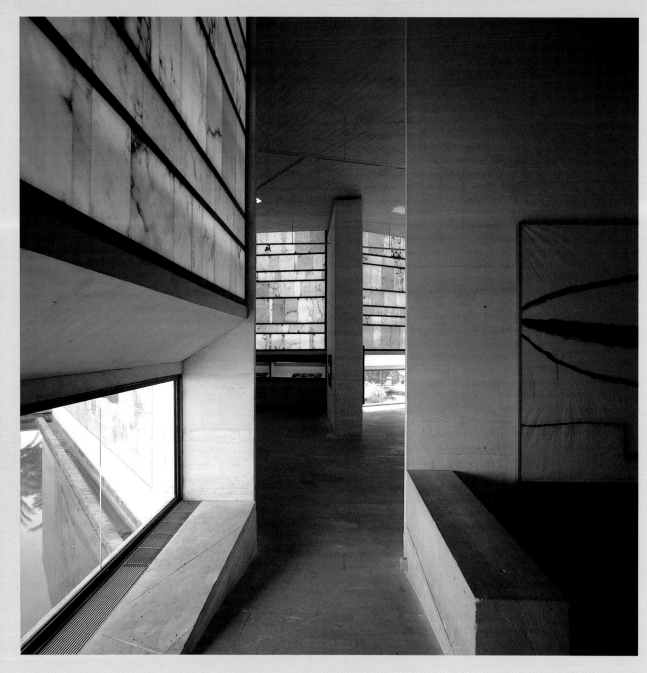

Direct route to mid-level galleries.
Opposite, clockwise from top left: Discursive flow between mid- and lower-level galleries; beacon of alabaster and translucent glass; embrasure window as a cue; lower-level plan of galleries.

Pilar and Joan Miró Foundation, Spain Rafael Moneo

Arriving at the entry porch of Rafael Moneo's 1993 museum in Palma de Mallorca, the visitor is confronted with a surreal image: a water-covered roof that merges with the distant sea, whose luminous sheet it abstracts and brings near. Following a staired descent to the lobby, the visitor proceeds indirectly into galleries. From here, the path peels away the building as it steps down the hillside. Routes weave in and out, diverging and intersecting between wedge-shaped walls, steered loosely by glimmers of light: low windows through which the eye slips out to water gardens; inclined horizontal louvres that filter the sunshine; geometric funnels carved from the roof; angled embrasures that guide like flares; and everywhere the warm, inviting glow of alabaster filling gaps between the walls. Routes thread between galleries in a sinuous manner that is more discursive than linear, splitting into many directions with turbulent and unexpected vistas, sudden contrasts of light and shadow, and periodic overlays of screens and parallax.

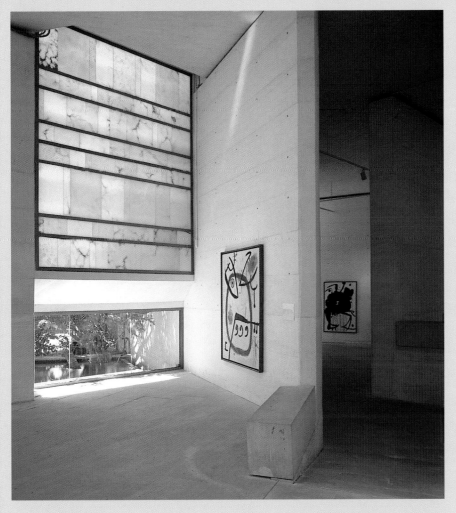
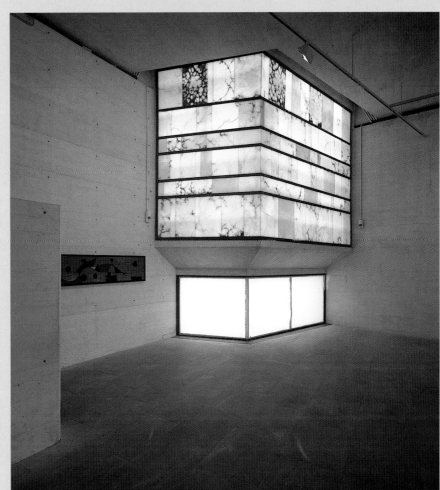
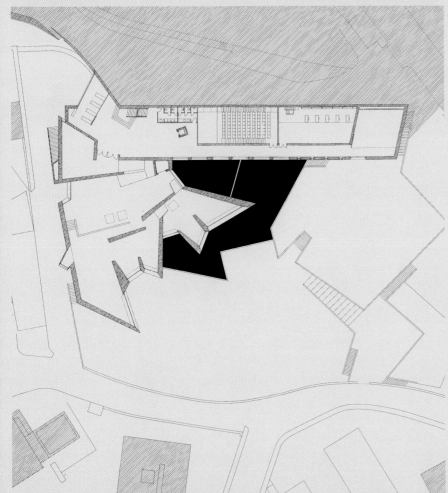
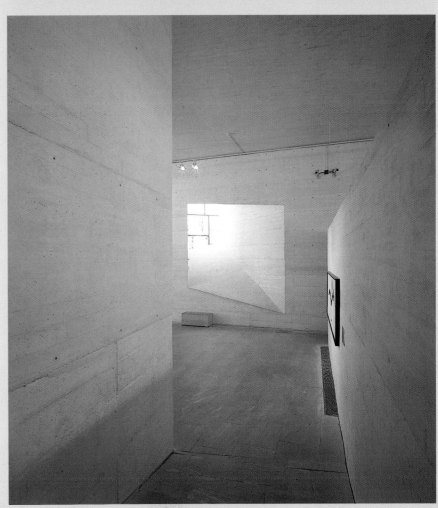

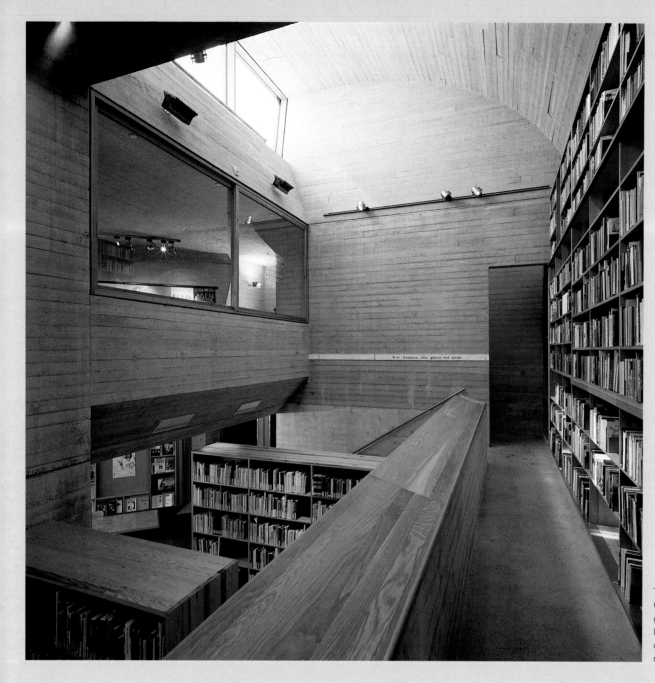

Toplit library on north side of corridor. Opposite, clockwise from top left: Sidelit gallery with reconstructed Aasen study; light-trap of retaining wall in toplit galleries; display case in south window; beginning of museum sequence looking west.

Ivar Aasen Centre, Norway Sverre Fehn

Carved from the heart of Sverre Fehn's museums are poetic journeys through pulsating light, the latter ranging from forest rhythms to the icy sparkle of glass cases. Embedded in a wooded hillside near Ørsta, the Ivar Aasen Centre, dating from 2000, occupies a line between its namesake's childhood home and the distant Voldsfjord, thereby linking the dark space of the linguist Aasen's roots with the bright horizon along which his fame spread. Marking out this promenade from woodland light to ocean light are galleries of varied illumination – those on the north protected by a huge, curving wall, which catches and distributes scarce Arctic light to an interflow of subterranean galleries, while those on the south alternate between dark alcoves and glazed rooms framing the glacier-carved valley and mountain.

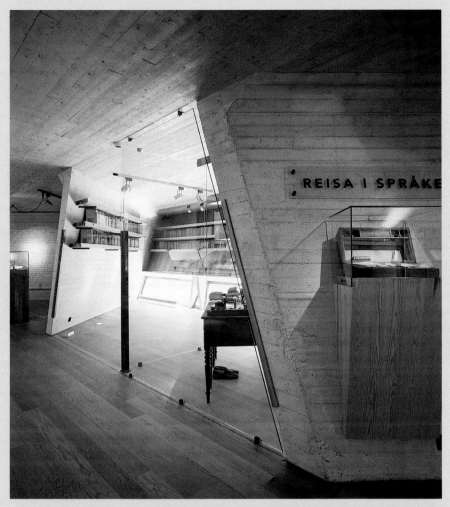
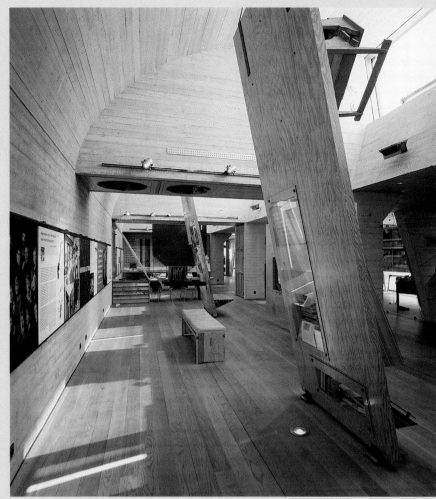
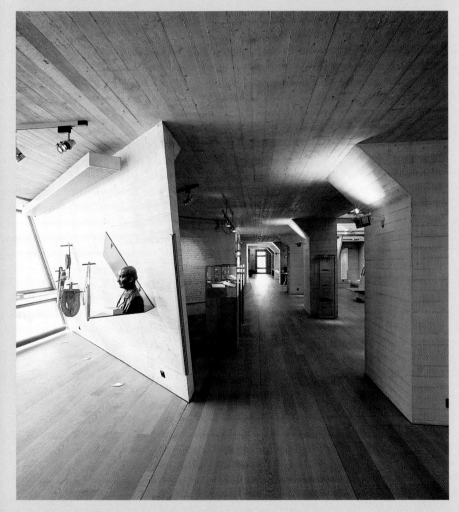

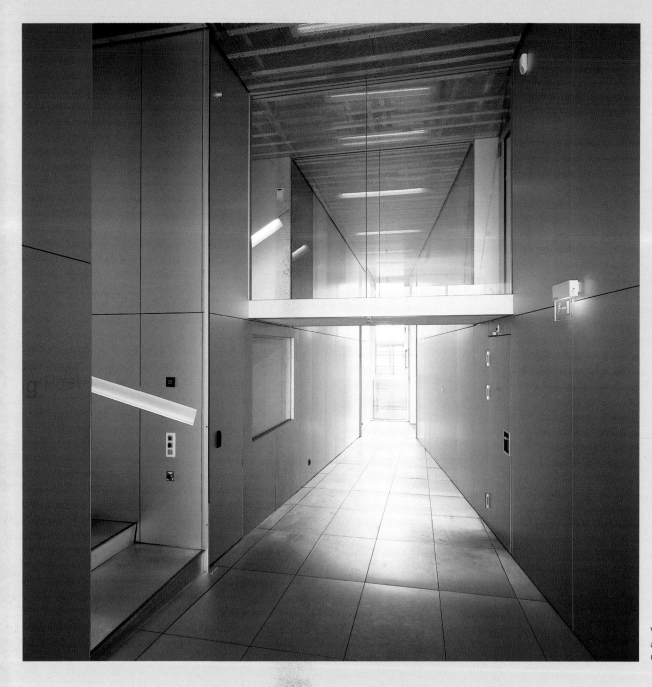

View back down trajectory ramp, with
ambassador's offices at left.
Opposite: Trajectory ramp along VIP level.

Dutch Embassy, Germany Rem Koolhaas/OMA

After traversing the zenithal light of an entry court, the journey through Rem Koolhaas's 2004 embassy building in Berlin darkens through a lobby and staircase only to step outside and into a glass tube that skirts the volume with a floor of green glass and overlooks the River Spree. Following this vertiginous phase, the route folds back into and tunnels through the building's centre along a rising series of stairs, whose landings lead to rooms marked by coloured light and whose way is guided by a brightly framed view of the city's iconic television tower. At the top, the tube again angles back on itself into other segments that bore through the mass or follow its envelope, before finally emerging at a café on the roof terrace. Underlying this erratic flow of light and space, compression and release, is Koolhaas's concept of a 'trajectory'. In place of any simple rhythm or unifying structure is a spiralling pathway close in spirit to the chance events and controlled chaos of jazz, whose zig-zag progression is far more important than the rooms it serves.

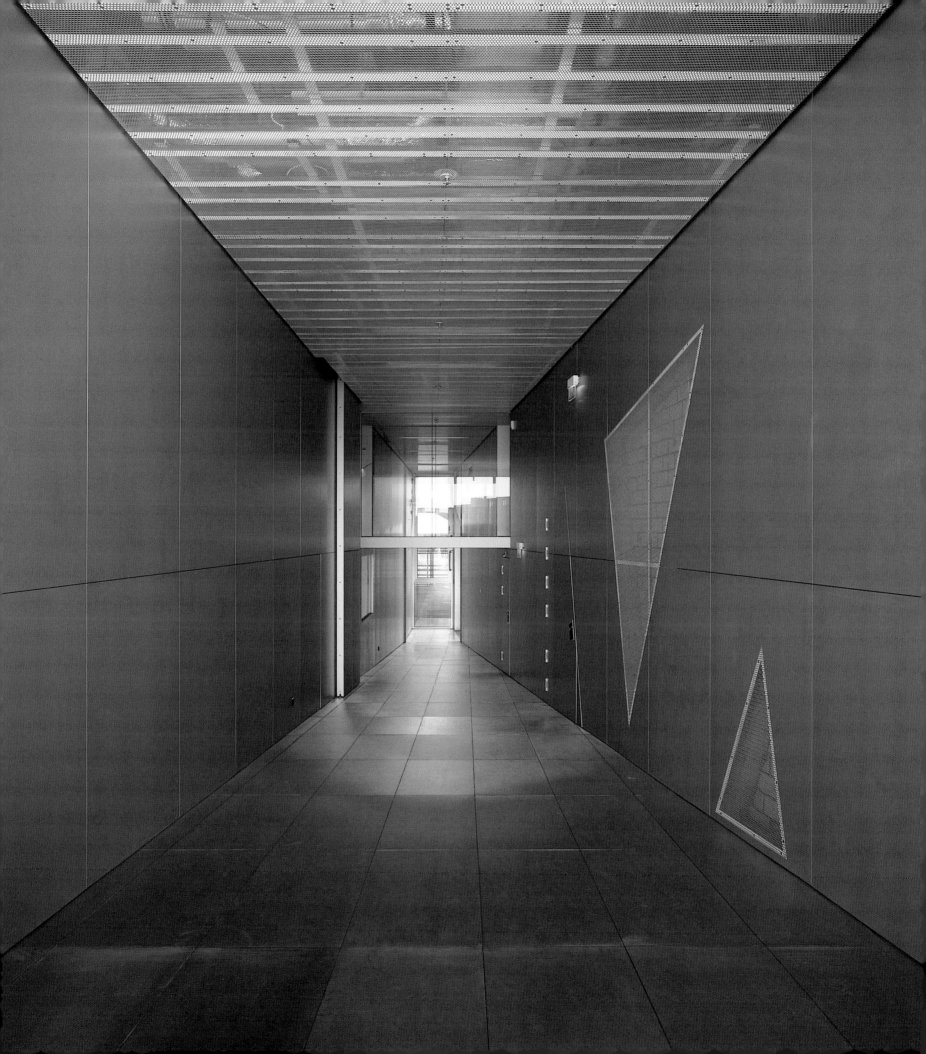

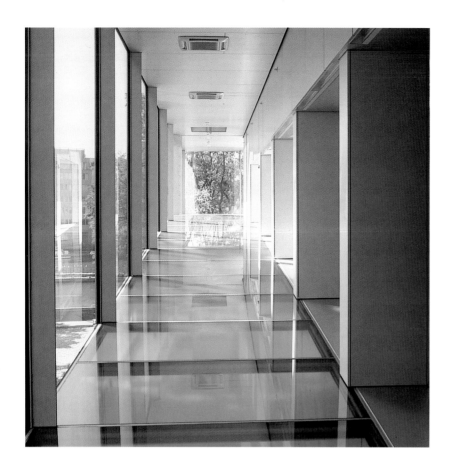
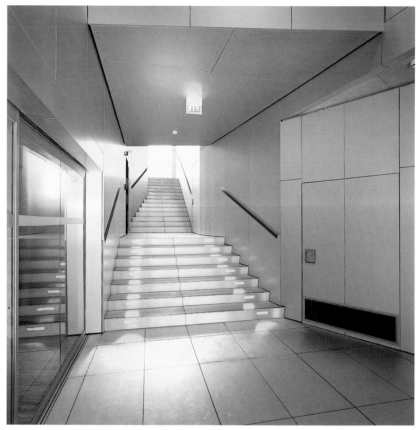
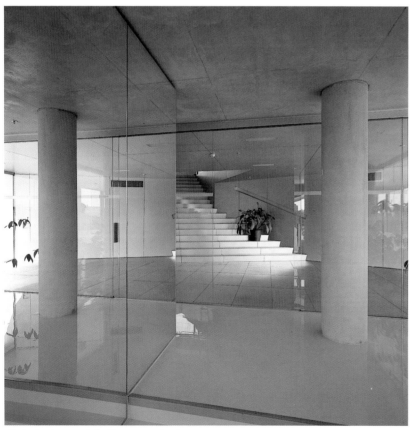
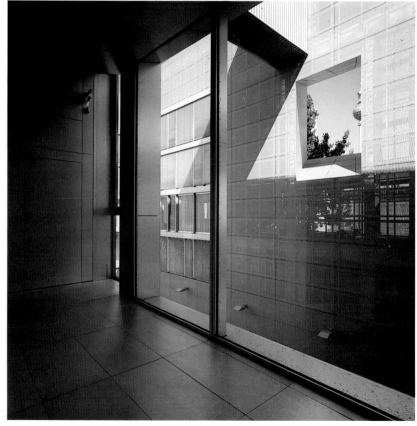

Clockwise from top left: Glass ramp of trajectory; trajectory re-entering building, and staired ascent along diagonal tunnel aimed to Alexander television tower; landing at 180º turn, with view through residence wing to television tower; trajectory passing by fitness room, with stair to rooftop café beyond.

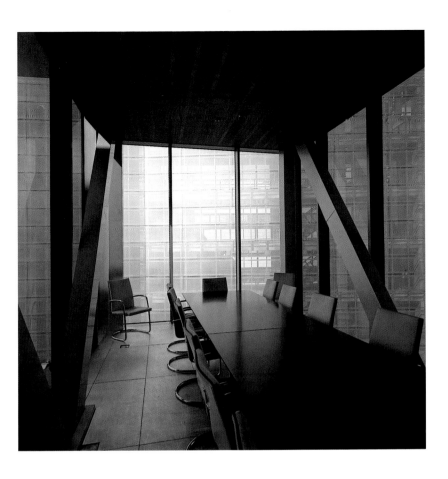

Top: Glass 'skybox' of ambassador's conference room, cantilevered over entry court.
Middle: Unfolded trajectory plan, with circles indicating turning points in route.
Above: Unfolded trajectory section, from entry/reception at left and rooftop café at right.

VEILS OF GLASS

REFRACTION OF LIGHT IN A DIAPHANOUS FILM

3 VEILS OF GLASS
Refraction of light in a diaphanous film

No aspect of architectural light has received more attention over the past century than the interplay of glass and transparency, a phenomenon pursued along two quite different, yet often overlapping, modes of thought and optical experience. Of predominant interest has been the practical value of large areas of clear glass, made possible by industrial production and resulting in a state of openness and lucidity. This uninterrupted passage of light depends on plate glass that is uniformly flat, then ground and polished to minimize all refractive disturbance and to keep what is seen through its lens as conspicuously objective as if no glass were present. Inherited from the Enlightenment is a kind of light that exposes things to the eye and the intellect, and resolves objects as thoroughly as possible.

Quite opposed to this lucid impulse are the poetic values of ambiguity and mystery attained when glass interferes with light rays, diverting and delaying their course of passage. If the former demands an absolute transparency with direct transmission of light, the latter strives for a veiled transparency where light transmission, to an appreciable extent, is indirect. Set against the rational urge to make glass almost disappear is an irrational desire for the opposite, to heighten the optic complications of glass and bring into play astigmatic qualities – both refractions and reflections – which induce glass to sparkle and glow, and exhibit its own ravishing presence.

Nineteenth-century iron-and-glass buildings, such as Decimus Burton's Palm House at Kew Gardens (1848; below), sought to merge these vitreous dreams. The revolutionary *jardins de verre* of northern Europe absorbed maximum daylight, but were also rendered lacy and shimmery, with sensuous bubble-like membranes that gave the light a subaqueous quality. This inclination was further extolled by the 'Glass Chain' in the early twentieth century. While setting out the programme for a new 'glass culture' in *Glasarchitektur*, poet and novelist Paul Sheerbart emphasized the power of glass to shine with 'glowing effects' like 'sparkling jewels'.[39] Sheerbart's ideas were strikingly prophetic: glass buildings as huge lanterns, glass fibres used for building shells, light columns and light towers, a crystal room with translucent floors, airports as glass palaces, floating glass architecture, a glass bridge. His contemporary Bruno Taut was equally enamoured with a transparency that is turbid, not clear, describing in *Alpine Architecture* (1917) his ideas for jewel-like volumes whose faceted glass would 'gleam' and 'sparkle in the sun'.

Realizing similar ideas were the leading architects of Europe and America, who manipulated the plasticity of glass to yield a complex optics that constantly changed under the impacts of light, thereby blurring while also rewarding vision. Among these achievements were the sparkling folds of Mies van der Rohe's unbuilt Glass Skyscraper (1921), the shifting geometry of glass in Johannes Duiker and Bernard Bijvoet's Zonnestraal Sanatorium (1928), the soaring glass staircase of Brinkman & Van der Vlugt's Van Nelle Factory (1930), the translucent lenses of Pierre Chareau's Maison de Verre, and the Pyrex tubing of Frank Lloyd Wright's Johnson Wax Headquarters (1939; opposite). These vitreous works were based on a transparency whose light transmission is slightly retarded, and whose views are disturbed and obscured by bewitching astigmatic effects. As

Palm House by Decimus Burton.

Johnson Wax Headquarters by Frank Lloyd Wright.

glinting reflections and refractive distortions are superimposed onto views, glass attains a magical presence that is there one moment, and gone the next.

The liberation of the human eye to look *at* as well as *through* diaphanous films – where the role of glass is to veil rather than fully reveal, and thereby incite one to 'gaze' – has developed into a widespread theme of contemporary architecture.[40] Wherever bent light produces images that are softened and only partially seen, as if glimpsed through an intervening mist, room is opened up for the eye to become creative in the *act* of seeing. The data of perception is replaced by fleeting sketches of things, which evade the full grasp of eye or mind. A perceptual and psychic improvisation is invited, as we sense what is only hinted at, and resolve trance-like images from out of our own dream-life. 'The hidden fascinates,' writes literary critic Jean Starobinski in *L'Oeil vivant*, and this 'fascination emanates from a real presence that obliges us to prefer what it hides, to prefer something remote, which it prevents us from attaining even as it offers itself.'[41]

Something of the same evasive perception is aroused by the aquatic transparency of Bill Viola, used to make images extra-involving and thereby induce self-reflection. In his video sequence *Five Angels for the Millennium* (2001), human figures are modulated by the lens of water into which they plunge and sink in slow motion, and then rise covered in droplets and streams, producing anamorphic and half-dissolved images that give reality an otherworldly beauty. It is the 'transformative' power of water, contends Viola, which helps make visible an 'invisible world of inner images'.[42] This approach is not far from the way architects are now exploiting glass, and often plastics, to construct phenomena whose sensuous pleasures demand real creative work on the part of the observer, requiring him or her to negotiate effects of overlapping images, obscuring reflections, dazzling interventions, and generally unstable perceptual readings. The visual experience of this deepened transparency is similar to that of an aquarium, whose glass wall is merely the outer lining of an optical medium beyond which lie mysterious, cloudy, ambiguous depths, and produces an optics where vision is fuzzy and the eye can plumb a volume of light.

To convert the building skin into an indistinct veil between outside and inside, Jean Nouvel employs 'glass as a lace'. The aim is to mystify and render seductive what is seen beyond, by superimposing over its scenery vague reflections and scintillating images. Nouvel has described this visual construct as 'hyper-perspective', in which glass is not merely a membrane to look through, but a projection screen upon which images are reflected, producing a 'poetry of haze and evanescence'. These laminous phenomena are the essence of his Cartier Foundation (1994; below), in Paris, where the optical interplay of free-standing glass walls mediates between building and

Cartier Foundation by Jean Nouvel.

Hospital Pharmacy by Herzog & de Meuron.

A sensuous play of transparency and reflection is often obtained by detached linings in the architecture of Herzog & de Meuron. Like a skin of water, the outer glass sleeve of their SUVA Building (1993), in Basel, adds a luminous sheen to the old masonry façade it covers, while blurring it with glass bands of varied transparency – ranging from transparent ribbons aligned with the windows behind, to the obscuring effects of both sun-catching prismatic panes and panels silkscreened with the company logo, the latter only coming into focus at close range. Conversely, glass walls are recessed behind the outer stone cage of the Dominus Winery (1998; p. 134), in Napa, California, to protect them from the sun, an arrangement that amplifies reflectivity by shadows and provides near and far images to view on films, giving the glass an elusive and slippery optical presence. Real and unreal are made to overlap, as are transported images, so as to break and reshape visual perspective.

Viola's water lens finds a close approximation in the deliciously smooth and lustrous wrapping of Herzog & de Meuron's Hospital Pharmacy (1998; left and below), also in Basel, whose outer glass sheath tends to fog reality and shift it slightly out of focus. Silkscreened onto this membrane is a fine filigree of small green dots, whose molecular pattern fragments and colours entering light, while blurring the rear wall with a bottle-green veil. Insulation panels on the back wall are covered with perforated aluminium sheets, whose shadowy holes introduce a second layer of dots. Based on grids slightly different in size, the two sets of dots are almost but not precisely aligned, producing *moiré* effects when viewed simultaneously, as well as a double-image that fluctuates before the eye. For a moving observer, the façade appears to quietly vibrate with a fluid motion, exerting a curious optical tension that makes one aware of the ricocheting light behind.

These dotted transparencies of Herzog & de Meuron draw on ideas and images from neighbouring disciplines. The aim of catching light on canvas, and making its energy palpable, was a dream of pointillist painters, such as Seurat, whose images were welded from thousands of dots of pure colour that mingle together and are recomposed on the human retina. The resulting luminous vibration causes the observer to play a critical role in forming the

street. Each transparent plane reflects slightly different images according to its location and the objects before it, and grows increasingly turbid as an observing eye penetrates three or more films. These impressions become pronounced at dusk, when the backdrop is dark and reflections are heightened by light and colour from city and sky. Expressed here is a human 'desire to build with diaphanous material', as Bachelard wrote in *Air and Dreams*, striving for an 'opaline solidification of everything in the insubstantial ether that we dearly love'.[43]

Hospital Pharmacy by Herzog & de Meuron.

finally perceived work. Related phenomena linked to modern lithography were explored by Pop artist Andy Warhol, who sought to eliminate the artist's hand by applying mechanical repetition to silkscreen processes. Evoked more directly by this powdery light is the digital imagery that now pervades contemporary culture: television screens, digitized photographs and half-tone printing where ink is applied in an array of fine dots. By these associations, pixellated glass offers not only a sensuous skin, but also a contemporary way of seeing – a mode of vision conditioned by reality that is seen through a veil of molecular light.

A more configurative technique of folding and pleating glass walls has been developed by architect Hiroshi Hara, to deepen and transform perspective in such buildings as the Yukian Teahouse (1988; right) and Iida City Museum (1988; below). At the latter, superimpositions of outside and inside in the zig-zag glass produce what Hara calls 'boundary obscurity', an optical intrigue and ambiguity amplified by highly tactile cobblestones and floors of polished black stone that magnify the weakest images seen against them. Hara's aim is not to amuse, but to draw the viewer into a more involving, yet also more inventive, manner of vision, one which combines powers of sight and insight, the seen and the sensed. Invading phenomena are no longer based on physical or even cognitive reality, but would seem to evoke the erratic images from out of our deepest mental structure, giving a shock to solid reality. Shifting from one mode of vision to another, his optics express a dream-like state amid tangible things, evoking here, as it did by entirely different means in the Japanese past, a 'fusion of reality and fiction'.

More seamless optics belong to curvaceous glass, whose continuous gradations gently warp and distort vision, as in the geometric glass cones of Jean Nouvel's Galeries Lafayette (1996; p. 90), in Berlin, or in the naturalized curves of Herzog & de Meuron's Library IKMZ (2005; p. 88), at Cottbus, the latter recalling the sinuous volumes exploited by Alvar Aalto in small building details, as well as in glassware. Curving optics are the sole focus of the Glass Pavilion at the Toledo Museum of Art (2006; p. 94) by Kazuyo Sejima and Ryue Nishizawa, who together form SANAA. The pavilion's replacement of

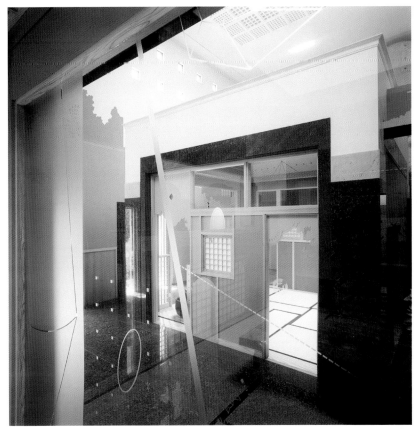

Yukian Teahouse by Hiroshi Hara.

matter with light, and near eradication of weight, offer a vivid image of the 'secret of lightness' praised by Italian novelist Italo Calvino in *Six Memos for the Next Millennium*.[44] In his eloquent meditations on the qualities indispensable to the art of living in our current age, Calvino gives a privileged place to the value of 'lightness', as does SANAA with its sinuous glass walls beneath a thin roof. As delicate and insubstantial as soap bubbles, the pavilion's glass-work disrupts any boundary between fluid and solid, and makes volumes go soft at the edges – ensuring that the building can never freeze into a

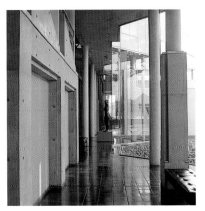

Iida City Museum by Hiroshi Hara.

permanent shape. The effect is liberating, for the uncertainty and collaging of boundaries demands that each viewer contribute to resolving what is unclear.

The seemingly effortless glass architecture of SANAA, more perceptual than material, bears a close resemblance to the glass pavilions designed since the 1980s by American artist Dan Graham, which take increasingly curved and layered forms. By coating glass with a thin mirror film, Graham creates what he calls a 'two-way mirror' that simultaneously reflects and transmits mobile images, producing an 'intersubjective transparency' where people and space on either side have superimposed views of each other. The emphasis is not on the physical apparatus, but on what appears through and upon its screen, similar to cinema's projections and illusions, so as to make people aware they are seeing *phenomenologically*.

The traffic of light in Graham's glass rooms shows a clear intent, as does the long tradition from Mies van der Rohe's Glass Skyscraper and Lloyd Wright's Wayfarers' Chapel (1951; below, left) to SANAA's Pachinko Parlour (1993; below, right), to divert rays of light on their journey to the eye. This phenomenon gives visible form to an otherwise invisible reality – the 'slowing of light' when passing through glass. In his renowned explication of quantum electrodynamics, *QED: The Strange Theory of Light and Matter*, American physicist Richard Feynman points out that 'light interacts with electrons throughout the glass, not just on the surface', and here, 'photons and electrons do some kind of dance'.[45] Feynman explains that light passing through a medium can go faster or slower than its conventional speed, and does not move only in straight lines. Recent experiments by Harvard physicist Lene Hau advance this notion, demonstrating that a pulse of light may actually be slowed to a standstill when passed through an ultra-cold cloud of atoms, a state she calls 'frozen light', or 'ultra-slow light'.[46] While observations of 'slow light' by Feynman and Hau lie outside our normal experience, they have the ring of phenomenological truth, for we can sense the different speeds of light in today's glass architecture, where light is sidetracked through many paths before collecting in our eye.

The internal bending and dispersal of radiation is most extreme in translucent membranes, which appear to trap energy and render it solid. Rather than

seeing distant objects partly fogged, the objects themselves disappear and are evident only through vague shadows cast upon the film from behind. These dark silhouettes interact with a new perspective opened up within the membrane: an internal illumination of matter that invites a viewer to gaze into the lens itself, and there discover an infrastructure of corporeal light. All of these phenomena come into play in the silkscreened membranes of Herzog & de Meuron, beginning with the 'tattooed glass' of their Ricola Factory and Storage Building (1993; p. 98), in France. Of particular beauty are the sketchy images imprinted on glass at the Eberswalde University Library (1999; p. 226), which produce semi-translucent walls whose ambiguous optics reveal as well as conceal. Screenprinted with serial images taken from newspapers, the glass bands suggest filmstrips made of reiterated frames. The eye alternately probes through a wispy veil, then pulls back to gaze at ethereal images traced on glass. Residual light caught by images is most beguiling around two thresholds: a glazed entry box and glass tunnel to the old library. Scrims here are complicated by each other's shadows, and are often viewed simultaneously, so as to overlay translucid impressions with one another and with echoes of identical images etched into the concrete walls.

The crystalline depths achieved in several works by Spanish architect Manuel Clavel Rojo derives not from external appliqué, but from the material structure of glass itself. This technique is exploited with artistic power in his modest but touching mausoleum at La Alberca (2003; opposite, above), whose window is laminated from narrow glass strips to liquefy sunshine and display the shadow of a steel cross. Clavel Rojo cuts the glass sheets with a rough edge, and then stacks them horizontally like wooden planks, thereby redefining the use of glass as a building material. Light is drawn through the sheets as in fibreoptics, to refract and reflect *within* the window's composite lens, and finally illuminate the edges and make them sparkle with a magic derived from being uneven. In a similar vein, Dutch architects Kruunenberg Van der Erve have used glass laminations to bring a watery glow to their Laminata House (2002), but with strips set vertically and continued around the entire perimeter.

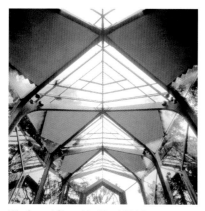

Wayfarers' Chapel by Lloyd Wright.

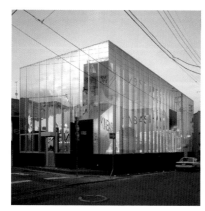

Pachinko Parlour by SANAA.

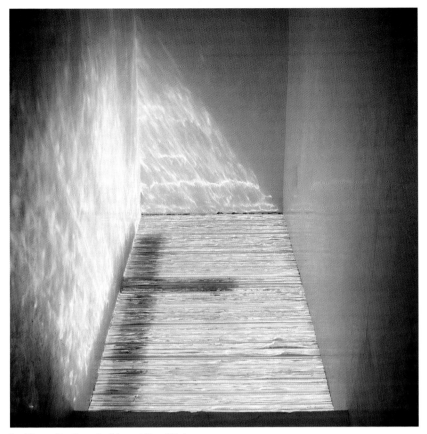

La Alberca Pantheon by Manuel Clavel Rojo.

Beyond its obvious insulating benefits, the double-glass wall has offered architects a creative tool to exploit the infill between detached sheets. Fibreglass panels of varied shape have been used by Fumihiko Maki, for example, to bring a translucent narrative to buildings such as his Kyoto Museum of Modern Art (1986; below, centre), whose irregular pattern controls light and views along twin staircases. Using equally unconventional means, Meinhard von Gerkan gave a unique optics to the cloister walls of his Christus Pavilion (2001; p. 100), in Volkenroda, Germany, infilling glass sheets with small

objects to challenge stained glass as a source of spirituality. Rafael Moneo employed two detached translucent linings for his Kursaal Auditorium and Congress Centre (1999; below, left and p. 104) to render the skin luminous and restrict views, and to hide and mystify a steel structure and give prominence to the lenticular properties of the outer and inner glass faces. At the same time, Moneo abstracted his translucent cubes and stripped them of gesture, heightening their power to reveal even the faintest shifts of light and weather along the volatile Costa Vasca.

The glass wrapping of Peter Zumthor's Kunsthaus Bregenz (1997; p. 108) was conceived as a 'body of light' as well as a sunscreen, absorbing while evoking the 'light of the sky' and 'haze of Lake Constance'. Translucency plays a different role within the museum, diffusing illumination to galleries *from above*, via a hidden plenum that creates a sense of disbelief in such a vertically stacked building. This secret source of natural light keeps visitors linked to what is taking place outside, causing the ceilings of otherwise introvert rooms to brighten and dim from east to west throughout the day, and culminate with an orange glow as the sun sets over the lake. Providing a stark contrast with this gauzy tower are the glass lanterns of Steven Holl's addition to the Nelson-Atkins Museum (2007; below, right and p. 64), which consist not of platonic cubes but of crystalline fragments that spill down the hillside. Wherever Holl's subterranean museum emerges from earth and reaches for sky, volumes are wrapped in a double layer of interlocking glass planks, some of which transmit light to the galleries below, while others give a luminous face to opaque walls. These shimmering forms, described by Holl as 'glass lenses' and 'shards of glass emerging from the landscape', were purified of colour by removing ferric oxide during manufacture, thereby eliminating the greenish tint typical of glass and producing a whiteness able to register faint shadows and colours of light. Planks were also imprinted on the exterior with a prismatic texture, and sandblasted on their inner face to offer a silky sheen with extremely soft shadows. The result is that every room stays in touch with nature through vague impressions cast upon the skin, and is suffused by an ethereal, somewhat foggy light that envelops and saturates the space.

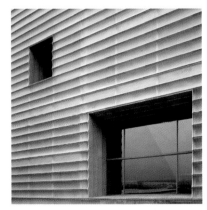

Kursaal Auditorium and Congress Centre by Rafael Moneo.

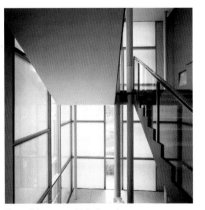

Kyoto Museum of Modern Art by Fumihiko Maki.

Bloch Building, Nelson-Atkins Museum by Steven Holl.

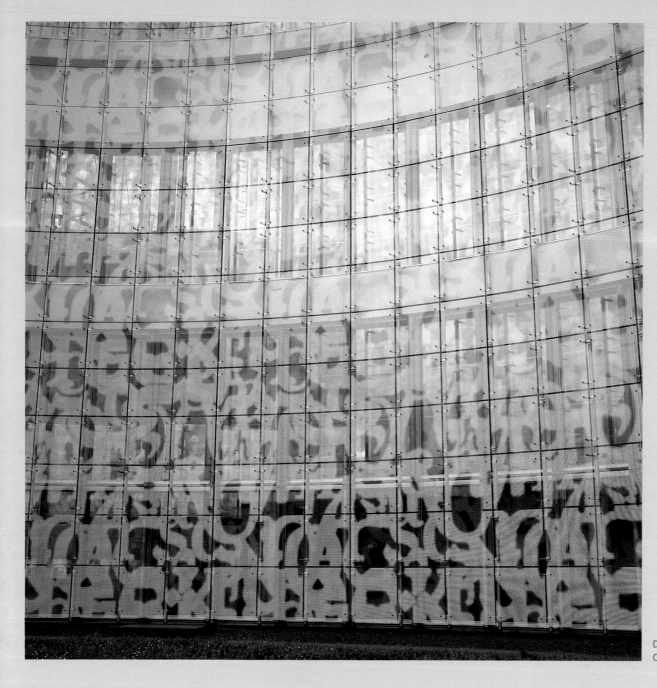

Double-glass wall at twilight.
Opposite: Exterior.

Library IKMZ, Germany Herzog & de Meuron

Stretched around the amoebic envelope of this library at Cottbus, built in 2005, are two layers of curving glass, whose hazy focus and double vision are heightened by an occasional appearance of solid wall, half-dissolved by the foreground veil. Complicating this fogged light are digitized letters from various alphabets, silkscreened in contrasting patterns on each glass layer. These alphabetic shapes are abstracted by pixellation and collage, causing their already blurry patterns to interfere with one another and merge or diverge, appear and disappear, with the changing sightlines.

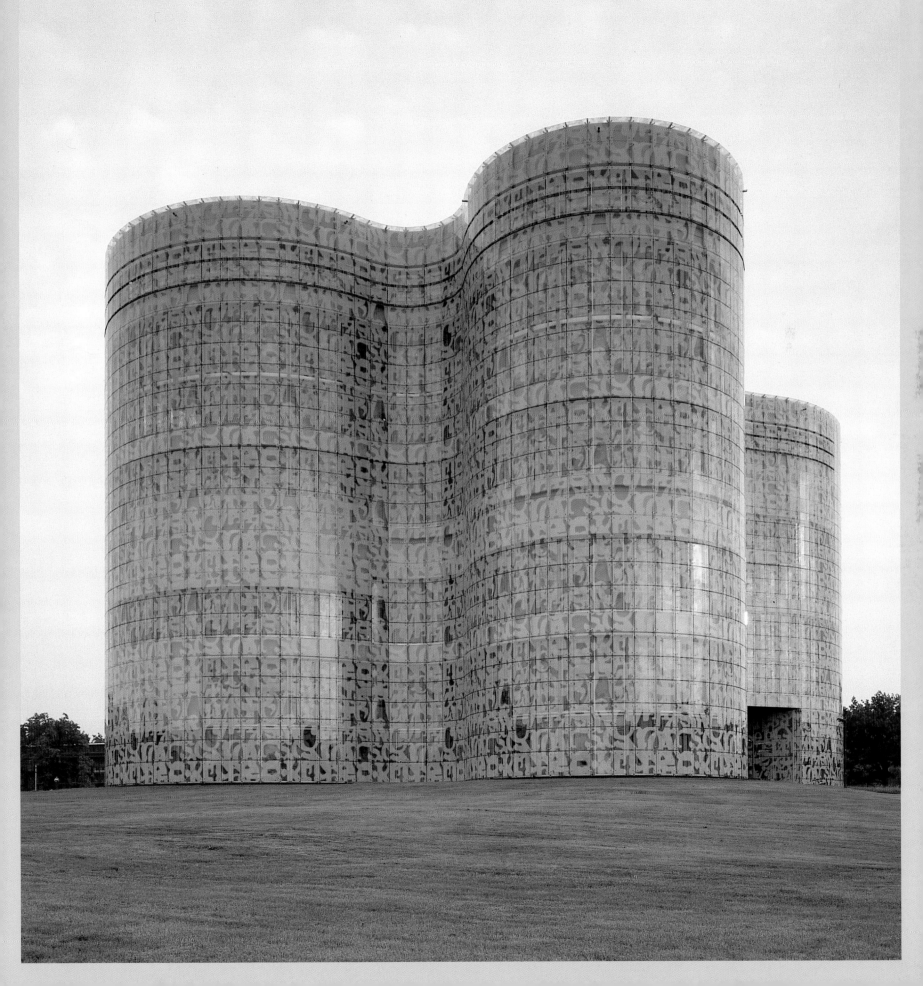

Projection of glass cone into office.
Opposite: View down into inverted glass cone.

Galeries Lafayette, Germany Jean Nouvel

Huge glass cones that open up the space and convey light into this 1996 shopping destination in Berlin also exert a transformative effect on human perception, as they bow and multiply fugitive images from side to side. Each gaze onto the swirling views in one of these funnels, whether a huge cone of urban scale or a small cone suspended above a conference room, picks up and is overlaid with sparkling anamorphic images. Bounced repeatedly around each curve, these images tell a dual story of light outside and activity within, allowing vision to exceed the limited scope of the physical eye.

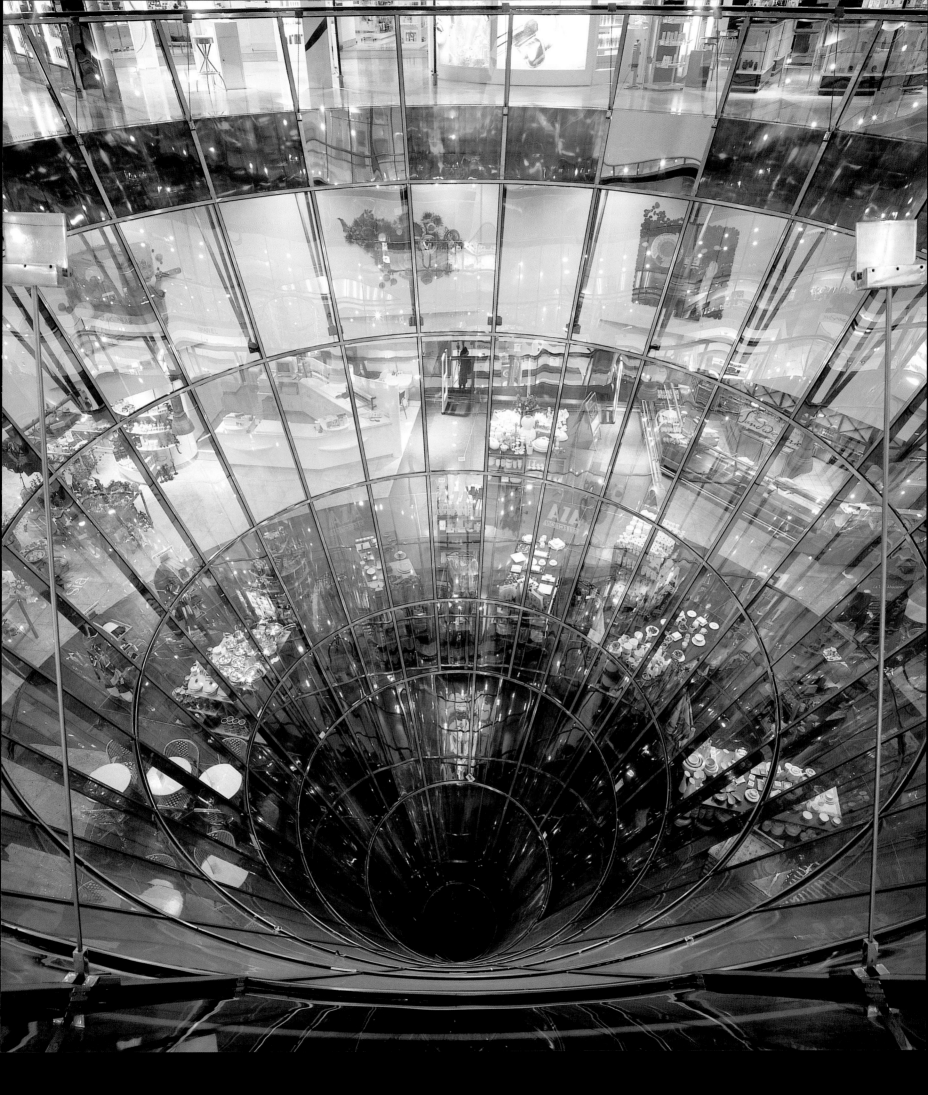

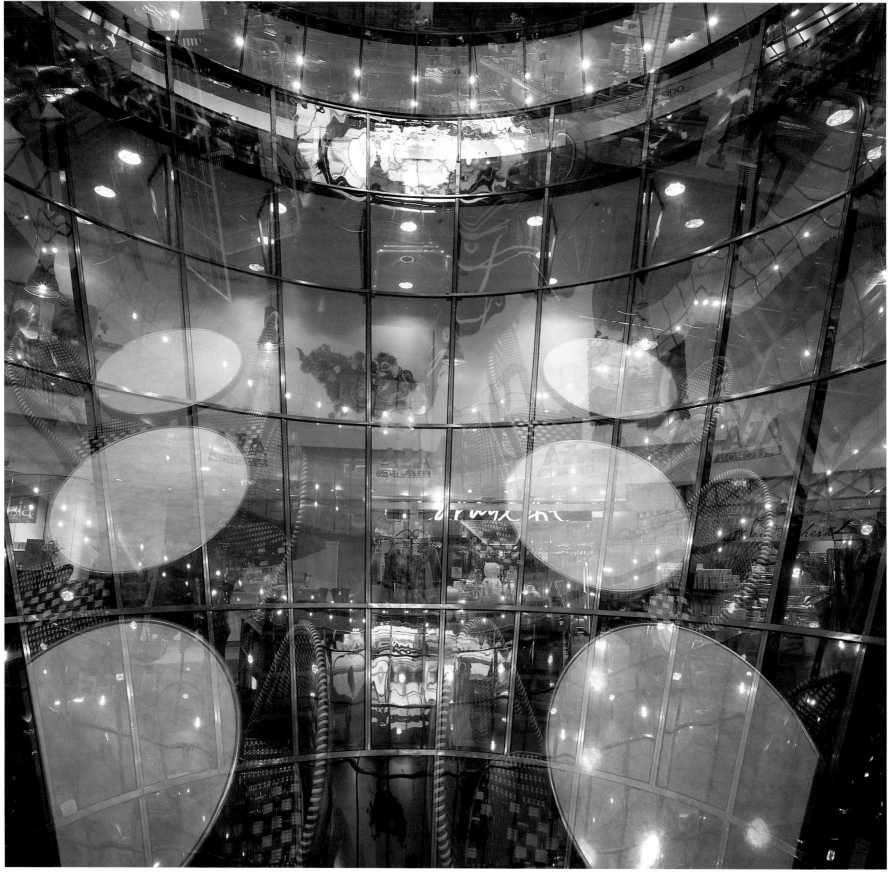

Anamorphic reflections at underground café.

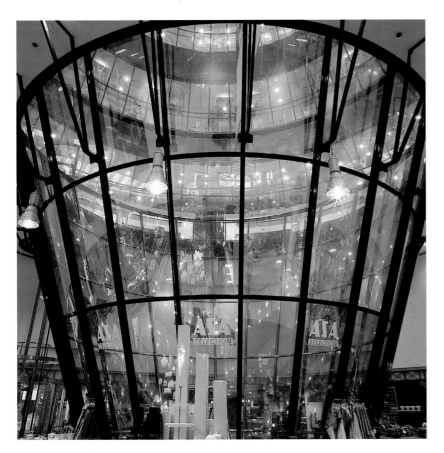

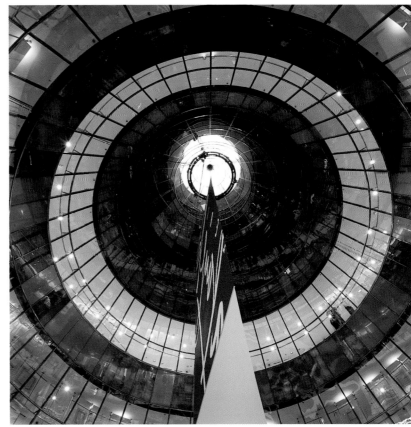

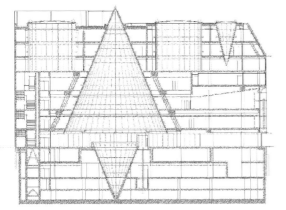

Above: Section.
Top, left to right: Inverted glass cone at underground level;
view up into central glass cone.

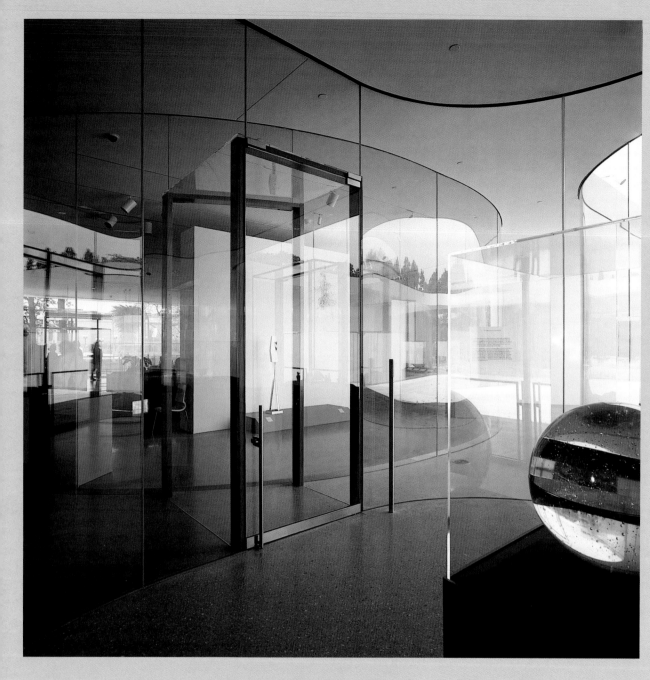

Galleries with transported reflections of outdoor space.
Opposite: View from foyer to exterior courtyard.

Glass Pavilion, Toledo Museum of Art, Ohio, USA
Kazuyo Sejima + Ryue Nishizawa / SANAA

Nothing appears but panoptic effects and fluid reflections in the serpentine curves of the exceptionally clear, low-iron glass used here at this 2006 museum extension. Nestled inside the outer glass skin are smaller glass cells, whose slippery optics evoke those of the art on display. These shimmery rooms have rounded corners that meet back-to-back, and are combined into a cellular structure of multiple layers. But the real enchantment stems from the doubled layers of curving glass, in which each lining is of a different and shifted radius, so as to warp simultaneous reflections to varying degrees. Light arriving horizontally around the perimeter, and diagonally through courtyards, is bent and dispersed throughout the interior, transporting and mixing images of nature with those of visitors and art objects. In addition to being viewed directly, the glass art appears unexpectedly in ghosted form, slipping around corners and caressing other images as visitors proceed through the pavilion.

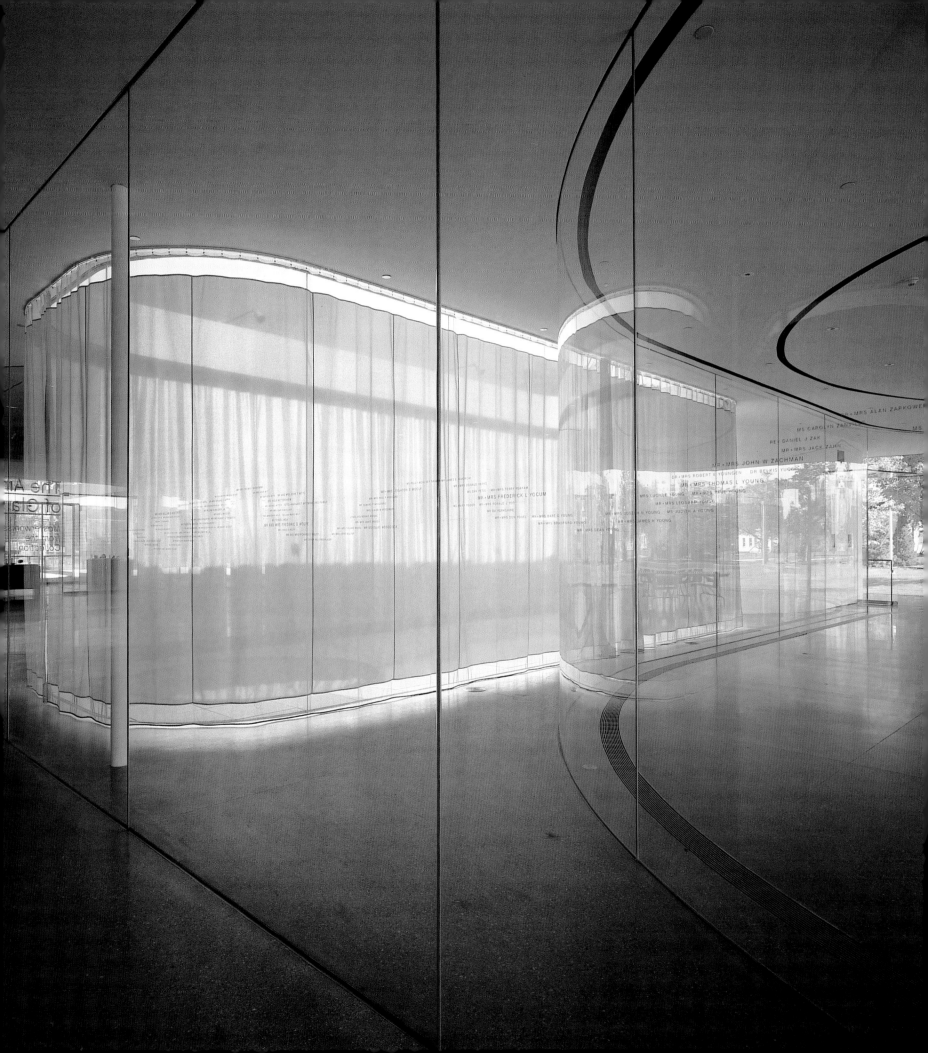

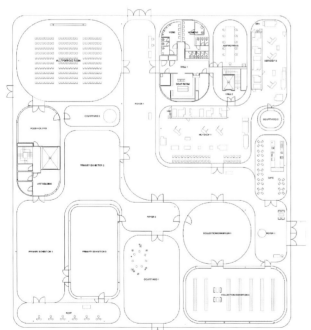

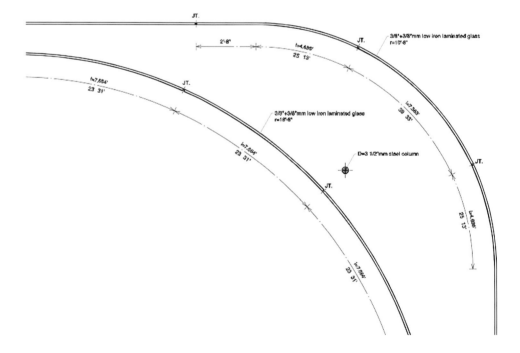

Above, left to right: Plan; detail plan of double-glass walls.
Top: Exterior.

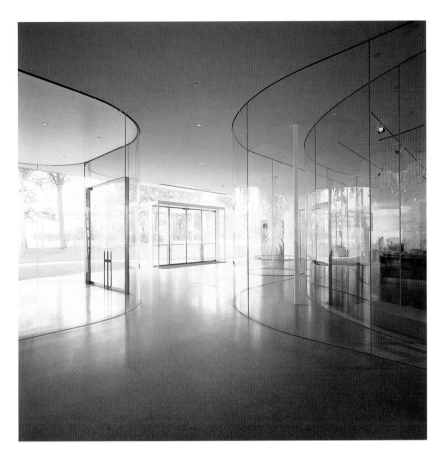

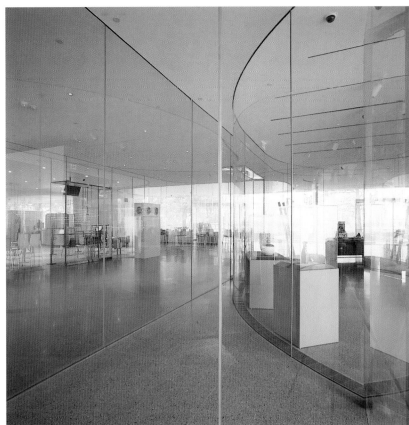

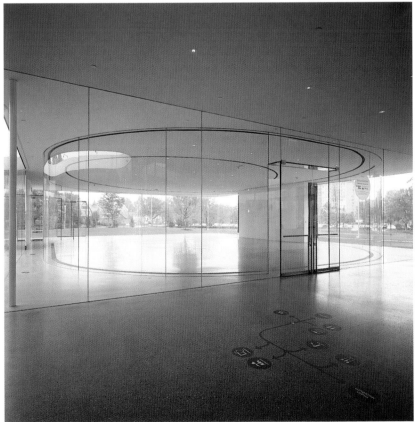

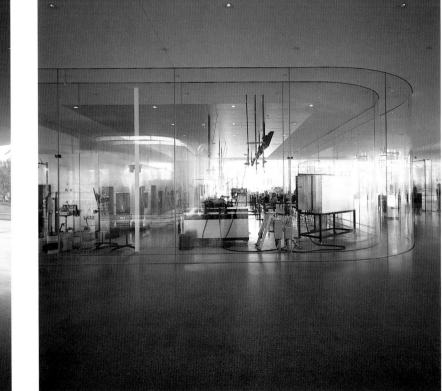

Clockwise from top left: South entrance with gallery at right;
glass linings between foyer and gallery; hot shop; multipurpose room.

Interior.
Opposite: Skylit roof soffit and wall.

Ricola Europe Factory and Storage Building, France
Herzog & de Meuron

Translucency was achieved at this 1993 factory building in Mulhouse with sheets of polycarbonate, a hollow synthetic resin, whose surface was graphically enriched by the successive imprinting of a photograph of a palm leaf, giving added depth to the material's inherent diffusion of light. The original photograph was deliberately abstracted by digitizing, resizing, and uniformly repeating the image, thereby creating a woven glow similar to that of a fabric, while avoiding the surface breaking up into separate units or conveying an identifiable figure. These membranes play on repeating images in contemporary art, such as the serialism of photographer Ray Metzker, whose single frames are absorbed into the warp and weft of a no longer quickly graspable composite image, causing a vacillation between abstract and real.

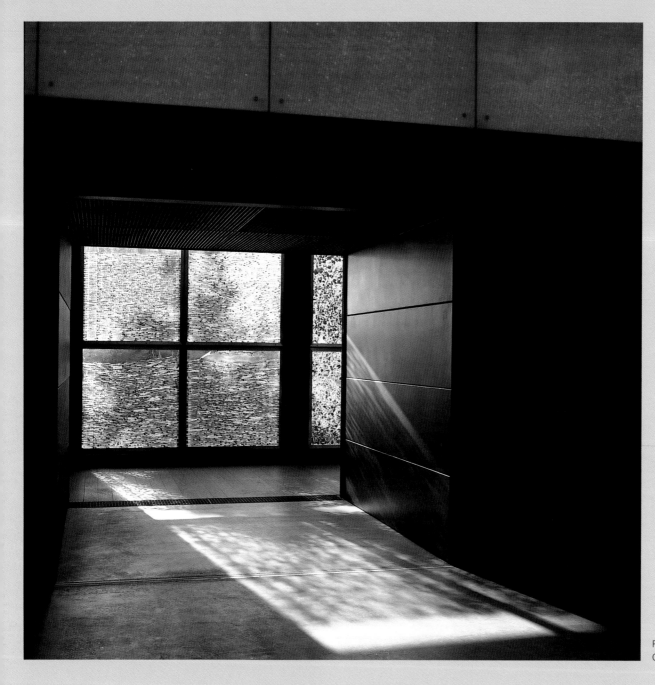

Passage into church from cloister beyond.
Opposite: Cloister with passage into church at left.

Christus Pavilion, Germany Meinhard von Gerkan

Surrounding this cubic sanctuary at Volkenroda, dating from 2001 and diffusely lit by plates of marble, is a cloister into which light is detoured by small objects in multiple form trapped between transparent sheets. Infilling double-glass plates are diverse materials and artefacts, whose substances intercept light in various ways and dapple the cloister with contrasting colours and shadow patterns. These filtration elements – including natural materials (sand, coal, wool and feathers), technological products (cables, machine parts and tools), and household elements (paper, clothes and toys) – are each subject to a surreal manoeuvre in which the object's unexpected setting confers upon it an aura of magic.

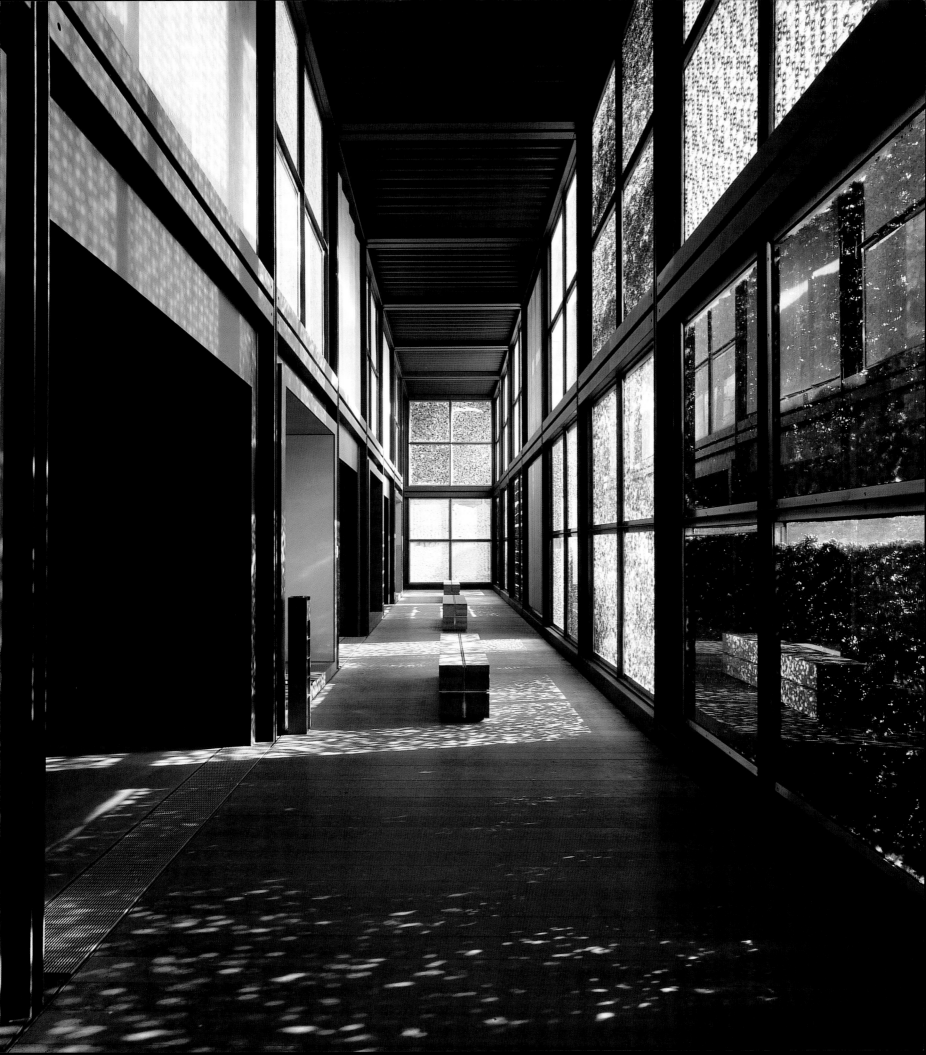

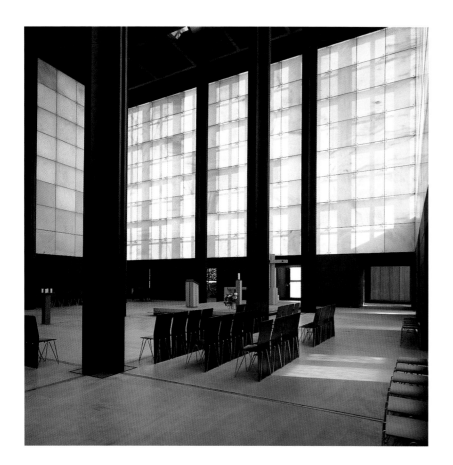
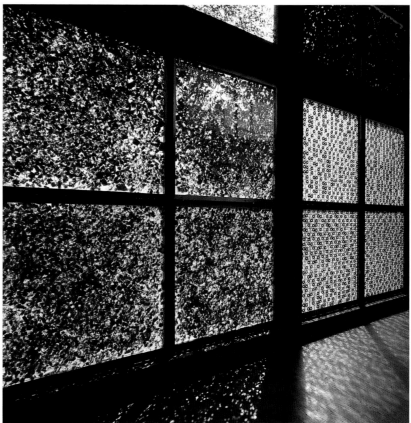

Above: Infill of natural and industrial materials to produce contrasting qualities of transparency and light.
Top, left to right: Church interior with translucent walls of marble plates; backlit double-glass walls.

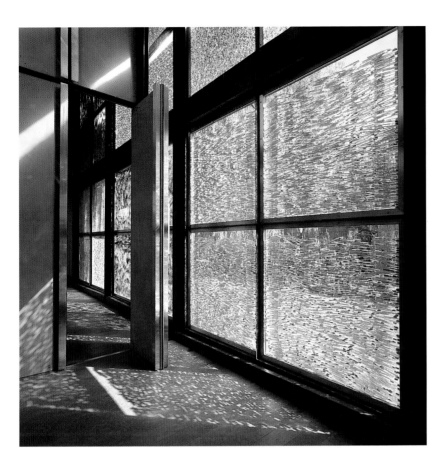
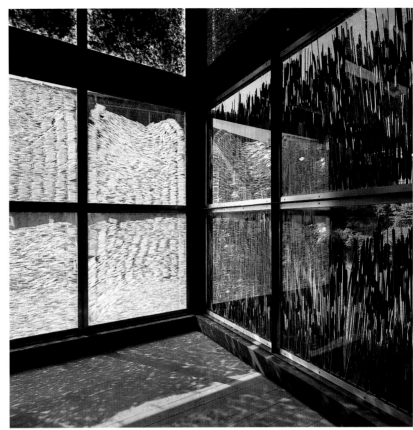

Above: Detail elevation of cloister wall.
Top, left to right: Cloister entrance; interplay in cloister walls of transparency,
translucency, reflection and projected light and shadow.

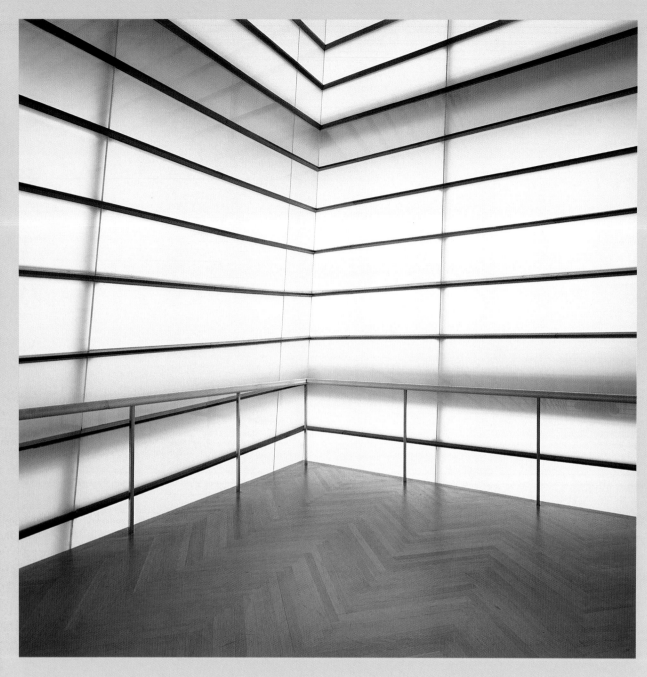

Corner of glass wall.
Opposite: Rear corridor.

Kursaal Auditorium and Congress Centre, Spain
Rafael Moneo

The glass cubes of this 1999 auditorium and conference centre echo San Sebastian's misty Basque climate as hazy lanterns inclined to the sea, evoking huge ocean rocks that are dark when dry, and glisten when wet. The double-glass shell is conceived as a sandwich to absorb its own structure and to develop its optics from contrasting faces, employing different kinds of glass for each side of the lens. The inner face is given a smooth lining, with horizontal strips of flat, frosted glass, while the façades are dressed with concave bands of translucent glass incised with fine convex striations, a combination that diffuses light while rendering the glass tactile. Even by day, the glass is alive with quiet pulsations reminiscent of the nearby sea. In these 'petrified waves fixed to a building fronting the sea', one is reminded of Adrian Stokes's words when describing the windows of Venice, which suggest 'the taut curvature of the cold under-sea, the slow, oppressed yet brittle curves of dimly translucent water'.

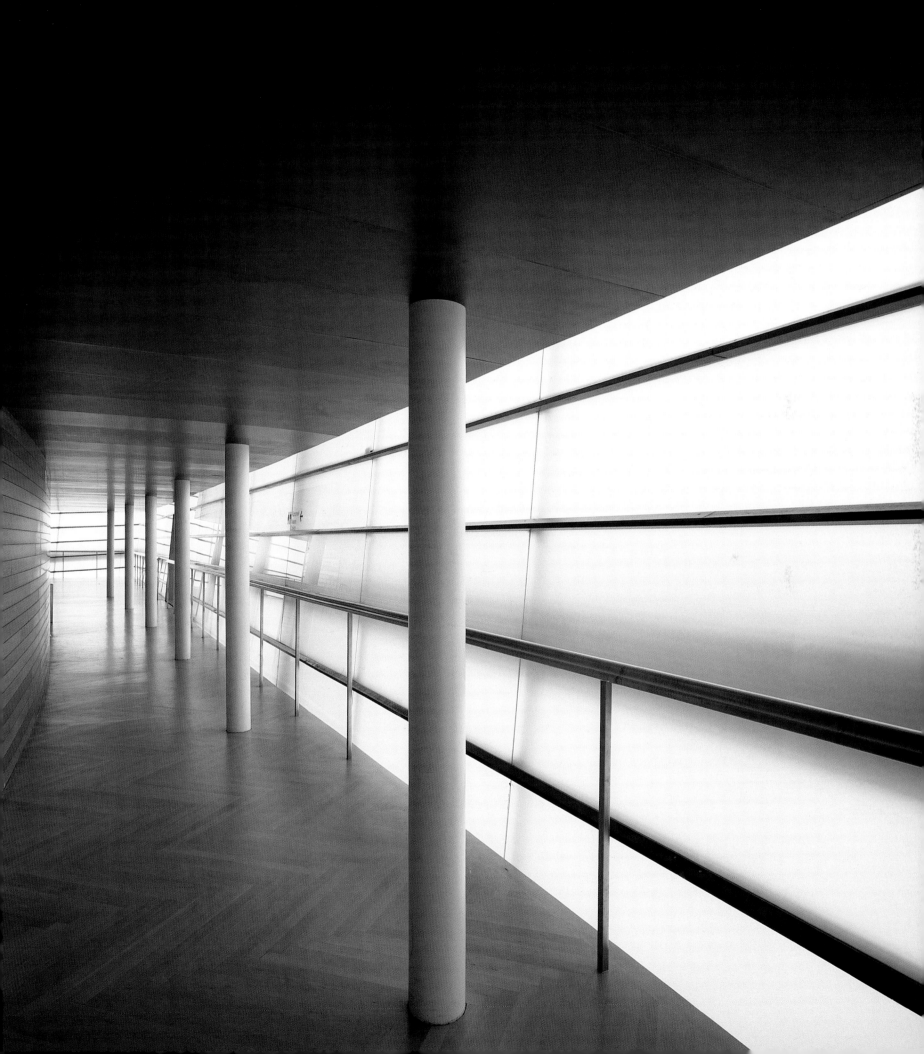

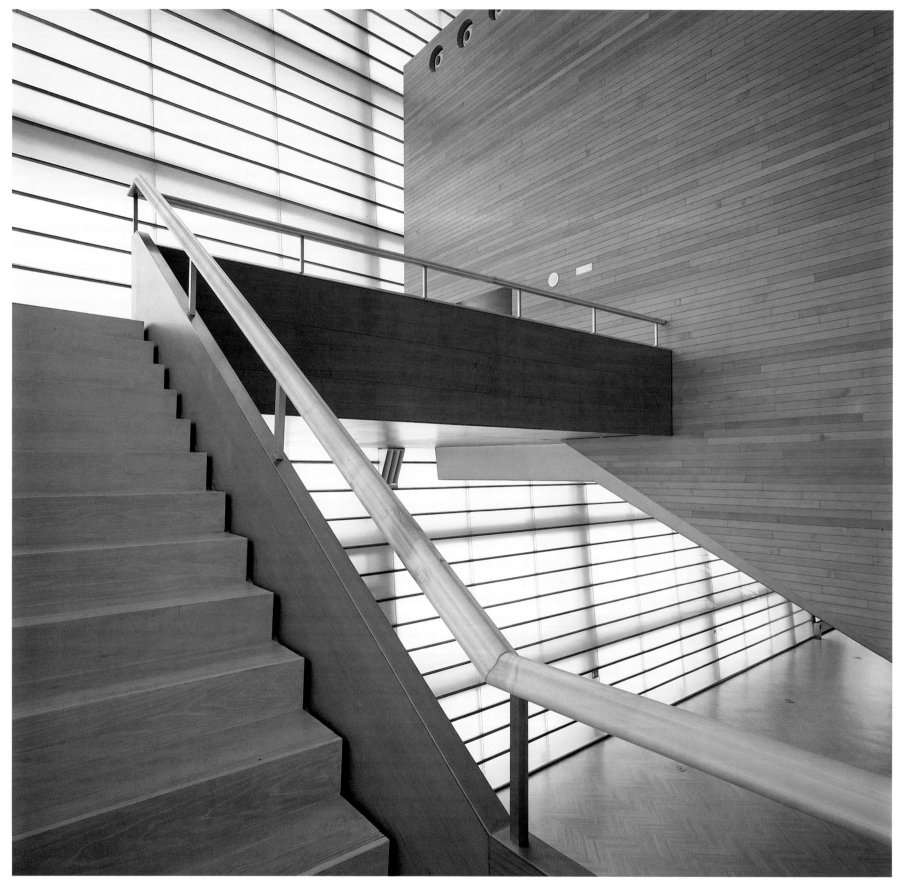

Stair to mezzanine level.

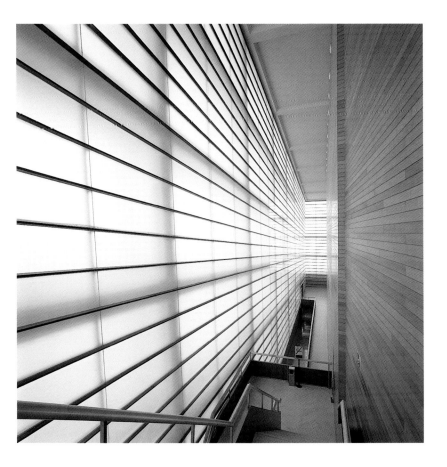
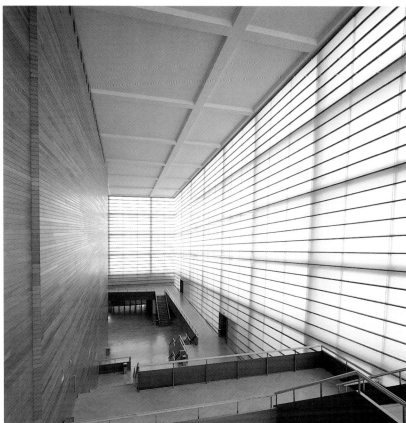

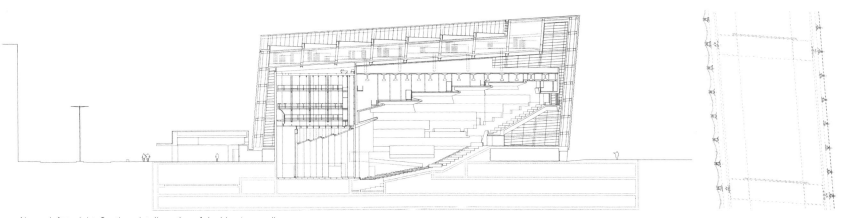

Above, left to right: Section; detail section of double-glass wall.
Top, left to right: Side corridor; foyer with auditorium at left.

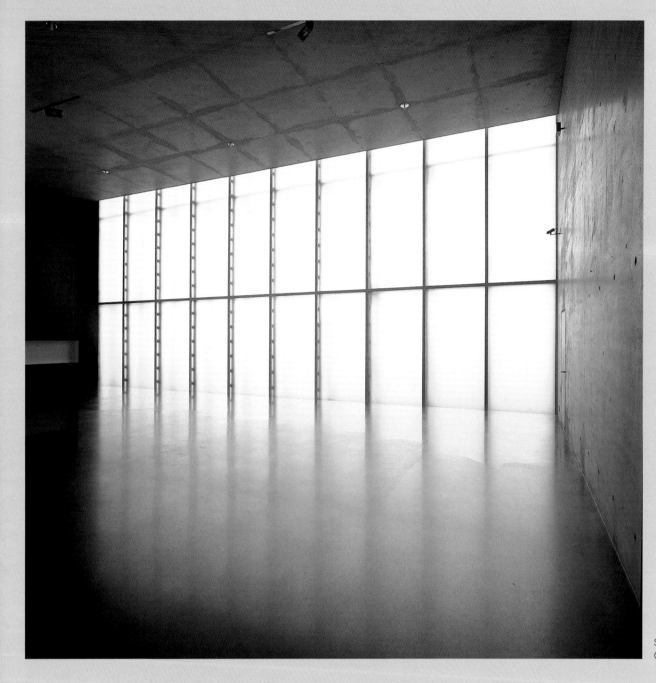

Skylit glass wall in lobby.
Opposite: Skylit staircase to gallery.

Kunsthaus Bregenz, Austria Peter Zumthor

The enigmatic sheathing at this 1997 museum on the edge of Lake Constance exerts a seductive power on the eye. Assembled from hundreds of finely etched sheets, positioned at slight angles with steel clamps, the airy panes overlap like diaphanous feathers or shingles, allowing light to circulate through and behind the scaffold. The displaced membrane permits an observer to visually penetrate various depths, detecting fuzzy intimations that fade with distance – lapping panes, steel lattice, diagonal stairs and concrete walls with glass bands. Concealed by these blurry hints, the museum presents an air of seclusion, as if shrouded in lake mist – strangely intensifying its physical presence even as it obscures reality. The cloudy translucence continues inside, in large windows at ground level, and as a low, misty veil hovering above galleries and stairs.

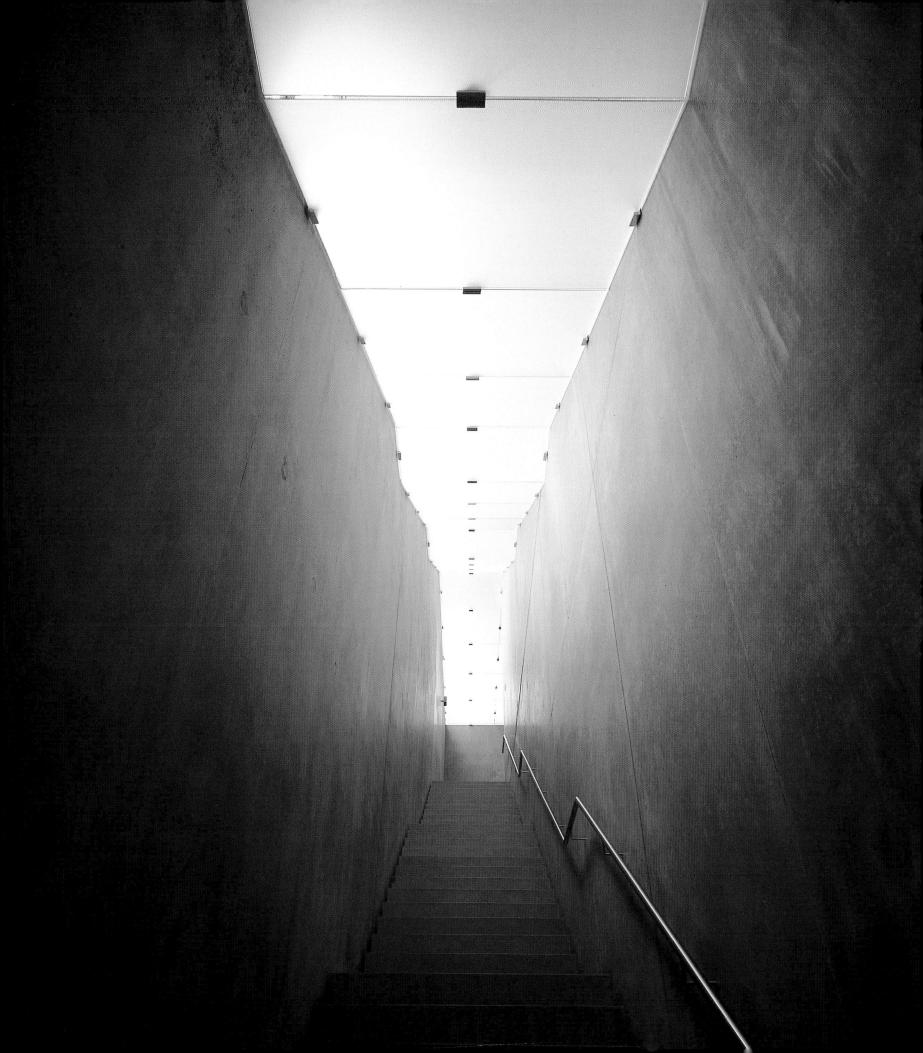

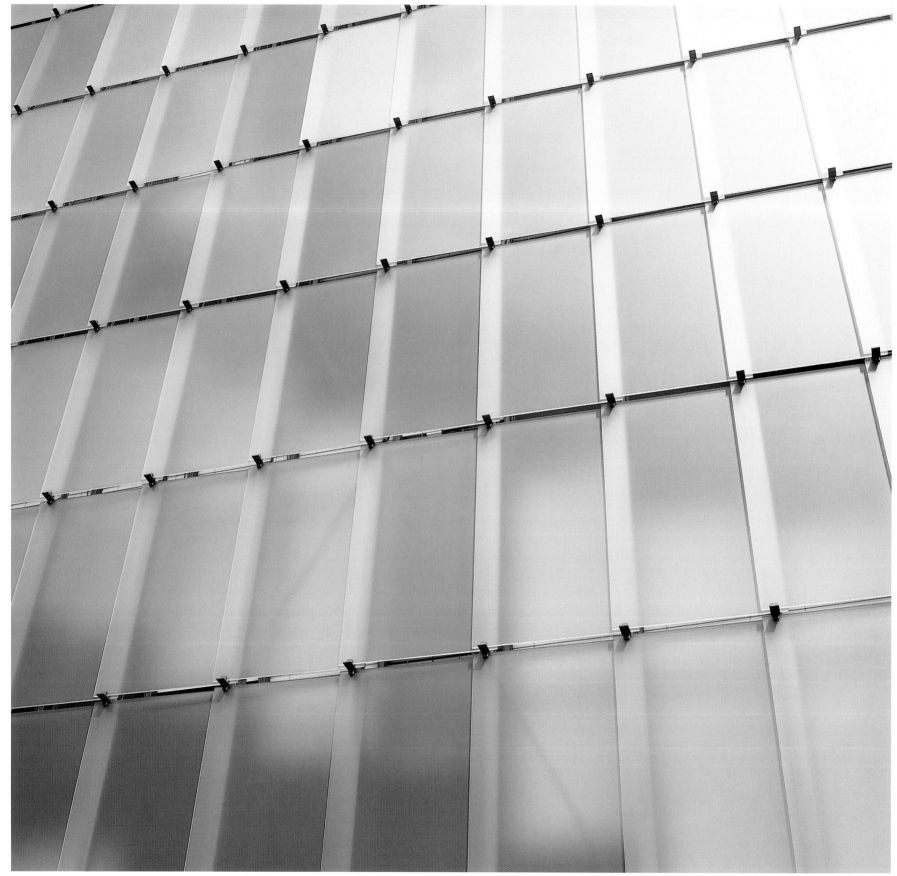

Exterior detail.

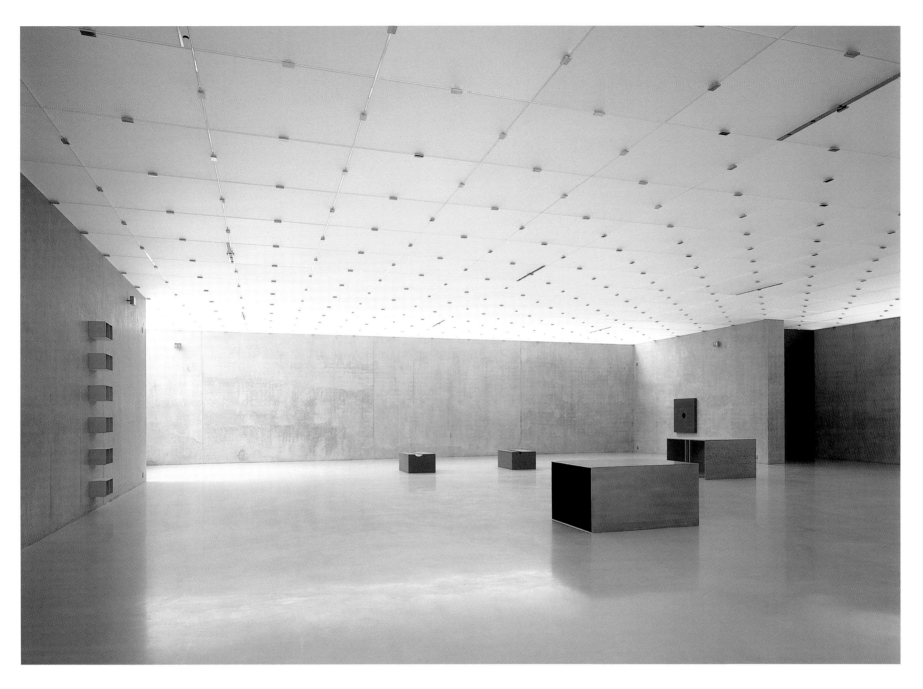

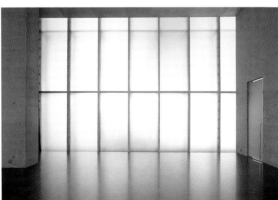

Above, left to right: Exterior with administrative building at right, and museum beyond; sunlitglass wall in lobby; detail of glass ceiling in gallery.
Top: Gallery.

ATOMIZATION

SIFTING
OF
LIGHT
THROUGH
A
POROUS
SCREEN

4 ATOMIZATION
Sifting of light through a porous screen

In his thoughts about the virtues of lightness attained by a 'subtraction of weight', in order to 'dissolve the solidity of the world', Italo Calvino finds a paradigm for this notion in the words of poets devoted to the 'atomizing of things'.[47] Among these is *De Rerum Natura*, by the Roman poet and philosopher Lucretius, which includes such descriptions as 'little motes of dust swirling in a shaft of sunlight in a dark room' and 'spider webs that wrap themselves around us without our noticing them as we walk along'. Within this model of weightless being, light is retarded not by refraction, but by the splintering and pulverizing of its routes. Evoked by such images in the realm of architecture is an art of the screen rather than the membrane, and a possibility of cancelling weight by aerating the boundary – reducing it to 'a weightless element that hovers above things like a cloud or, better, perhaps, the finest dust or, better still, a field of magnetic impulses'.[48]

The capacity of a mesh to fracture without obstructing light, and to disintegrate objects into air, has endless precedents in vernacular, as well as monumental, architecture. I am thinking of the huts loosely woven from reeds in tropical regions, the lacy wooden *mashrabiya* of the Middle East, or the pierced stone screens lining Mughal buildings in India (such as the Palace of Winds at Jaipur), all arising in hot climates to cut heat and glare without impeding ventilation and to minimize visual exposure. Architecture's current fascination with this phenomenon differs from the past, however, in the materials, technology, extent, layering, and often multiple scales with which light is percolated. Of particular interest today is the controlling of a screen's proportion of holes and material finish to create a kind of porous wall that is simultaneously gauzy and luminous, offering mysterious yet scintillating views that excite our powers of imagination.

Screened light has particularly deep roots in Japan, honed not only by a humid climate and culture of restraint, but also by the contemplative mood of Zen (below, left). The array of traditional screens developed to sift light as well as air – including bamboo sudare and wooden lattice – is now being rethought in an industrial language of expanded metal and perforated aluminium, more machined and bright than in the past, but with no less power to shade and cool while inducing a sense of repose. As objects crumble when gleaned through one of these fine meshes, the world appears less solid or clear, and therefore less prone to logical vision. Colours fade, surfaces empty, outlines melt, leaving a vaporous scene with the power to tranquillize a viewer, sedating both eye and mind, and inducing nerves to unwind and the soul to relax. Just as it did in the country's tea culture and Zen monasteries, the atomized light of modern Japan provides a slightly withdrawn, soft-focus view conducive to meditation.

Using thin sheets of porous metal, architects such as Fumihiko Maki, Toyo Ito, Itsuko Hasegawa and Jun Aoki have been particularly adept at re-creating the store of mystery and introspective feeling that is so distinct to Japanese architecture. As light trickles through and gets caught in one of these silvery webs, as in Maki's TEPIA (1989; p. 120) or in Ito's Gallery U (1991; below, right), in Yugawara, the boundary disintegrates in a vibrating

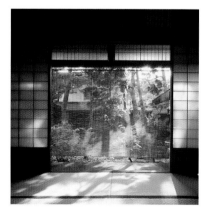

Yoshijima House, Japan.

Cona Village
by Itsuko Hasegawa.

Gallery U by Toyo Ito.
Opposite: Nagoya Design Expo Pavilion
by Itsuko Hasegawa.

haze at the edge of physical existence. To use the phrase of Czech novelist Milan Kundera in *The Unbearable Lightness of Being*, these architects are 'lifters of metaphysical weights'.[49] The fluidity of this image has been of central interest to Hasegawa, who envelops buildings such as her Nagoya Design Expo Pavilion (1989; previous page) with meshes shaped into metaphors of nature, thereby equating the haze of light floating in space with phenomena such as wavery clouds, drifting mist and swirling smoke.

Another part of the world in which atomized light has cultural roots is Scandinavia, where human perception has been conditioned for millennia by the obscuring effects of forest and mist. The problem of adapting this sensibility to an arctic climate has been of particular concern to Helsinki architects Heikkinen-Komonen, leading them to place industrial mesh both outside walls to envelop stairs and mask façades, as well as inside to wrap while vaguely linking rooms – in either case giving a bleary view and feathery substance to boundaries resistant to winter. Impalpable screens in their Emergency Services College (1992; below), in Kuopio, Finland, and Rovaniemi Airport Terminal (1992; p. 122), also in Finland, remove weight while dissolving forms into the landscape and rooms into one another. Questions of how to adapt each screen's optical behaviour to its particular context have led the architects to work like opticians in adjusting the interplay of perforation size, surface finish, and illumination levels before and behind. A fine balance is sought between light and shadow, transparency and opacity, materiality and ethereality in order to create a sensation of lightness and a world of ambiguity that includes confusion, where images tend to emerge and vanish as one moves through a building.

More broadly expressed in these atomizations is a vision of reality developed over the past century, stemming from discoveries in physics, which demonstrate that matter and energy are interchangeable and involve the interplay of two kinds of particles: electrons and photons. In such a view, it is no longer possible to think of objects with excessively sharp and rational outlines as rigid things standing against and separate from the fluid forces of energy in air. This changing paradigm is reflected in attempts by architects to

Hôtel St James by Jean Nouvel.

irradiate solid boundaries and to more closely mingle energy and matter, using aerated screens to lighten reality in two ways: pulverizing physical mass and emphasizing its opposite.

The perceptual freedom of aerified boundaries has been linked by some architects with fractal geometry, where energy is jelled into physical form and contours are corroded by light. The idea of the fractal (from the Latin *fractua*, meaning 'irregular'), a term coined by mathematician Benoît Mandelbrot in 1975 and elaborated upon in *The Fractal Geometry of Nature*, refers to the geometric irregularity in many of nature's most exquisite forms, and is summarized in Mandelbrot's aphorism that 'clouds are not spheres, mountains are not cones, coastlines are not circles, and bark is not smooth, nor does lightning travel in a straight line'.[50] Mandelbrot's ideas of 'fractal shores and coastlines' and the 'phenomenon of scaling' find repeated expression in the buildings of Jean Nouvel, who describes his own approach as wrapping volumes with 'fractal boundaries' in order to 'blur the edges of a building' and to 'restrain any reading of solid volumes'.

Emergency Services College
by Heikkinen-Komonen.

Nouvel's experiments with airy cages range from the motorized aluminium diaphragms of the Institut du Monde Arabe (1987; p. 126), in Paris, to the rusty sheeting of metal duckboards used to clad the Hôtel St James (1989; opposite), near Bordeaux, and the silver-grey meshes of varied proportion that loosely cling to the Culture and Congress Centre (1999; p. 130) in Lucerne. Rooms or scenery glimpsed through one of these porous curtains presents an image that sublimates and attracts, suggestive of the tempting allure of something forbidden, the challenge of the unknown, and the thrill of detection. The extra-retinal fuzziness incites imaginative activity, for the half-sketched outlines of things are left open for each viewer to fill in and give final form. While such deliberately imperfect views may annoy the logical side of the mind by erasing part of the literal world, it is precisely this loss that awakens and enlivens the creative world of the psyche, offering us nothing but giving us everything. By eroding an objective reality that exists apart from us, these diaphanous edgings, more cloud-like than solid, shift the emphasis to a kind of architecture that is based upon, but is also transformed by, human perception. The work insists upon our involvement since it only takes shape with creative vision, and, because of this charged relationship, allows us to perceive ourselves perceiving.

The eating of light into spongy boundaries and Euclidean forms is of equal concern to Herzog & de Meuron, and is most beautifully realized in the porous stone block of their Dominus Winery (1998; p. 134), in Yountville, California, and in the leaf-inspired perforations of copper that sheath the De Young Museum in San Francisco (2005). The mediation of outside and inside shifts to a state of surveillance in the copper bands wrapping their railway Central Signal Boxes (1995, 1997; below and overleaf), in Basel. These outer baskets of horizontal strips, ostensibly shielding electrical equipment and providing shade for computer terminals, are twisted around windows into faintly anthropomorphic louvres that barely stretch open. While creating filtered views outward, the strips make it difficult to see in, similar to evasive window blinds and implying the shyness of eyelashes and the optic advantage of masks or veils worn over the face.

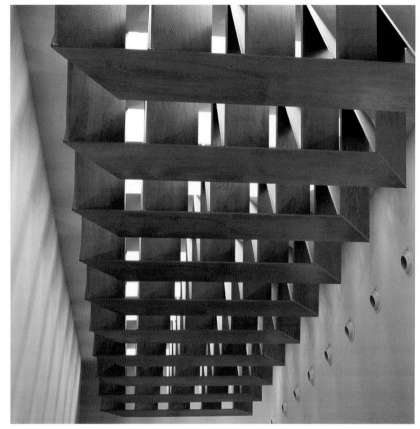

Almería Archaeology Museum by Paredes Pedrosa.

There is neither countenance nor fogged view whatsoever in the punctured steel cube of Heinz Tesar's Donau City Church (2000; p. 138). As coolly machined as the apertures of Nouvel's Institut du Monde Arabe, the cylindrical holes of Tesar's box are so widely spaced that the eye must peek through one after another in isolated glimpses. At the same time, these discrete openings are so numerous and repetitive that the wall is rendered infinitely porous without ever losing solidity, as if the boundary were perforated to its utmost limit before it could dissolve into a mesh.

Central Signal Box by
Herzog & de Meuron.

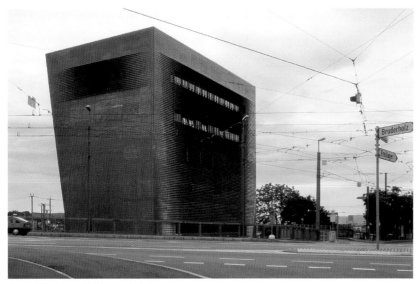

Central Signal Box by Herzog & de Meuron.

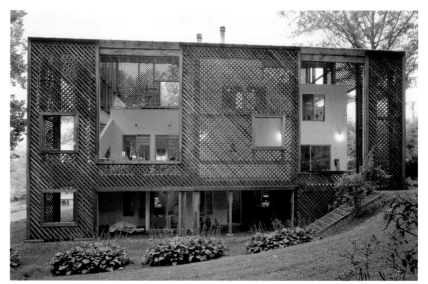

Zimmermann House by William Turnbull.

Set against these industrial fabrics are efforts by architects to construct screens of soft wood, so as to resonate with nature on many levels, while linking them to the present age by severe abstraction. Light filtered through a timber lattice is able to share in the emotional benefits of human associations with wood, an effect immediately sensed in something as modest as the wooden baffles hung below skylights in Paredes Pedrosa's Archaeology Museum at Almería (2005; previous page). More comprehensive is the approach to wood-filtered light by Baumschlager & Eberle, who wrap simple boxes in a continuous rhythm of wooden slats, reminiscent of William Turnbull's Zimmermann House (1975; above, right). The perceptual power of these wooden screens, as with the fuzzy metalwork of Nouvel, depends upon a hard-edged and prismatic object – something recognizable and easily grasped – which human perception can erode and transform. As splintered light obscures and mystifies the volume it cloaks, the building loses its object-hood and becomes a subject of interpretation. Particularly intriguing is the optical behaviour of Baumschlager & Eberle's BTV Wolfurt (1998; opposite,

left), whose continuous larchwood revetment protects a glass membrane behind, while exerting a flirtatious air of secrecy. Slats are arranged in two layers that protrude and recede in a chequerboard pattern, allowing some panels to slide open horizontally as shutters – an effect described by the architects as a 'hypersurface' with 'different ranges of transparency'.

The semi-transparent timber lattice used by Reitermann & Sassenroth to wrap their Chapel of Reconciliation (2000; opposite, right), in Berlin, plays upon and attempts to heal its historically charged site. Located in the no-man's land between the Berlin Wall's once continuous inner and outer rings, the chapel transforms its setting with a porous boundary that connects rather than divides, and offers a filtered view to lure passers-by inside. Completely surrounding the oval chapel of rammed earth is a continuous ambulatory lined with a curtain of vertical slats, into which eyes can peer from every angle and witness the absorption of city and nature.

Cleft light reaches a poetic extreme in a number of small, unpretentious works by American architect Fay Jones, notably his Thorncrown Chapel

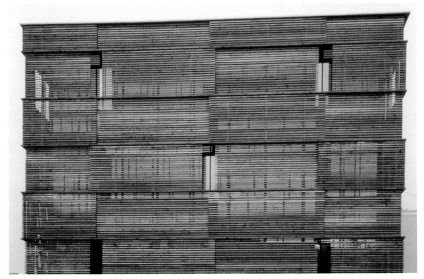

BTV Wolfurt by Baumschlager & Eberle.

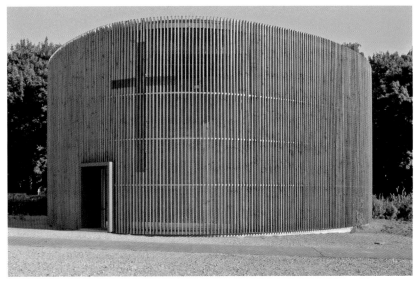

Chapel of Reconciliation by Reitermann & Sassenroth.

(1980; p. 140) and Mildred B. Cooper Memorial Chapel (1988; p. 144), whose rhythmic tonalities echo those of the Ozark forest in this northwestern corner of Arkansas. Not least of the primal pleasures in Jones's chapels is the exquisite balance between the timeless need to feel rooted in the earth and a contemporary desire for the opposite – a loss of heaviness, to be sure, but also an urge for imaginary levitation and oneiric flight. In his contemplation of lightness as a value reflecting the vitality of a new millennium, Calvino touches on this other, more active dimension. Lightness, he suggests, derives from a yearning to resist 'the entire world turning into stone: a slow petrification'.[51] He goes on to point out that the monstrous weight of the first industrial revolution, manifested in factories and steel mills, has evaporated in the recent electronic revolution, which is based upon the computer with all its invisible forces of software, enacted through electrical charges and currents. Calvino discovers beneath this image a deeper urge, and existential ground, in the human desire for flight, finding paradigms for winged freedom in folk tales where people or things are suspended in air to free the imagination, and 'make possible a flight into a realm where every need is magically fulfilled'.[52] It should be remembered that this urge for mobility and flight was always part of the Modernist dream, going back to Frank Lloyd Wright and Le Corbusier, but in the work of Jones it is expressed in a more metaphysical than gestural manner, and is thereby felt more intensely.

In all these experiments with pulverized light, we find boundaries invented whose blurry limits endow façades with ethereal qualities inherently different from their geometry. Light becomes caught in screens, sometimes fleetingly, and as the viewer moves around them, the screens seem to intermittently turn solid, translucent, or transparent, and the next moment dematerialize into nothing. The real wall and building mass appear to fade away, leaving behind a mesmerizing sensation of energy that seems to vibrate in front of the object itself. As boundaries slip out of focus, at one moment coming into shape and the next moment empty yet loaded with energy, they give to architecture a dream-like quality that invites us into their formulation.

Tensioned aluminium screens in lobby, with view out to street.
Opposite, clockwise from top left: Interplay of screen and glass in gallery; screens in gallery; *moiré* pattern of aluminium screens on exterior staircase; atomized view of Tokyo.

TEPIA, **Japan** Fumihiko Maki

Fabricated of finely perforated aluminium sheets, the elegant metal curtains of this 1989 science pavilion express two ideas central to the Japanese conception of space: *ma* and *oku*. *Ma* indicates what the architect calls an empty interval or 'space between' volumes, while *oku* refers to a spatial quality defined by an elusive and secret sense of depth. These 'illusions of secret places' are produced by successive layers of mesh, whose shape-shifting boundaries are ephemeral and woolly. Gauzy sheets are hung behind glass and around staircases, and, most beautifully, stretched from cables in the entry hall to fog views into the building and out onto the chaotic Tokyo scenery. We are reminded in this fine dust of light, with its *moiré* patterns and half-glimpsed images, of the Japanese search for a solitude still in touch with the world, and a contemporary urge to subvert habitual modes of seeing, empowering the mind's eye by giving it room to manoeuvre.

Departure lounge.
Opposite: View to lobby from upper level.

Rovaniemi Airport Terminal, Finland

Heikkinen-Komonen

Particularly intriguing at Heikkinen-Komonen's 1992 terminal is the suspension of horizontal grey mesh from dark ceilings to create a veiling mist suggestive of the climate outside. The porous metal shrouds the darker space beyond, causing mechanical ducts and electrical fixtures to dissolve into the blackness. Complementing this canopy are vertical layers of mesh, whose role is to orient and choreograph passengers as they move towards their flights. Along this route, screens turn increasingly fine, transforming from large black grids into a molecular glow around departure lounges. The closer one gets to flight, the more one encounters hazy phenomena and vaporous images. At the final limit, the traveller crosses a lustrous bridge sheathed in screens and glass. This transparent slot runs just outside the terminal glazing, hovering between the airfield on one side and its mirror image on the other. For a thrilling moment, one encounters virtual flight, hinting at what is to come.

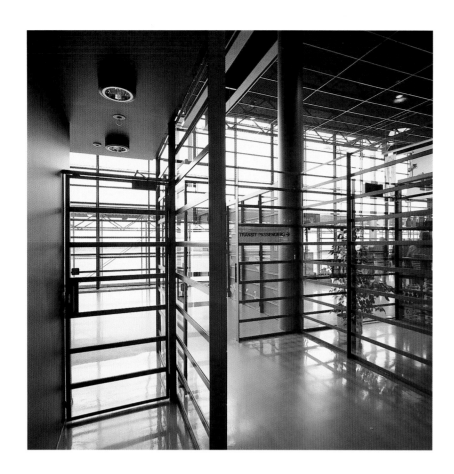

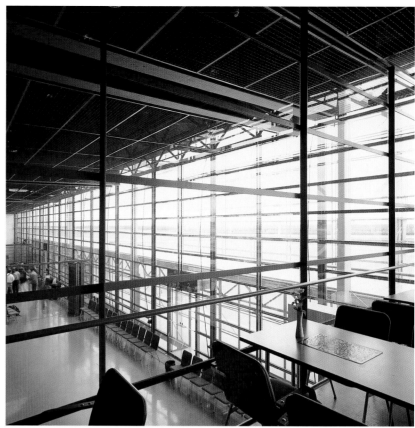

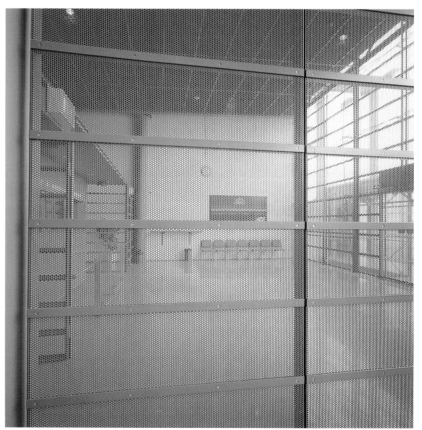

Above: Arrival gate.
Top, left to right: View to airfield from lobby; view to airfield from café.

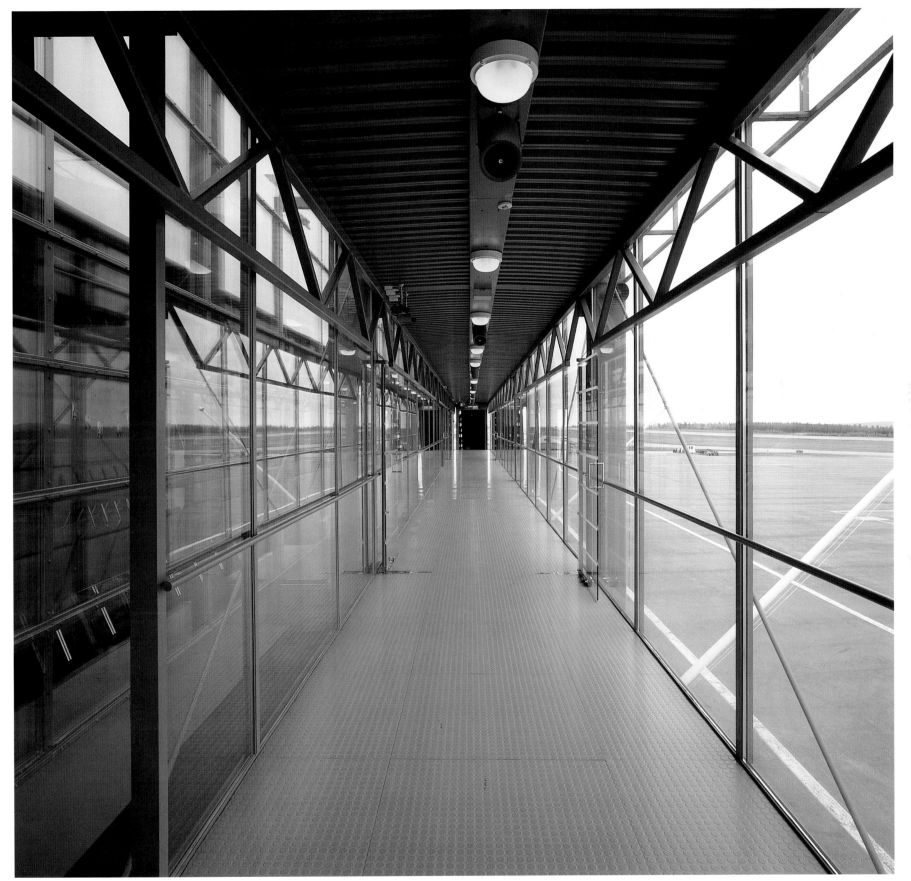

Transitional passage between terminal and airfield.

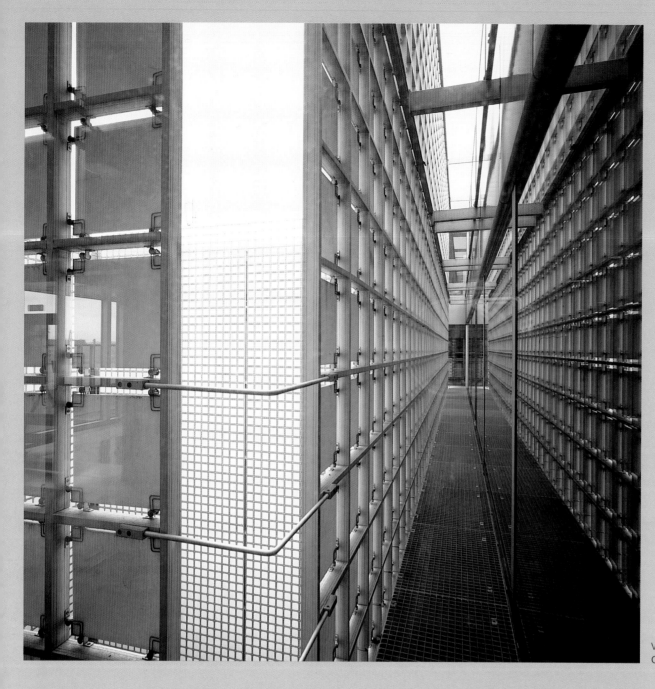

View through white marble screen to courtyard.
Opposite: View across elevator bank to staircase.

Institut du Monde Arabe, France Jean Nouvel

The prismatic volumes of this 1987 cultural centre in Paris provide necessary objects for atomized light to work upon. Massive and razor-sharp forms establish a stable reference that powdery light can smudge and rarefy, causing the architectural equilibrium of figure and ground to vacillate with the hour and weather. The agents of this optical quiver include camera-like apertures that contract and widen with the waxing and waning sun, porous layers of aluminium framing and stairs, and an open grid of marble plates that surrounds the courtyard. Epitomized in this opposition is a central theme of contemporary architecture, in which perceptual ambiguity is counterpointed by its opposite – geometry, precision and a lucidity of form. Produced within this steady state that is made to continually break apart is an oscillation between alternating values, attaining an elusive harmony between order and disorder.

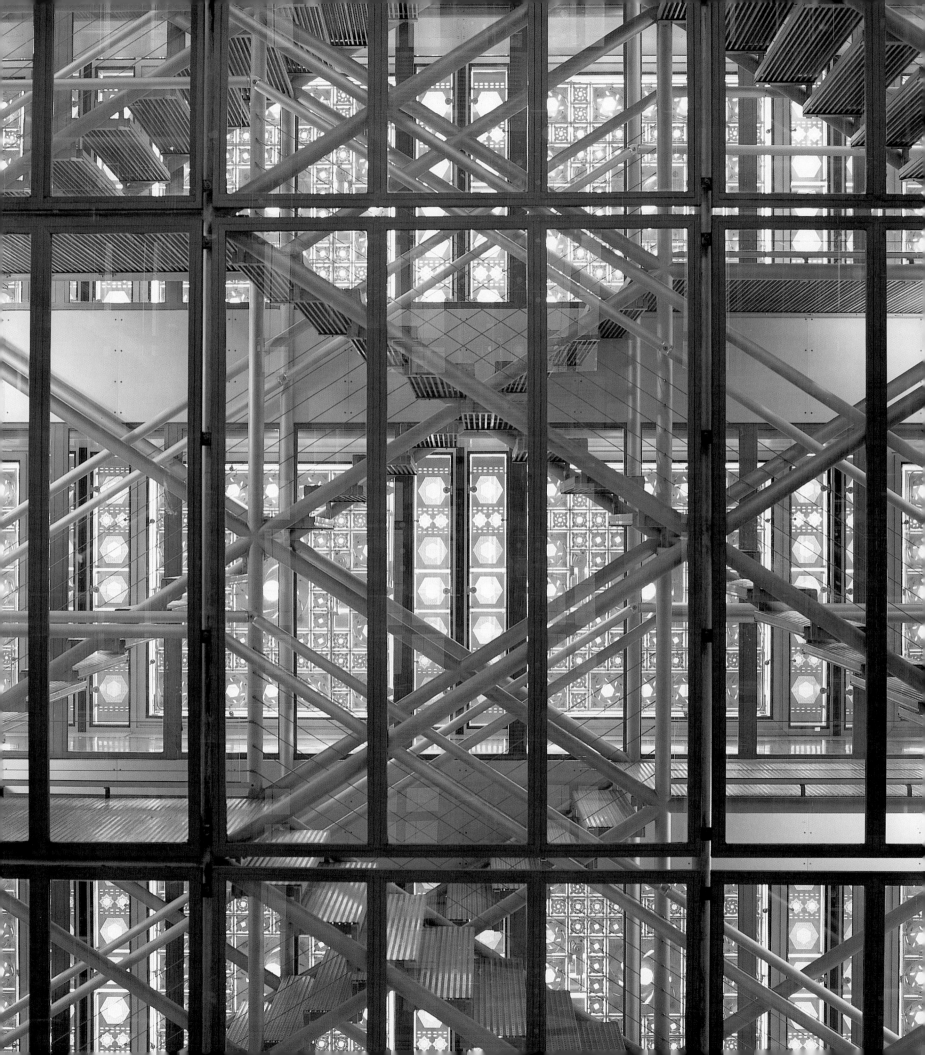

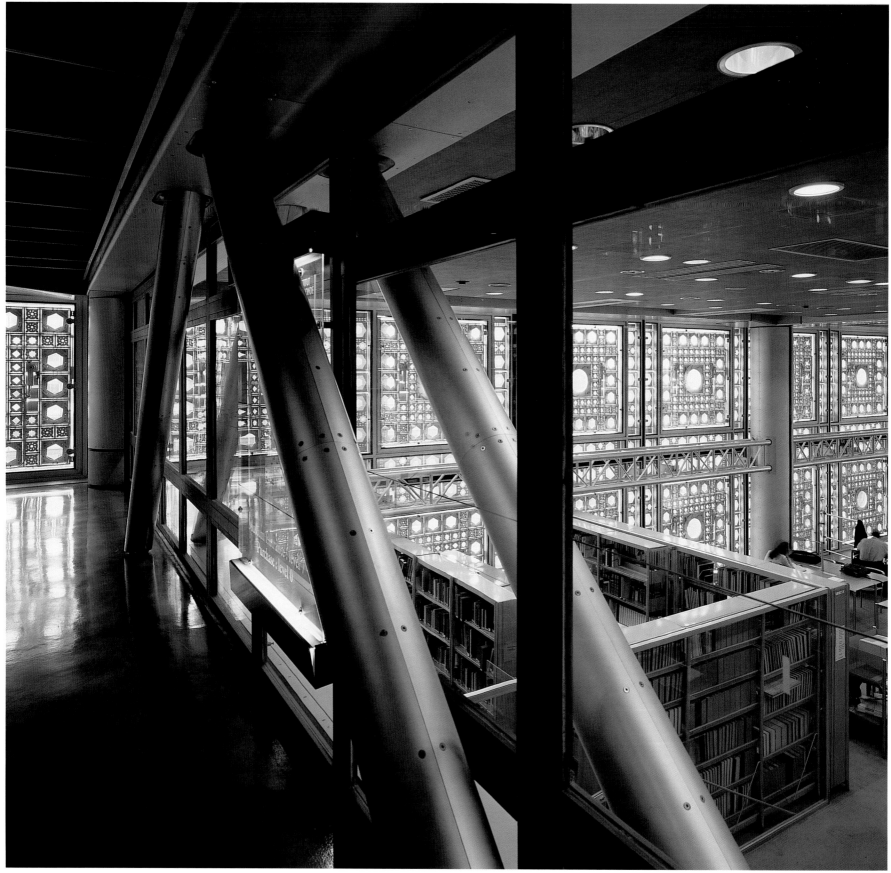

Library.

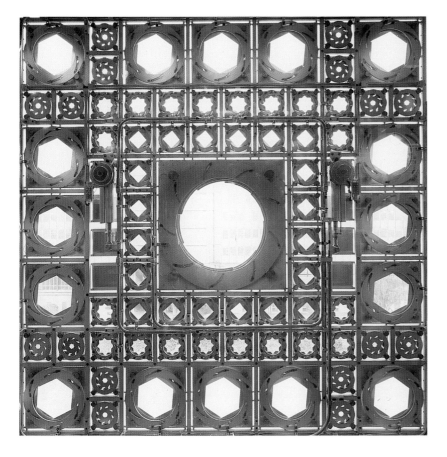

Clockwise from top: Shutters open (left) and closed (right);
motorized shutters of southwest wall; detail of marble screen.

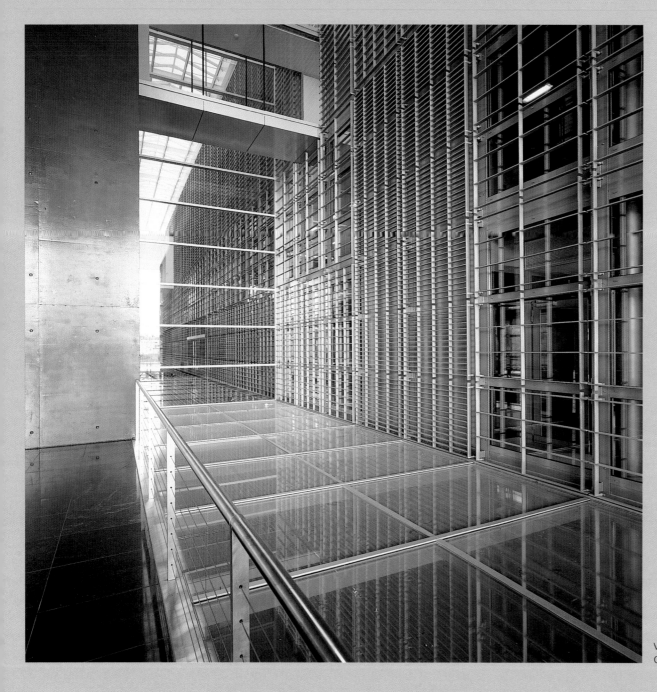

View to museum wing from terrace.
Opposite: Double staircase to concert hall foyer.

Culture and Congress Centre, Switzerland Jean Nouvel

Here at this 1999 cultural centre in Lucerne, the intricate weave of light against shadow alters density to suit and express the building's varied functions, becoming more tightly woven where discreet activities demand extra veiling. Emphasizing the fractal blur is a detachment of grids from the building shell, whose displacement and foregrounding dissolve away contours and frustrate logical vision. This collage effect, complicated by laced-over window reflections, gives façades a perceptually ambiguous double-reading as both planes are viewed simultaneously. Such superimpositions are especially rich around vertical cages of outdoor stairs, densely plaited from quicksilver lines of column and beam, grid and rail, tread and landing. Least substantial are the finely perforated metal scrims of twin staircases that lead to the concert hall, whose interference patterns and *moiré* effects flicker and mutate as one ascends, continually shifting their degrees of transparency and surrounding the climb with amorphous, fog-like, hinted-at scenes.

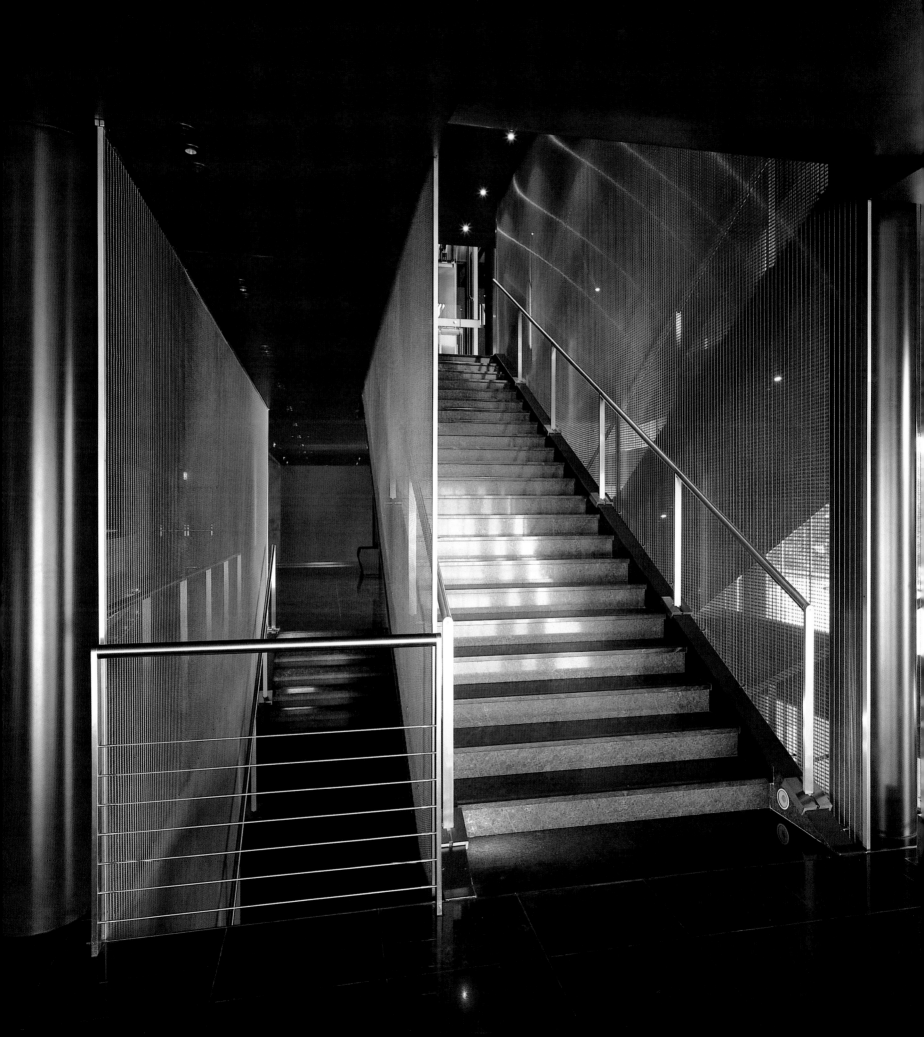

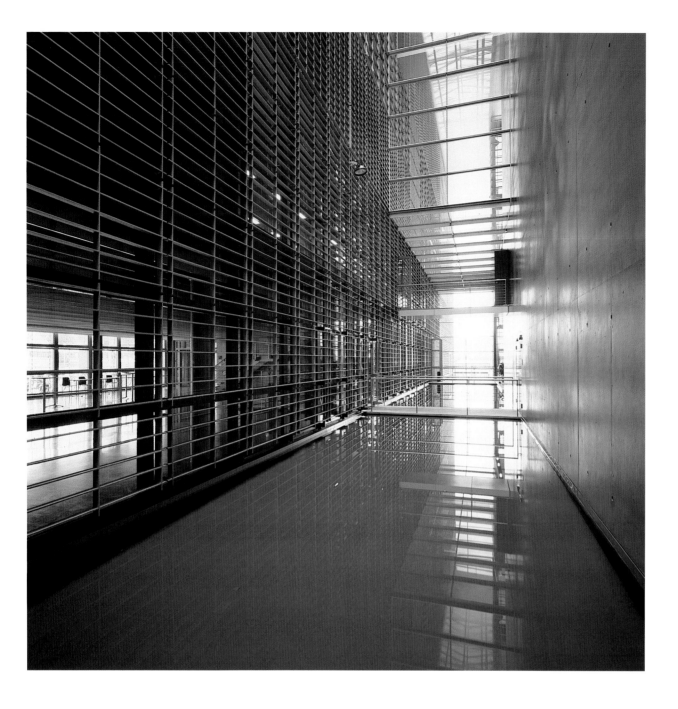

Above, left to right: Shifting grids of west façade; grid detail.
Top: Water garden.

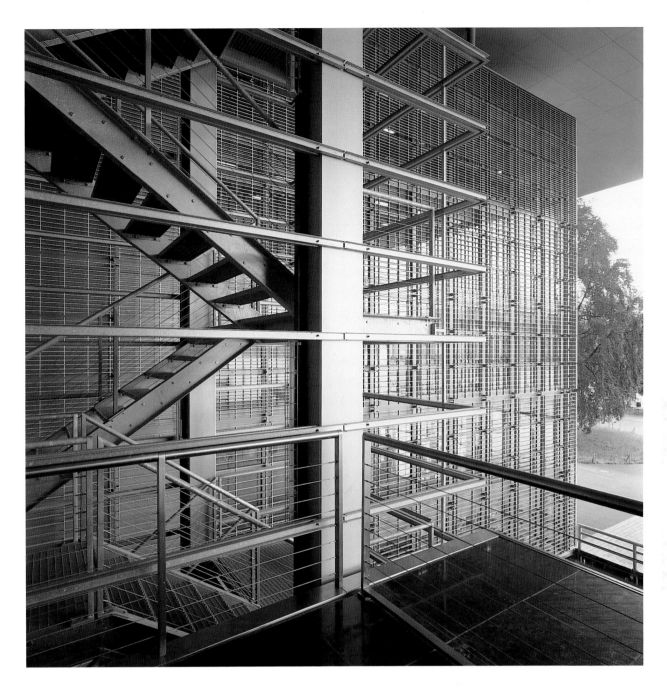

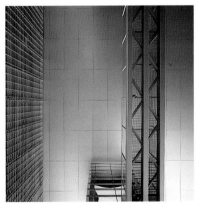

Above, left to right: Multiple layers of grid and mesh beneath cantilevered roof;
upward view of varied screens in façade, bridge and staircase; detail of staircase screen.
Top: Rectangular grids of outdoor stair and façade.

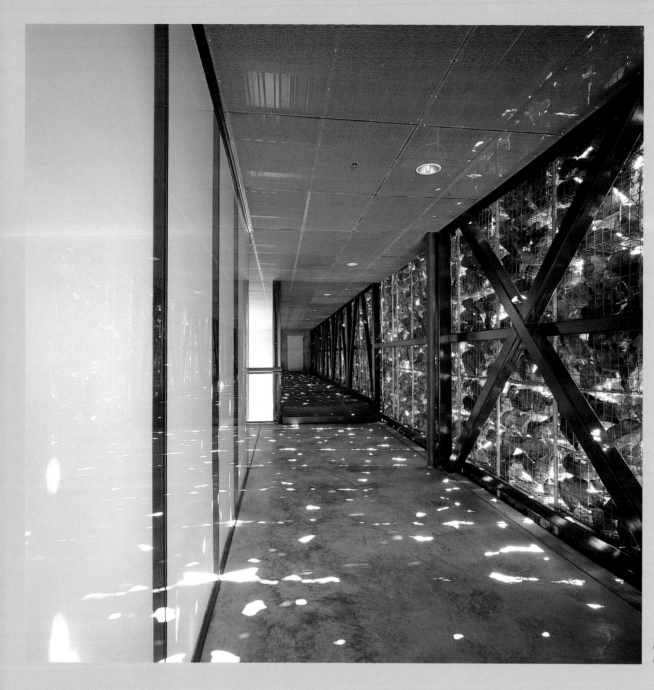

Open-air corridor at sunset.
Opposite: Splattered sunlight on glass wall.

Dominus Winery, California, USA Herzog & de Meuron

Cladding the simple monolith of this 1998 winery in Napa Valley is an ingenious transmutation of stone, turning a normally solid substance into an airy screen. While arising from a direct response to the hot and dry Californian climate, aimed to reduce thermal impacts on wine storage while satisfying the client's wish to minimize conditioned air, these walls are also a vehicle to obtain the most hallucinatory effects from commonplace materials and unorthodox construction. Gabions containing green basalt offer indistinct glimpses out to the vineyard, which remain opaque for all but perpendicular views and alter transparency with every slight shift of the eye. One is immediately struck by how these loose stones celebrate the Earth, but equally intermix radiation and matter, evoking the same fusion of sun and soil that sustains the miracle of wine. Complementing these geologic yet strangely celestial walls are glass partitions and gauzy meshes of reflective metal covering the rooms, whose effect is to reconcile the opposites of archaic and contemporary, rough and smooth, primitive and refined.

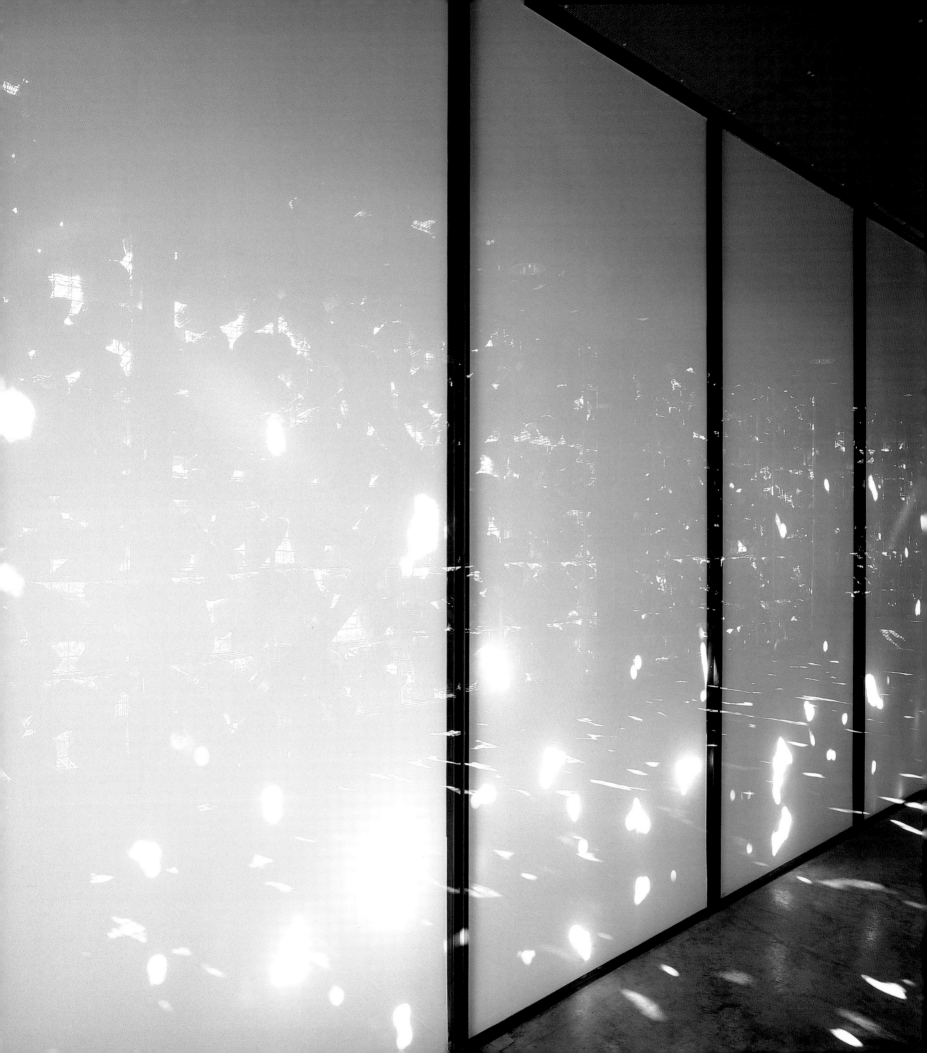

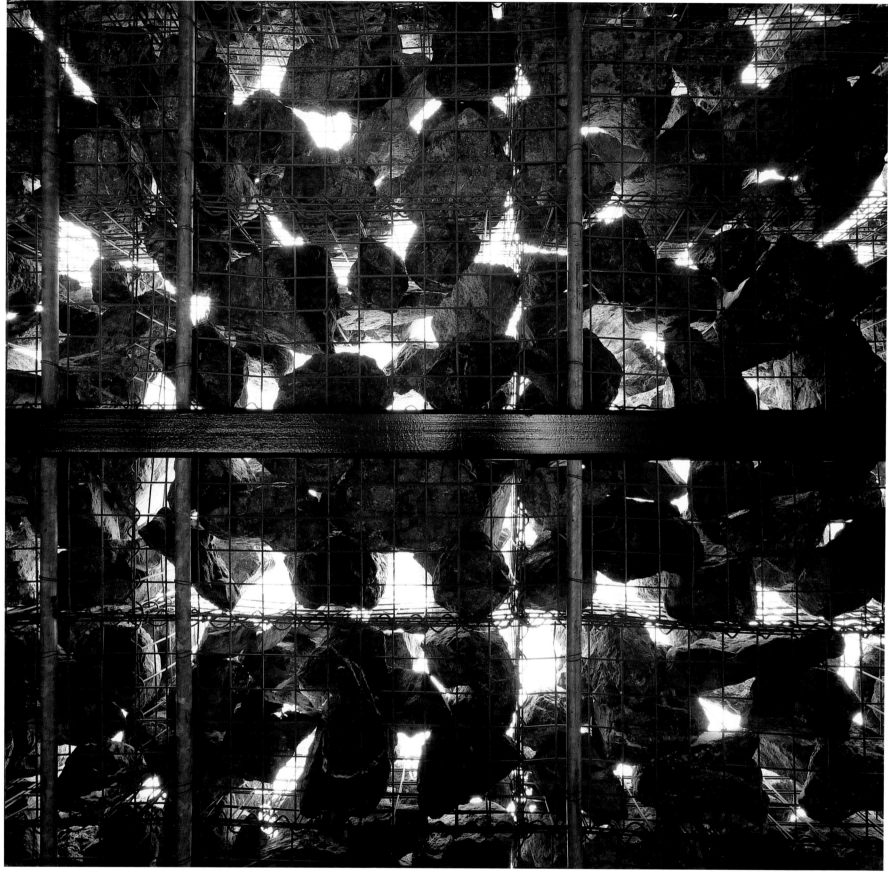

Gabions with dark-green basalt.

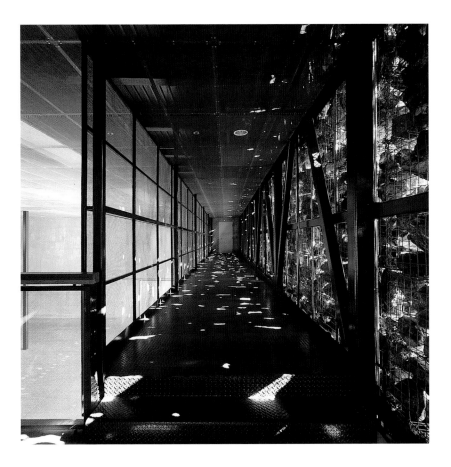

Top, left to right: Bridge to vats for wine fermentation; glass wall of administrative area.
Middle: Exterior.
Above: Longitudinal section.

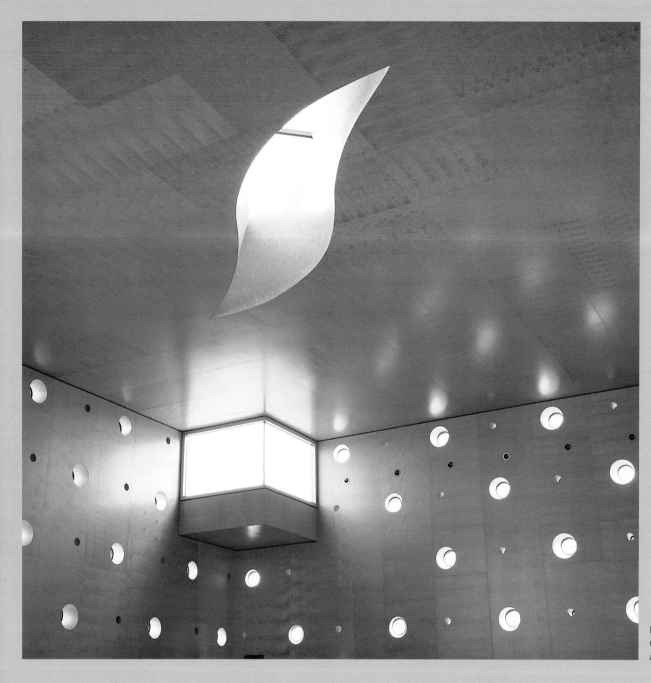

East corner, with lantern and 'light wound' of skylight.
Opposite, clockwise from top left: Perforated wall behind
altar; entrance; detail of exterior cladding; section.

Donau City Church, Austria Heinz Tesar

Playing upon an eerie fusion of industrial and artistic, similar to certain screens by Jean Nouvel and Herzog &
de Meuron, is Heinz Tesar's pierced box, dating from 2000, at the Donau-City 'apartment-park complex' in Vienna.
Peppering the walls are conical windows of two sizes, suggestive of portholes and arranged in a grid with mechanical
overtones, but also bored with funnel-like shapes whose plasticity is echoed in the two corner lanterns and a ceiling
gash with lyrical curves. The solid boundary is so punctured and hollowed at multiple scales that, to use Italo Calvino's
words, 'emptiness is just as concrete as solid bodies'. Softening and multiplying the seepage of light is a smooth
reflective inner lining of birch panels, whose warmth exudes a friendly glow. To an extent not seen since Shoei Yoh's
Light-Lattice House (p. 28), Tesar's enclosure seems shaped more out of figures of light than of solid material, tipping
the balance between energy and matter.

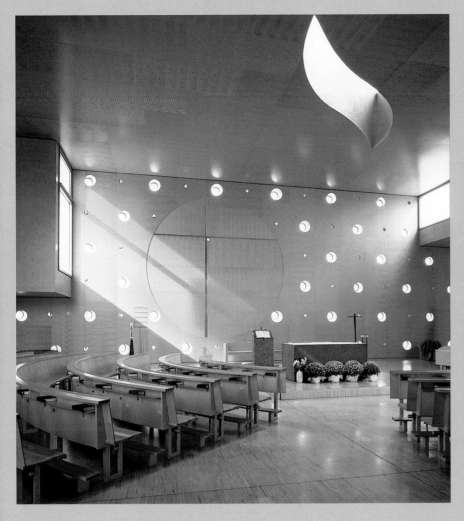

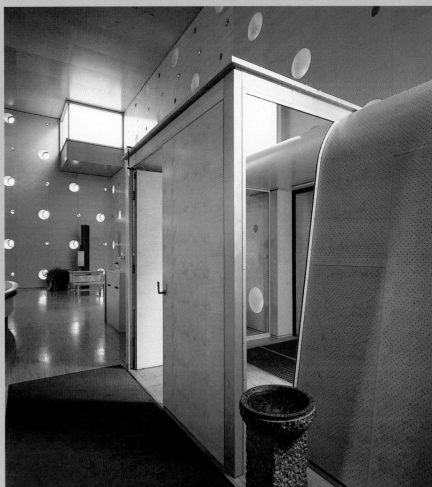

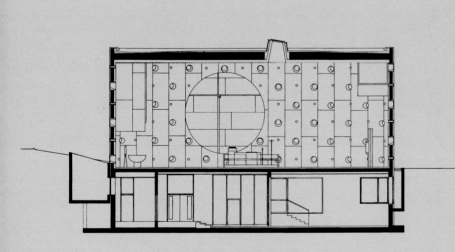

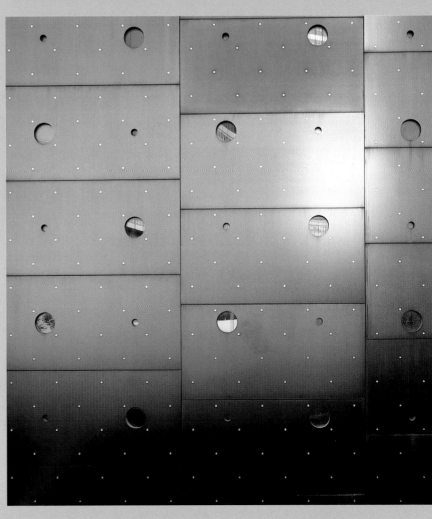

Chapel ceiling.
Opposite: Exterior cross-bracing.

Thorncrown Chapel, Arkansas, USA Fay Jones

Nowhere is the elemental appeal of wooden screens more touchingly expressed than in the simple cage of the Thorncrown Chapel in Eureka Springs, Arkansas, dating from 1980 and assembled from narrow members of Southern pine. Showing an equal and unconcealed debt to the latticed walls of traditional Japanese houses and the 'light screens' of Frank Lloyd Wright, Fay Jones elaborates the screen into a skeleton of every possible scale. Webbings of wall echo into roof, and shrink into micro-worlds of lamp, door, pew and chair. In such a thicket, one is no longer merely bounded by, but physically inhabits an image of lightness with dream-inducing powers. Jones has captured in this luminous abstraction one of mankind's most poetic images, the bird's nest, which, as Gaston Bachelard reminds us in a magnificent chapter of *The Poetics of Space*, carries depths of intimacy that transcend its hiding place.

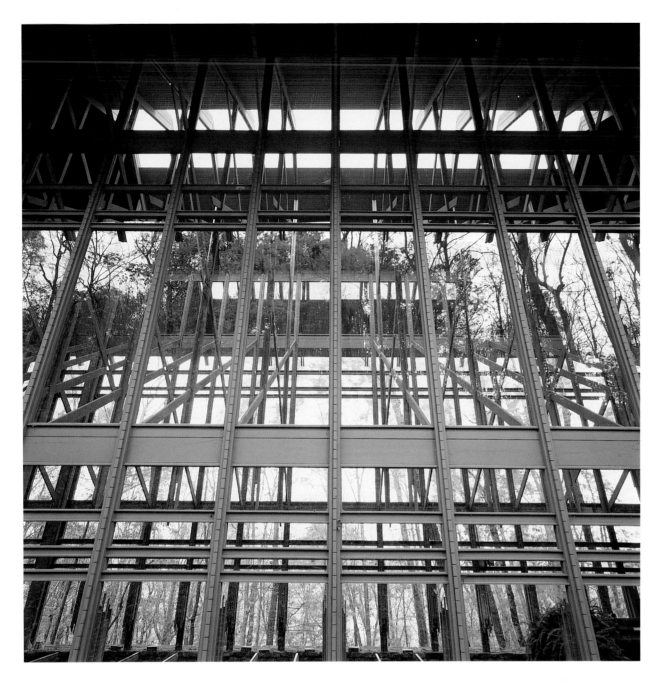

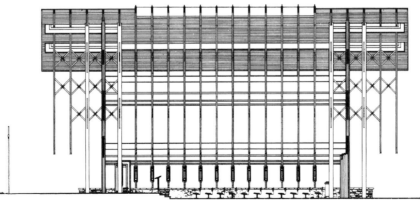

Above, left to right: Longitudinal section; plan.
Top: Interplay of skeleton and trees.

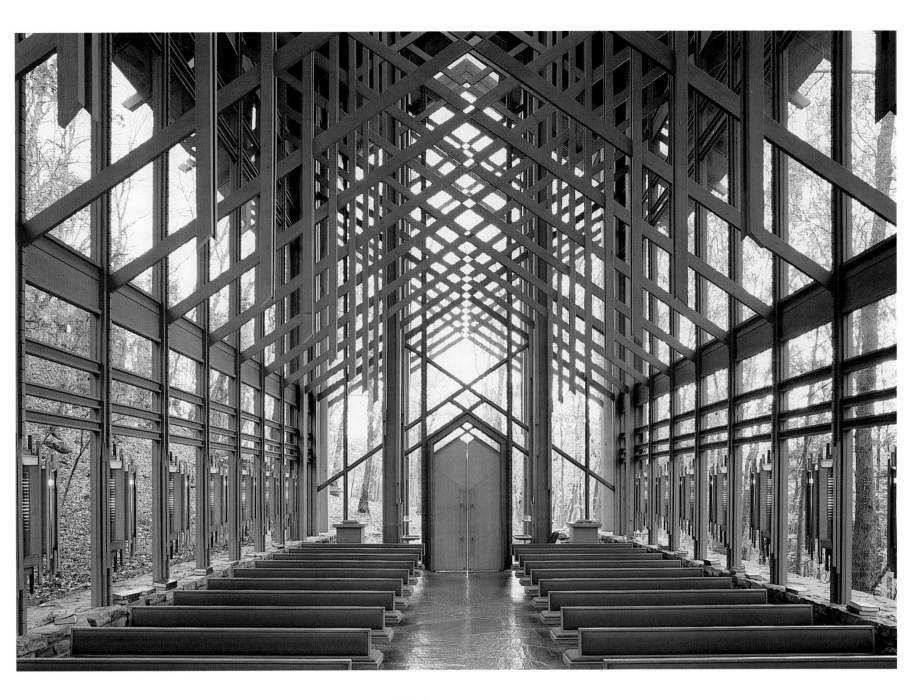

Above, left to right: Upward view at entry; exterior at dusk.
Top: Interior looking to entrance.

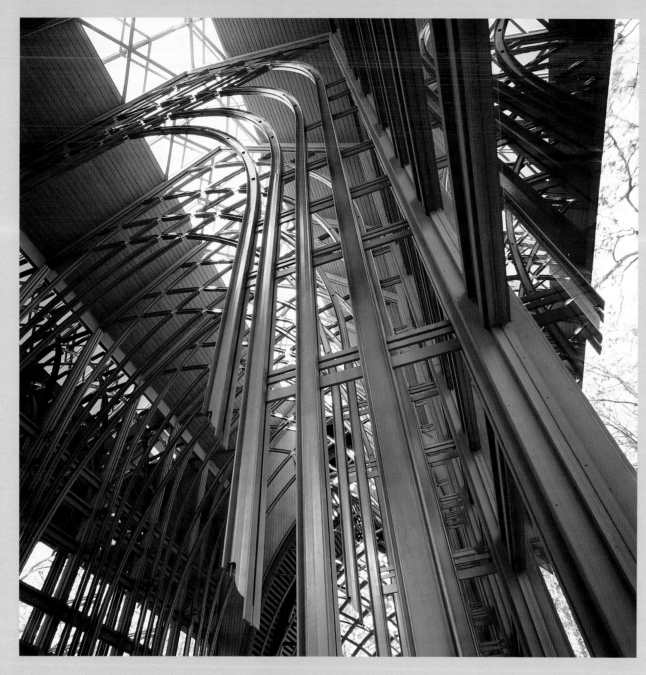

Continuity of inner and outer lattice.
Opposite: Exterior detail.

Mildred B. Cooper Memorial Chapel, Arkansas, USA
Fay Jones

The concoction of forest light so dear to Jones is forged here in Bella Vista from skeletal steel as well as from wood. The thin tensile members used at this 1988 chapel are curved to evoke bent saplings, and thereby remain metaphorically linked to nature. As dappled light sifts into the fragile, faintly Gothic construction, it reveals how striated screens are so repeated and multiplied that barely any evidence of solid mass remains. Illumination virtually erases all infill, apart from vestigial bits of roof, and optically corrodes volumetric seams – notably an open ridgeline and hollow metal joints – to make the building appear consumed with energy, and less substantial than it actually is.

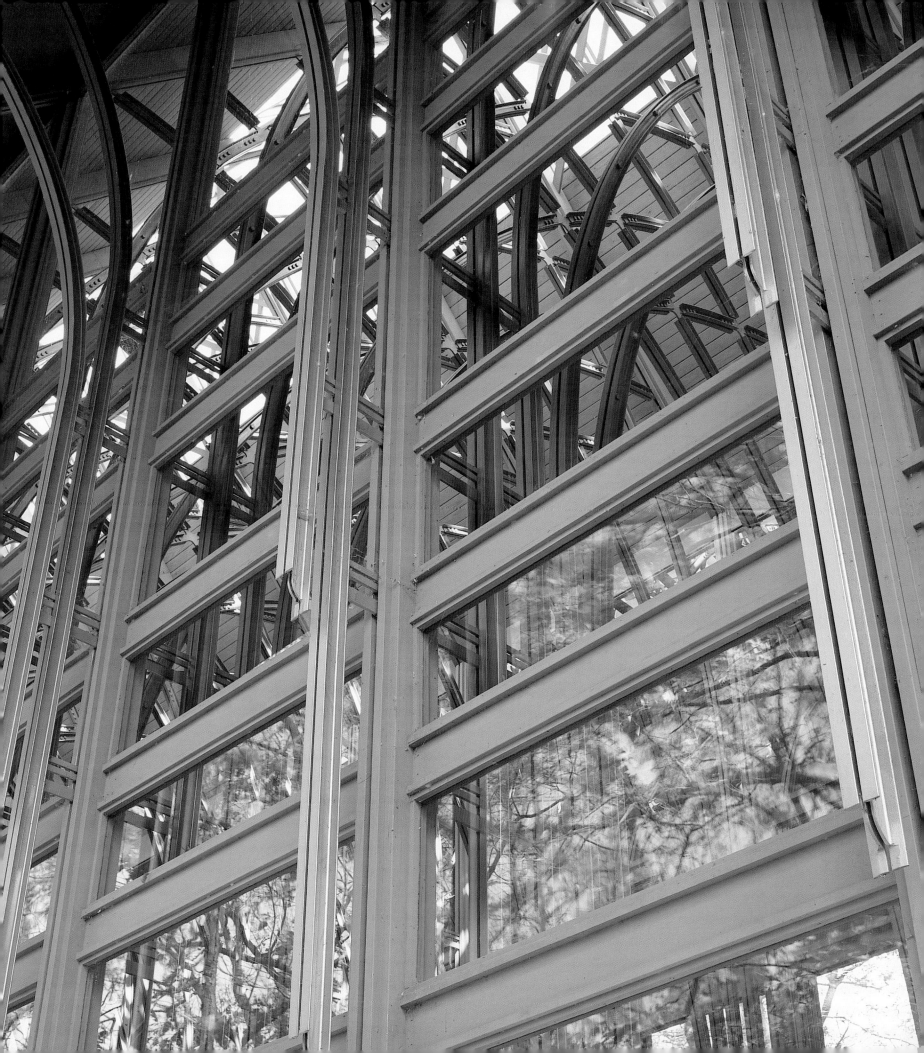

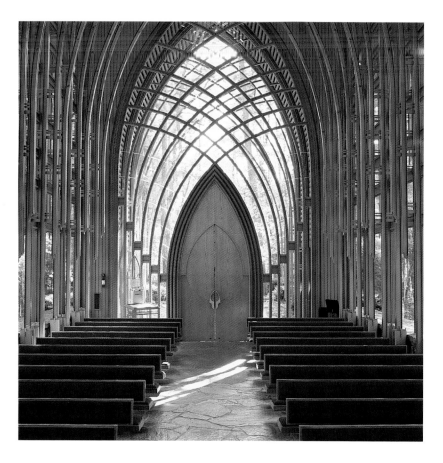

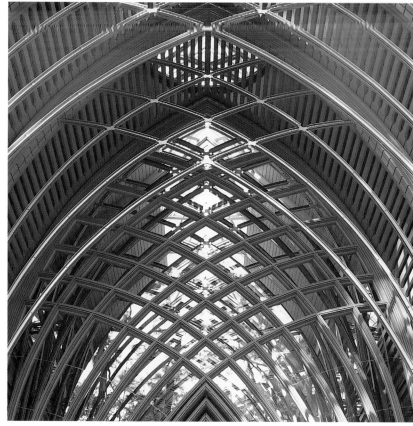

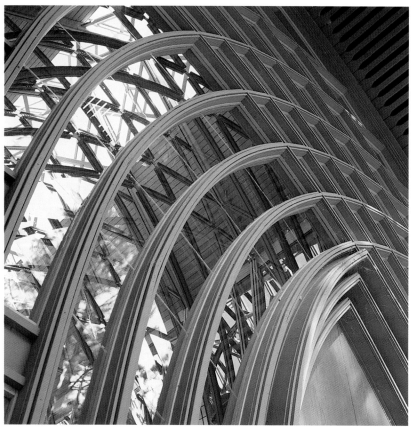

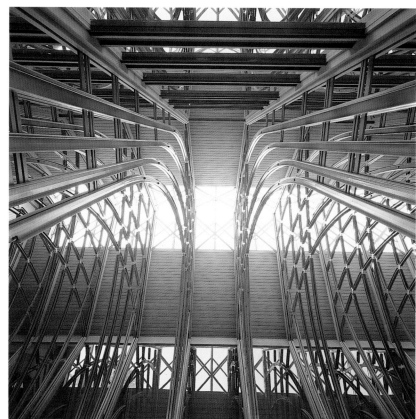

Clockwise from top left: Interior looking to entrance;
curvilinear steel structure; chapel ceiling; lattice above door.

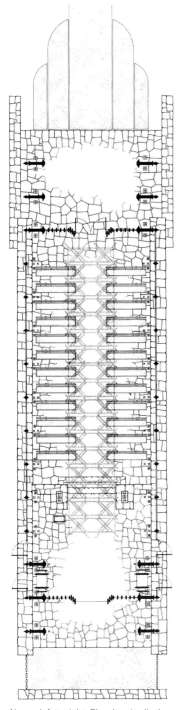

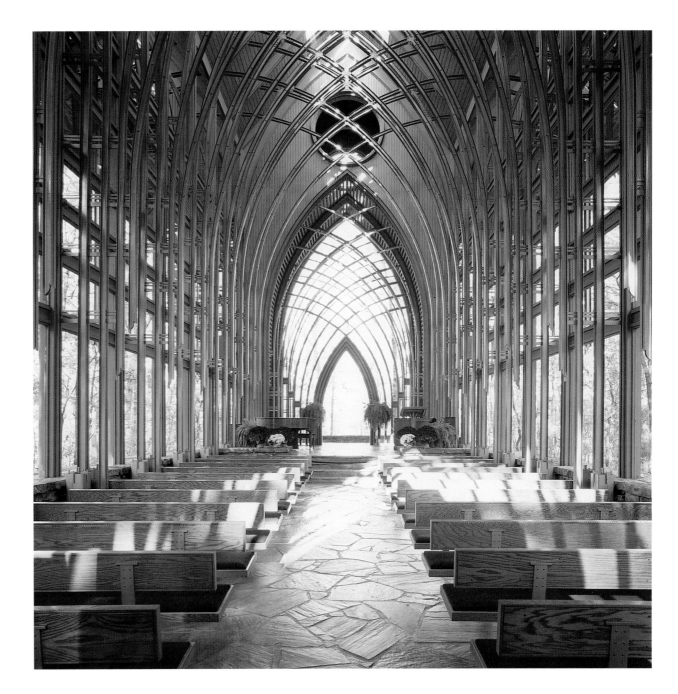

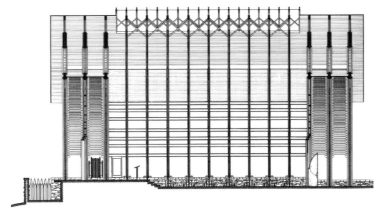

Above, left to right: Plan; longitudinal section.
Top: Interior looking to altar.

CANALIZATION

CHANNELLING OF LIGHT THROUGH A HOLLOW MASS

5 CANALIZATION
Channelling of light through a hollow mass

The revolutionary attempts of modern architecture to permeate buildings with natural light and fresh air aimed to convey the healthful benefits of nature to as many rooms as possible, but also expressed an openness and mobility that characterized the age. In exploring a morphology of open form, pioneers such as Frank Lloyd Wright, Le Corbusier, Alvar Aalto and, later, Herman Hertzberger went beyond the conventional solution of maximizing light by expanding the size and proportion of glazing in building envelopes. More radical were their efforts to carve out routes for natural forces to penetrate the innermost depths of a building, transforming the paradigm of a cellular mass into something new – a spatial lattice riddled with tunnels for daylight to travel through. Among these seminal works were Wright's various skylit atriums, lined by interior windows and 'light screens'; the porous and offset sections developed by Le Corbusier for his Maison La Roche (1923; below, left), in Paris, and Shodan House (1956), at Ahmedabad, India; the light scoops and funnels carved from the heart of Aalto's museums and libraries; and the spongy matrix of wells and pores in Hertzberger's Centraal Beheer (1972; opposite), at Apeldoorn. In such excavated structures, daylight absorbed around the perimeter is directed through a network of channels to where it is needed inside. The ingeniousness of these pervious forms was paralleled by an equal fascination with the *quality* of light being allocated, shaped by collecting radiation from specific portions of sky, and then sculpting that energy with the same vessels used to conduct its flow, thereby giving formless light a memorable character.

Contemporary efforts to expand upon these early models of permeability are producing a new generation of hollow structures, whose daylit voids continue to transcend the criteria of rational illumination, merging poetic and pragmatic values of light. Cavities in these infinitely porous masses are conceived, in part, as optical tools with which to distribute light, devised to steer while measuring out and restraining its flow. Within such a structure, light attains hydraulic expression, rendered visible in fluent rays as well as channels moulded to guide its course, their contours seemingly carved by the penetrating force of radiation.

Some of the most ingenious experiments with canalized light are the smallest in size, where routed through the hidden thickness of a building shell. This hollow *poché* has illusionistic roots in the sourceless light of Bernini and others, and was a favoured device in the slots and tubes of Le Corbusier. In the more rational hands of Gunnar Birkerts, the wall becomes a malleable substance from which to carve out voids for illumination to secretly travel along, and transform its intensity and direction while conducted inside. Since the 1960s, Birkerts has piped daylight through angled slots in a number of introspective buildings, such as the IBM Offices in Southfield, Michigan (1979), where energy is detoured by successive reflections off concave aluminium faces, so as to bend and redirect incident light up and laterally into rooms, while scattering rays to minimize glare. This mechanism, devised to shed light and open views after at least two reflections, and described by Birkerts as a 'linear periscope', reappears in his Corning Museum of Glass

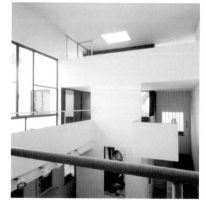

Maison La Roche by Le Corbusier.

D.E. Shaw Offices by Steven Holl.

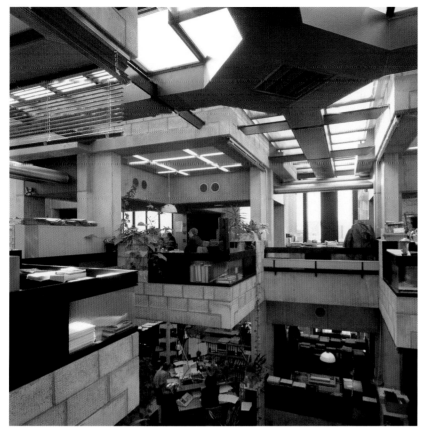

Centraal Beheer by Herman Hertzberger.

(1980), in New York State, but is adapted to backlight displays of subtle glass art, thereby redefining the traditional functions of window and wall, the former conceived as a conduit rather than a hole.

To restore an emotive dimension to the indirect light of his D.E. Shaw Offices (1991; opposite), in New York, and Chapel of St Ignatius (1997; p. 44), in Seattle, architect Steven Holl formed channels with offset openings between double walls. Exterior windows are baffled by an inner lining, so that light arrives mysteriously and must travel laterally via reflections before diffusing inside through jigsaw cut-outs. Playing a critical but unseen role in these layers is intensely hued paint that has been applied to the hidden inner face, allowing daylight, as it journeys to rooms otherwise closed to the everyday world, to turn painterly and become charged with feeling.

Long inspired by baffled light and its apogée in eighteenth-century Bavaria, Juha Leiviskä takes a far purer and more rhythmic approach to the laminar shell, reinventing his precedents through an abstract language of parallel slits between overlapped walls, as seen in his museum for the Finnish town of Kajaani (1985; below). After capturing most available light, precious at arctic latitudes, countless slots usher the weak illumination inside by successive reflections off pure white planes, causing opaque walls to glow from within. Light flows tangentially through these layered cracks, and arrives in abundance despite minimal glazing, a procedure best illustrated in Leiviskä's two churches at Myyrmäki (1984; p. 30) and Männistö (1992; p. 34), where delicate light arrives between interleaved walls, whose tonal range is nuanced by various sized gaps, and whose colour derives largely from the ephemeral hues of sun and sky.

Distinguishing further the geometric slots employed by Leiviskä and Holl from their Baroque precedents is a perfusion of light that is no longer hieratic or figural, but is shaped instead by contemporary ideas such as collage, whose fragments arouse a double-vision central to abstract art. As Leiviskä's walls dematerialize in the light they transport, their planes oscillate in a Cubist interplay of plane and depth, expanding creative perception by breaking up objects into component parts whose alternative properties are transparent to one another, and are viewed simultaneously. Like the 'canvas of broken parts' envisioned by William Carlos Williams, luminous walls fragment and float within a fluid light, while their superimposed sheets are infused with energy and appear diaphanous, suggesting the visual recession of atmospheric perspective.[53] In the manner of a *papier collé*, the ethereal walls present an expanded field of action, whose layers can be explored at will by a roaming eye, and appear strangely tactile and active, intensified to the point, to use Kandinsky's phrase in describing Cézanne's still lifes, where they 'cease to be inanimate'.[54]

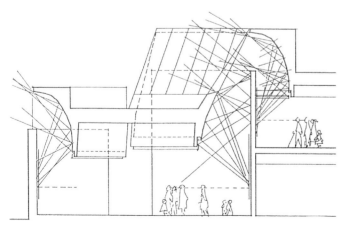

Kajaani Art Museum by Juha Leiviskä.

Tadao Ando's slotted architecture takes canalized light in a different direction: to heighten the inward calm of buildings by closing horizontally and opening vertically, allowing silent walls to incandesce with washes of light from above. This language results in nested volumes with cracks between, through which penetrates zenithal light, producing unexpectedly luminous boundaries remote from earthly distractions. While Ando's pensive boxes are periodically incised with a few narrow slits to seep light and peek outside, the majority of illumination is shepherded through a spatial network of rifts and wells, gardens and courts, carved into the overall mass and feeding light to hidden windows.

Influenced by Ando's geometric wrappings, and sharing his wish to reconcile desires for introspection and communion with nature, Alberto Campo Baeza bases his work on concentric structures that draw light into perimeter courts, where it is stripped of heat and glare before bouncing inside off pure white walls. The stepping down of illumination that defines his Guerrero House (2005; p. 40), as much as Ando's Kidosaki House (1986; below, left), is based on a prolonged journey of light, whose slow ebbing into darkness amplifies the feeling of refuge in a hot climate and the sensuous pleasure found in shadows. The function of high layered walls, however, is not merely to secure shade and shelter, for the carousel of light upon these boundaries keeps dwellers in touch with a distant sky. The same dialectic of shady retreat and solar display gains a civic dimension in Carlos Ferrater's Auditorium and Conference Centre (2004; p. 156), in Castellón, whose walls and roofs are 'folded' to allow light to detour into otherwise closed concrete volumes.

But why limit concentric walls to a tangential routing of light, when they can, as adeptly, relay in a more direct and abundant perpendicular illumination? This question is posed by Allmann Sattler Wappner in their Church of the Sacred Heart (2000; p. 160), by keeping the lid solid while wrapping space in two porous linings, each exerting a different but consecutive modulation on horizontal light. Conceived as a box within a box, each layer of ambulatory and church serves a complementary role in light filtration. An external skin of steel and glass diffuses a substantial amount of arriving daylight, which is then cut down severely as it filters through wood slats to the church proper, the largest

portion delivered to the altar. The concept of a double lining containing a plenum also applies to Jensen & Skodvin's Mortensrud Church (2002; p. 164) in Oslo, but here the crucial layer for subduing light is an inner lining of mortarless stone. Light is caught around a perimeter of passages and courts, ambulatory and chapels, while the sanctuary itself remains dark and moody, giving entrancing power to the few rays able to penetrate cracks between stones.

The growing desire in art museums for natural lighting that is evenly balanced, but stripped of ultraviolet rays damaging to artwork, has produced some of the most stunning recent innovations with canalized light. In several examples, daylight is gathered horizontally, rather than vertically, and then routed through a zig-zag course to galleries below. Such is the case in Gigon & Guyer's Kirchner Museum (1992), located in Davos, Switzerland, where the problem of eliminating light obstruction by snow was solved by raising the solid roof above each gallery to form a lantern. Diagonal and often upward-reflected illumination is collected within each tall plenum, below the roof, where it is supplemented and mixed with artificial light as needed. Radiation is then bent 90º and guided down through a translucent ceiling, so as to evenly fill the room below with an exceptionally soft, white glow. A similar tactic appears five years later in Peter Zumthor's Kunsthaus Bregenz (1997; p. 108), but modified into a double plenum – first a surrounding layer of space behind the building's detached skin, followed by horizontal layers between stacked galleries, making each level appear enigmatically lit from above.

Attention is solely on zenithal light in museums designed by Renzo Piano, whose creative efforts are largely focused on moulding stations within the roofs of these buildings to gradually modify falling rays, while removing ultraviolet wavelengths. Instead of a cap, the roofs are built up from a series of layers, stretched and delaminated to develop within them a labyrinth of cavities. The porous apparatus is able to gather maximum light from the sky, expose this energy to modulations along its descent, and finally shed an abundance of illumination conducive to viewing works of art. Based on extensive computer study and model simulation, each detached segment of roof has its own assigned task in gathering, intercepting, bending and filtering light arriving

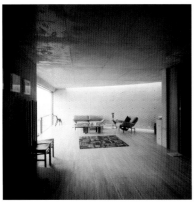

Kidosaki House by Tadao Ando.

Menil Collection by Renzo Piano.

Beyeler Foundation by Renzo Piano.

León City Morgue by BAAS.

from the sky vault. The first of these imaginative structures, covering the Menil Collection (1987; opposite, centre), in Houston, is an ethereal canopy of concrete blades that glides overhead from room to room. Each blade is curved into an S-section, whose directional optics are extruded and repeated to admit the gentle north light, while tempering the sun by double reflections of every ray. Suspended from white steel trusses, the stratified roof is inexplicably buoyant, seeming to glide over galleries and ride upon currents of light and air. Among the lessons of Piano's progressively stratiform roofs – the Cy Twombly Gallery (1995), also in Houston; the Beyeler Foundation (1997; opposite, right), in Riehen, Switzerland; the Nasher Sculpture Centre (2003), in Dallas – is the variety of ways vertical light is channelled inside to define a building's basic character. Daylight seeps into the first by negotiating an external canopy of fixed louvres, then a sloping hipped roof of glass, followed by ultraviolet filtering glass, a layer of mechanical louvres that adjusts with sun, and finally a stretched cotton fabric to disperse ultra-soft light to the galleries. In the Beyeler Foundation's waffle-like roof, daylight is relayed through nine succes-

sive leaves and plenums, beginning with white-fritted glass louvres and ending with a perforated metal scrim, resulting in a uniform whitish-grey illumination that is utterly still. With its sculpture collection, the Nasher Centre could accommodate more daylight with a broader range of wavelengths, leading to a cast aluminium sunshade with small hooded cones whose ducts aim north.

While only zenithal light penetrates the subterranean León City Morgue (2000; left and p. 166) by BAAS, the roof disappears apart from a few mysterious wells and angling tubes, evoking allegorical themes of death and the afterlife. Set entirely below the ground plane, the roof marked only by a sheet of water with resurrective meaning, the building is opened to the sky by subtraction, through vertical shafts and cutaway earth. A more cavernous excavation is the sole source of daylight in Gunnar Birkerts's addition to the law library at the University of Michigan (1981; below, left). Providing yet another illustration of the precision with which he exploits the laws of optics to transport light, the huge 'daylight canyon' employs canted walls to collect and then bounce falling light to all three sunken levels. Sloped to behave as both light traps and reflectors, and oriented to the solar course, retaining walls are washed during the day by scissoring patterns of sun and shade, to offer an orientation device with sensuous pleasure for underground readers.

Inspired by the efficacy of the Roman atrium and Spanish patio, architects working in Mediterranean climates often channel sun through a central well, to mitigate the light of heat and glare before disseminating it *from within*. Drawing upon while redefining this ancient tradition is Norman Foster's Carré d'Art at Nîmes (1993; p. 170), a mediathèque whose hollow core conducts light through six storeys, and feeds illumination along its descent to passing levels via glass walls. More austere is the secret well carved from the heart of Alberto Campo Baeza's Caja Granada Headquarters Bank (2001; below, right). The strong Andalusian sun is intercepted by the roof's brise soleil, whose deep cells cut down entering light before passing it into a huge void, from where it gradually filters into offices through a membrane that is half glass and half stone. As the sun reaches its midday zenith, a few bright beams shoot into the well to electrify while seeming to construct the space. These beams

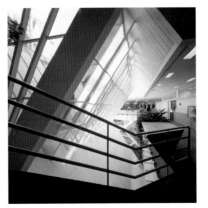

University of Michigan Law Library Addition by Gunnar Birkerts.

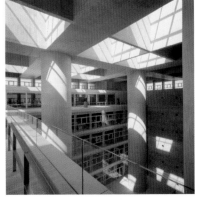

Caja Granada Headquarters Bank by Alberto Campo Baeza.

exert a dramatic presence in the hollow cube, which has been emptied of all but a few forlorn pieces of furniture and the huge columns to magnify the emptiness. Slanting rays seem at this time to have carved away the internal volume (a frequent theme of light corrosion in the work of Campo Baeza), as if the void's stepped section had been sculpted by the pressure and energy of light itself, as in rock eroded by flowing water. The cavity's dual lining is matched to the solar course, with its shaded planes rendered transparent, and sun-struck planes clad in alabaster. Much of the building's internal magic comes from this stone veil and its vague impressions, oozing light and creating intrigue, while rising six storeys without break from courtyard to roof.

Diagonal carving determines the entire section of Mansilla + Tuñón's Castellón Fine Arts Museum (2000; below, left), in Spain. To hollow the building mass, a double-height space with a huge north window is gradually stepped down through all five exhibition levels. This tiered path results in a different lighting condition for each gallery, becoming progressively darker towards the bottom, while opening a vista through the museum and between floors. A finer scale of channelled light occurs around the perimeter, ranging from folded monitors to a detached sheathing of corrugated aluminium slats, whose curves disperse light and streak the staircase with spots of sun. By contrast, the hollows scooped from Jean Nouvel's Galeries Lafayette (1996; p. 90) in Berlin are vertical and geometric, their conical voids lined with glass to propel illumination downward while absorbing a portion at each level. Reminiscent of Alvar Aalto's 'crystal skylights' or I.M. Pei's glass pyramids, Nouvel's funnels are varied in scale and deployed at many points in the plan, ensuring that the entire building is riddled with daylight.

A quite different morphology of light canals is being developed by architects who prefer to open masses with ruptures rather than cavities. Ryoji Suzuki is a leading proponent of an architecture of fissures, in which sheets of light are drawn into the building to segment and dissect volume into parts, an idea best illustrated in his Kohun-ji Temple (1991; below, right). The concept of a structure of cracks, to convey light at close intervals, is formulated instead as parallel slices along the longitudinal axis of Richard Meier's

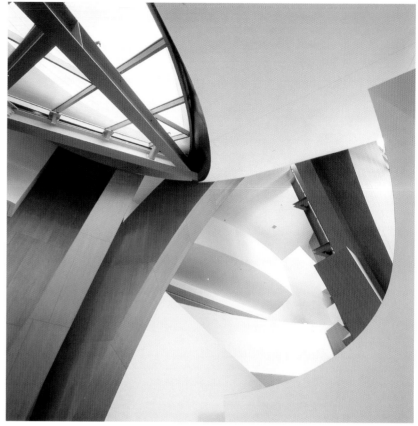
Walt Disney Concert Hall by Frank Gehry.

Barcelona Museum of Contemporary Art (1995; p. 172), whereas the vertical cuts in Mansilla + Tuñón's Archaeological Museum (1996; below, centre and p. 176) in Zamora, Spain differ in size and orientation, and pinwheel around a central void to siphon varied amounts of illumination to galleries below.

Daylit clefts are singular and iconic in the minimalist boxes of Heikkinen-Komonen, and introduce luminous streaks that give each building its basic identity, from the diagonal slash of the Arctic Circle into their Rovaniemi Airport Terminal (1992; p. 122), to the endless linear incision through the

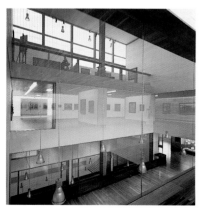
Castellón Fine Arts Museum by Mansilla + Tuñón.

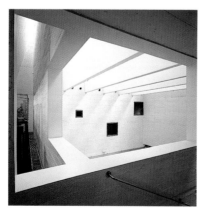
Zamora Archaeological Museum by Mansilla + Tuñón.

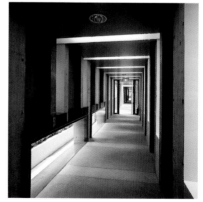
Kohun-ji Temple by Ryoji Suzuki.

Emergency Services College (1992; see p. 116), in Kuopio. The compact mass of their Finnish Embassy (1994) in Washington, DC is cleaved by a skylit hall that brings light to each floor of this necessarily introvert building. Suspended within this vertical chasm are smaller elements such as stairs, bridges, conference rooms and restrooms, finished to pass on the falling light with reflective claddings of copper sheeting, stainless steel and pale wood.

Returning to the science of fractals, one way this discipline has influenced ideas of permeability is the alternative it offers to a single scale of Euclidean measurement based on length, depth and thickness. Some of the most ambitious attempts to open built masses to light recognize that fractal boundaries offer a paradigm for channels with multiple scales, where voids appear within voids and exist simultaneously at large and small size. Models of this kind of open form, where a huge surface area is contained within a limited volume, were initially visualized by mathematicians whose inventions carry their names: the Peano Curve, the Koch Snowflake, and, especially suggestive for architects, the Menger Sponge (below, left), first described by mathematician Karl Menger in 1926. It depicts a cubic volume hollowed by infinite self-embedded holes, in which larger holes contain ever-smaller holes, a structure most humanly expressed in Hertzberger's Centraal Beheer (see p. 151).

Recently inspired by fractal images of constructed air, Steven Holl has designed daring new models of channelled light. Derived from the Menger Sponge, his Simmons Hall at MIT (2002; below centre) is based on what Holl calls 'sponge voids in section' and 'force fields of energy'.[55] While many 'pores' opening the mass are restricted to a thin outer skin, Menger's image is more persuasively echoed in the large cavities subtracted from the roofline for outdoor terraces, and, most provocatively, in organic voids open to sky and cave-like in contour, boring deeply inside at steep angles. These irregular voids form daylit lounges at the heart of the building and, like tiny urban plazas, bring illumination into the dormitory's social centres.

Organic carvings of residual space, allowing light to spill through the core of multi-storey buildings, are increasingly the hallmark of Frank Gehry, who describes in a documentary with director Sydney Pollack his fascination with the unimaginable space left between objects in a wastebasket. Something of this same labyrinth of voids opens up channels for raining light in his Guggenheim Museum Bilbao (1997), and more so at the Walt Disney Concert Hall (2003; opposite and p. 248) in Los Angeles. Protected outside by a luxuriant fringe of unfolding metallic leaves, which funnel intense sun to window slits, internal hollows are softly caressed by skimming light, making their curves appear voluptuous, almost peristaltic or womb-like in character, not unrelated to the flower paintings of Georgia O'Keeffe or the maternal voids of Henry Moore. Mixed into this illumination is radiation falling through gaps in the roof, described by Gehry as 'skylights in the form of an unfolding flower', to produce 'an all-pervading energy flow'. Finished with white plaster and pale wood, the sinuous walls and tiered levels further propel the light they receive, causing spaces to melt and merge in a glowing Piranesian fantasy.

For over half a century Maurice Smith has been pursuing an orthographic permeability, whose branching channels of light and space are fractal-like, but accrued through addition rather than subtraction, and conceived as a 'three-dimensional habitable field'. Finding an analogy in the open structure of words in poems by Charles Olsen and the hieroglyphic schemas and collaged hues of painter Paul Klee, Smith assembles buildings out of half-open corners and walls, so that every volume breathes with the light it shares with neighbours. Especially pervious is his Manchester House (1995; below, right), perched along the Atlantic coast north of Boston, and erected from large, prefabricated sections of frame and window. These inherently porous volumes contain every scale of opening, from huge to small window clusters, from skylights and wells to slots and cracks, and small rhythmic slits in latticed walls and staircases, producing a slow intermingling of light from outside to inside and room to room in every direction. In reconceiving the Modernist dream of buildings opened to the healthful presence of natural light, but without being stripped of territorial intimacy and value, Smith is pointing the way to a reconciliation of humanized density with Le Corbusier's call to 'bring back the sky', allowing the 'the sun, which governs all growth, to penetrate the interior of every dwelling, there to diffuse its rays, without which life withers and fades'.[56]

Menger Sponge.

MIT Simmons Hall by Steven Holl.

Manchester House by Maurice Smith.

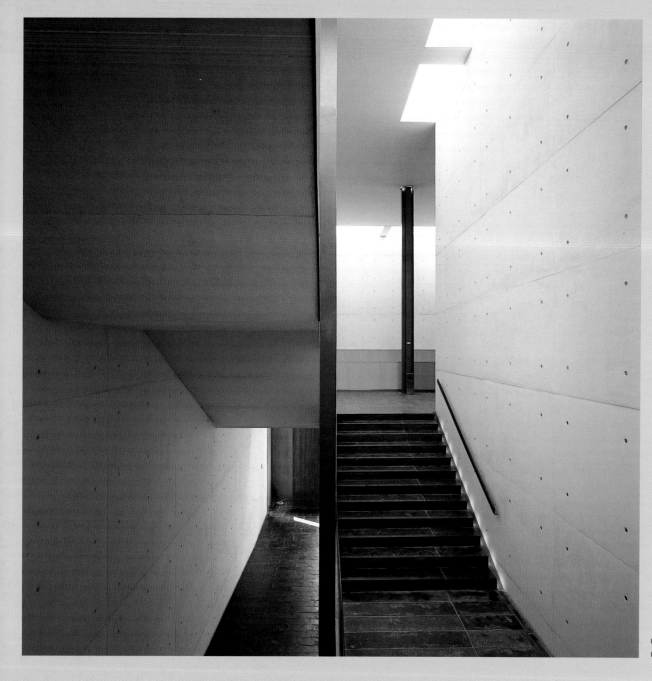

Contrasting folds of three different light sources.
Opposite: Successive light wells of staircase.

Auditorium and Conference Centre, Spain
Carlos Ferrater

To alleviate the intense Valencian sky at this 2004 conference centre in Castellón, Ferrater devised what he calls 'folded skylights', in which 'the ceiling folds back over itself' to trap and defuse calculated angles of sun, and then guide below this illumination through spatial fissures and circulation zones that divide the main halls. This phenomenon reappears at smaller size in the south-facing wall, where rusty steel baffles, conceived as a 'double inner façade', intercept sun and, upon several reflections, release it inside to rooms lined with glass. The interstitial zone of roof and wall behaves, in Ferrater's words, as 'a shadow through which light comes in', its depth determined by the sun's inclination, making the boundary *más grueso que el papel* (thicker than paper).

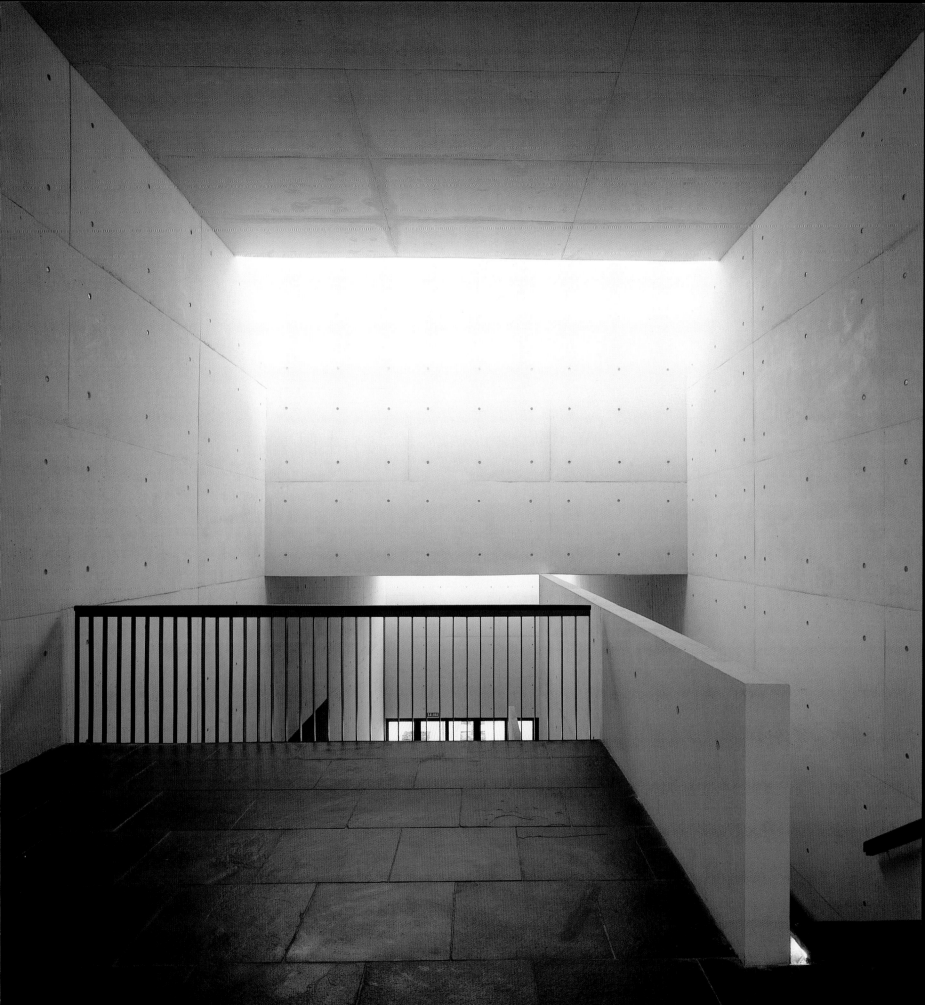

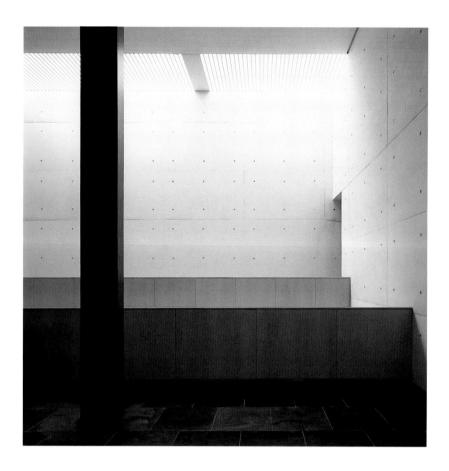

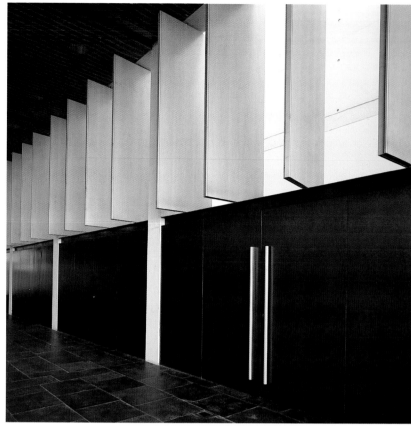

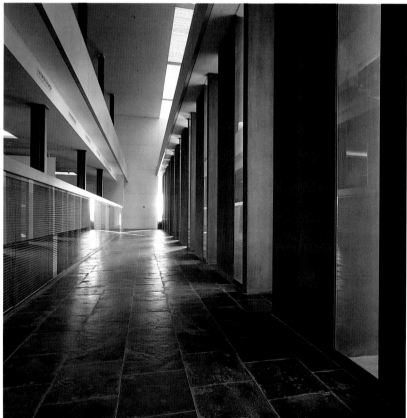

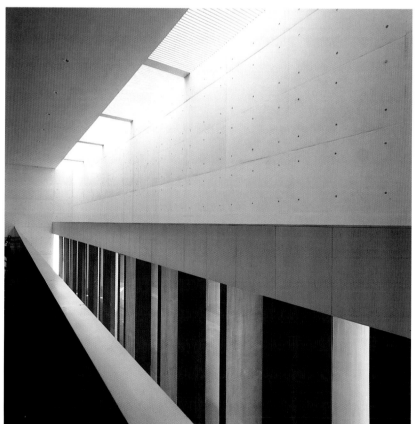

Clockwise from top left: Upper-level foyer; pivoting wood baffles of exhibition hall, with light slot beyond; mixture of zenithal and horizontal light; passage with folded steel baffles at right and glazed interior rooms at left.

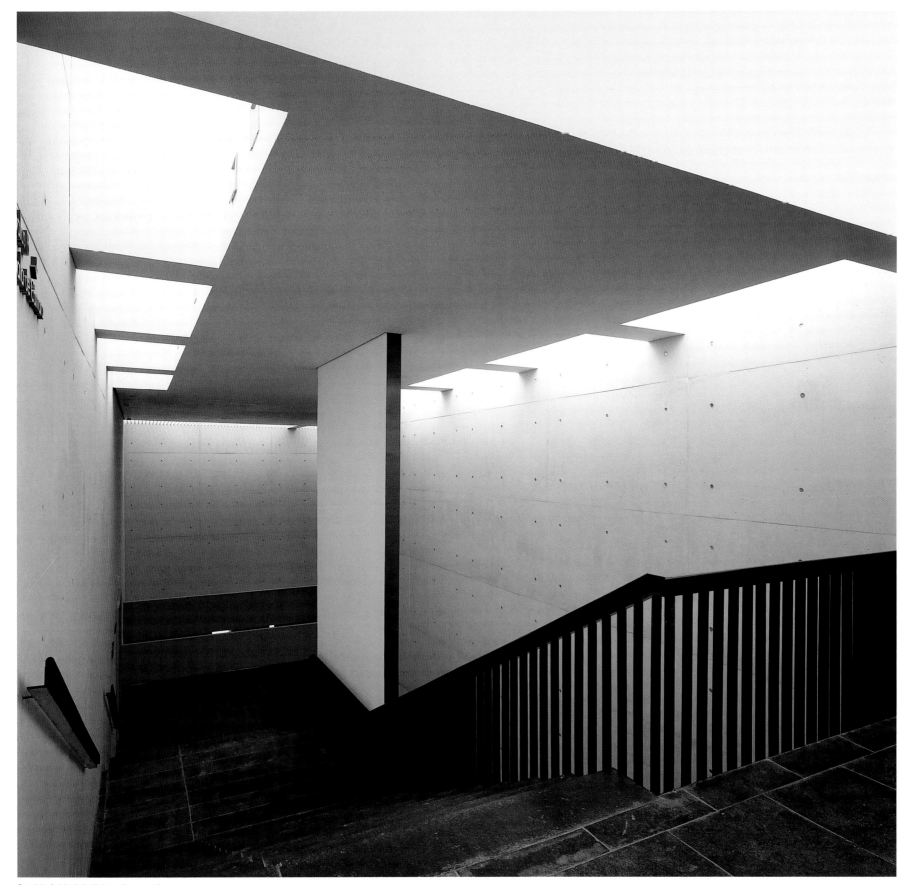

Double-folded skylights above staircase.

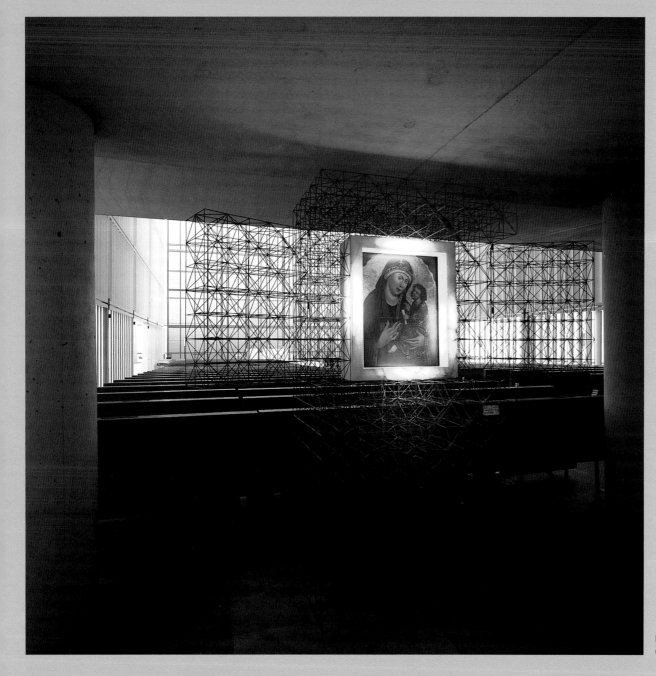

Narthex looking into sanctuary.
Opposite: Interior looking to altar.

Church of the Sacred Heart, Germany
Allmann Sattler Wappner

The artistry of this church in Munich, built in 2000, derives from the way each pervious layer subtly transforms the flow as well as quality of light. An outer glass skin gradually shifts from clear to cloudy as one proceeds into the church, so as to increasingly diffuse light while making a transition from profane to sacred without dimming the ambulatory. At the same time an inner lining of maple slats twists progressively open towards the altar, amplifying brightness at the holiest part of the church. Both end walls add a finer, yet also symbolic, filtration – a glazed entry façade imprinted with tiny blue nails to tinge that moment, and behind the altar a mesh of brass-copper alloy woven with a cross – combining to offer a welcoming sequence of cold to warm colouration.

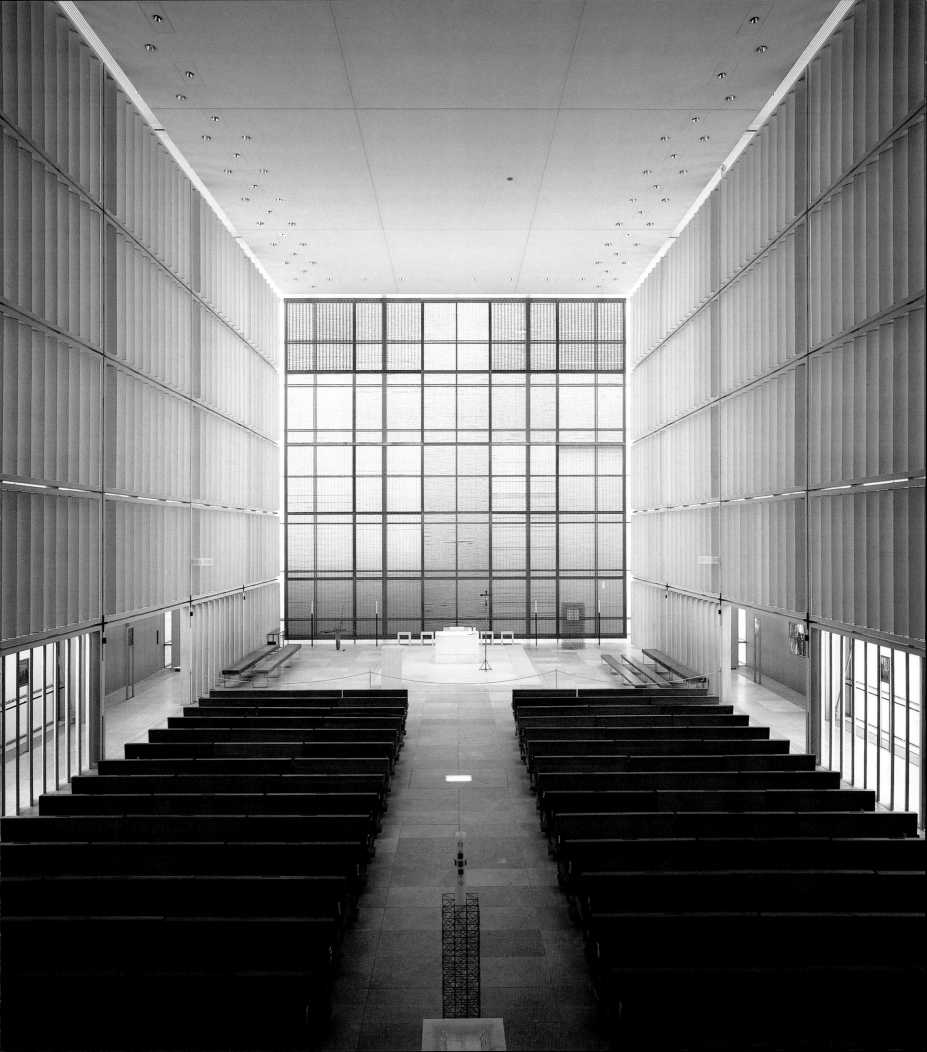

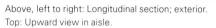

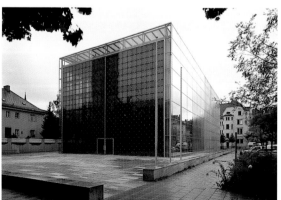

Above, left to right: Longitudinal section; exterior.
Top: Upward view in aisle.

Above, left to right: Altar space; entrance lobby with silkscreened blue nails.
Top: Side aisle, with sanctuary at left.

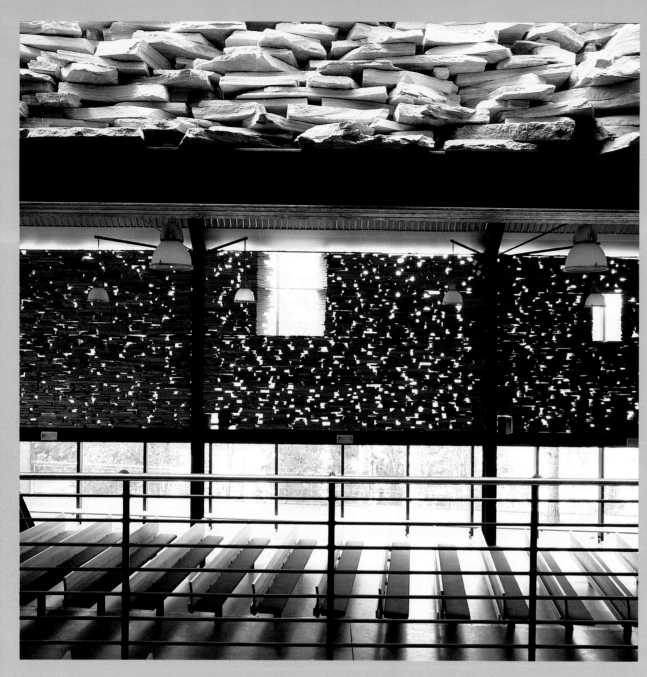

View across nave, with gallery light slot in foreground.
Opposite, clockwise from top left: View across nave from
gallery; interior looking to altar; plans of ground level
(above) and gallery level (below); transverse section.

Mortensrud Church, Norway Jensen & Skodvin

Showing an obvious debt to Herzog & de Meuron's Dominus Winery (1998; p. 134), the sieve-like stone lining at this 2002 church just outside of Oslo serves to turn down the light to a mystical glow, producing an intensely black but sparkling ambience suggestive of the night sky, whose presence dominates the Nordic world. Flat and unmortared pieces of slate are held within a steel frame, and wrapped outside by a transparent skin, allowing each layer to perform a different function. Responding to the scarcity of light at arctic latitudes, especially during long winters, but also a fusion of Pantheism and Christianity, earth and sky so typical of Scandinavia, the porous stonework is elevated above the floor and opened by several cracks in the roof to allow extra doses of northern light to slip in around the edges.

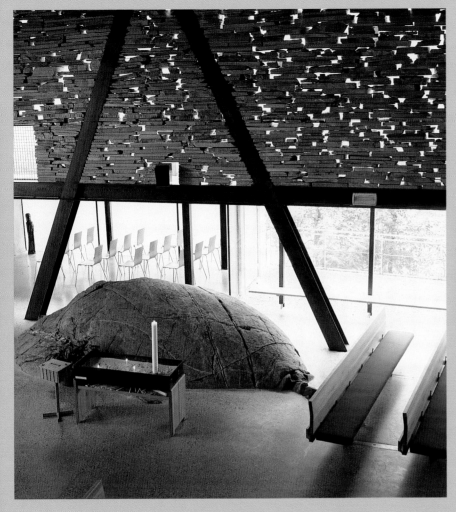

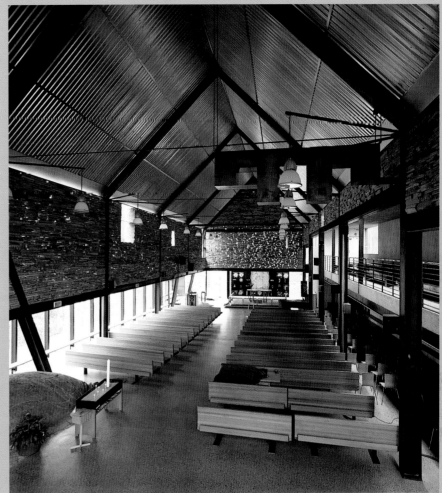

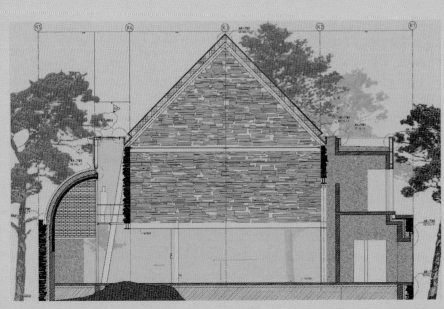

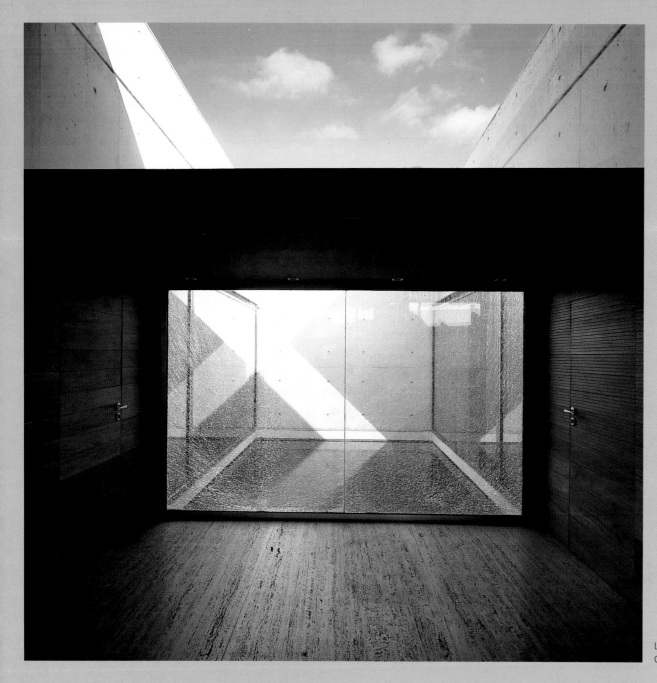

Light well between private viewing rooms.
Opposite: Chapel interior, with four 'fingers of light'.

León City Morgue, Spain BAAS

Most of the light that reaches the interior of this morgue, built in 2000, is conveyed by a grassy incline to gently illuminate the glass-lined hall where families of the deceased gather. Along the building's more private and technical eastern edge, light is delivered through cubic voids carved from the roof, each forming a water court whose liquid sheet bounces light to the rear of the hall, balancing ambient illumination. More importantly, these cuboids bring consoling light to the building's most introspective zone – the private rooms for family grieving – linking the point of sorrow with an image of hope from the heavens. By contrast, the subterranean chapel is lit by five enigmatic concrete tubes, projecting from the rooftop water at contrasting angles to catch various moments of the afternoon sun. Conceived as 'mysterious fingers in search of light for prayer', these Corbusian tubes siphon light to the five different voids carved from the chapel wall and ceiling.

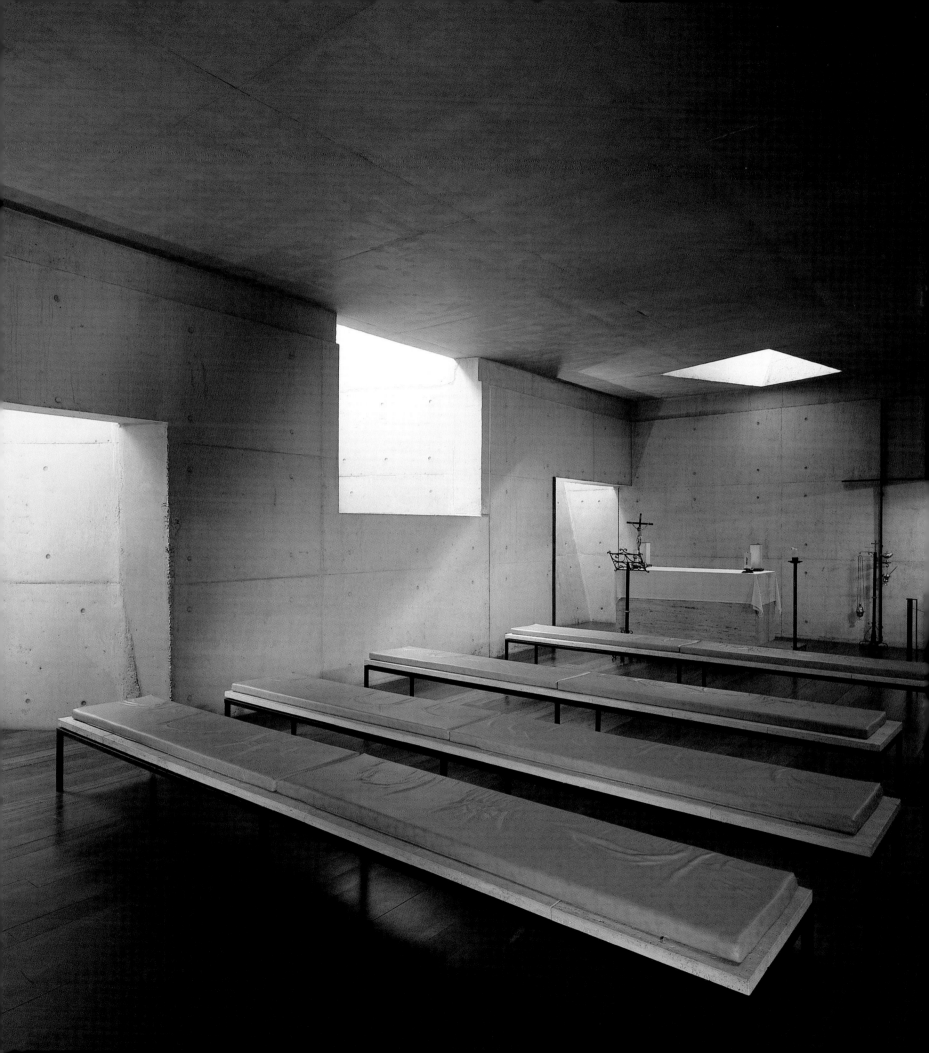

Above: 'Fingers of light' above chapel.
Top: Main hall.

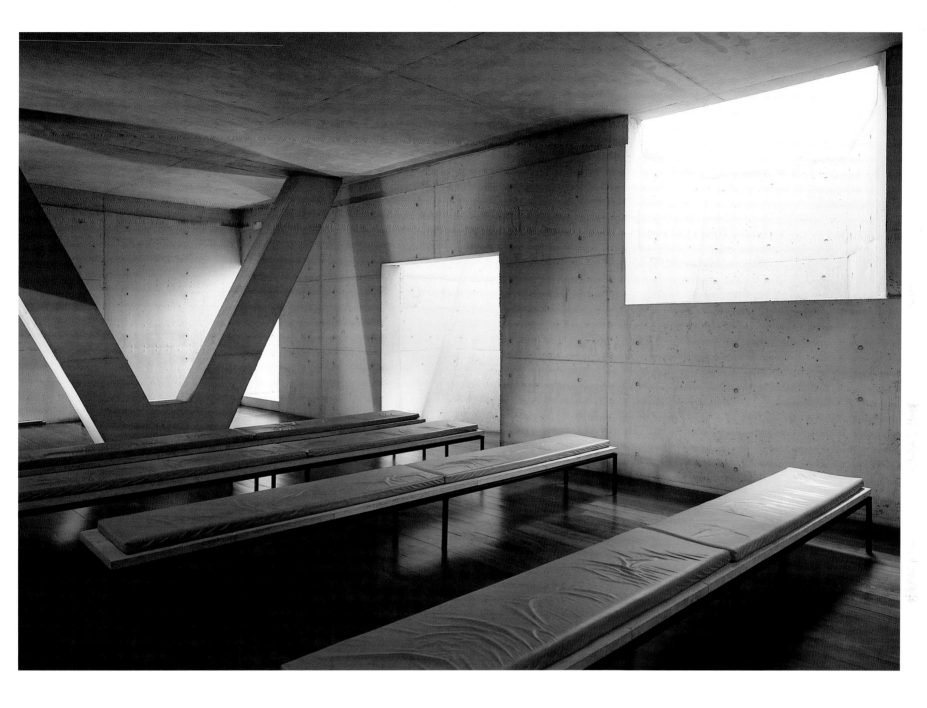

Above: Sections and roof plan showing the 'fingers of light'.
Top: Rear of chapel.

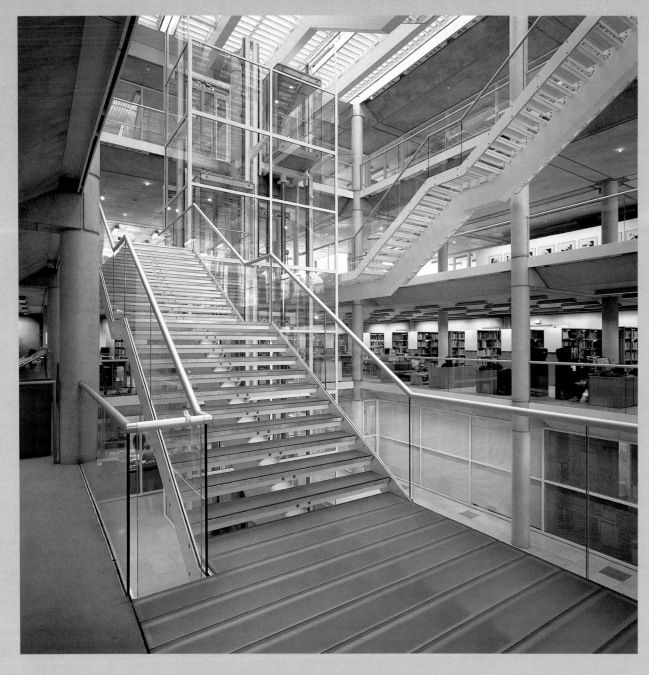

Atrium at library level.
Opposite: Upward view of glass stairs.

Carré d'Art, France Norman Foster

Protecting the lightwell of this 1993 mediathèque in Nîmes from the Provençal sun is a detached screen of metal sun-shades, followed below by stretched fabrics to further soften the subdued illumination – a modern abstraction of the traditional awnings used to shelter Mediterranean patios. The building's *tour de force* is the series of translucent plat-forms and bridges that criss-cross the void, providing access to levels without blocking the downpour of radiation. Glass *passerelles* connect each floor to a magnificent glass staircase supported on thin steel frames. Arousing wonder, as well as levitation, is the experience of seeming to walk on air and climbing through a shower of light.

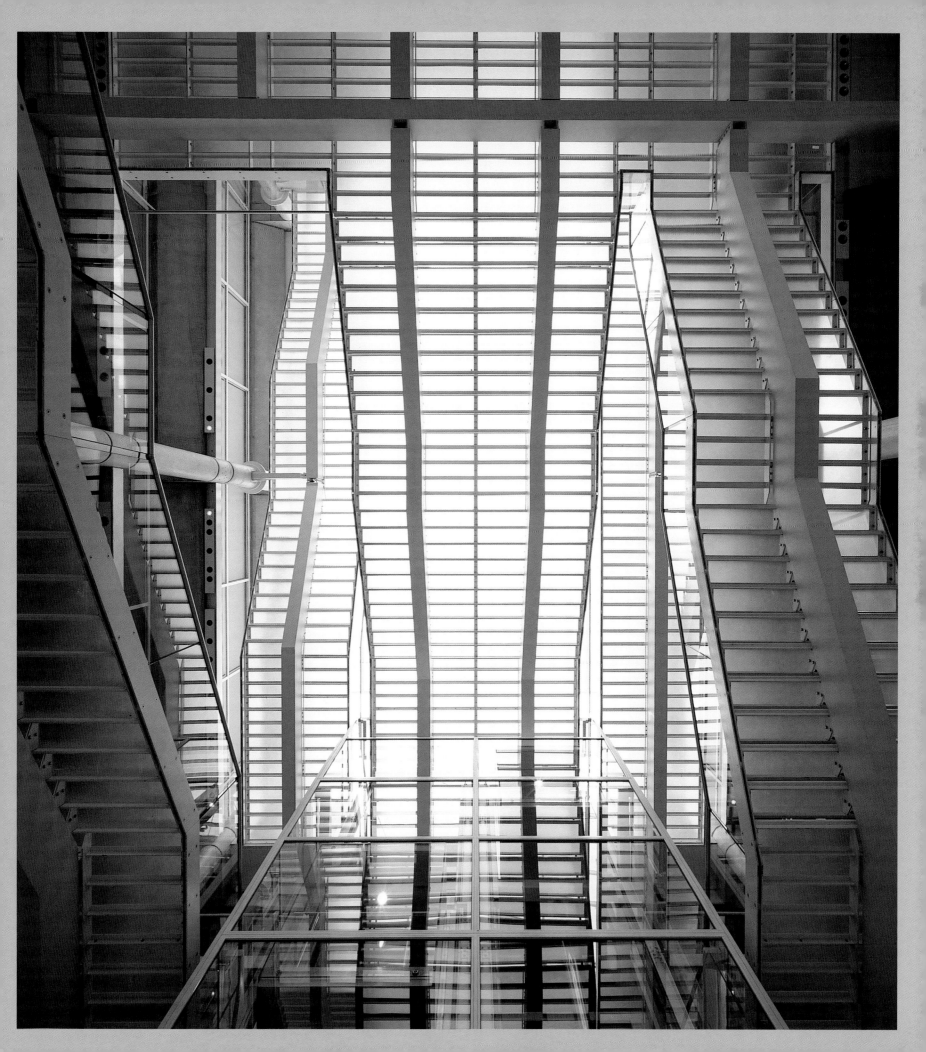

Lightwell near lobby.
Opposite: Central hall with view of ramp.

Barcelona Museum of Contemporary Art, Spain
Richard Meier

The laminous structure of this museum, dating from 1995, begins outside with detached sunscreens and reiterates through the building's depth with a series of fractures from roof to floor. As daylight washes through the parallel rifts, it sets off a progression of on-and-off tones that visitors encounter as they wind their way up ramps and cross glass-covered thresholds to galleries, before finally arriving at displays illuminated by roof slits – a composition totalling sixteen wall planes and sheafs of light.

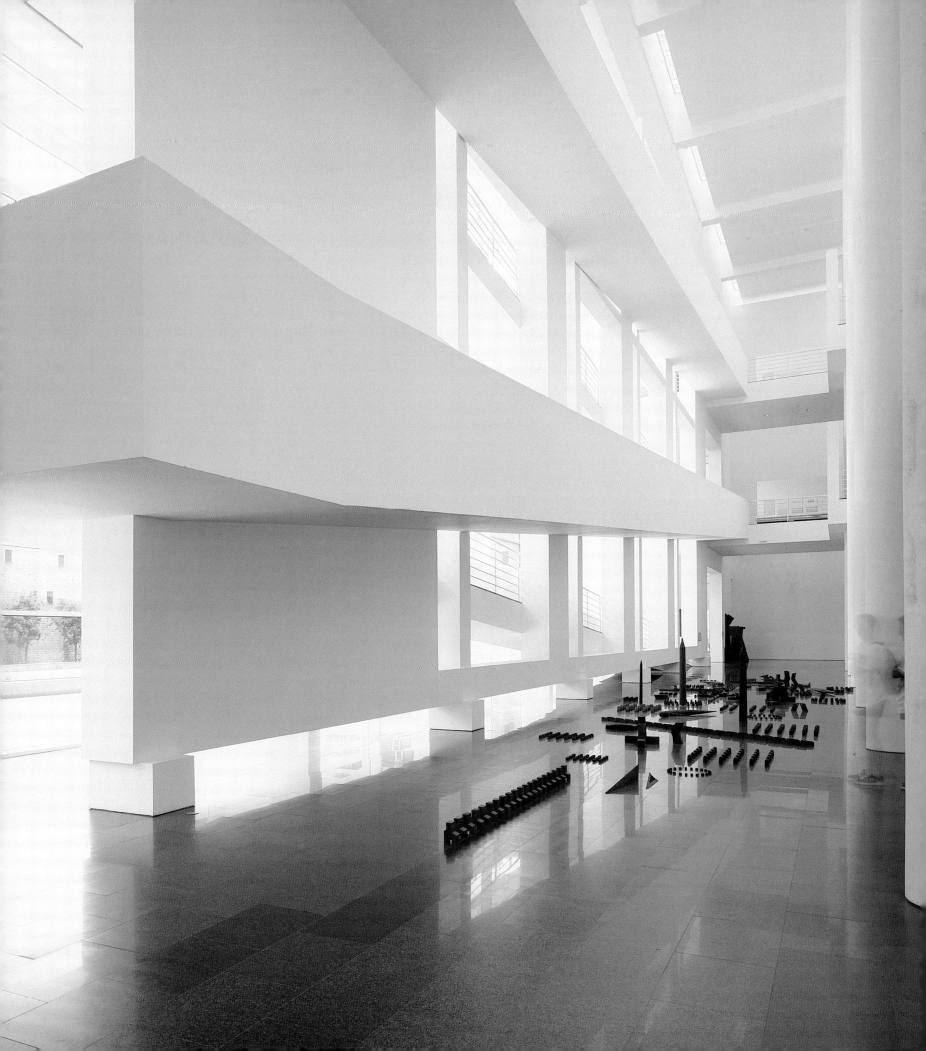

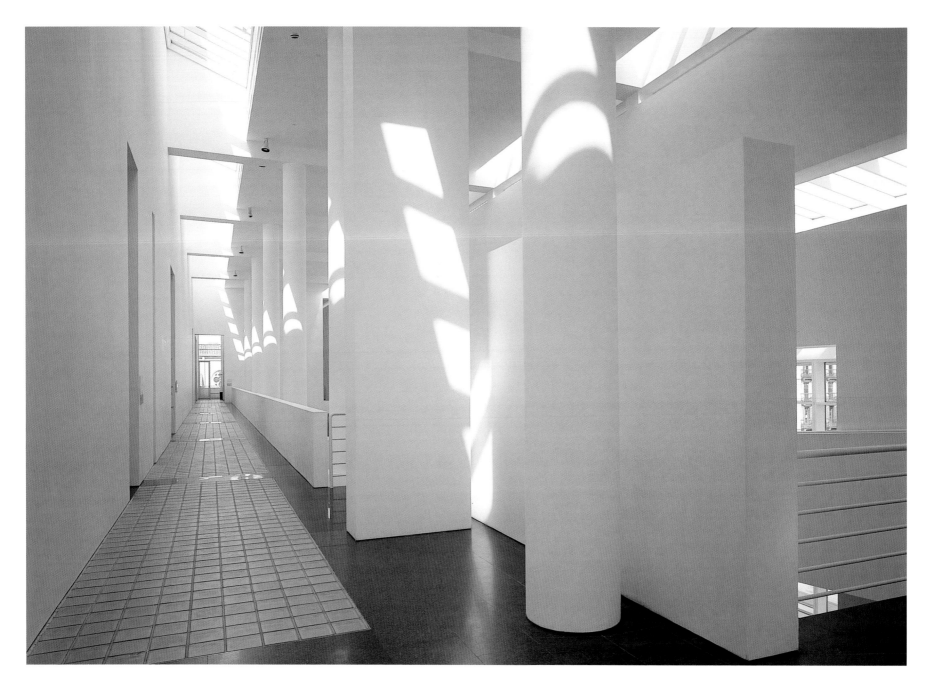

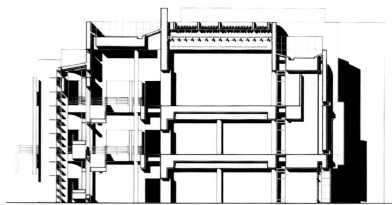

Above: Transverse section.
Top: Upper-level mezzanine and glass floor, with galleries at left.

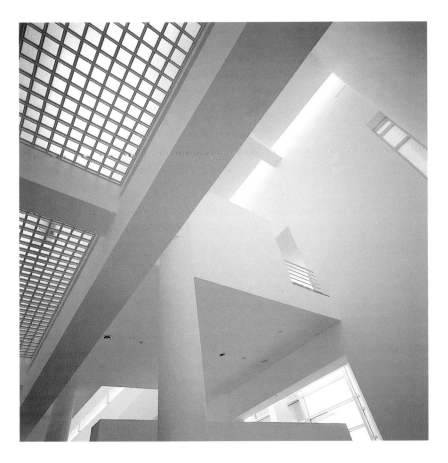
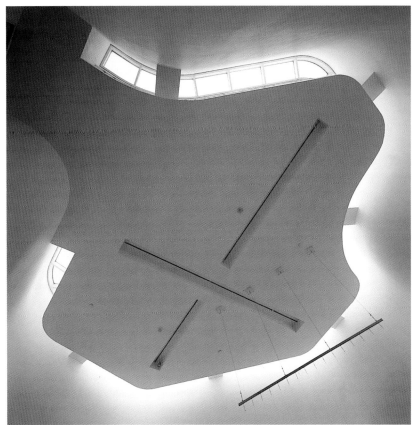

Clockwise from top left: View to upper level with glass floor at left;
ceiling of 'piano-shaped' gallery; central hall with ramp at right and galleries at left;
upper level, looking from gallery to top of ramp.

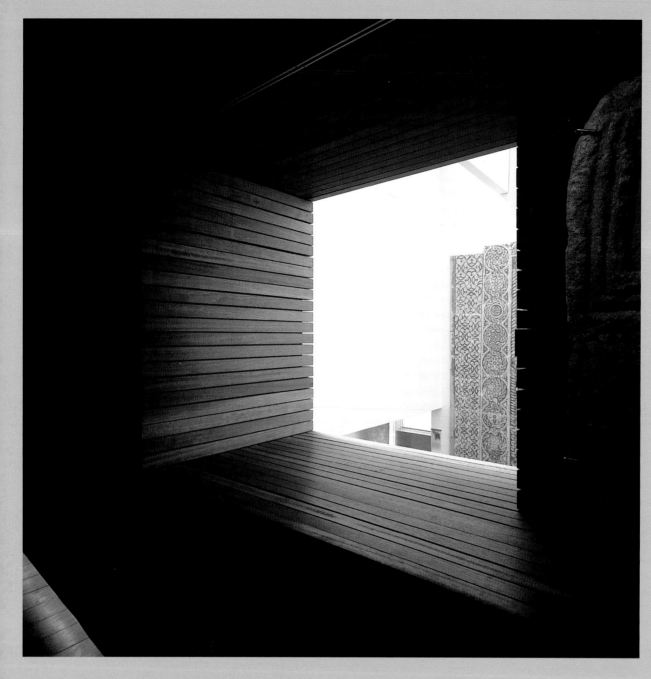

Shared light from central gallery, viewed from ramp.
Opposite, clockwise from top left: Light slot of staircase;
light well in mid-level gallery; openings between galleries of
varied levels; exploded axonometric.

Zamora Archaeological Museum, Spain

Mansilla + Tuñón

To conduct zenithal light into this 1996 museum's introverted stone box, multiple slots were incised in the roof and cubic mass, whose language echoes a rocky gorge that cleaves the museum's hillside entrance. Light captured from different parts of the sky by steeply pitched monitors is transported down through narrow gaps to galleries set at various levels, its rain visualized by glancing shadows on board-imprinted white concrete. Conversely, the visitor winds upwards through these cracks and falling light, from a dark entry zone to galleries of varied illumination. Particularly evocative are gashes cut between the new construction and the medieval walls at the museum's rear, using sheets of light to illuminate artefacts while arousing architectural memories.

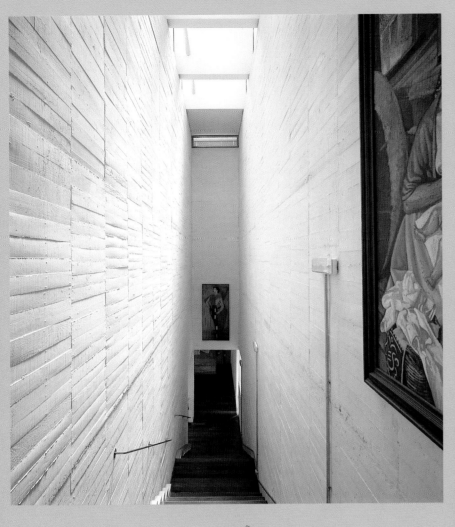
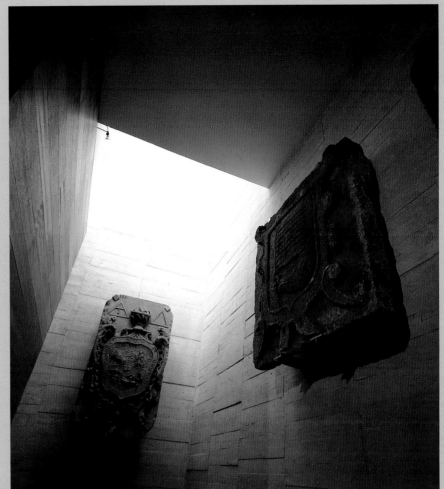

ATMOSPHERIC SILENCE

SUFFUSION
OF
LIGHT
WITH
A
UNIFIED
MOOD

6 ATMOSPHERIC SILENCE
Suffusion of light
with a unified mood

For centuries, architects have tried to grasp – and better control – the elusive ability of natural light to create its own spirit of place when imbuing a building with mood. A light of this kind does not merely illuminate form or episodically dazzle the eye, but creates an overall atmosphere, whose phenomena have become so intimately linked that they blend into a radiant whole, vibrant with modulations. The result is an ambience that bathes every object in one's field of vision, and whose unity of impression and total effect are grasped by the eye at a single glance, directly affecting the sensibility independent of logic.

The challenge to constructing a luminous atmosphere is the degree of restraint it demands. It is only when forms are quieted down and surfaces reduced to a single material or closely matched tones that a nuanced mood can coalesce and be seen as a whole. The nearly uniform reflectance allows light and shade to clarify forms rather than materials, producing a total effect to which each individual tone contributes, and linking objects with the atmosphere that envelops them. Perhaps due to the discipline required to so thoroughly underplay formal expression and ornamentation, the most compelling examples of atmosphere have historically developed in cultures constrained by either regional forces or spiritual belief. The climatic limitations and simple materials of indigenous architecture, such as the humble adobe of desert climates, the ochre stone of Dordogne villages, or the whitewashed stucco of Aegean hill towns (below), often led to a monochromatic play of light, whose ambience was a fortunate byproduct rather than a conscious aim. Conversely, the sublime reduction employed by builders with metaphysical aspirations, and vows of material poverty, produced an atmospheric intensity that was deftly controlled and rarely equalled. Purged of excess and sensitized to light, the simple stone voids of Cistercian abbeys (opposite, below left) and the plain woodwork of Zen temples still exude a tranquil air conducive to the spiritual life.

The individual largely responsible for returning a metaphysical aim to contemporary architecture was Louis Kahn, whose paramount interest was the close relationship of light and silence, and the source of this marriage in a 'monolithic space'. The power of his work, as seen in his Salk Institute at La Jolla, California (1965; opposite, below centre), is based on inducing bare forms to glow in a peaceful yet eloquent way, and thus be empty without being vacant. Kahn employed archaic geometry and naked walls to refine his buildings to an irreducible essence, a pre-condition for his ultimate aim: to enchant space with wondrous moods. Revealed in his work is a constant awareness of the simplicity required for buildings to transcend their physical limitations, while avoiding busy surface effects that might interfere with light's subtle and marvellous, yet tenuous, appearance. The elemental reduction attained by Kahn with naked concrete has since the 1970s been simplified even further by Tadao Ando and broadened in range of moods by others, including Henning Larsen and Schultes & Frank. Architects continue to demonstrate the remarkable truth that atmosphere in buildings is most powerfully expressed with modest means, and the presence of absence.

Today's architects who are inclined, as was Kahn, to virtues of simplicity continue to chasten the voids into which light is poured. They shape and position sources of light to shed subtly varied illumination on a limited palette of

Santorini, Greece.

unadorned materials, using few elements with much repetition, while avoiding formal rhetoric and gesture. What sets these current aspirations apart from the past is the range of building types in which luminous atmosphere is sought, but also the extent to which buildings are purified into vessels for light without sacrificing their utility or richness, not to mention the impact of industrial materials and technologies on achieving a serenity expressive of our time.

This contemporary vision is even evident in the twilit abbeys designed by the monk Hans van der Laan, especially his St Benedictusberg Abbey (1986; p. 186), in Vaals, whose ambience stems from a reductive purity of typology and geometry unimaginable in the past. Visualized in Van der Laan's architecture are many ideas posed by Max Picard, particularly his notions that 'silence belongs to the basic structure of man' and that buildings can be 'reservoirs of silence'.[57] Blending simple and humble materials into an orthographic language, made possible by reinforced concrete, Van der Laan constructs a world in which 'it is as though the light were taking possession of the wall on behalf of silence', and, in doing so, helps counter the plight observed by Picard that 'nothing has changed the nature of man so much as the loss of silence', manifested architecturally in increasingly noisy and posturing forms.

Van der Laan's tenebrous work also points to a timeless source of atmosphere in architecture – beguiling shadows that gather in space and enhance faint light, whose sublime mixture has long been exploited by builders of churches, temples and mosques. Such is also the case in Tadao Ando's architecture, as seen at his Forest of Tombs Museum (1992; right), in Kumamoto, where palpable shadows magnify the faint light playing over neutral colours and stark geometries. The origin of Ando's mastery of shade lies partly in the exquisite reductions of Kahn, as well as those of Luis Barragán and various Scandinavian architects, but derives equally from a Japanese love of frail light and the beauty of dark places (below, right). The charm of a Japanese room comes from 'dim shadows within emptiness', writes novelist Junichiro Tanizaki in his magnificent book *In Praise of Shadows*. He goes on to describe 'the soft fragile beauty . . . of fading rays clinging to the surface of a dusky

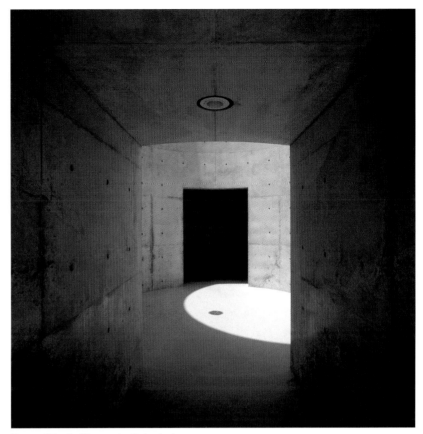

Forest of Tombs Museum by Tadao Ando.

wall, there to live out what little life remains to them'.[58] Shadows of this kind are the essence of Ando's Church of Light (1989; p. 190), suggesting a place of repose as compelling as any from the Japanese past, while drawing attention to the muted light as it carves like a knife into the darkness.

The approach to shade taken by Peter Zumthor at his baths in Vals (1996; p. 60) is inherently chthonic, creating a spell out of scant light and glowing mist that intensify the experience of being in caves. The continuous use of a single material – greenish-grey gneiss – gives a uniform texture and light

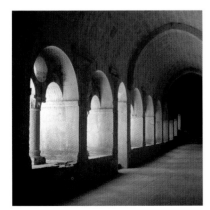

Le Thoronet Abbey, France.

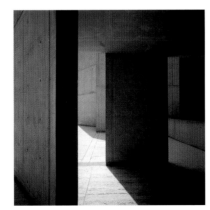

Salk Institute by Louis Kahn.

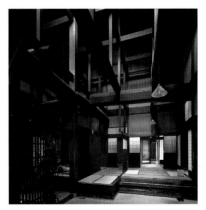

Yoshijima House, Japan.

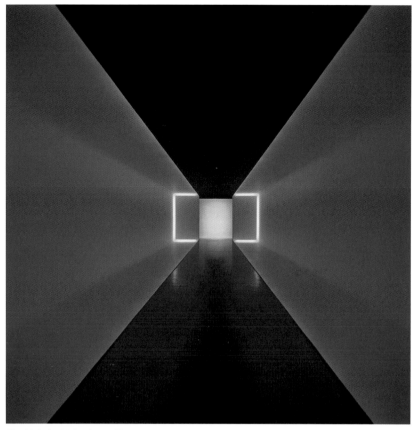

The Light Inside by James Turrell.

reflectance to solids and voids, as if every surface was sculpted from mono-lithic rock. Further emphasizing the shadowy silence are neutral mortar, frameless openings, and interlocked slabs at corners. Raining into the dusky air is another atmospheric element – beams of light from cracks in the roof, whose spreading rays visualize the descent of energy, and draw one of many analogies between water and light. Zumthor describes his conception at Vals as 'a pure mass of shadow', into which he puts in light as if 'hollowing out the darkness, as if the light were a new mass seeping in'.[59] Illumination unfurls along walls at a tangential angle, increasing its own ethereal presence as well as deepening shadows beneath stone courses. Completing the incantation is a diffusion of light into various states of warm water, giving the liquid a con-gealed glow that dissipates above into phosphorescent vapour.

Such impulses in architecture have paralleled and been influenced by the minimalist movement in art that arose in the 1950s. In the most exquisite of these works, reduction is not an end in itself but a manoeuvre to bring forth an immaterial essence, often an infinitely subtle glow described by critic Lawrence Alloway as 'a veil, a shadow, a bloom'. These emanations can only be vaguely grasped by the spectator, who is urged to fill in the rest with his or her own imagination. Artist Robert Irwin describes this encounter as 'first-hand perceiving', made possible by art that leaves its space as empty as possible in order to break down perceptual habitation. One thinks of the glowing vibrations of Agnes Martin, the pneumatic hues of Mark Rothko, the skeletal voids and striated tones of Sol LeWitt, the luminous, serial metal boxes of Donald Judd that reflect onto neighbouring walls, the solid light and colour fields of Dan Flavin's fluorescent tubes, and the light that one can touch with the eye, free of any object, in James Turrell's installations, such as his site-specific project for the Museum of Fine Arts, Houston (1999; left).

Similar distillations appear in the stage arrangements of American artist and playwright Robert Wilson, whose barren glow recalls how the 'empty' part of a Chinese or Japanese painting can occupy as much as two-thirds of the picture. Pervading Wilson's lonely spaces is a metaphysical presence whose emotion springs from what can only happen in a total void. The set-tings devised for *Bluebeard's Castle* (1995), for instance, are flooded by bursts of coloured light, whose brief appearances are separated by darkness, and then immediately regenerated in contrasting tones that bathe the back-drop as well as the stage. Visited by a few silhouettes of actors and props, all that is left in this extreme abstraction is an air of dream-like, almost delirious luminosity. Wilson shares with many architects, past and present, a prefer-ence for the emotional intensity only possible with coloured light, whose specific tone can govern the overall mood of a space and reach every corner

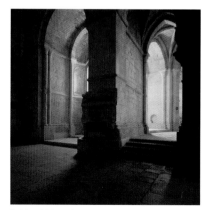

Poblet Abbey, Spain.

Fushimi Inari Shrine, Japan.

Neuendorf Villa by Pawson & Silvestrin.

with its own special flavour. We find antecedents of this painterly art in the golden ambience of a Cistercian monastery built from a single kind of stone (opposite, below), or the reddish-violet air of Chartres cathedral, issuing from the predominant hues of stained glass, or the pure red glow of the Fushimi Inari Shrine in Kyoto (above, left), resulting from vermilion paint on its 'thousand *torii*'. More recently there is Rafael Moneo's blended amber light seeping through alabaster walls, or the gold mist acquired from bronze mesh in Wandel Hoefer Lorch + Hirsch's Dresden Synagogue (2001; p. 204).

Going further than almost any architect since Barragán in building space out of coloured light is fellow Mexican, Ricardo Legorreta. Basing his palette on gravelly plaster painted with a mix of pulsating hues, Legorreta gives light a strong haptic presence, while so binding it with colour that each becomes indistinguishable from the other, and can range in one building, as in his Bel Air House (1998; p. 200), from yellow or burnt orange to pink or red, blue or purple. The coloured light concocted for the Neuendorf Villa (1992; above, right) by London architects John Pawson and Claudio Silvestrin is far more

austere, almost monastic, its earthen tones derived from Mallorca's reddish terrain to fuse the atmosphere into its landscape. Hollowed from a solid cube is an interlinked complex of empty rooms – simple cavities with echoes of antiquity, but also sharing Le Corbusier's search for 'great primary forms which light reveals to advantage'. Further investing this Mediterranean dream is the strange magic of huge walls immersed in silence, reminiscent of the solitary poetry of deserted squares depicted on canvas by Giorgio de Chirico, within whose colours and lengthy shadows one discovers a meta-physics of the void.

Completely opposed to the strong emotions resulting from light that is permanently coloured is the calm ethereality of pure white architecture. Reflecting every wavelength of visible light, white produces an immaculate finish from which everything physical has been removed, leaving nothing in place but an unearthly glow whose simple beauty can no longer be improved by subtraction. Entirely uniform in light reflectance, each shifting form or texture produces a new highlight or shadow, which is intimately linked with other subtle and almost indefinable tones. Washing over walls, like bare canvas, are exceptionally faint colours of light, painted by fleeting tints of sun and sky, leaf and cloud. These delicate veils of shade and hue are a central experience of pristine white architecture, epitomized in Greece's island villages, whose plastic forms are bathed in a light that seems to vibrate in front of the surface and take on a real presence.

Architects who strive to put into practice similar visions of luminous whiteness often fail to model the light they reflect, producing bright objects bereft of shadows. Such a paucity of atmosphere tended to impoverish the white stucco architecture of early Modernism, which, though inspired by a 'radiant new world', retained something of a hospital air in its taut, white containers. The first steps towards recovering a more nuanced whiteness occurred in Scandinavia, where Modernist sensibilities were tempered by the moody Nordic sky and play of light upon the winter snow for half the year. Gunnar Asplund in Sweden, Alvar Aalto in Finland, and Jørn Utzon in Denmark (below) forged a gentle white ambience from plastic volumes and

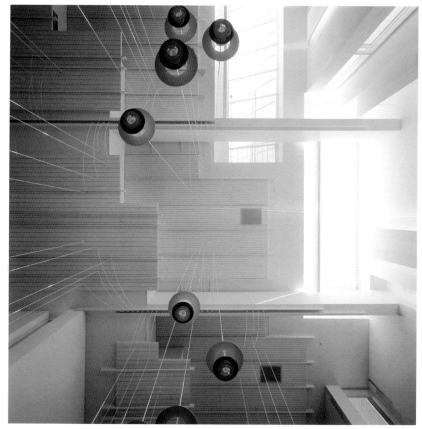

Männistö Church by Juha Leiviskä.

graduated light, beginning a tradition that continues to evolve in the hands of architects such as Kristian Gullichsen, Claesson Koivisto Rune and Henning Larsen.

Standing out among all is Juha Leiviskä, in whose gleaming purifications can be seen the influence of Balthasar Neumann's undulating voids. Upon entering one of Leiviskä's churches, such his Männistö Church in Kuopio, Finland (1992; above and p. 34), one has the impression of stepping into another world, defined by nothing but soft gradations of white light, which

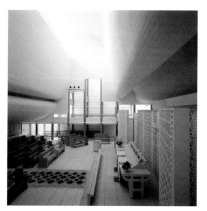

Bagsværd Church by Jørn Utzon.

filters in as if by spiritual osmosis. A smooth skin of white paint coats every bare surface, presenting little to the eye but an empty glow. While calming to nerves, the whiteness is aflutter with the gentle modulations produced by an overlap of planes in rhythmical sequences. As with echoing sounds that occur only in vacant space, this fluttering light heightens the void by its rise and fall of whispering sequences, which float through space and die away like a Gregorian chant. The atmosphere is varied by illumination floating down over some walls, while cloaking others in faint blue shadow, veiling planes in a graduated haze that is completely surrounding and suspending. The scanty means and gentle iterations of Leiviskä's light bear close analogy to the minimalist music of Estonian composer Arvo Pärt. Just as a mystical spell is created in chants and hymns, by emphasizing the empty void in which faint, lingering sounds resonate, so it is in Pärt's 'tintinnabuli style'.[60] The stark instrumental work *Für Alina* (1976), for instance, is built up from the quiet, haunting, and thoroughly hypnotizing sounds of piano, violin and cello, which mirror one another with notes added to the scale on each iteration. As Pärt comments: 'I could compare my music to white light which contains all the colours. Only a prism can divide the colours and make them appear: this prism could be the spirit of the listener.'[61]

Whiteness stirred by fluttery shadows is often used by architects to satisfy another contemplative need: a mood conducive to heightened perception and thoughtful reflection in museums of art. It is not vacancy that is sought in the rhythmic white glow of museums such as Richard Meier's at Barcelona (1995; p. 172), but a serenity capable of invoking reverie. With similar intent, Gigon & Guyer strive for what they call an 'all-over' conception, resulting from a continuous coat of white plaster on every surface above a pale grey concrete floor. Light pours through directional monitors into the bare white voids of their Winterthur Art Museum addition (1995; below, left) in such a way as to open up 'a richness of perception . . . comparable to what a picture from Robert Ryman can communicate with white as a carrier of light and shadow of varying form-giving structures'.[62] As in Ryman's silent, all-white abstract paintings, the monochromatic reductiveness at Winterthur is recomplicated by shadows. Rows of sheds over each gallery emit a series of tonal waves, their pure white light tinged with violet, casting on walls the faintest shadows that melt away in the counterlight of neighbouring sheds. These gentle emissions bring to rooms a breath-like calm, broken only by colourful art and pictorial views framed by windows.

The most remarkable trait of the whiteness developed in Iberian architecture, exemplified in the work of Alberto Campo Baeza (below, centre), is the severe austerity with which it makes a presence. Another leading proponent of light displayed on mute, almost benumbing walls is Álvaro Siza, whose atmosphere tends to evoke gravitas rather than joy (below, right). Interrupting Siza's stillness are liquid episodes in which the pale illumination wavers and drains into shadow, often around transitional elements of entry or window, parapet or stair. Such is the case at his Galician Centre of Contemporary Art (1993; p. 208), whose secret glow is hidden inside a granite crust, as well as at his Santa Maria Church (1996; p. 212), in Marco de Canavezes, whose proportion of wall to fenestration and detail, not to mention human size, is so exaggerated that visitors are made acutely aware that they are entering a place of utter emptiness. But it should be remembered that it is precisely this emphatic sense of desolation amidst radiance which can give buildings a sense of blissful poverty – widely considered the essence of spirituality.

Winterthur Art Museum Addition by Gigon & Guyer.

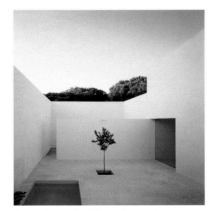

Gasper House by Alberto Campo Baeza.

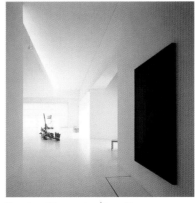

Serralves Museum by Álvaro Siza.

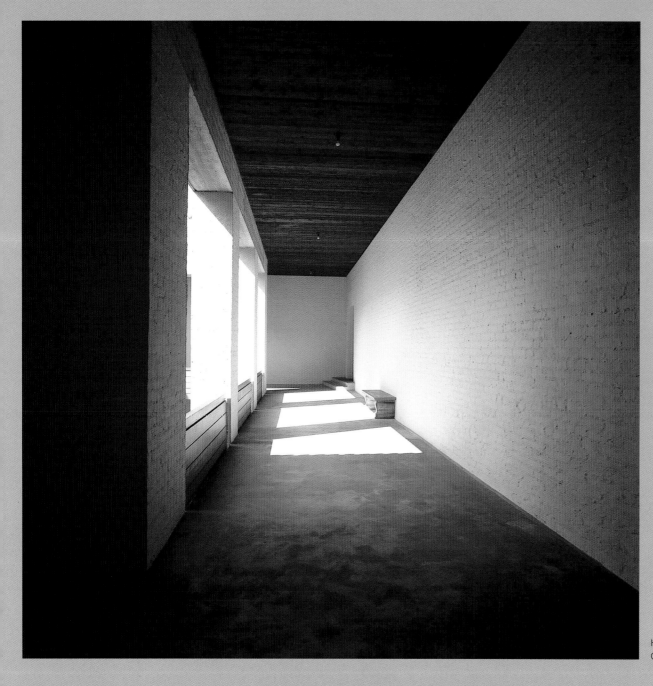

Hallway to church.
Opposite: Crypt with side chapels at right.

St Benedictusberg Abbey, The Netherlands

Hans van der Laan

As in the *Pittura Metafisica* of Italian painter Giorgio Morandi, the stillness of matter in Van der Laan's simple forms arouses a feeling of haunted beauty, due to the lyrical eloquence found in such humble things. Moody light and long shadows make a strong presence among the columns, walls, pews and cells at this 1986 abbey at Vaals, built of stone blocks and bricks lightly roughed in with mortar, as well as planks of wood painted pale blue, and pavements of cement and river pebbles. An eerie stillness is produced in the church by light that is shed from a high row of square openings, carving softly into the shadowy colonnades. More mystical still is the underground crypt, its intensely dark nave aroused from one side by sidelit chapels, whose illumination sends a trail of lines across the floor and casts a dim sacred aura over the unaffected space.

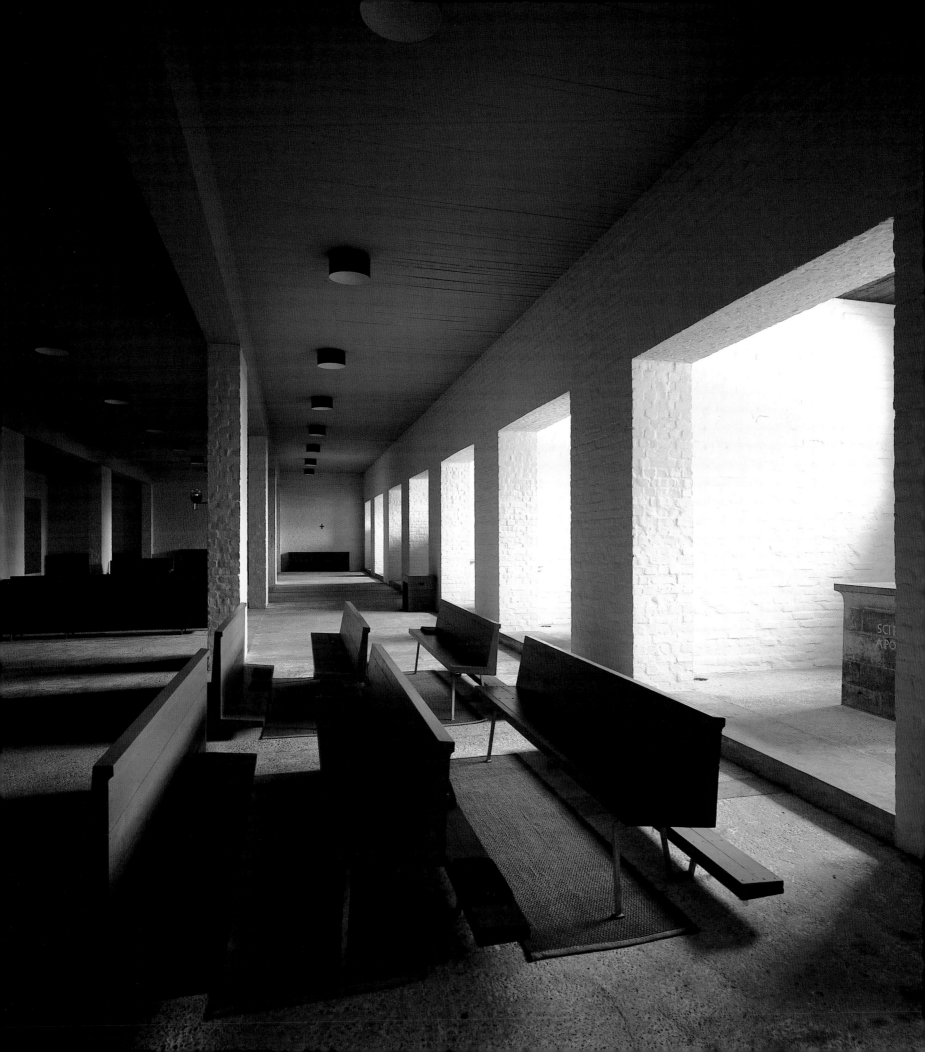

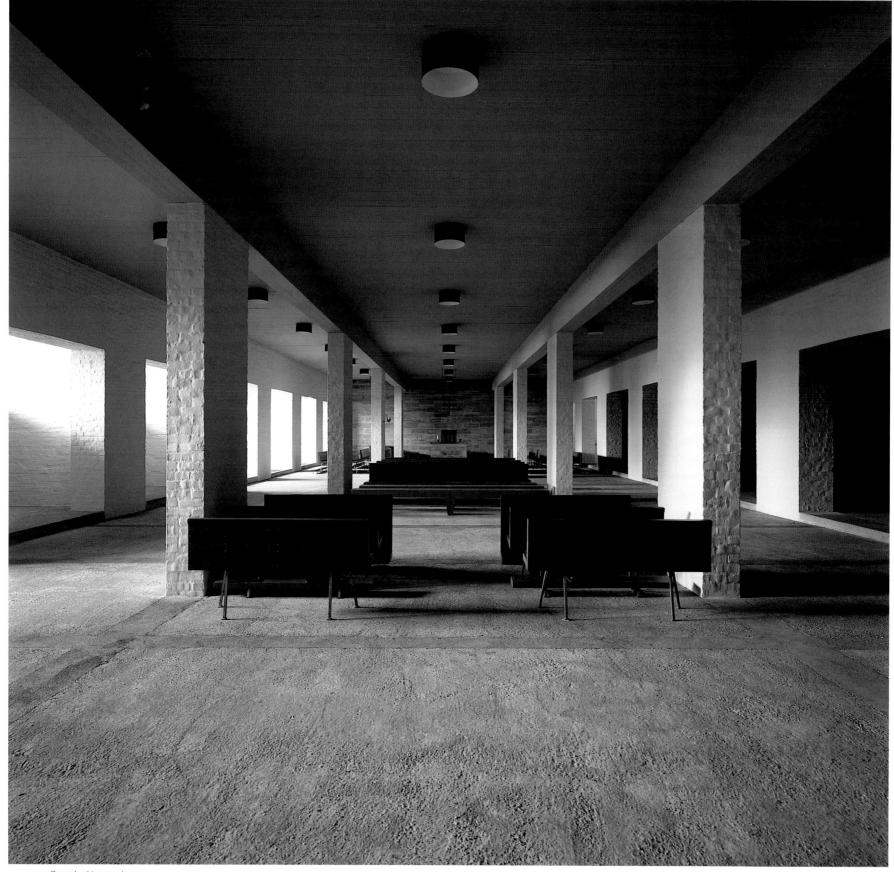

Crypt looking to altar.

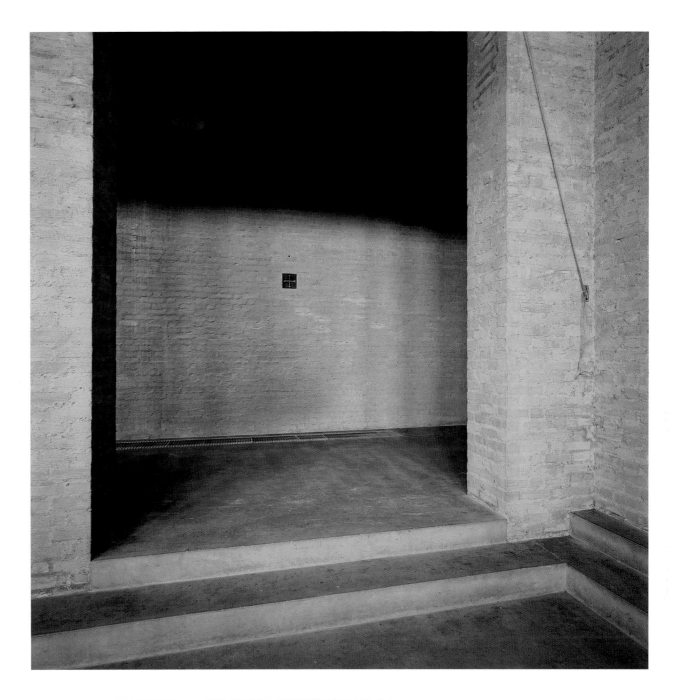

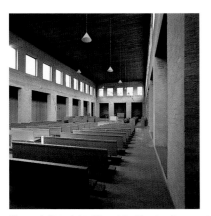 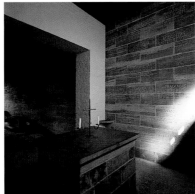 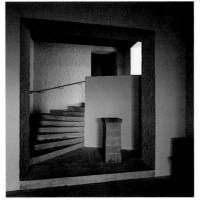

Above, left to right: Church looking to altar; crypt chapel; descent to crypt.
Top: Coloured shadows in ambulatory of church.

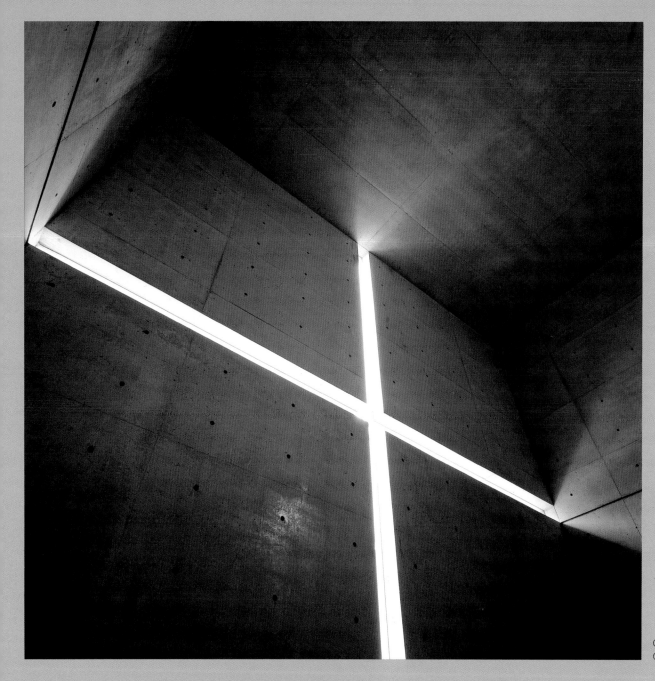

Cross of light.
Opposite: Intersecting walls.

Church of Light, Japan Tadao Ando

Of all of Ando's tenebrous works, the Church of Light, dating from 1989 and located in Ibaraki, especially satisfies Junichiro Tanizaki's longing for 'the dream-like beauty, mystery, and magic of shadows'. Entering the pitch darkness through cracks and fissures are small amounts of light, whose glow acquires a heightened presence before fading away over bare concrete. Differently oriented slits capture contrasting tones of sun and sky, painting some walls pale yellow and others violet. Like a transfusion, two kinds of atmosphere fill the void: a thick darkness that obscures what is solid and veils the physical limits of space, and slivers of light that cut through walls while spraying on them a faint afterglow. The overall blackness enlarges our pupils, and sensitizes our minds to this trickle of energy. Though soothing to the nerves, the dim chamber also presents a work that is not merely a record of light, but *is* light, made manifest in sensory form.

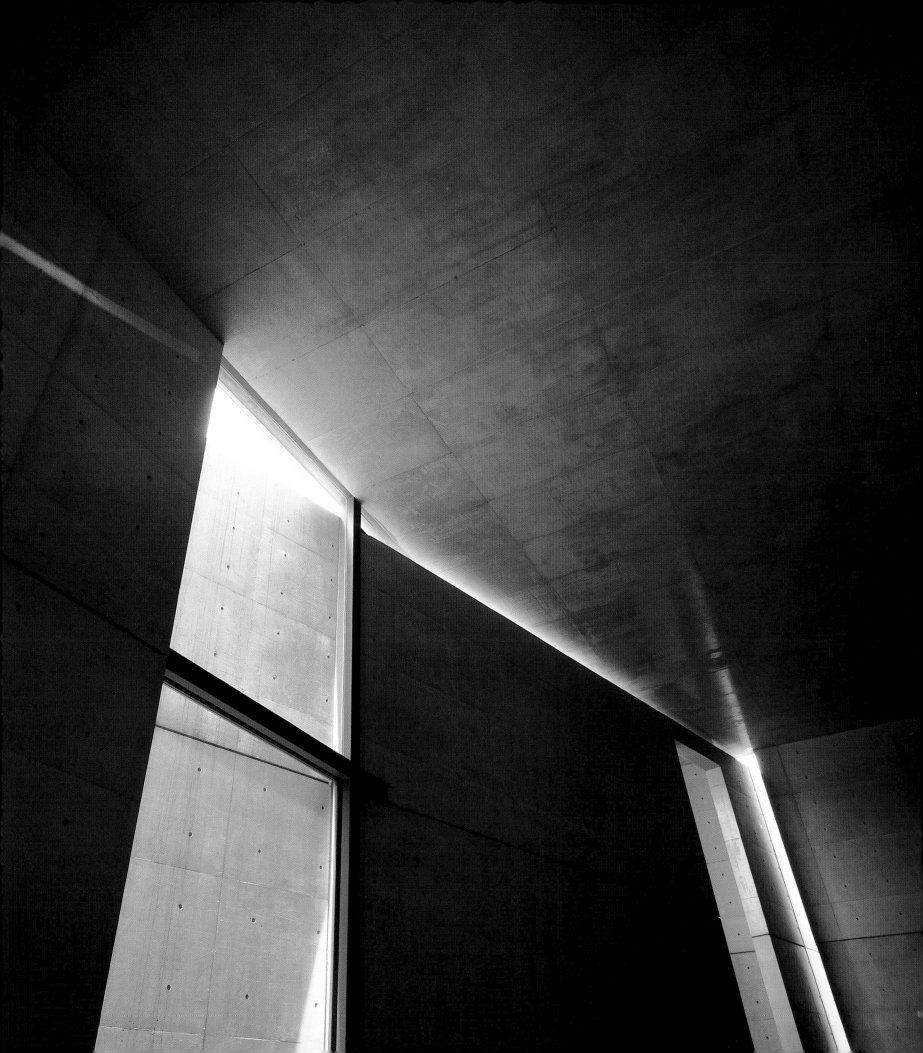

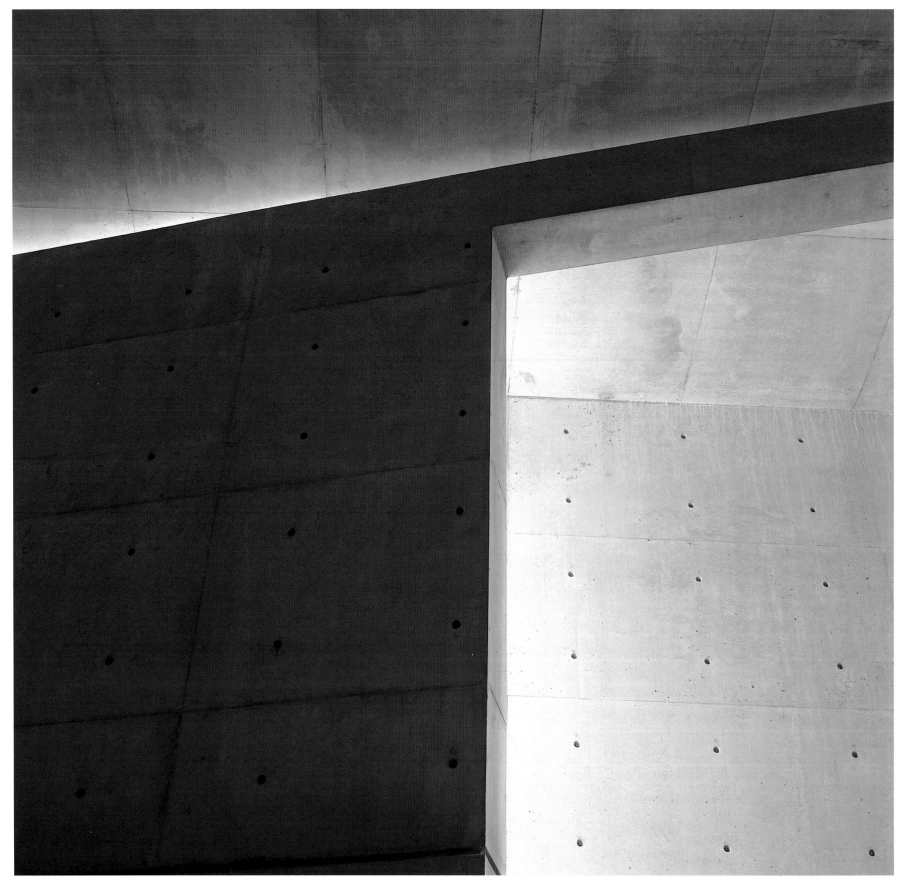

View from church to entry ceiling.

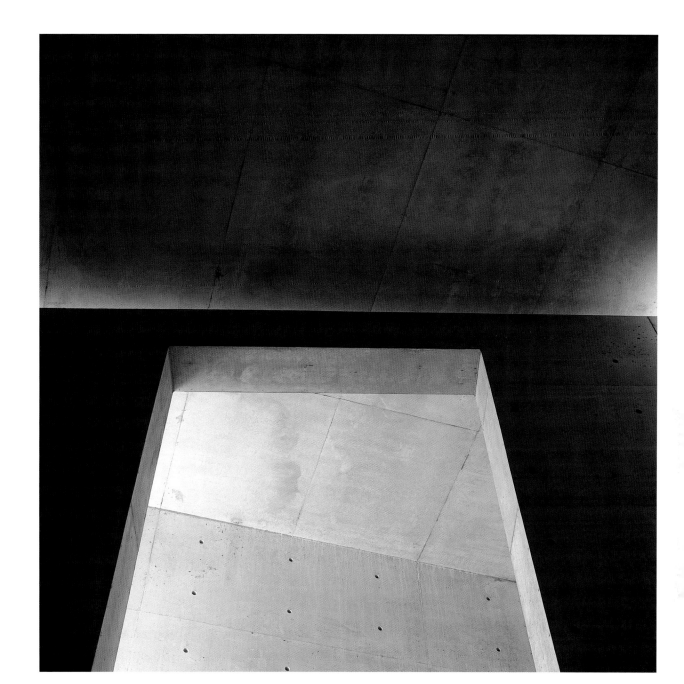

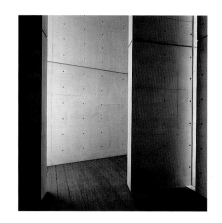

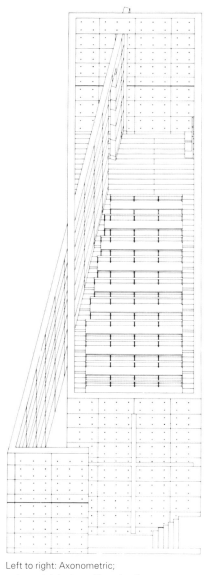

Left to right: Axonometric;
entry portal; juxtaposition of walls
tinged by sunlight and skylight.

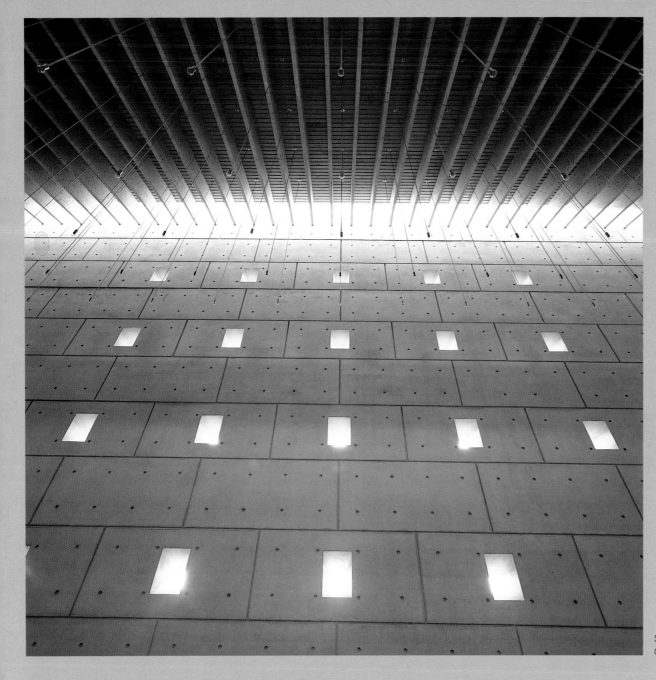

Side wall.
Opposite: Interior looking to altar.

Enghøj Church, Denmark Henning Larsen

A poverty of materials is used to full advantage at this 1999 church in the Danish town of Randers. Bare concrete walls, whose only decoration is imprinted formwork, are grazed by light from rooftop slits and punctured with holes that glow without any visible source. After perceptually corroding the roof supports and making it seem to magically hover, light is then bounced onto facing slopes of the timber ceiling, pooling shade in its skeletal frame and warming the room's emotional temperature. All these effects reinforce the poetic power of the roof, and its metaphoric evocation of a ship's keel, whose image carries special resonance in the Nordic world.

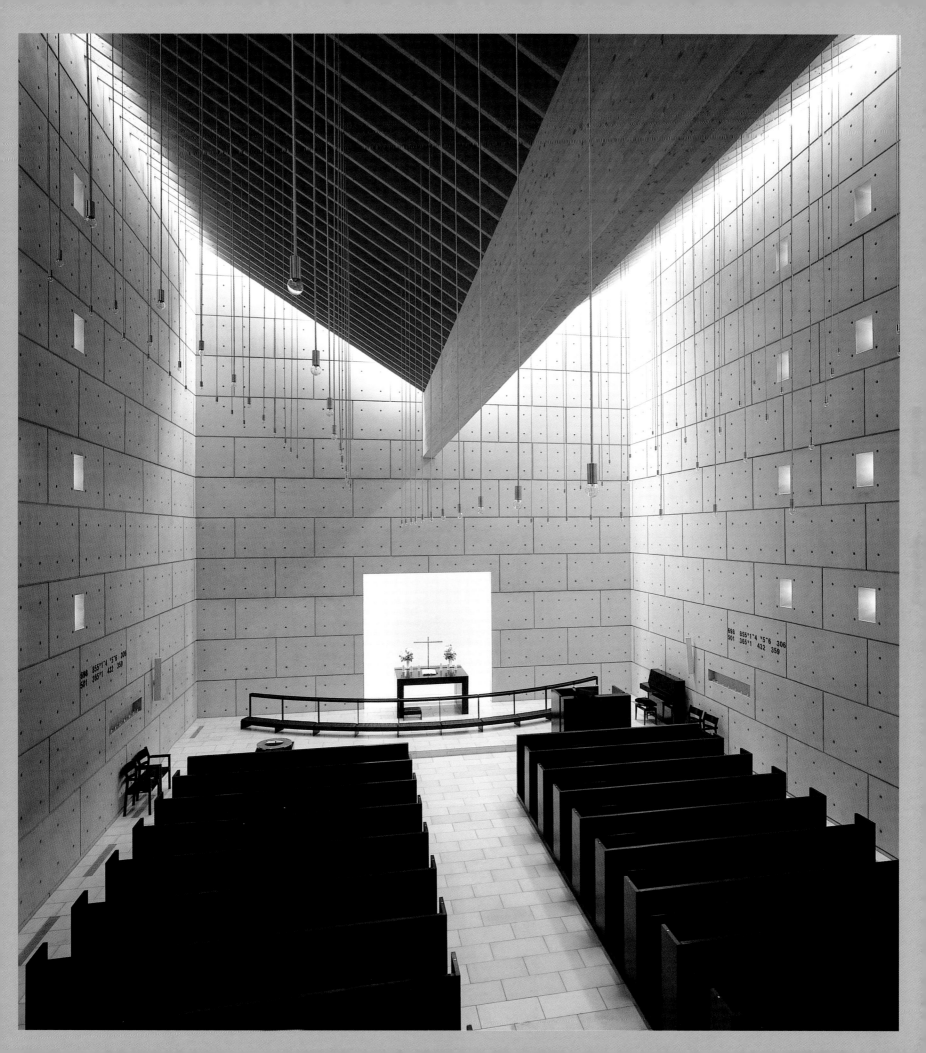

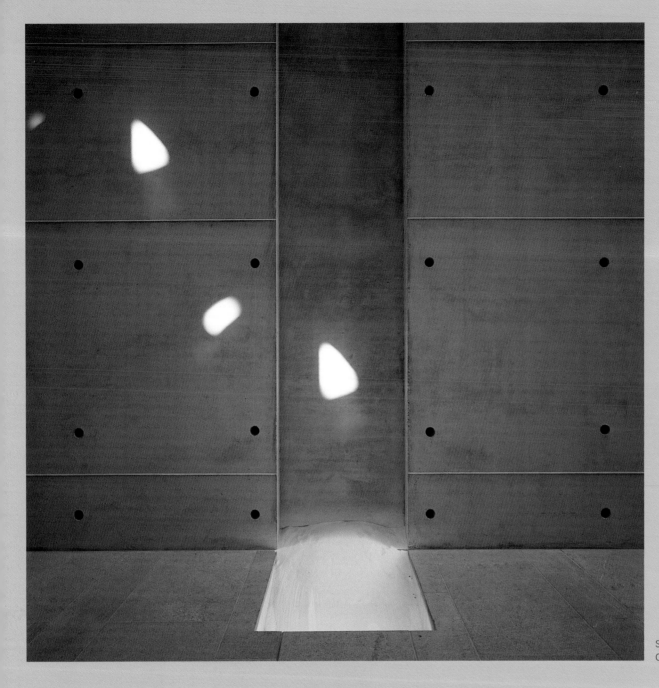

Sunspots and illuminated sand in floor recess.
Opposite: Ceiling, with 'light capitals' above columns.

Baumschulenweg Crematorium, Germany
Schultes & Frank

Wavering in mood between archaic and contemporary, there is nothing present in the voluminous main hall of this 1998 crematorium in Berlin but a forest of monumental concrete pillars, dappled with roving spots of sun. The source of these sparks are holes in the roof above columns, described by the architects as 'light capitals', whose uncanny appearance, combined with long cracks in the roof, gives radiation a transcendental force and makes the building appear as a ruin. The ritualistic atmosphere continues into funerary chapels that are tinged by sky, their blue ambience tensed by yellowish lamps and bars of sun.

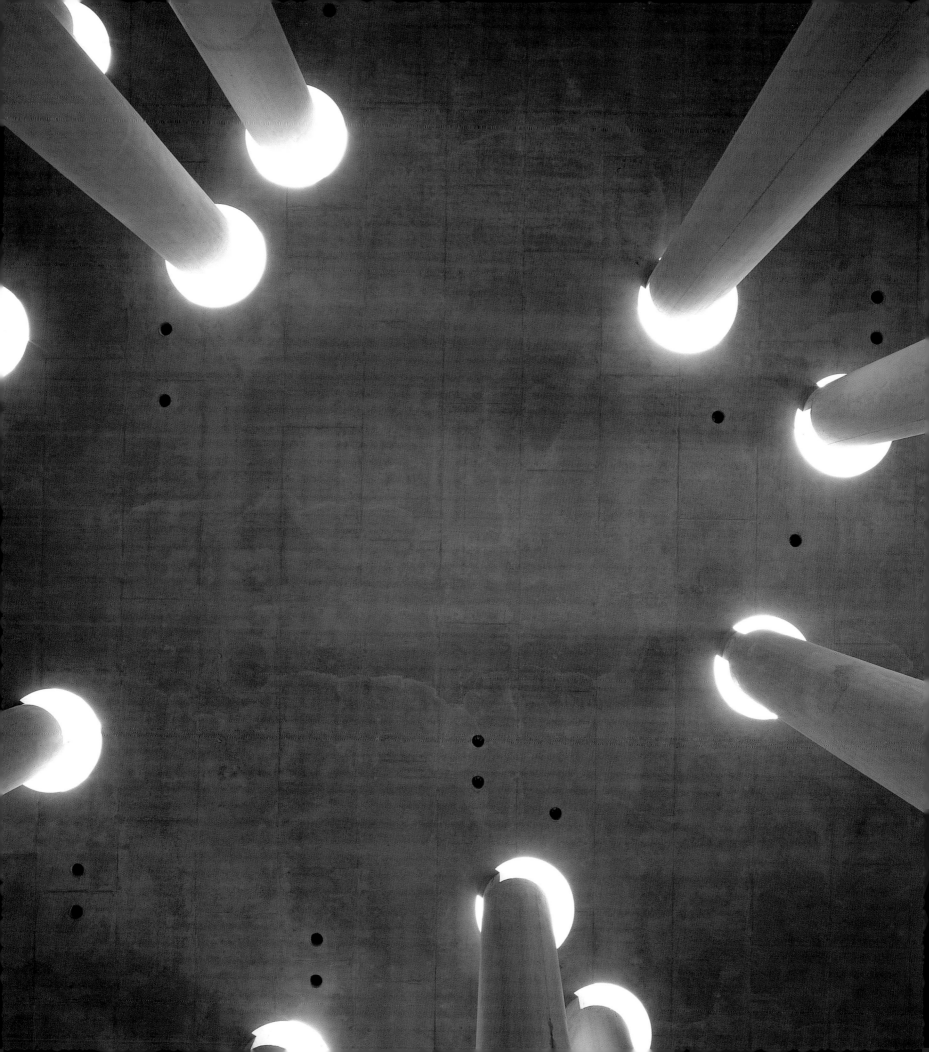

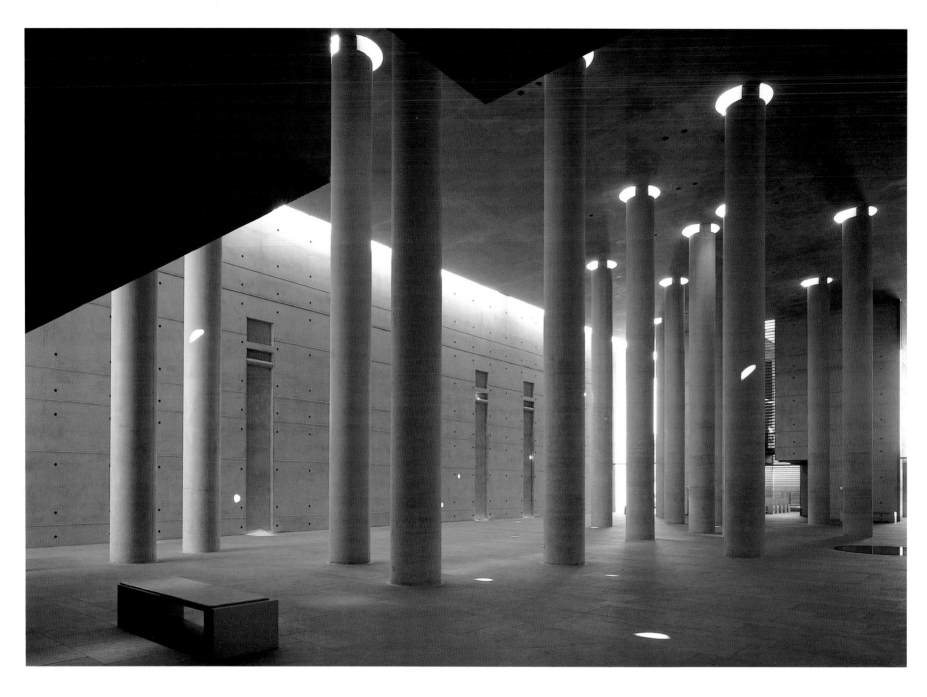

 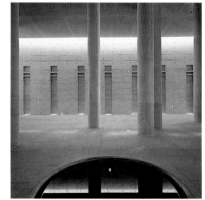

Above, left to right: Plan; hall with circular font in foreground.
Top: Hall viewed from large chapel.

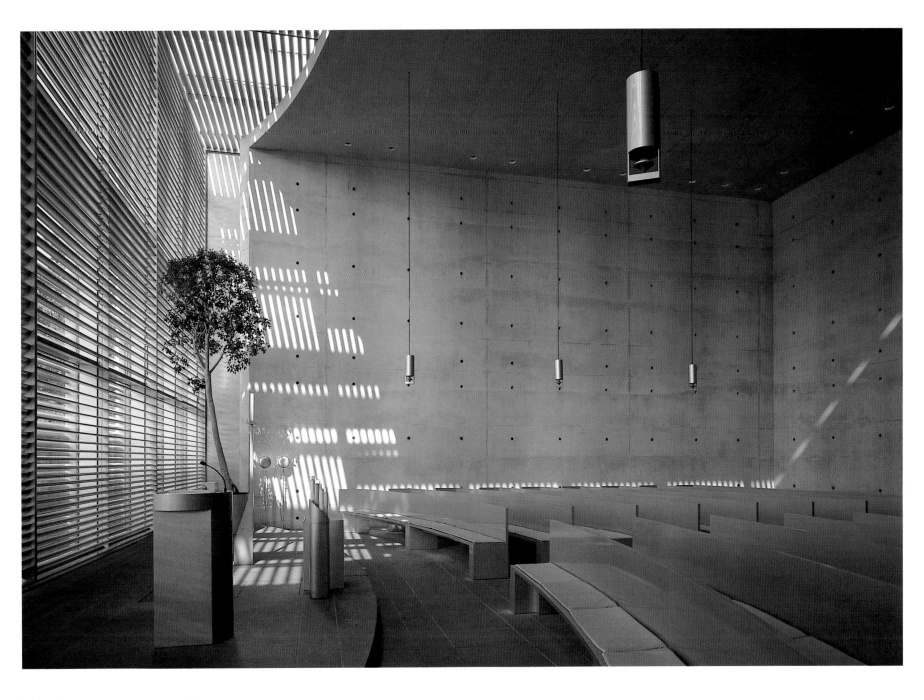

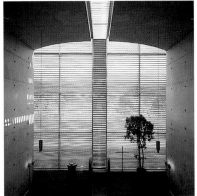

Above: Small chapel.
Top: Large chapel.

Entry viewed from interior corridor.
Opposite: Upward view at entry.

Bel Air House, California, USA Legorreta + Legorreta

Strong cubic masses of trowelled plaster in Ricardo Legorreta's 1998 house in Los Angeles are painted a uniform wine red, setting up a counterpoint as the visitor enters a tall vestibule painted the opposite hue: a deep cobalt blue. Encountered in close succession, whether coming or going, the deliberately opposed hot and cold tones purify and enhance the colour intensity of one another. Dimly lit by a single window and vertical slit, the arrival space feels like a chapel, and initiates the house with a moment of wonder, a theme that continues throughout the house in other shifting, luminous colours – the orange glow of a staircase, radiant yellows beneath a skylight, sheafs of light along a dark hallway, a dream-like blue tree in a reddish court.

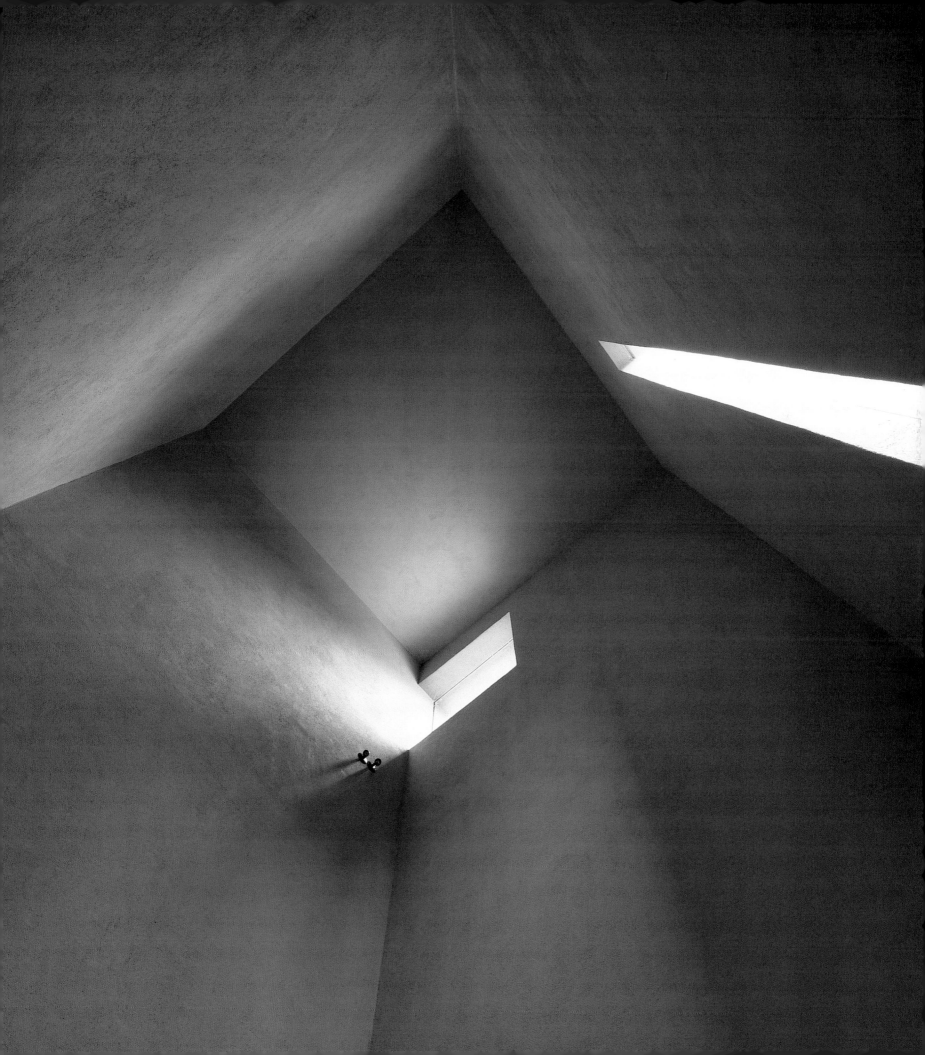

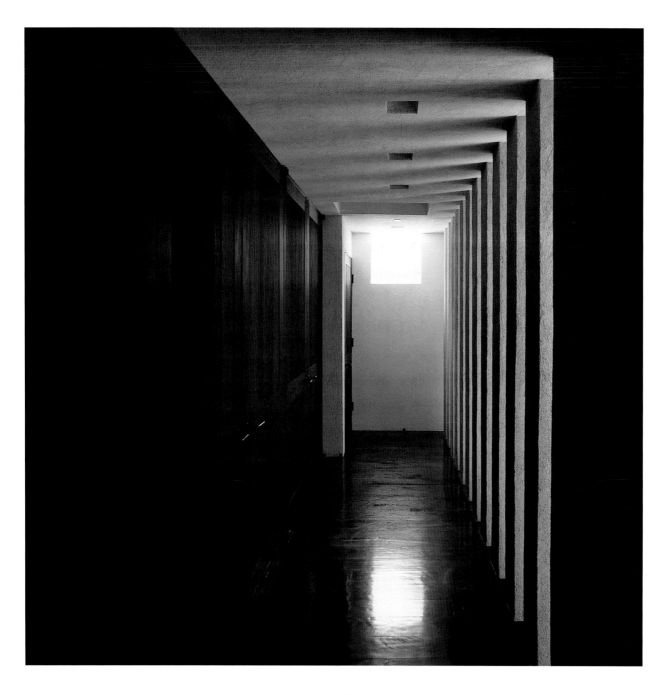

 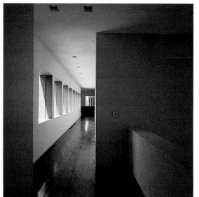 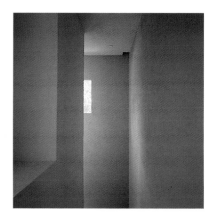

Above, left to right: View through lattice to interior court; upper-floor hallway; staircase.
Top: Passage with light slits.

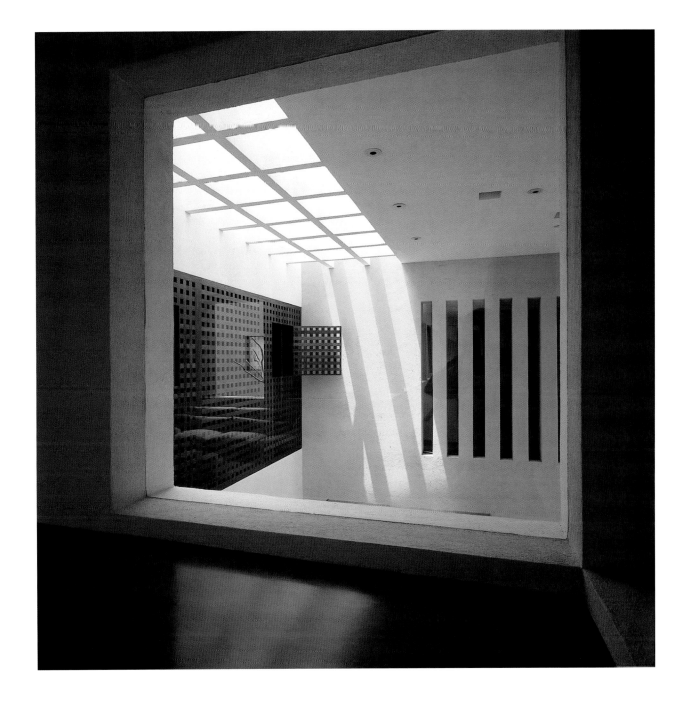

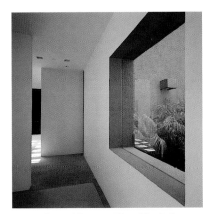

Above: Ground-floor corridor with window to garden.
Top: View to interior court from hallway.

Detail of backlit mesh viewed from pews.
Opposite: View through mesh into sanctuary.

Dresden Synagogue, Germany
Wandel Hoefer Lorch + Hirsch

Hidden like a secret inside the darkness of the Dresden Synagogue, built in 2001, is an indistinct aura of golden light. Illumination enters the solid stone cube through a solitary skylight and side window, whereupon the radiation is filtered immediately through a bronze mesh enwrapping the congregation space. When diffusing through this metallic curtain, light becomes uniformly coloured, concentrating like a fog and then spreading out to faintly touch neighbouring walls, before dying away in the surrounding shadows. Suggesting a diaphanous tent with obvious Jewish symbolism, the bronze scrim forms a world within a world, whose sacredness is defined less by material than by a mystical haze of coloured air.

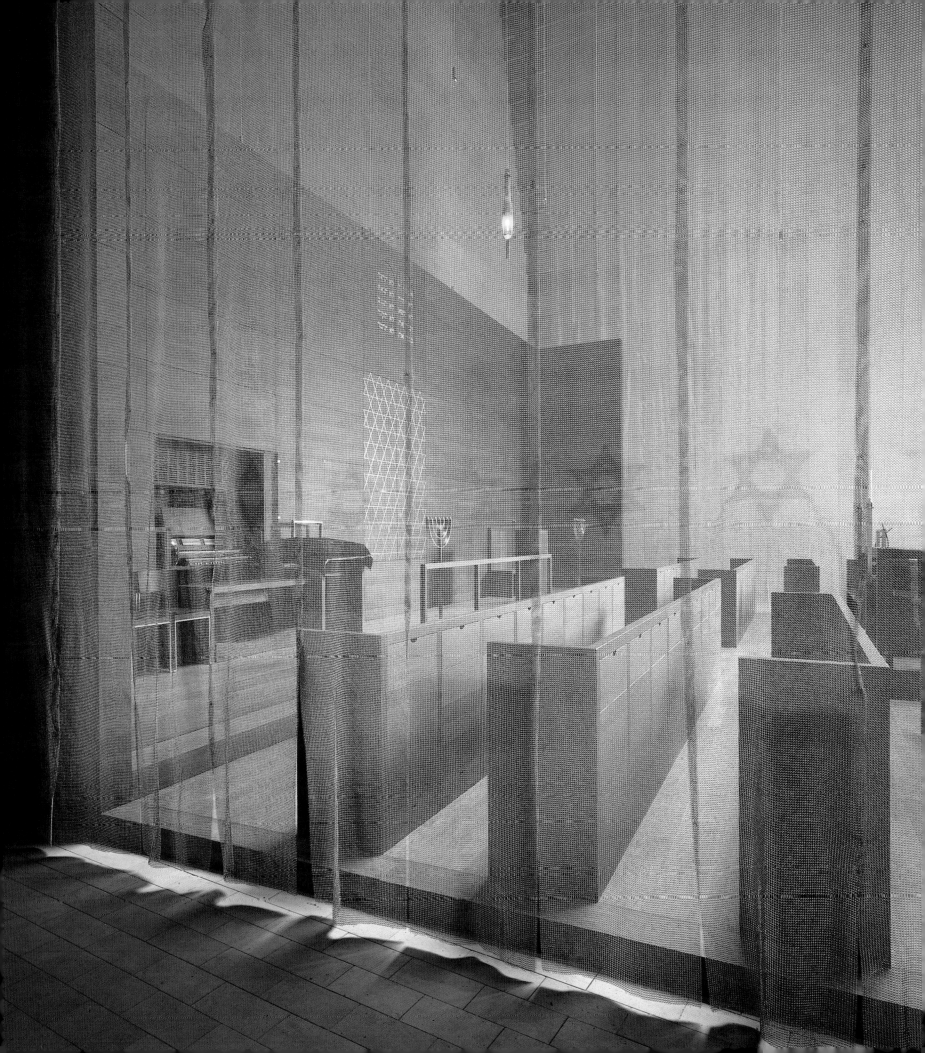

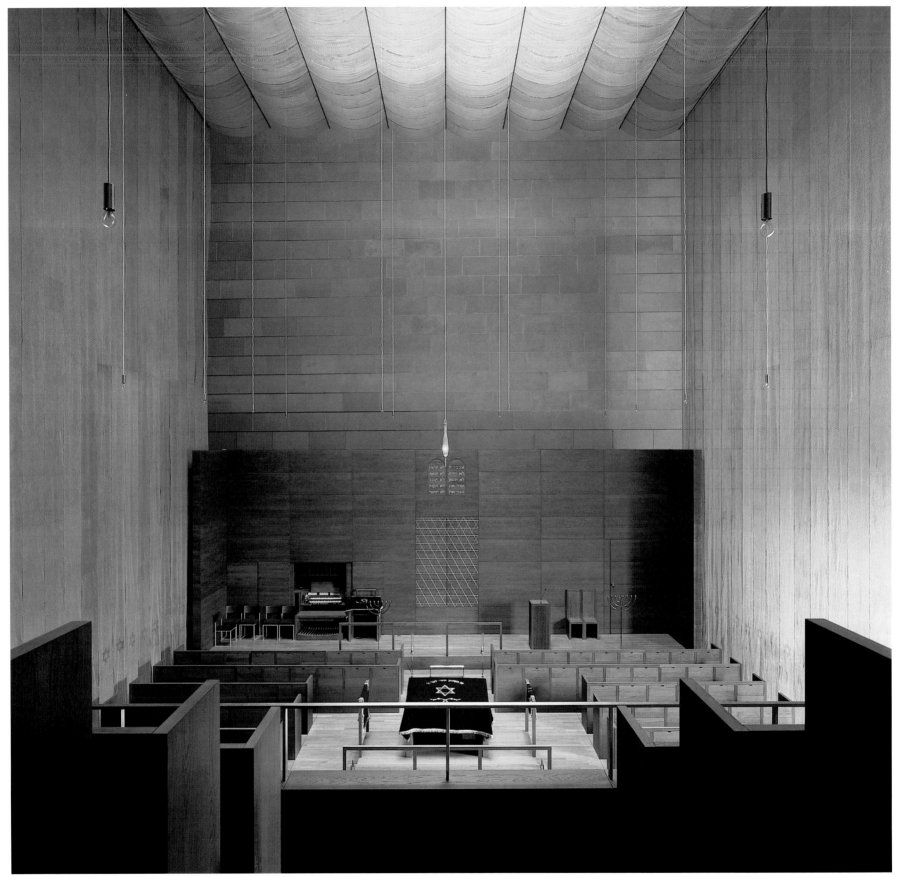

Sanctuary with Torah.

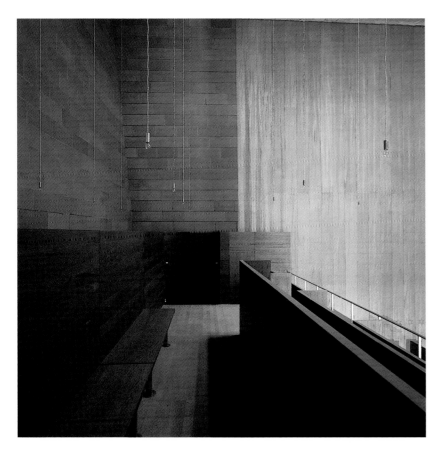

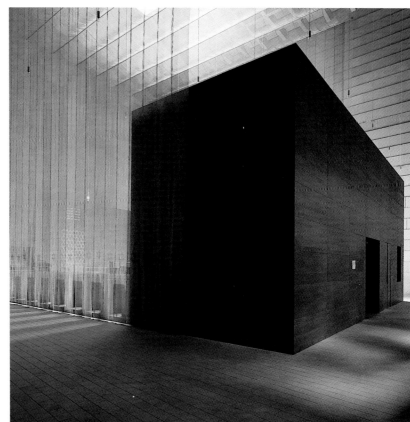

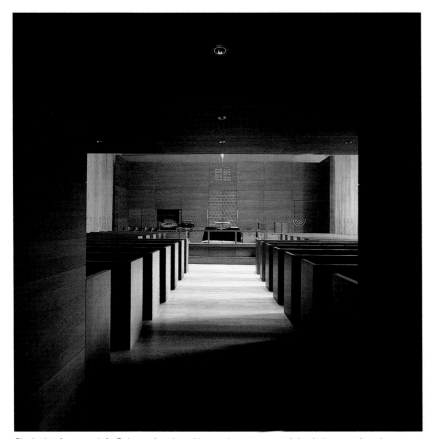

Clockwise from top left: Balcony; interior with wooden mass containing balcony stair and passage into sanctuary; section; dark threshold to sanctuary.

Upper-level corridor between galleries.
Opposite: Gallery ceiling and exit bridge.

Galician Centre of Contemporary Art, Spain Álvaro Siza

All upper surfaces in the lobby zone of Siza's 1993 museum in Santiago de Compostela are coated with white-painted plaster, occasionally brightened with figural light in a few deep windows. Floors are clad in polished white marble, whose shimmer folds up into wainscoting and solidifies into sills and benches, parapets and countertops, all contiguous with the pavement. This duality of lustrous base and matte canopy creates an image of verticality, which is then subverted by unstable reflections that perceptually liquefy the ground. Accentuating the dissolution are folds in the faintly translucent marble, whose angles pick up glimmers from the windows and present an elusive light-filled mass similar to Eduardo Chillida's alabaster series *Elogio de la luz* (1965–90). The reverse effect, now toplit if equally mysterious, is produced in galleries by dropping the ceiling into a baffle, to wash soft light around the walls and evenly illuminate the paintings displayed there.

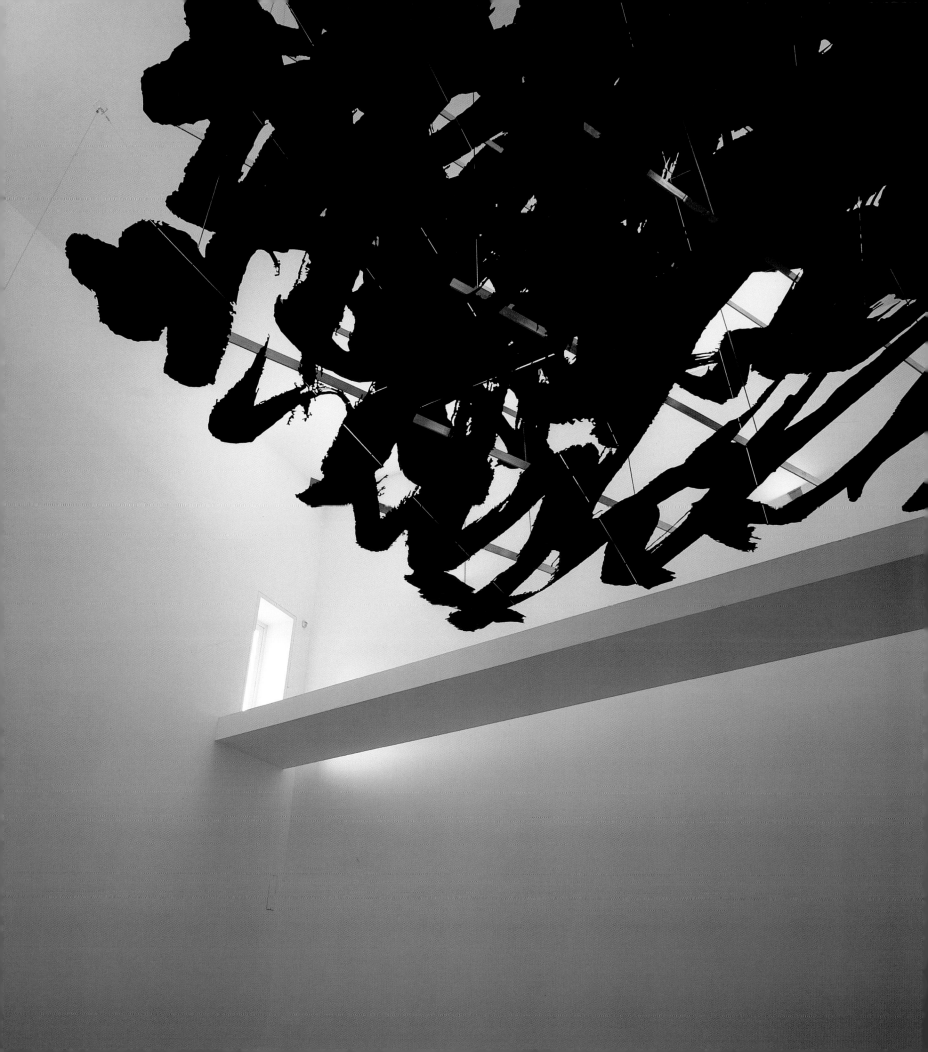

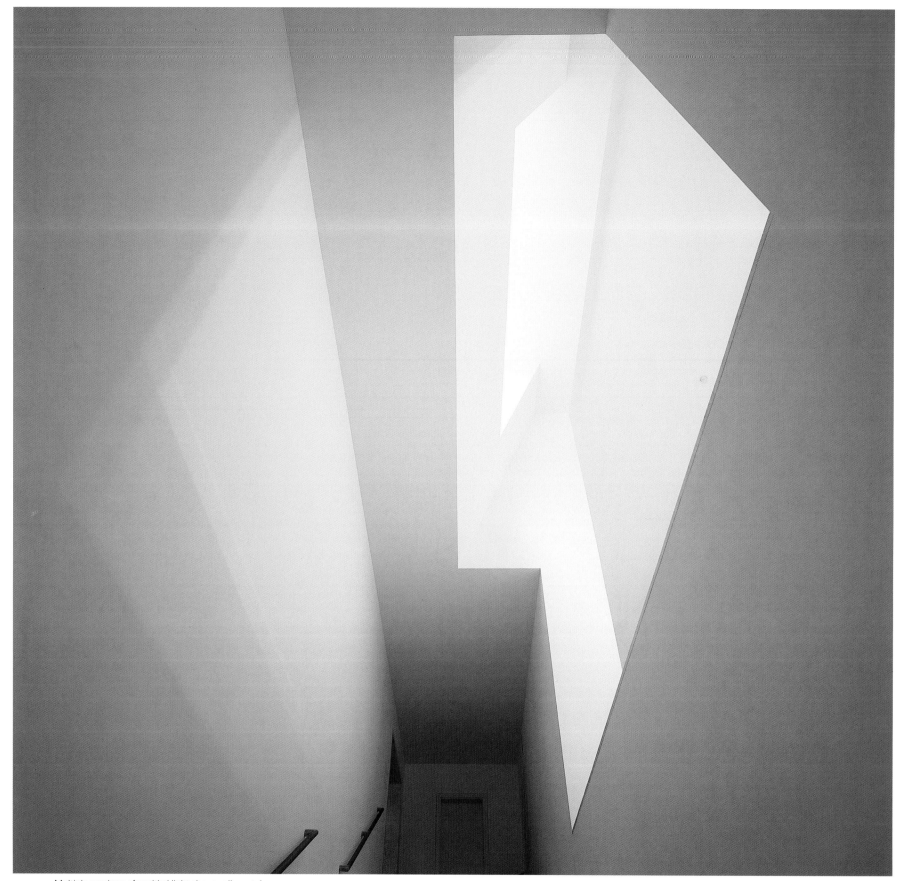

Multiple carvings of zenithal light above gallery stair.

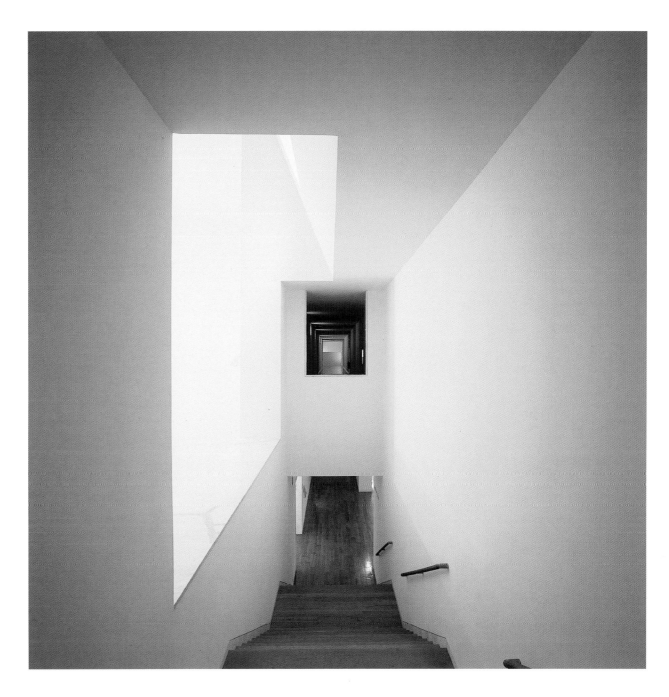

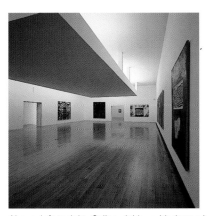
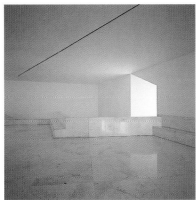

Above, left to right: Gallery; lobby, with deep window leading to lower level.
Top: Window at left overlooking the lobby, and views ahead to gallery corridors.

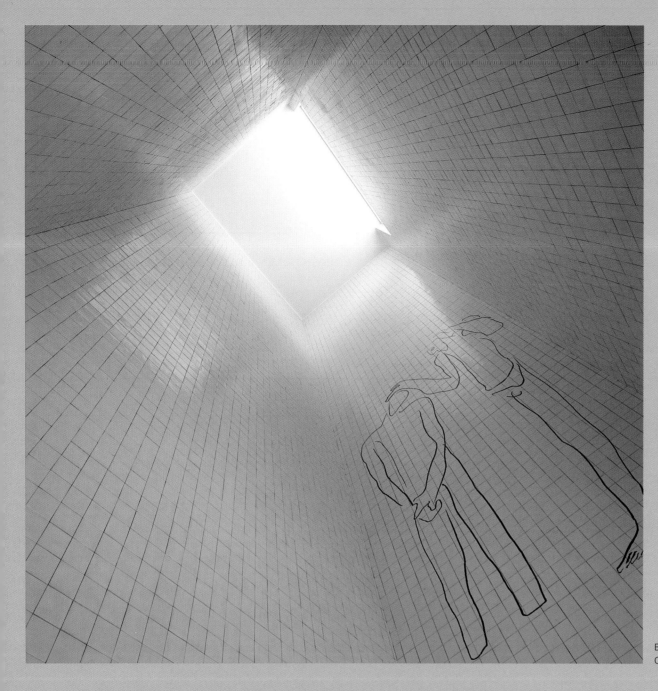

Baptistery lightwell.
Opposite: Mortuary chapel.

Santa Maria Church, Portugal Álvaro Siza

Light emitting from three high windows in the north wall of this 1993 church in Marco de Canavezes appears, through its force of radiation, to press in and deform the solid plane, causing it to inwardly tilt and bow. Directional light then paints the void with *sfumato* effects, whose soft tonal play is enhanced on such barren walls. Helping to stabilize the cross-current of light and reassert the liturgical axis are two blind windows behind the altar, illuminated by a hidden vent. Contrasting moods develop in other areas, such as the baptistery, where raining light glances over hand-made ceramic tiles and brings a fluid gleam to the place of ablution. Different again is the mortuary chapel beneath the church. Reached by a series of dusky stairs and winding corridors, this gloomy, chthonic realm culminates in a glowing void for the casket, set below the light vent.

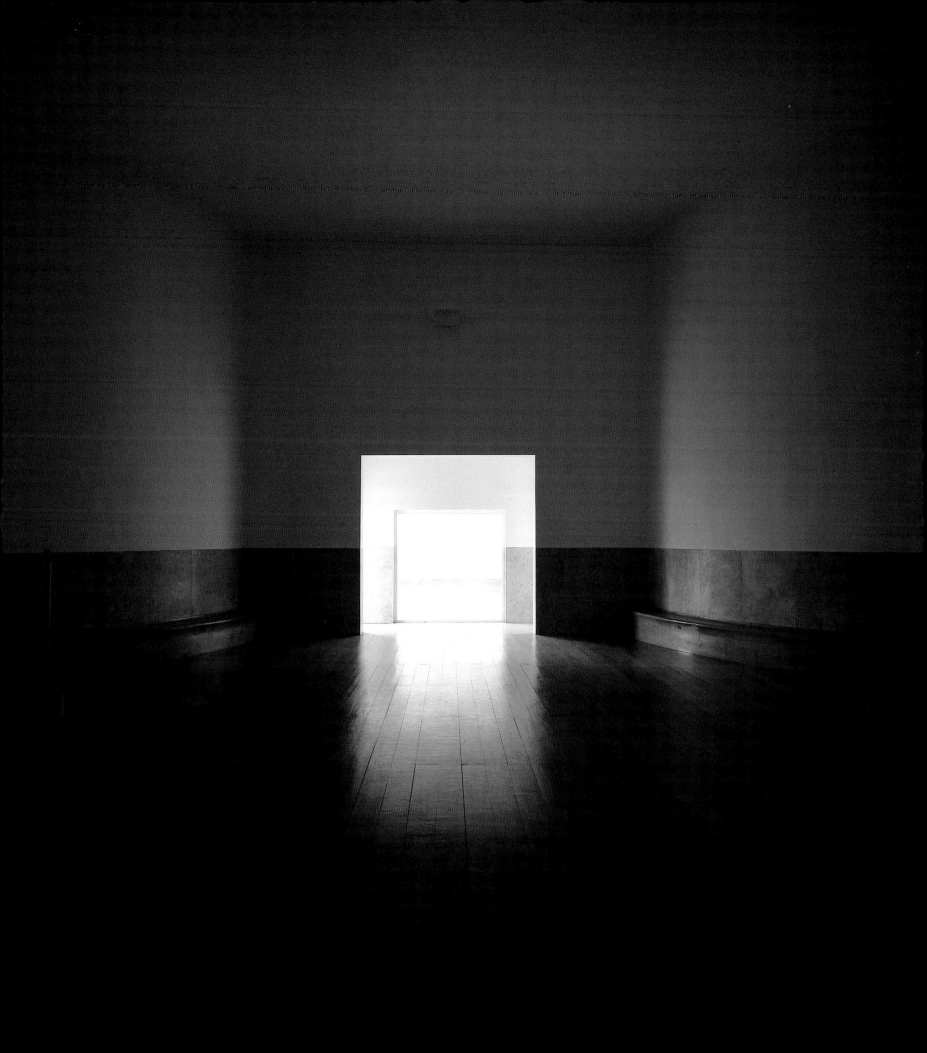

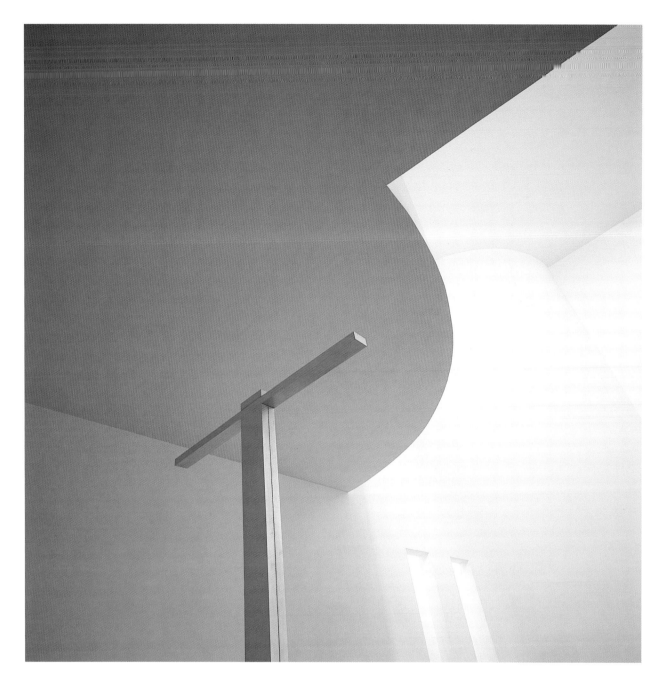

 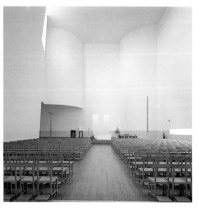 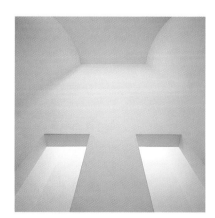

Above, left to right: Side window; interior looking to altar; light vents behind altar.
Top: Ceiling above altar.

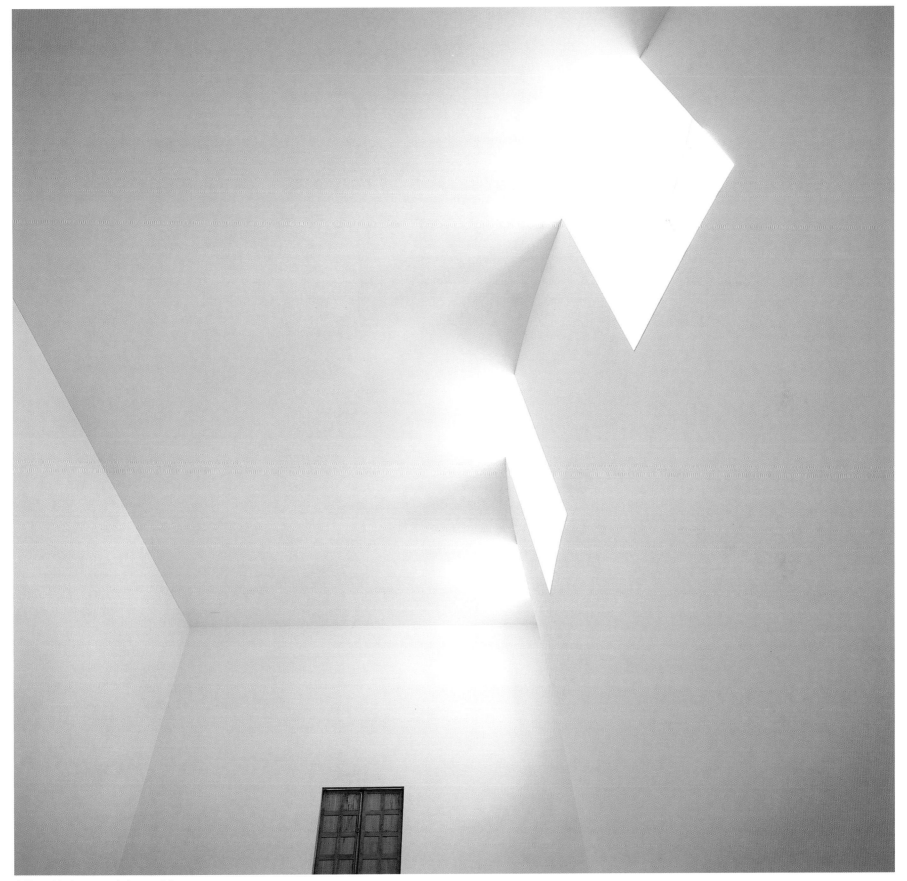

Ceiling with clerestory windows at right.

LUMINESCENCE

MATERIALIZATION OF LIGHT IN PHYSICAL MATTER

7 LUMINESCENCE
Materialization of light in physical matter

The capacity of light to penetrate matter and temporarily produce an inward glow and intensity of being is a timeless source of human wonder. At such moments, light exerts a mesmerizing, even miraculous, power to transform otherwise mute objects and dull materials and make them shine with an elevated beauty and a sense of being more fully alive. Throughout history, we find examples of buildings being rendered luminous by the manipulation of materials to increase their sensitivity to light. One thinks of the Greek stonemason chiselling and fluting translucent marble for temples (below, left); the Byzantine mosaicist cutting tesserae to soak up light and induce church ceilings to shimmer and sparkle; the Persian tile-maker sitting on a mat under the sun, grinding quartz to a fine powder and mixing in pulverized glass, before adding metallic oxides to create the 'Seven Colours of Heaven'; or the medieval glass-maker at Chartres (below, right), adding powdered sapphire to molten glass and applying stains of copper and silver chloride to the hardened surface. In more recent times are the examples of the phosphorescent tile-work at Gaudí's Casa Batlló (1907) and shadow vibrations across the uneven bricks at Sigurd Lewerentz's Church of St Peter (1966), in Klippan, Sweden.

While some of these older building crafts are virtually impossible to replicate today, due to cost constraints and lost traditions, industrial materials and modern technology offer fresh opportunities for contemporary architects to reanimate physical things with a metaphysical dimension that is increasingly missing in a commodified world. New forms of luminous matter are being created through a range of innovations in the fabrication, assembly and finish of materials to enhance or alter their natural properties. In addition to tinkering with the optics of glass and screens, architects are exploring the more difficult task of making inherently opaque materials receptive to light. Concrete is rendered lustrous as silk by the waxing of its surface or the absorption of latex paint, and given deeper effects from admixtures of pulverized quartz, silicon carbide, powdered aluminium or copper dust. Even the matte substance of wood can be sawn and re-sawn, polished or scraped to enhance shadow play on its grainy relief. Stone is cut to reveal sparkling minerals hidden within, or laid in uneven courses to flutter with glancing light. Metals are sandblasted, oxidized with acid, atomized and sprayed over other metals, and treated with heat or chemicals to attain unique patinas and textures responsive to light and weather. Most extraordinary is the baffling glow imparted to unconventional materials – everyday insulation, plastics associated with industrial buildings, metals found in aircraft, warehouses, roadworks or ships – that suggests a kind of alchemy at work, as well as a surreal tactic of unexpectedness and magic.

Related experiments to fuse light with matter have been of central concern to abstract artists from Jackson Pollack to Isamu Noguchi in their attempts to present light as something more than depiction, making use of what Gaston Bachelard calls 'material imagination', as opposed to 'formal imagination'. A transmutation of material into energy continues today in the work of many artists; the physicality of paint employed by Gerhard Richter, for instance, includes metallic pigments spread over aluminium boards, whose

Parthenon, Greece.

Chartres Cathedral, France.

wet surfaces are then scratched with brushes and smoothed with a squeegee. To make wood quiver with tiny ripples of light, sculptor Kain Tapper chisels and hones, rubs and grinds, smears and burns his raw wood blocks. In Eduardo Chillida's hollowed-out alabaster cubes (below), their substance clouded by mineral deposits, we find internal corridors and chambers that have been carved out for light to travel along, producing a mild irradiation that appears to be inherent within the stone itself, leading poet Octavio Paz to describe these works as 'blocks of transparency, in which the form becomes space and the space dissolves in oscillations of light'.[63]

Something of the same metamorphic power is applied to in-situ concrete by one of today's most accomplished 'alchemists', Tadao Ando, who speaks of 'making walls abstract by rays of sunlight' and 'handling concrete to instill it with such intensity as to provoke and startle the human spirit'. In refining but then going beyond the *béton brut* of Le Corbusier and chiaroscuro of Kahn, Ando impresses his surfaces with a subtle relief that only appears under grazing light. For Herzog & de Meuron, the imprinting of concrete is not the result of the making process as it is for Ando, but derives from a variety of technological applications developed in other fields. Underlying the architects' efforts to subvert the normal use of materials, and to squeeze some latent poetry from them, is a deeper concern: to elevate the 'ontological state of matter' by dismantling it 'from any other function than "being"'.[64] Using the semi-industrial process of inscribing concrete with repetitive but abstract photographic images, they have succeeded, especially at the Eberswalde University Library (1999; p. 226), in projecting onto the surface an ornamental but highly light-sensitive layer.

A more plastic approach is taken by Rafael Moneo to inwardly illuminate poured concrete, working as a sculptor to carve cells able to trap light in immensely thick boundaries. Openings in the walls and roof of his Miró Foundation (1993; p. 72), in Palma de Mallorca, are hewn in depth and then extruded further by tubular volumes beyond the envelope, so that light appears held *within* the substance. Gallery walls continue this language at larger size, fanning out with angled planes to catch varied amounts of illumi-

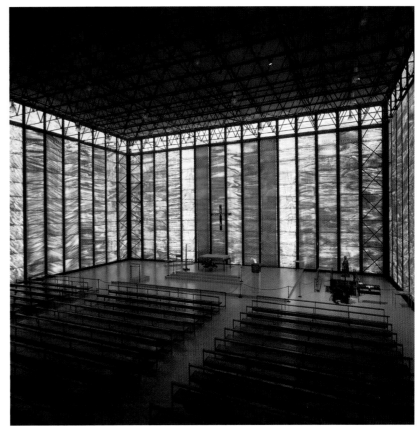

Pius Church by Franz Füeg.

nation, thereby suggesting a transfusion of light into manifold pores of a solid block. More monumental are the light chambers in Moneo's Lady of the Angels Cathedral (2003; p. 230), in Los Angeles, beginning with latticed walls containing toplit chapels and culminating in a huge trough above the altar, whose glowing alabaster is so closely matched to the earthen concrete that the former appears as a smouldering version of the same basic substance.

Stone is another ancient material being reassessed with modern tools to enhance its susceptibility to light, altering its properties according to the way

Elogio de la luz by Eduardo Chillida.

it is sawn and finished, and then assembled and jointed. This solid substance becomes a membrane in the hands of Moneo, who slices it so thin that it turns translucent and can be raised into a mineral curtain. This idea revives an ancient tradition that can be traced from the alabaster windows of early Christian churches to such Modernist cages, infilled with marble, as SOM's Beinecke Library (1963) or Franz Füeg's church (1966; previous page) in Meggen, Switzerland. At both Mallorca and Los Angeles, Moneo has arranged his alabaster sheets into horizontal bands of differing widths, held between steel bars, to throw attention to the light's journey *inside* the stone, before being shed inside as a coloured mist. As light seeps through, it is refracted and deflected by veins and particles, while illuminating the stone's hidden anatomy and geological history, giving the membrane an inward perspective and a subcutaneous depth. Thus the stone slabs, quite apart from their explicit function to moderate sun and emit a serene illumination, reveal a glowing metaphysical landscape beneath the surface. Aroused by these curtains is a curiosity of magical things similar to Miró's paintings, a connection made also by Moneo, who contends that in 'transforming the windows into gigantic and unexpected lamps, they have something of invented geology, as if they were one of those objects that Miró discovered while eagerly examining the ground as he walked: yet clearly out of scale'.[65]

In seeking to express 'the mystical nature of a world of stone' at his Thermal Baths (1996; p. 60), at Vals, and make it 'shine and vibrate', Peter Zumthor had the quarried gneiss cut into planks like lumber, using three different thicknesses to vary the courses, which were then vertically stacked in stratifications suggestive of their mountain origin.[66] Attention was paid as well to textures inherent *within* the metamorphic stone, sawing and polishing edges to bring out their mineral constitution, and exposing fragments of mica and quartz – drawing our eyes *into* the stone to find there something faintly aglow. Zumthor's most consequential decision was to lay the slabs in courses that alternately recede and protrude, producing a relief that is flat under frontal illumination, but ripples as light trickles down from roof slits, picking out ledges and shading overhangs to make the wall palpitate. 'I like . . . to go

about lighting materials', he explains, 'in the knowledge of the way they reflect and to fit everything together on the basis of that knowledge.'[67]

Even something as lacklustre as plaster can be transfigured by infusions of light-responsive particles. At the Alhambra in Spain (below, left), for instance, Islamic plasterers mixed finely ground marble into gypsum paste, then polished the hard surface with pumice and bone marrow to give the plaster the faint luminescence of cream-coloured marble. Drawing upon ancient Venetian techniques, Carlo Scarpa rendered the *stucco lucido* of his Olivetti Showroom (1959; below, centre) vaguely translucent and reminiscent of lacquer or marble by blending marble dust, coloured pigments, glue and linseed oil into the lime composition, and then building up the surface slowly in layers, whose varied sand textures – diaphanous in parts, opaque in others – react differently to light. As light is drawn beneath the surface, Scarpa's plaster comes aglow from within, producing a subtle sheen that constantly shifts from transparent to softly reflective, and gives the otherwise hard material a vaporous, almost ethereal character.

Venetian techniques of sensitizing plaster to light have been taken up and modified more recently by Steven Holl, most stunningly in his addition to the Nelson-Atkins Museum (2007; below, right and p. 64), in Kansas City. White-plaster finishes of lobby and circulation spaces were hand-trowelled, with each coat completed in one application before drying, followed by polishing to impart an unexpected shimmer and luminous range. The result is a substance that shifts all awareness from matter to light, but also possesses a mottled sheen with transparent layers and deep reflections. Quite opposite effects were produced by Holl at the Chapel of St Ignatius (1997; p. 44), in Seattle, by etching the plaster while it set and introducing a *chiaroscuro* effect similar to that of the shadow-filled grooves in Renaissance *sgraffito*. While the human hand is again inscribed into the texture, the plasterers here combed the wet surface with a hatchwork pattern of alternate motions. Left in the finish is a corduroy pattern of valleys and ridges whose orientations respond differently to incident light, making tones brighten or dim, appear or disappear, and sometimes reverse, according to angles of view and illumination.

Alhambra, Spain.

Olivetti Showroom by Carlo Scarpa.

Bloch Building by Steven Holl.

Shisendo, Japan.

Wood's fibrous nature offers different opportunities to architects. To enhance and reveal its latent beauty, Japanese carpenters would traditionally, and laboriously, hand-rub sawn boards to work out the soft tissue and bring the grain into relief. In addition to the soft lustre produced as oils were rubbed into the wood while polishing, absorbing some illumination below the surface, the uneven and irregular texture served to both model and reflect light in its microstructure of hills and valleys (above). Related to this aura of depth is the cloudy glow of *shoji*, and round or square *shitajimado*, whose

paper sheets reveal at close range a complex weft and weave. One can gaze into and visually explore the organic substance of these paper walls, whose anatomy remains hidden until struck by light arriving from behind, creating unlimited optical depths in a material that could not be more physically shallow. Rather than resorting to handicraft, contemporary efforts to overcome wood's opacity and dullness tend to exploit mechanical methods of milling, construction and finish. This process is immediately apparent where commercial plywood, its industrial origins left exposed, becomes a medium of light modulation – an approach characterizing several Bay Area houses by Joseph Esherick, including his Bermak House (1963; below), in Oakland, as well as recent works by Stuttgart-based Cheret + Bozic, particularly, and most beautifully, in their Catholic Community Church (1998; p. 236), at Sontheim.

More lustrous is the effect obtained by Riepl Riepl with smooth birch plywood in their St Francis Church (2001; p. 234), where the satiny finish is animated by a faint *chiaroscuro* from directional light, guided over a slight texture of uneven sheets with noticeable joints. Although based on a similar raw material, the interior cladding of birch plywood used at the Donau City Church (2000; p. 138) by Heinz Tesar is given a robust sculptural treatment. Soft, gleaming wood with imperceptible joints continues unbroken over ceiling and wall, but also folds around lantern and window, floor and pew, and wraps into curves about each of two thresholds. This plasticity implies a hollowed substance, whose surface is rubbed and finished to spread the glow to every corner and pore. An impression of light suffusing depths *inside* wood is especially strengthened by the reveals of conical windows and of a sinuous skylight cut from the roof. Bringing subtler depths are fogged reflections from multiple sources, together with a gilt cross incised within a plywood circle behind the altar, whose rotated grain catches contrasting angles of light and turns the orb into an aura that hovers before the wall itself.

Other than glass, no building material has been subject to greater optical scrutiny over the past century than metal. Among the early achievements in this genealogy are the bronze sheathing of Mies van der Rohe's Seagram Building (1958), whose tactile warmth was beautifully matched to amber-grey

Bermak House by Joseph Esherick.

Yale Centre for British Art by Louis Kahn.

glass and bronze mullions; the cinnamon-brown colour of Corten steel in Eero Saarinen's John Deere Headquarters (1963); and the soft iridescence of stainless steel in Louis Kahn's Yale Centre for British Art (1974; above), whose patina exudes the dull glow of pewter. For some architects, the incomparable sheen found in metal, with its fluid counterpoint of dark reflections and brighter highlights, is worthy of simulation with metallic paint. By casting subtly varied illumination on this otherwise smooth and uniform finish, the lustrous depth attained is almost as cloudy and pensive, if never as rich, as the silver leaf on buildings past. Accenting the wide tonal range of Zumthor's wooden Caplutta Sogn Benedetg (1988; p. 240) is a nuanced reflection of silver paint, seen beyond and through an inner lining of wooden posts. A different manoeuvre perceptually complicates the aluminium paint in Brückner & Brückner's Tirschenreuth Chapel (2000; p. 244). Silvery walls are closely matched to the monochromatic, hazy, and softly reflective opaline glass covering windows, producing a continuous ripple of highlight and shadow, advance and recession on what is almost a single substance.

It is a narrative as well as plasticity of metal that Rem Koolhaas exploits in his Dutch Embassy (2004; p. 76), in Berlin, to make sleek aluminium partake of light and give visitors a sense of penetrating into, then out of and back into again, a gleaming metallic mass. Offering a prelude to this lustrous world, like an honorific carpet spread out to the city, are aluminium granules embedded in the synthetic resin of an entry ramp. These powdery glints mutate into a continuous skin that lines both exterior and interior. Cladding floor and stair are rough, hard-alloyed aluminium sheets. Extending the quiet sheen to wall and ceiling is a far smoother aluminium face laminated onto fibre boards, whose blurry tones fold, without interruption, into recessed and illuminated hand-rails of extruded aluminium, as well as into pure metal volumes of mullion and column, cabinet and screen, door and bridge. One's entire visual field, therefore, is taken up with monochromatic reflections of varied intensity, as they recede or dissolve and give pronounced depth to a sheen which the metal seems to take in and gently absorb, melting it back further and further. Although equally based on an aluminium palette, the luminous depths of Toyo Ito's Yatsushiro Museum (1991; opposite, below left) are achieved by an entirely different operation: bowing and layering paper-thin sheets to produce a virtually diaphanous metal. The suppleness sensed initially as a cloud-like loft of silvery roofs is translated inside the building as a loose collage of perforated metal and an extraordinary ceiling of lacy mesh.

Architecture's legacy of metallurgic experiment has been especially embraced by Frank Gehry, who describes his search for 'new materials that play with the light' according to the way they are 'scratched, rubbed, buffed and coated', and exposed to 'the right mix of oil, acids, rollers and heat to arrive at the material we want'.[68] Thus the stainless-steel façade of his Weisman Museum (1990) was curved and burnished to enhance the dim Minnesota skies. A more muted glow was sought in the lead-coated copper sheeting of the Toledo Visual Arts Centre (1992; below), its faintly iridescent patina resembling certain stainless-steel works of the American sculptor David Smith, who deliberately burned and polished metal before inscribing it with a grinding wheel to impart faint lines capable of optical diffraction.

Toledo Visual Arts Centre by Frank Gehry.

Guggenheim Museum Bilbao by Frank Gehry.

Different again are the smooth stainless-steel plates of the Walt Disney Concert Hall (2003; p. 248) and the highly tactile titanium skin, a metal associated with aeroplane parts and golf clubs, used to clad Gehry's Guggenheim Museum Bilbao (1997; above). The latter's thin sheets were exposed to chemicals and heat during fabrication to develop a warmth and character missing from metals such as stainless steel, and were subsequently given a pillowy texture during construction by panels that bow from points of connection, leaving a surface with multiple scales of shimmer and shadow.

Gehry's concern for adjusting the colour and reflectivity of each finish to suit the character of light in the sky gives to his buildings a contextual bond easily overlooked by observers enthralled or irritated by their sculptural bravura. While also seeking to closely relate light and place, Heikkinen-Komonen use memory as well as juxtaposition to bring evocative power to the metal finishes of their Finnish Embassy (1994; below, right), in Washington, DC. The materials used here have been tinged green to blend into the wooded site, and, more importantly, to evoke the Nordic world for its expatriate occupants. Already faintly coloured from passing through trees and trellises, daylight is filtered through green-tinted glass and shed upon moss-green granite and copper panels with their uneven green patinas. This is the same principle of poetic metaphor that led Frank Lloyd Wright to coat buildings with bronze-lustre tiles and horizontal shadows redolent of the American prairie, Alvar Aalto to give both woodwork and tile a rhythmicality suggestive of Finnish forests and lakes, and Carlo Scarpa to impart a lustre to plaster similar to that of Venetian lagoons and Veneto skies.

Any sign of naturalization is eradicated from the armoured shell of Tesar's Donau City Church, using a dark luminescence to deliberately resist and step apart from its setting, and inject into the banal site a work of solitary magic. Playing upon a perennial counterpoint of hard outer crust and soft inner lining, the metal exterior and plywood lining heighten a sense of spiritual refuge and intimacy within. Completely covering the machined cube are rectangular sheets of chromium steel alloy, whose properties are exploited to shroud the church in a strange and paradoxical 'black light'. At first sight, the walls appear pitch-black with bluish overtones, but on closer inspection their shadowy depths are seen to emit a series of uneven muted reflections, whose colour and brightness shift with the passing sun and are even present on overcast days. The slightly iridescent steel, its tones simultaneously warm and cool, becomes in the shade an inky violet, and under the setting sun a soft gold with a scatter of blue, followed by a more uniform purplish pink. Adding perceptual depth to the dusky glow, which seems to recede far beyond the surface, are a rhythm and faint unevenness of steel plates, giving the skin a mosaic quality; window perforations that turn dark or bright according to their reflections; and the twinkling light of recessed drill holes capped with highly reflective metal – a flicker from within that Tesar calls 'notes of natural light'. One does not look *at* this mysterious metal, but peers *into* it, as if into a dark pond or night sky where one discovers a hidden glimmer. Teasing the eye by appearing and disappearing, the optical hide and seek is suggestive to the imagination – encouraging, even *demanding*, that the viewer become an active participant in giving shape to what is seen.

Yatsushiro Museum by Toyo Ito.

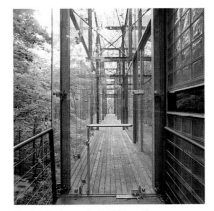

Finnish Embassy by Heikkinen-Komonen.

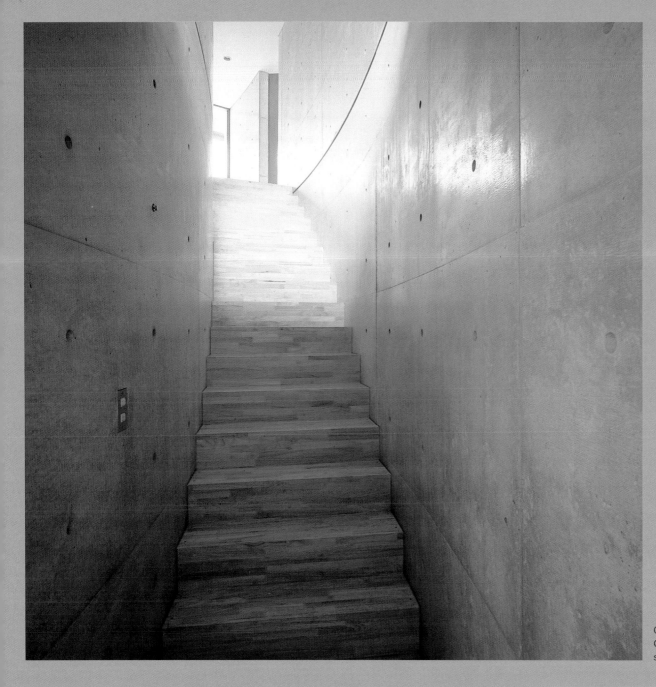

Concrete slot of staircase.
Opposite: Varying responses to light and shadow in concrete walls of corridor.

Ito House, Japan Tadao Ando

The chemistry of light in the concrete of this 1990 house in Tokyo begins with a repetitive stamp of plywood sheets employed in the formwork, accompanied by shadows collecting within recessed joints and holes remaining from steel ties, and – most fascinating – barely perceptible waves left by a slight warping of the plywood during the curing process. Superimposed on these modelled shadows is a highly irregular latexed sheen, absorbed from grey paint on the formwork, along with a subsequent silicone finish that gives the surface a sporadic lustre similar to Japanese *raku*. Distinct as well is the concrete's unique blend of cement and aggregate, which produces a pale, almost whitish-grey substance, more luminous than ordinary concrete. The highest notes in the tonal scale come from occasional slits in the walls, making the backlit concrete appear inwardly radiant. What is normally a drab material is transfigured into one that is sensuous, almost translucent, its satiny glow deepened by vague highlights and shadows ranging from grey to pure black.

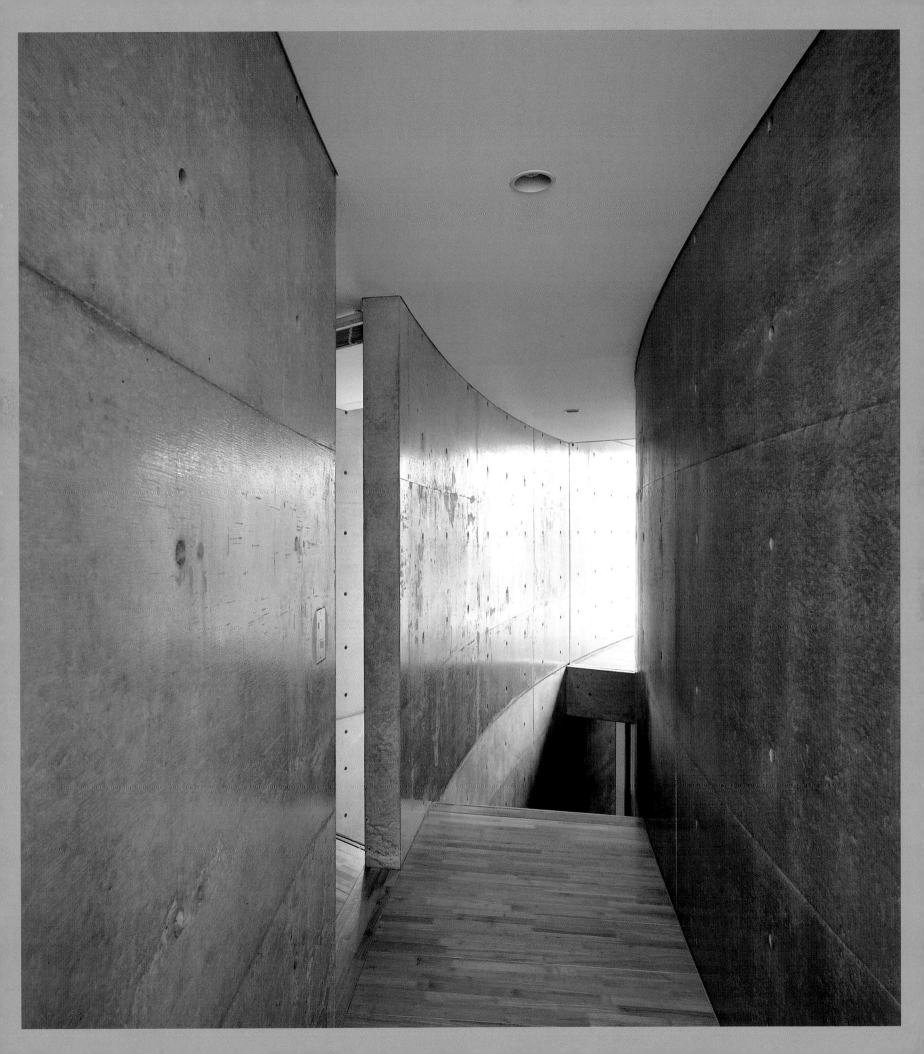

Entry and façade.
Opposite: Simultaneous patterns on glass and concrete.

Eberswalde University Library, Germany
Herzog & de Meuron

At this 1999 university library in northern Germany, digitized versions of newspaper clippings are stamped into the concrete, creating an effect similar to etching plates. The relief is produced during fabrication, when the image is drawn not by ink, but by a retardant that slows curing, allowing more liquid portions of each image to be rinsed out with water and brushes. Augmenting the pictorial shadows are subtle reflections concentrated in the raised figures of each image, but impressed entirely *beneath* the wall plane and into the concrete itself. Depending on the angle of view and incident light, the engraved surface can appear exceptionally hard and flat or softly topographic. Most mesmerizing is the influence of the changing weather on the grey substance, turning it silver and strangely metallic under diffuse skies, then golden at sunset, violet and purple towards dusk, and finally disappearing at night to leave yellow strips of translucent glass. Similar images silkscreened on glass interact with those on concrete, unifying the two materials with an interplay of pattern and depth.

Above, left to right: Detail of glass doors; detail of concrete and glass wall; entrance at night.
Top, this page and opposite: Imprinted concrete under changing light.

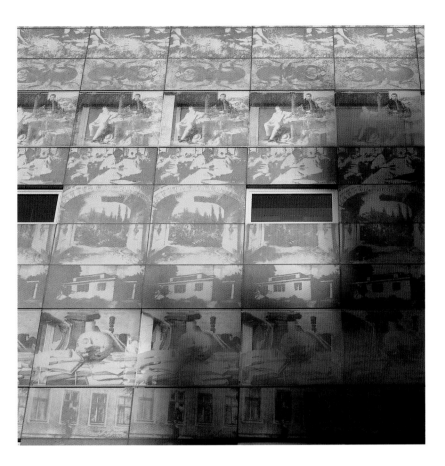

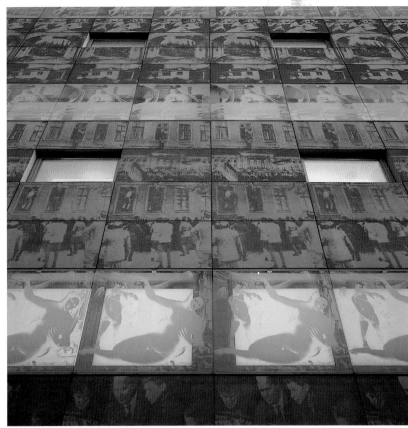

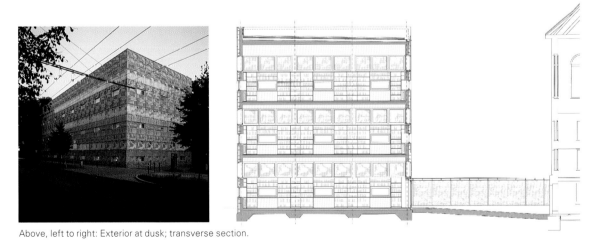

Above, left to right: Exterior at dusk; transverse section.

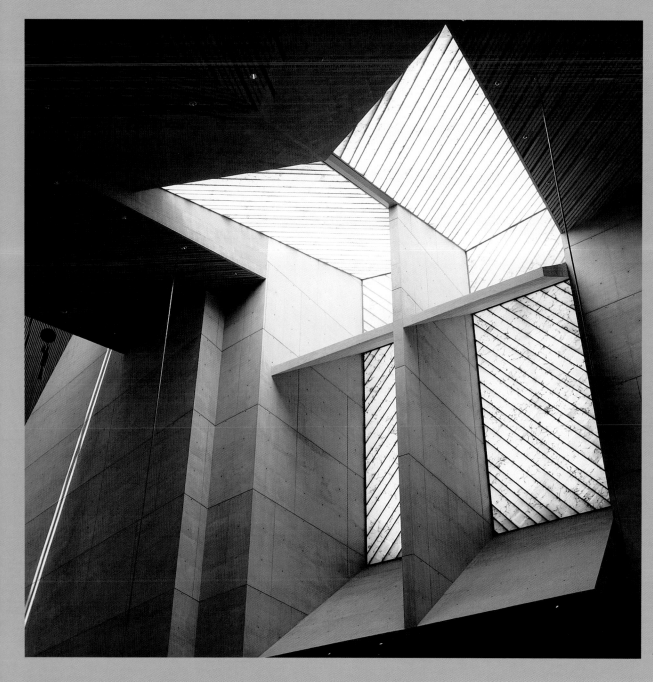

Skylight with abstract cross above altar.
Opposite: Alabaster window of ambulatory,
framed by concrete walls of chapels.

Lady of the Angels Cathedral, California, USA
Rafael Moneo

The alabaster employed at this 2003 cathedral in Los Angeles carries an added spiritual dimension analogous to that of stained glass, whose wedding of light and colour invested the windows of Gothic cathedrals with sacred significance, much as the Virgin was thought to be infused by a ray of light from God. Yet while diffusing throughout the interior a sublime atmosphere, which resonates with and seems emitted by earthen concrete, the architect's stonework is otherwise unlike medieval glass, for it is devoid of representational icons and, like abstract art, draws upon light's material rather than formal expression. Found deep within the stone is a radiance shaped not by religious dogma, but by mineral and sedimentary hues, whose heavenly and earthly fusion gives the church a pantheistic tone in which the supernatural is reconciled with the natural.

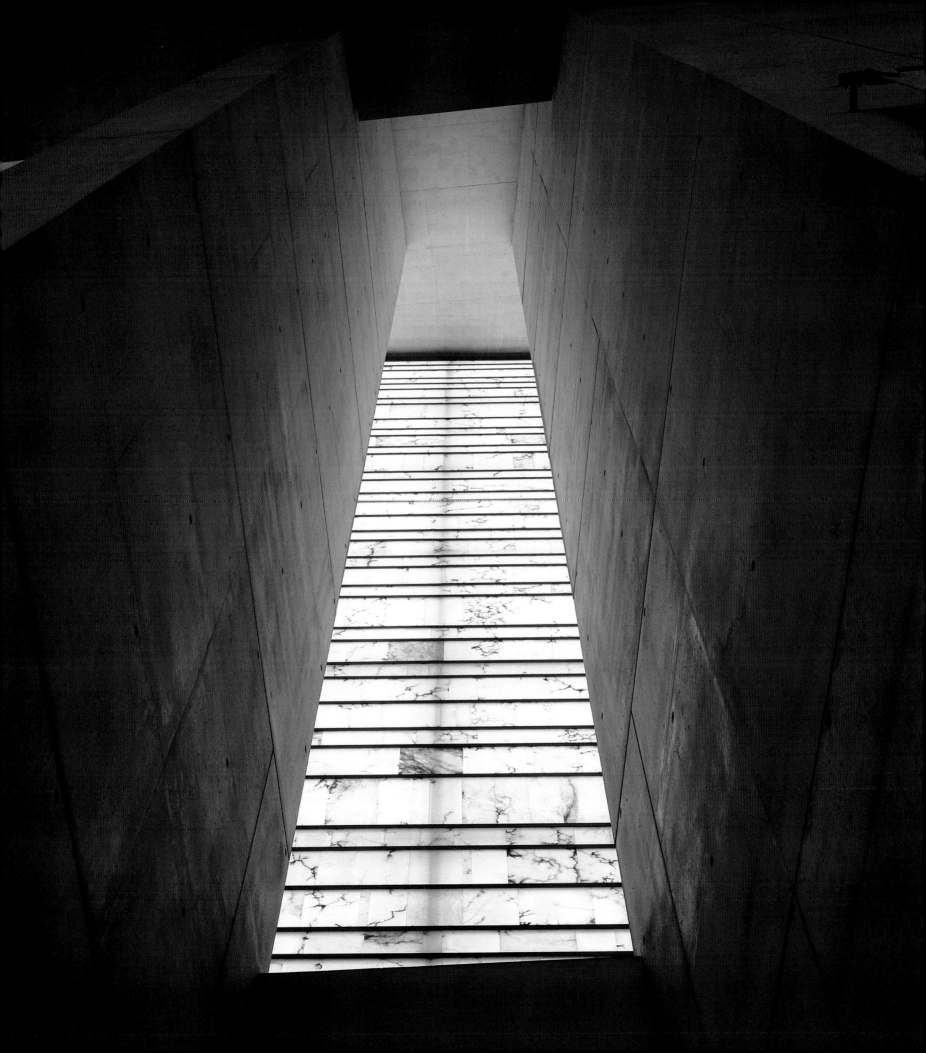

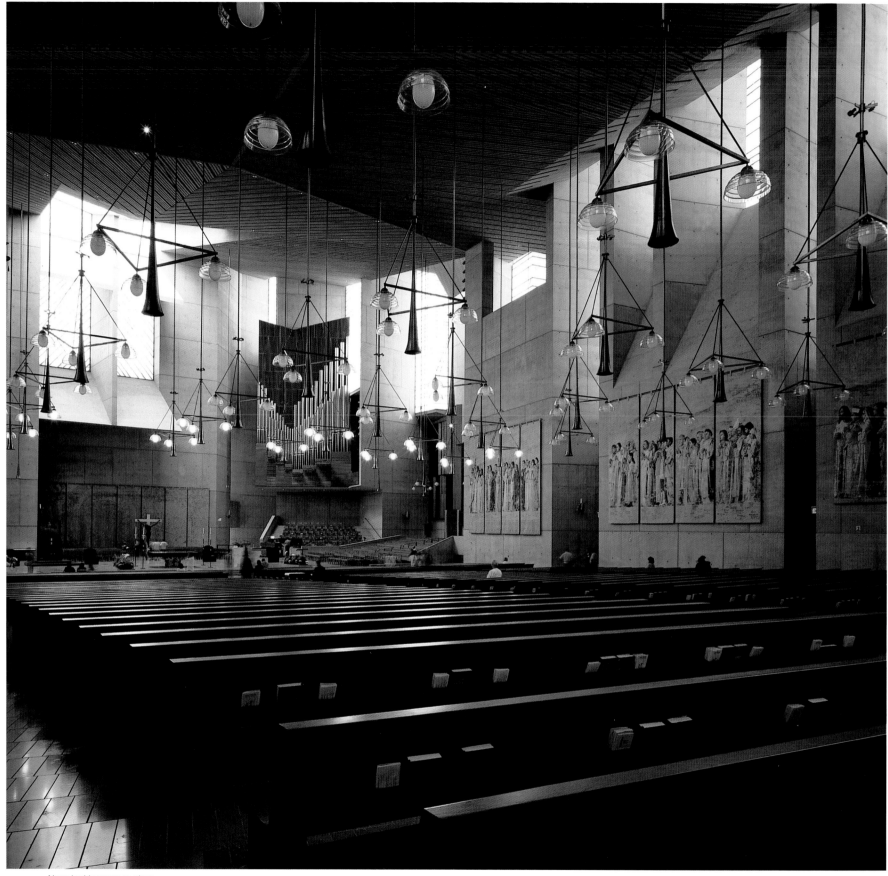

Nave looking east to altar.

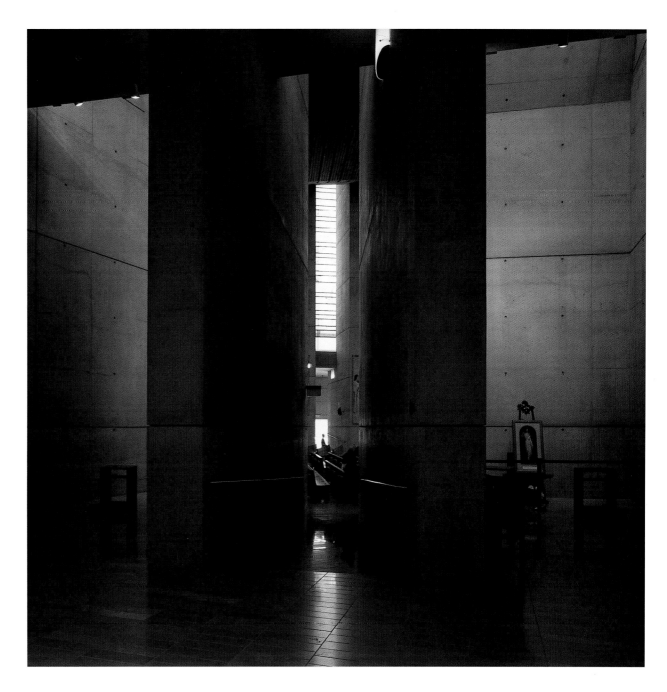

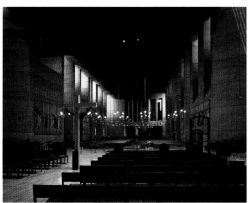

Above, left to right: Nave looking west; longitudinal section.
Top: Side chapels, with ramp into nave.

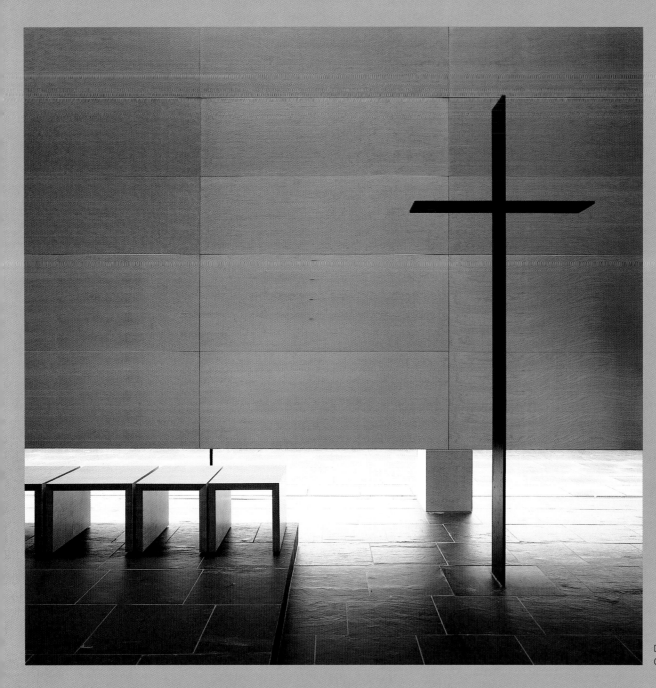

Detail of altar wall.
Opposite: Sanctuary and altar space.

St Francis Church, Austria Riepl Riepl

The liturgical importance of Riepl Riepl's altar wall for this 2001 church in Steyr is emphasized by a vertical wash of light from above. Appearing in this illumination are subtle shadows that emphasize a slight bowing of smooth plywood sheets and bring to the surface a tremulous glow that strengthens and weakens with the changing weather and time of day. Complicating the wavery sheen is light arriving from other angles, especially from slits along the floor that bounce illumination *upwards*, throwing delicate counter-shadows on the woodwork.

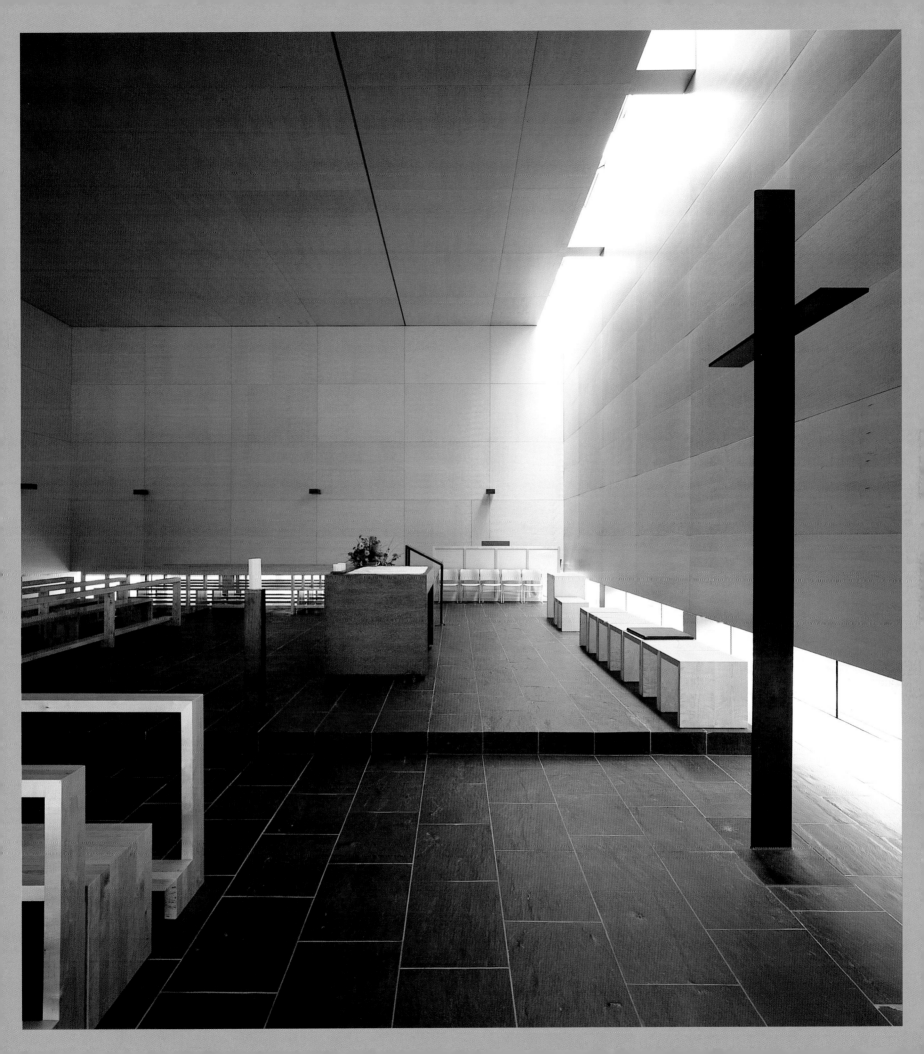

Ceiling detail.
Opposite: Altar.

Catholic Community Church, Germany Cheret + Bozic

The nondescript and unfinished character of commercial plywood, which has been left as raw as possible, becomes a source of evocative possibilities at this church, dating from 1998, in Sontheim. Forming a cupola over the building is a honeycomb structure, built of plywood and porous only to zenithal light. As illumination falls through the cells, it grazes over coarse wood plies to accent their texture with shadow and light, while picking up the colour of the wood to infuse the cells with a warm, friendly glow. Due to light trapped in its hollows, which vary in brightness according to depth, the porous structure appears self-luminous. But the church's real poetic power derives from the way in which such a modest and commonplace material is transformed into a source of wonder. It is precisely by emphasizing the practical and utilitarian state of plywood that it can become something so new and startling, and so evocative when held up as a subject of contemplation. Artistic manipulation has turned one of architecture's most humble materials into an eloquent means of expression.

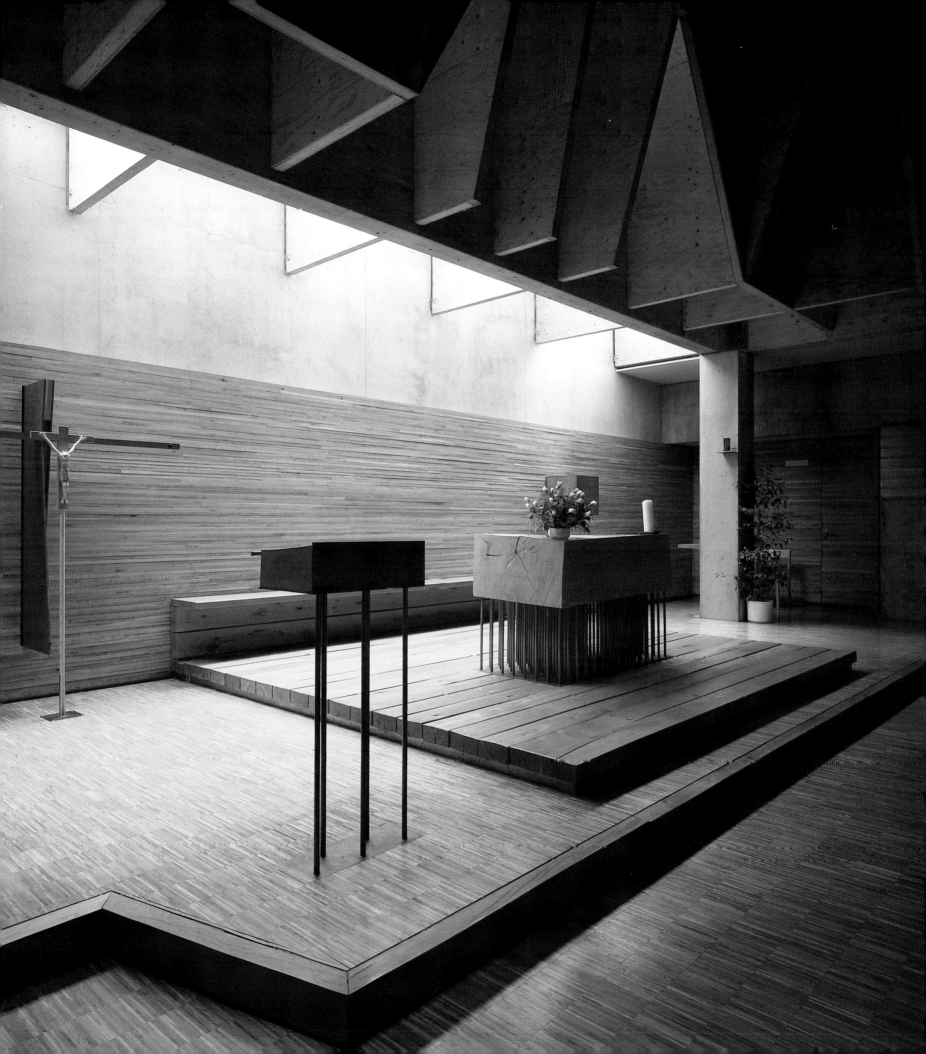

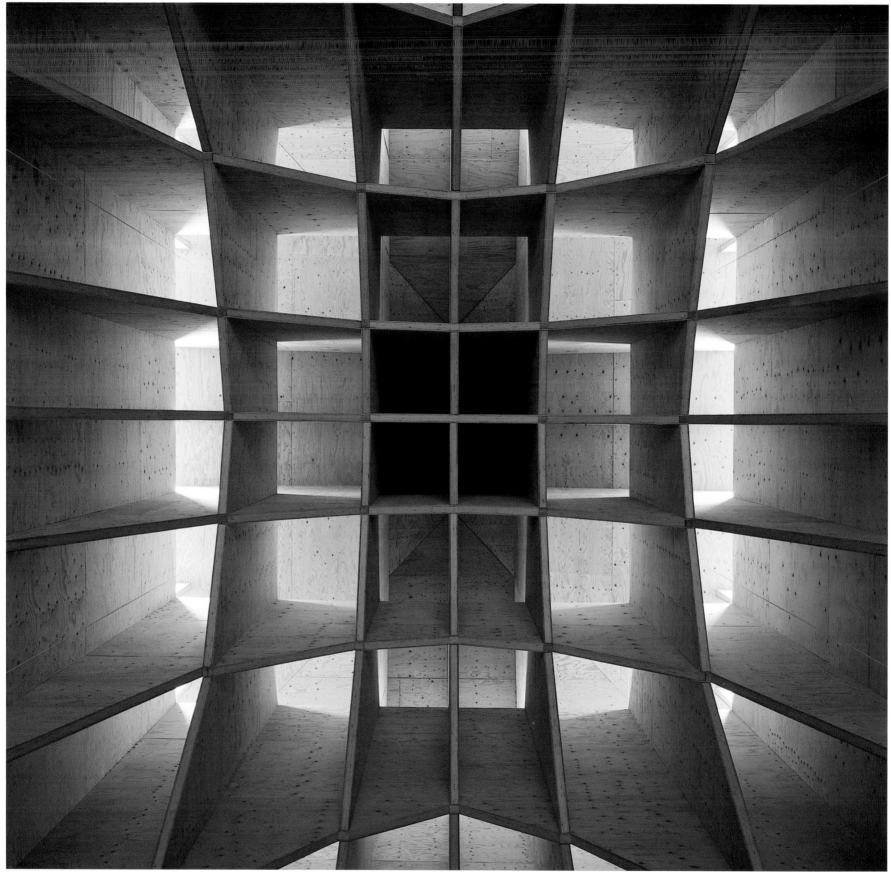

Plywood ceiling.

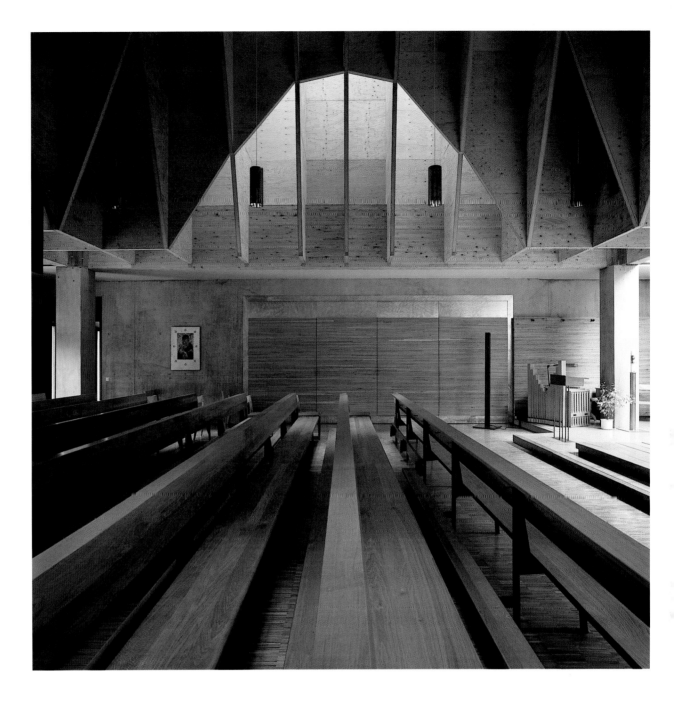

Above: Longitudinal section.
Top: Interior with altar at right.

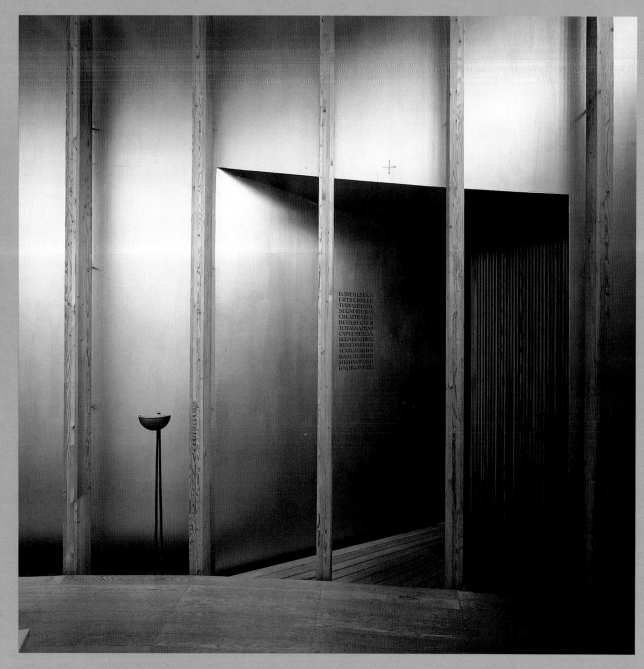

Entrance.
Opposite: Ceiling.

Caplutta Sogn Benedetg, Switzerland Peter Zumthor

Several manoeuvres are exploited at this 1988 chapel in the Swiss town of Sumvitg to give wood a radiant impression, sensed initially as an evolving brightness of differing timber species and finishes. While the material is not inherently luminous, it is made to appear so by simultaneous and successive contrasts. Following an exterior of dark, weather-blackened wood shingles, lighter woodwork around the entry seems far brighter, a progression that continues inside with even lighter floorboards and culminates in nearly white wooden pews. The floor's brightness is further exaggerated by a juxtaposition with a recessed border of shade, a chiaroscuric effect repeated in the haloed and shadowy timber roof, making struts more visually pronounced as a tracery of ribs. The final touch in this graduation is the luminescence of silver paint applied to perimeter walls, whose reflections are blurred by shadows cast from detached columns and by highlights caught from high windows, enveloping the room in what the architect calls an 'abstract panorama of light and shadow'.

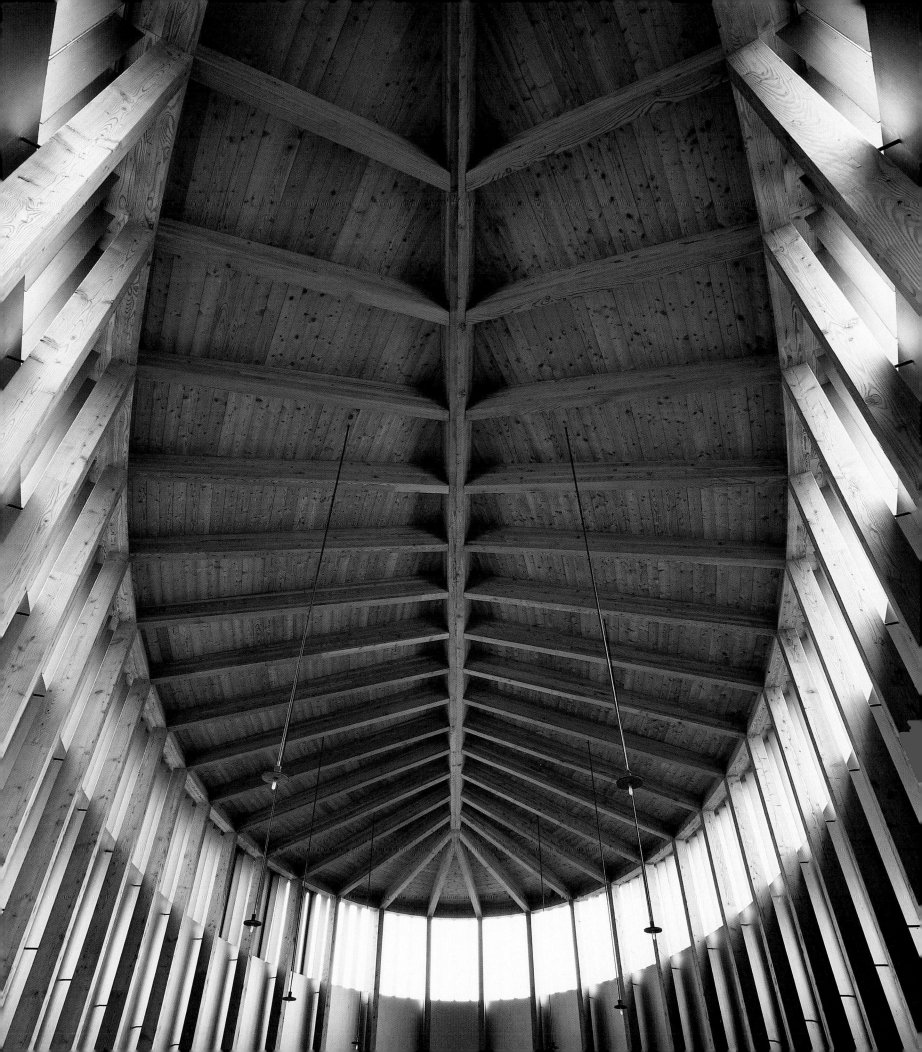

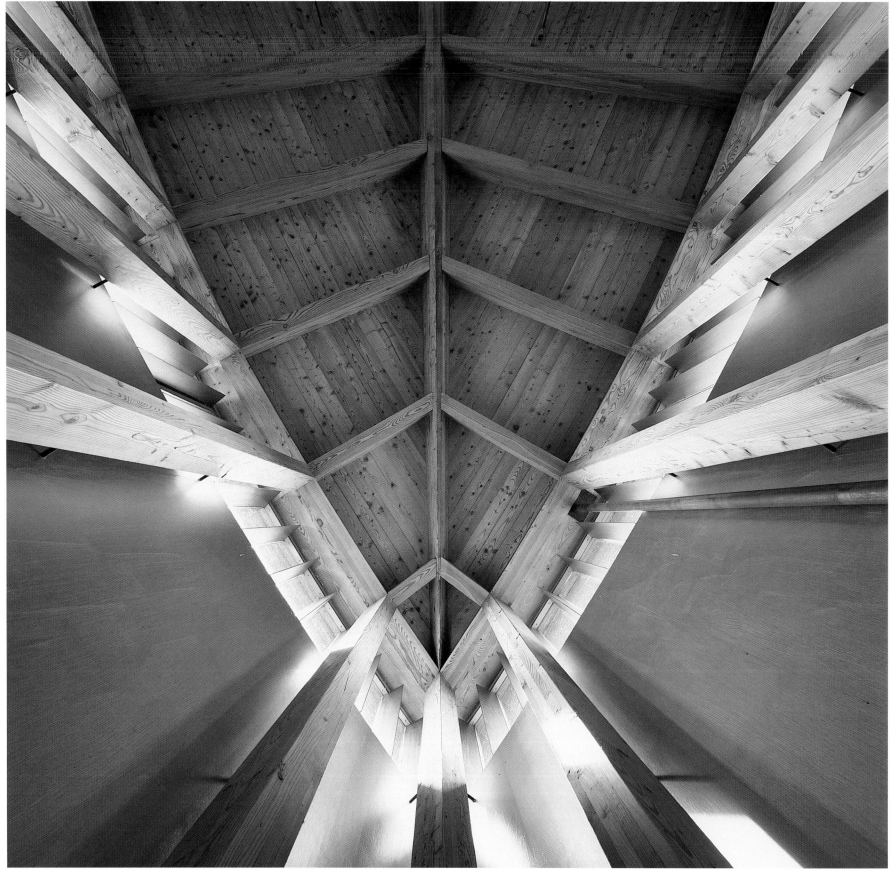

Ceiling detail.

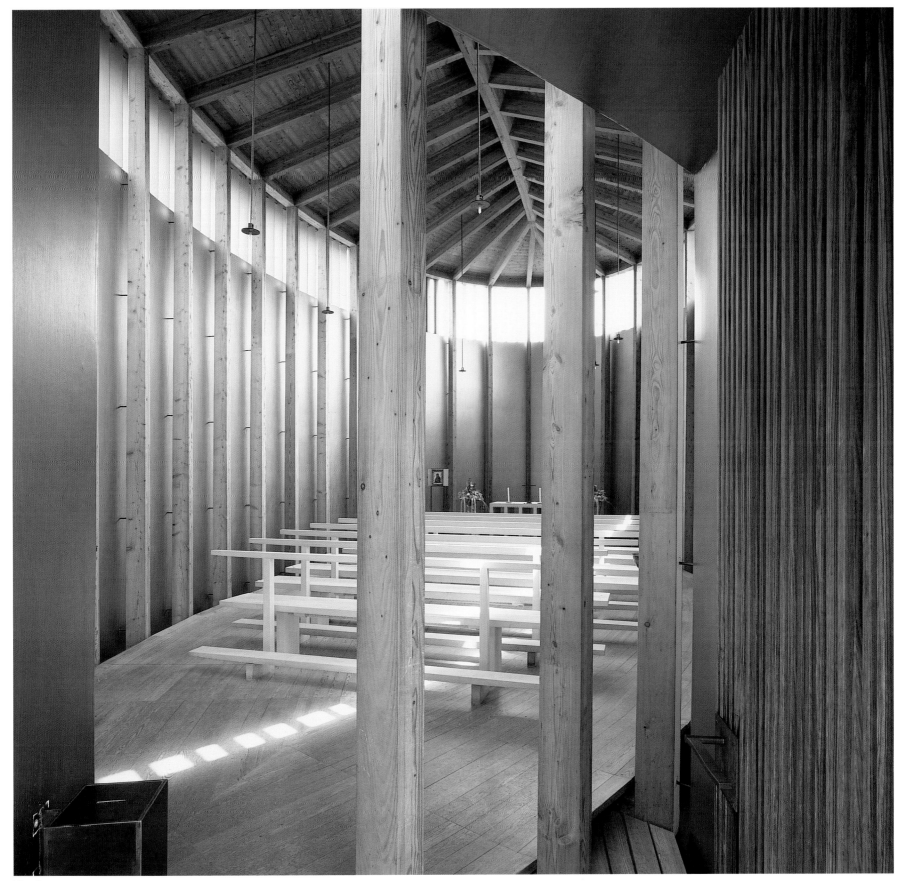

View from entrance.

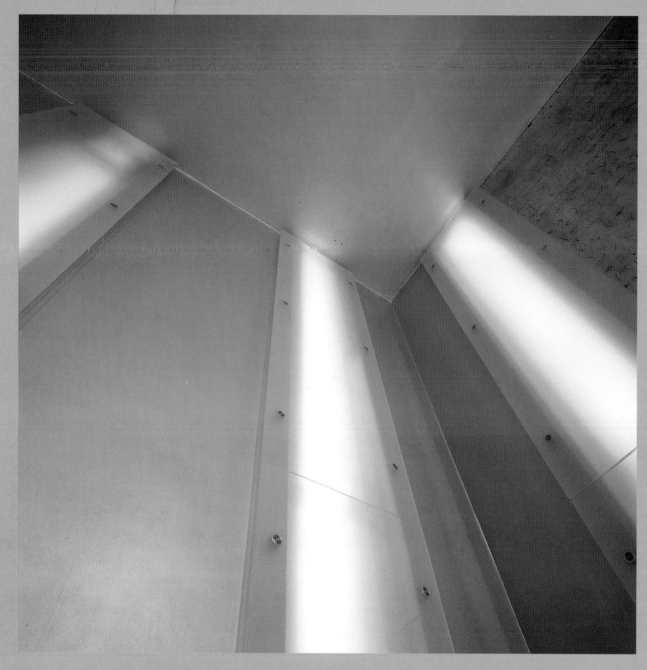

Corner detail.
Opposite: View into chapel from entrance.

Tirschenreuth Chapel, Germany Brückner & Brückner

Illumination arrives in the astonishingly simple yet graceful cube of this chapel in Bavaria, dating from 2000, through a series of vertical cuts in the wall, whereupon light is immediately diffused by translucent sheets that cover and overlap the window slits so as to soften and spread radiation as if by an intervening fog. Receiving this gentle illumination from multiple sources are walls coated with aluminium paint, whose smooth texture and colourless tones resemble and blend into the glass, causing the entire room, in the architects' words, to 'melt into light and become luminous'.

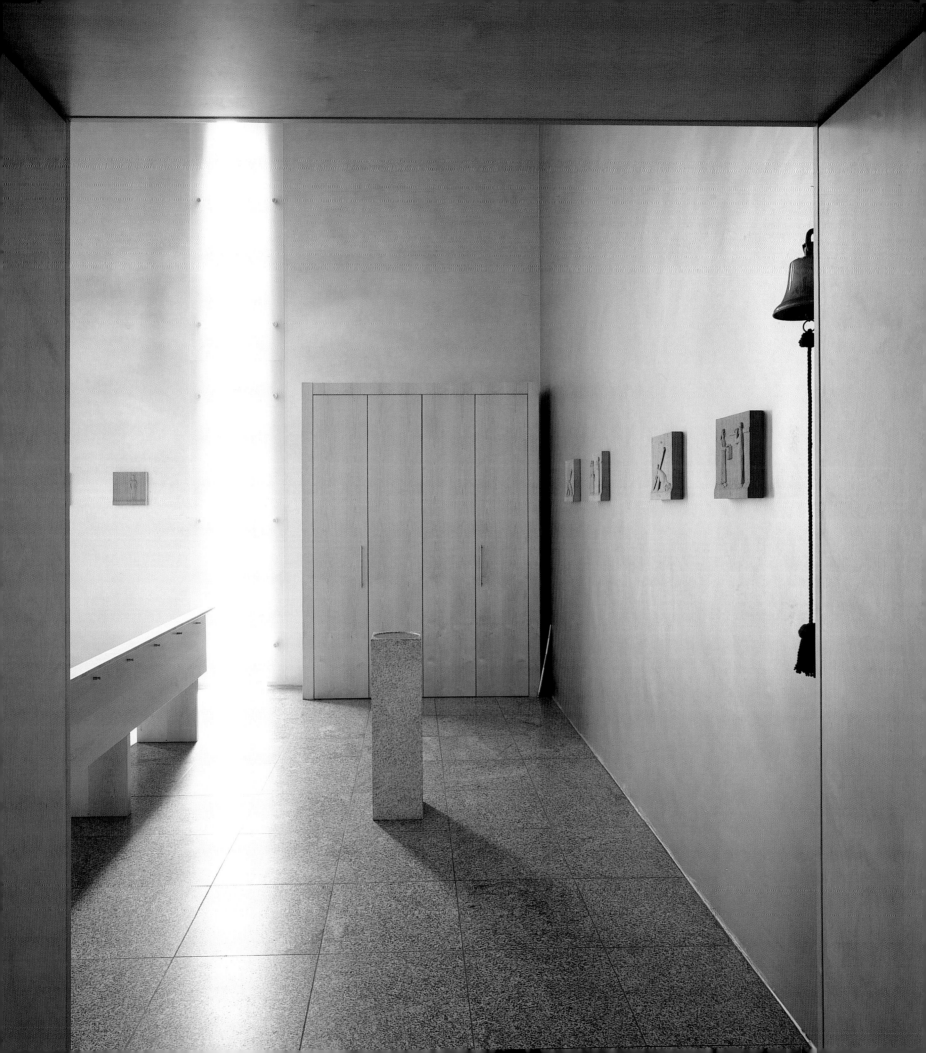

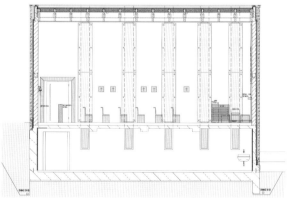

Above: Longitudinal section.
Top: Wall detail.

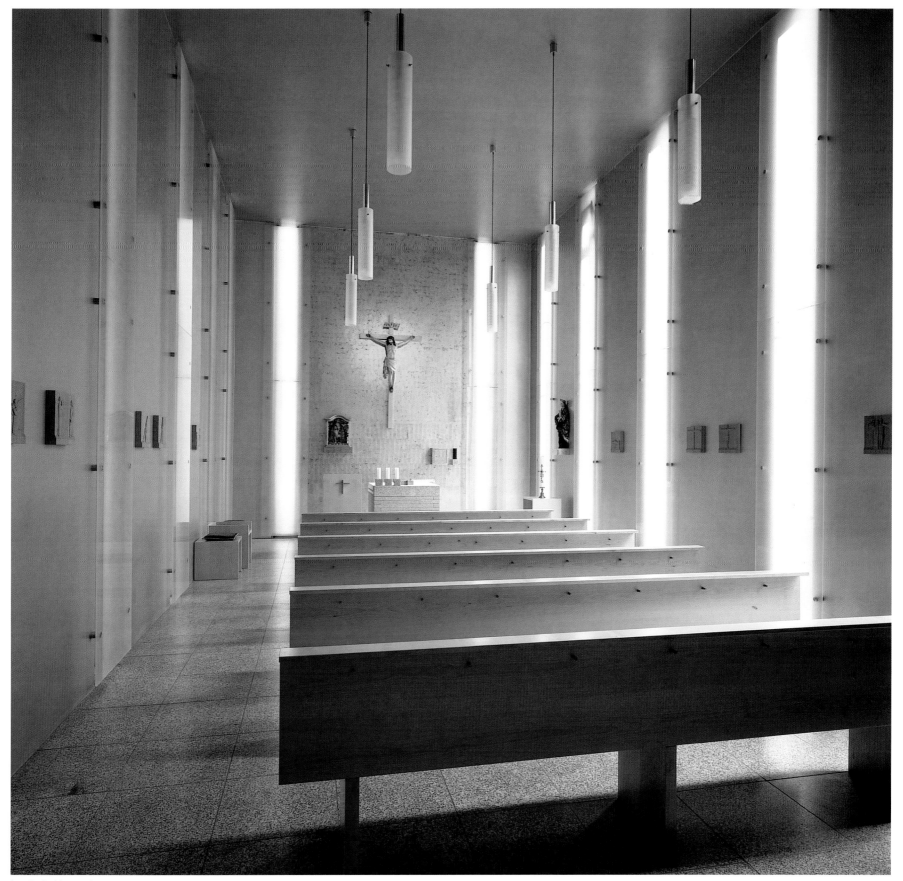

Interior looking to altar.

Meeting of stainless-steel curves.
Opposite: Reflections from neighbouring steel curves.

Walt Disney Concert Hall, California, USA Frank Gehry

To reduce the blinding reflections of the Californian sun on this 2003 music hall in Los Angeles, Gehry had its curving stainless-steel plates wire-brushed in multiple directions, producing a soft lustre that mitigates glare. Clipped to aluminium frames supported by steel mullions, each plate has a single curve, though the variety of curves gives an impression of sails billowing out in three dimensions. Unlike at Gehry's Guggenheim Museum Bilbao, the metal 'sails' have been smoothly finished with subtle seams to enhance the continuity of tonal gradations, emphasizing the plasticity rather than the texture of light, and making use of fogged reflections to create added depth. Despite their radiance, the steel curves hold and distort intriguing impressions of sky and city, as well as ricochets of light from one to the other. Especially seductive are the amorphous reflections, where one curve catches and blurs the image bounced from a neighbouring, often hidden, surface, producing a phantasmagoric glow that draws one's vision into a space that lies within, and even beyond, the physical material.

Exterior with window.

Above: Elevation.
Top: Reflections of sky and garden on stainless steel.

NOTES

1 M. Minnaert, *Light and Colour in the Open Air*, trans. H.M. Kremer-Priest (London, 1937).

2 E. Husserl, *Ideas: General Introduction to Pure Phenomenology*, trans. W.R.B. Gibson (London, 1931).

3 G. Bachelard, *The Poetics of Space*, trans. M. Jolas (New York, 1964), 33–34, 46; Bachelard, *The Flame of a Candle*, trans. J. Caldwell (Dallas, 1988), 4.

4 S.E. Rasmussen, *Experiencing Architecture* (Cambridge, Massachusetts, 1959), 186–214.

5 M. Heidegger, *Poetry, Language, Thought*, trans. A. Hofstadter (New York, 1971); M. Merleau-Ponty, *Phenomenology of Perception*, trans. C. Smith (London, 1962).

6 C. Norberg-Schulz, *Genius Loci: Towards a Phenomenology of Architecture* (New York, 1980), 6, 14, 54.

7 See, for instance, my *Poetics of Light* (Tokyo, 1987), *Light in Japanese Architecture* (Tokyo, 1995), and *Masters of Light: Twentieth-Century Pioneers* (Tokyo, 2003).

8 J. Pallasmaa, *The Eyes of the Skin: Architecture and the Senses* (London, 1996).

9 S. Holl, J. Pallasmaa and A. Pérez-Gómez, *Questions of Perception: Phenomenology of Architecture* (Tokyo, 1994), 63.

10 P. Zumthor, *Thinking Architecture* (Baden, 1998), 9; Zumthor, *Atmospheres* (Basel, 2006), 61.

11 A. Campo Baeza, *La idea construída* (Madrid, 2002), 21.

12 *The Poetics of Space*, 51.

13 M. Eliade, *The Sacred and the Profane: The Nature of Religion*, trans. W.R. Trask (New York, 1959), 11.

14 J.N. Lockyer, *The Dawn of Astronomy* (Cambridge, Massachusetts, 1964); G.S. Hawkins, *Stonehenge Decoded* (Garden City, New York, 1965).

15 D.T. Suzuki, *Zen and Japanese Culture* (Princeton, 1959), 380–81.

16 H. Bergson, *Matter and Memory*, trans. N.M. Paul and W.S. Palmer (New York, 1991), 205.

17 Ibid., 73.

18 S.K. Langer, *Feeling and Form: A Theory of Art* (New York, 1953), 109, 112.

19 Ibid., 112–113.

20 Ibid., 110.

21 Merleau-Ponty, 69.

22 A. Tarkovsky, *Sculpting in Time: Reflections on the Cinema*, trans. K. Hunter-Blair (Austin, 1986), 63.

23 From an interview by the author with Juha Leiviskä on 3 March 1996.

24 M. Picard, *The World of Silence*, trans. S. Godman (Chicago, 1952), 166.

25 W. Benjamin, 'The Work of Art in the Age of Mechanical Reproduction' (1936), in W. Benjamin, *Illuminations*, trans. H. Zohn (New York, 1968), 236.

26 *Bill Viola: The Passions*, ed. J. Walsh (Los Angeles, 2003), 212.

27 Ibid., 214.

28 S. Holl, *The Chapel of St Ignatius* (New York, 1999), 92; *Bill Viola: The Passions*, 214.

29 The refractive behaviour of dichroic glass derives from applications of micro-thin coatings of metallic oxides, which selectively reflect and transmit differing wavelengths.

30 E.N. Bacon, *Design of Cities* (New York, 1967), 19, 20.

31 Le Corbusier, *Oeuvre Complète*, vol. 1 (Zurich, 1943), 60.

32 G. Cullen, *The Concise Townscape* (London, 1961), 9, 17–20, 106–110.

33 W.C. Williams, *Selected Essays* (New York, 1954), 307.

34 *Selected Writings of Charles Olson*, ed. R. Creeley (New York, 1966), 15–17.

35 M. Heizer, 'The Art of Michael Heizer', in *Artforum* (December 1969).

36 G. Vattimo, *The End of Modernity: Nihilism and Hermeneutics in Postmodern Culture*, trans. J.R. Snyder (Baltimore, 1991), 85–86.

37 Tarkovsky, 57–80, 117.

38 G. Tinazzi, 'The Gaze and the Story', in M. Antonioni, *The Architecture of Vision: Writings and Interviews on Cinema* (New York, 1996), xxiv.

39 See *Glass Architecture by Paul Scheerbart and Alpine Architecture by Bruno Taut*, ed. D. Sharp (New York, 1972).

40 An important manifestation of this development was the 1995 exhibition 'Light Construction' held at the Museum of Modern Art in New York and documented in T. Riley, catalogue, exhibition, *Light Construction* (New York, 1995).

41 J. Starobinski, *The Living Eye*, trans. A. Goldhammer (Cambridge, Massachusetts, 1989), 1–2.

42 *Bill Viola: The Passions*, 218.

43 G. Bachelard, *Air and Dreams: An Essay on the Imagination of Movement*, trans. E.R. Farrell and C.F. Farrell (Dallas, 1988), 43.

44 I. Calvino, *Six Memos for the Next Millennium* (New York, 1993), 12.

45 R.P. Feynman, *QED: The Strange Theory of Light and Matter* (Princeton, 1985), 17, 109.

46 L.V. Hau, 'Frozen Light', in *Scientific American* 285:1 (2001): 66–73.

47 Calvino, 8–9.

48 Ibid., 15.

49 M. Kundera, *The Unbearable Lightness of Being*, trans. M.H. Heim (New York, 1984), 33.

50 B.B. Mandelbrot, *The Fractal Geometry of Nature* (New York, 1977), 1.

51 Calvino, 4.

52 Ibid., 28.

53 W.C. Williams, 'The Broken Vase', unpublished manuscript in the Yale Library Collection of American Literature.

54 W. Kandinsky, *Concerning the Spiritual in Art* (New York, 1947), 36.

55 S. Holl, *Parallax* (New York, 2000), 305.

56 Le Corbusier, *The Radiant City* (New York, 1967), 129; Le Corbusier, *The Athens Charter*, trans. A. Eardley (New York, 1973), 55.

57 Picard, 15, 168.

58 J. Tanizaki, *In Praise of Shadows*, trans. T.J. Harper and E.G. Seidensticker (New Haven, 1977), 20, 18.

59 *Atmospheres*, 59.

60 About tintinnabulation, Arvo Pärt writes: 'Here I am alone with silence. I have discovered that it is enough when a single note is beautifully played. This one note, or a silent beat, or a moment of silence, comforts me. I work with very few elements – with one voice, with two voices. I build with the most primitive materials – with the triad, with one specific tonality. The three notes of the triad are like bells. And that is why I called it tintinnabulation.' A. Pärt, quoted in the sleeve note to *Tabula Rasa* (ECM, 1977), and in P. Hillier, *Arvo Pärt* (Oxford, 1997), 87.

61 A. Pärt, quoted in the sleeve note to *Für Alina* (ECM, 1976).

62 'Annette Gigon Mike Guyer 1989–2000, The Variegated Minimal', special issue, *El Croquis* 102 (2000), 21.

63 O. Paz, 'Chillida – vom Eisen zum Licht', catalogue, exhibition, *Eduardo Chillida – Skulpturen* (Hanover, 1981), 21.

64 'Herzog & de Meuron 1983–1993', special issue, *El Croquis* 60 (1994), 15, 23.

65 From an unpublished writing by Rafael Moneo, April 1993.

66 P. Zumthor, *Three Concepts* (Basel, 1997), 11; *Thinking Architecture*, 11.

67 *Atmospheres*, 59.

68 C. van Bruggen, *Frank O. Gehry: Guggenheim Museum Bilbao* (New York, 1997), 141.

BIBLIOGRAPHY

C. Adock, *James Turrell: The Art of Light and Space* (Berkeley, 1990).

'Annette Gigon Mike Guyer 1989–2000, The Variegated Minimal', special issue, *El Croquis* 102 (2000).

G. Bachelard, *Air and Dreams: An Essay on the Imagination of Movement*, trans. E.R. Farrell and C.F. Farrell (Dallas, 1988).

——, *The Flame of a Candle*, trans. J. Caldwell (Dallas, 1988).

——, *The Poetics of Space*, trans. M. Jolas (New York, 1964).

E.N. Bacon, *Design of Cities* (New York, 1967).

W. Benjamin, 'The Work of Art in the Age of Mechanical Reproduction' (1936), in W. Benjamin, *Illuminations*, trans. H. Zohn (New York, 1968).

H. Bergson, *Matter and Memory*, trans. N.M. Paul and W.S. Palmer (New York, 1991).

Bill Viola: The Passions, ed. J. Walsh (Los Angeles, 2003).

W. Bragg, *The Universe of Light* (New York, 1959).

I. Calvino, *Six Memos for the Next Millennium* (New York, 1993).

A. Campo Baeza, *La idea construída* (Madrid, 2002).

Le Corbusier, *The Athens Charter*, trans. A. Eardley (New York, 1973).

——, *Oeuvre Complète*, vol. 1 (Zurich, 1943).

——, *The Radiant City* (New York, 1967).

G. Cullen, *The Concise Townscape* (London, 1961).

M. Eliade, *The Sacred and the Profane: The Nature of Religion*, trans. W.R. Trask (New York, 1959).

D.S. Falk, D.R. Brill and D.G. Stork, *Seeing the Light: Optics in Nature, Photography, Color, Vision, and Holography* (New York, 1986).

R.P. Feynman, *QED: The Strange Theory of Light and Matter* (Princeton, 1985).

Glass Architecture by Paul Scheerbart and Alpine Architecture by Bruno Taut, ed. D. Sharp (New York, 1972).

L.V. Hau, 'Frozen Light', in *Scientific American* 285:1 (2001).

G.S. Hawkins, *Stonehenge Decoded* (Garden City, New York, 1965).

M. Heidegger, *Poetry, Language, Thought*, trans. A. Hofstadter (New York, 1971).

M. Heizer, 'The Art of Michael Heizer', in *Artforum* (December 1969).

'Herzog & de Meuron 1983–1993', special issue, *El Croquis* 60 (1994).

P. Hillier, *Arvo Pärt* (Oxford, 1997).

S. Holl, *The Chapel of St Ignatius* (New York, 1999).

——, *Parallax* (New York, 2000).

S. Holl, J. Pallasmaa and A. Pérez-Gómez, *Questions of Perception: Phenomenology of Architecture* (Tokyo, 1994).

E. Husserl, *Ideas: General Introduction to Pure Phenomenology*, trans. W.R.B. Gibson (London, 1931).

W. Kandinsky, *Concerning the Spiritual in Art* (New York, 1947).

G. Kepes, *Light as a Creative Medium* (Cambridge, Massachusetts, 1964).

M. Kundera, *The Unbearable Lightness of Being*, trans. M.H. Heim (New York, 1984).

S.K. Langer, *Feeling and Form: A Theory of Art* (New York, 1953).

J.N. Lockyer, *The Dawn of Astronomy* (Cambridge, Massachusetts, 1964).

B.B. Mandelbrot, *The Fractal Geometry of Nature* (New York, 1977).

M. Merleau-Ponty, *Phenomenology of Perception*, trans. C. Smith (London, 1962).

M. Minnaert, *Light and Colour in the Open Air*, trans. H.M. Kremer-Priest (London, 1937). Republished as *Light and Colour in the Outdoors*, trans. L. Seymour (New York, 1993).

C. Norberg-Schulz, *Genius Loci: Towards a Phenomenology of Architecture* (New York, 1980).

J. Pallasmaa, *The Eyes of the Skin: Architecture and the Senses* (London, 1996).

D. Park, *The Fire within the Eye: A Historical Essay on the Nature and Meaning of Light* (Princeton, 1977).

A. Pärt, sleeve note to *Für Alina* (ECM, 1976).

——, sleeve note to *Tabula Rasa* (ECM, 1977).

O. Paz, 'Chillida – vom Eisen zum Licht', catalogue, exhibition, *Eduardo Chillida – Skulpturen* (Hanover, 1981).

M. Picard, *The World of Silence*, trans. S. Godman (Chicago, 1952).

H. Plummer, *Poetics of Light* (Tokyo, 1987).

——, *Light in Japanese Architecture* (Tokyo, 1995).

——, *Masters of Light: Twentieth-Century Pioneers* (Tokyo, 2003).

S.E. Rasmussen, *Experiencing Architecture* (Cambridge, Massachusetts, 1959).

T. Riley, catalogue, exhibition, *Light Construction* (New York, 1995).

Selected Writings of Charles Olson, ed. R. Creeley (New York, 1966).

J. Starobinski, *The Living Eye*, trans. A. Goldhammer (Cambridge, Massachusetts, 1989).

D.T. Suzuki, *Zen and Japanese Culture* (Princeton, 1959).

J. Tanizaki, *In Praise of Shadows*, trans. T.J. Harper and E.G. Seidensticker (New Haven, 1977).

A. Tarkovsky, *Sculpting in Time: Reflections on the Cinema*, trans. K. Hunter-Blair (Austin, 1986).

G. Tinazzi, 'The Gaze and the Story', in M. Antonioni, *The Architecture of Vision: Writings and Interviews on Cinema* (New York, 1996).

C. van Bruggen, *Frank O. Gehry: Guggenheim Museum Bilbao* (New York, 1997).

G. Vattimo, *The End of Modernity: Nihilism and Hermeneutics in Postmodern Culture*, trans. J.R. Snyder (Baltimore, 1991).

W.C. Williams, *Selected Essays* (New York, 1954).

——, 'The Broken Vase', unpublished manuscript in the Yale Library Collection of American Literature.

A. Zajonc, *Catching the Light: The Entwined History of Light and Mind* (New York, 1933).

P. Zumthor, *Atmospheres* (Basel, 2006).

——, *Thinking Architecture* (Baden, 1998).

——, *Three Concepts* (Basel, 1997).

ARCHITECT INFORMATION

Allmann Sattler Wappner
Church of the Sacred Heart, p. 160
Nymphenburger Straße 125
80636 Munich, Germany
info@allmannsattlerwappner.de
www.allmannsattlerwappner.de

Tadao Ando
*Water Temple, p. 24; Church of
Light, p. 190; Ito House, p. 224*
Osaka, Japan
www.andotadao.com

BAAS
León City Morgue, p. 166
Montserrat de Casanovas 105
08032 Barcelona, Spain
baas@jordibadia.com
www.jordibadia.com

Brückner & Brückner
Tirschenreuth Chapel, p. 244
Franz-Böhm-Gasse 2
95643 Tirschenreuth, Germany
mail@architektenbrueckner.de
www.architektenbrueckner.de

Veitshöchheimer Straße 14
97080 Würzburg, Germany
mail-wue@architektenbrueckner.de

Alberto Campo Baeza
*Asencio House, p. 36; Guerrero
House, p. 40*
Estudio Arquitectura Campo Baeza
Almirante 9, 2 izq
28004 Madrid, Spain
estudio@campobaeza.com
www.campobaeza.com

**James Carpenter Design
Associates**
Sweeney Chapel, p. 48
145 Hudson Street, 4th Floor

New York, New York 10013, USA
info@jcdainc.com
www.jcdainc.com

Cheret + Bozic
Catholic Community Church, p. 236
Nägelestraße 7
70597 Stuttgart, Germany
buero@cheret-bozic.de
www.cheret-bozic.de

Sverre Fehn
Ivar Aasen Centre, p. 74
Oslo, Norway

Carlos Ferrater
*Auditorium and Conference Centre,
p. 156*
C/Balmes, 145 bajos
08008 Barcelona, Spain
carlos@ferrater.com
www.ferrater.com

Norman Foster
Carré d'Art, p. 170
Foster + Partners
Riverside, 22 Hester Road
London SW11 4AN, UK
enquiries@fosterandpartners.com
www.fosterandpartners.com

Frank Gehry
Walt Disney Concert Hall, p. 248
Gehry Partners
12541 Beatrice Street
Los Angeles, California 90066, USA
www.foga.com

Heikkinen-Komonen Architects
Rovaniemi Airport Terminal, p. 122
Kristianinkatu 11–13
00170 Helsinki, Finland
ark@heikkinen-komonen.fi
www.heikkinen-komonen.fi

Herzog & de Meuron
*Library IKMZ, p. 88; Ricola Europe
Factory and Storage Building, p. 98;
Dominus Winery, p. 134; Eberswalde
University Library, p. 226*
Rheinschanze 6
Basel, Switzerland
info@herzogdemeuron.ch

Steven Holl Architects
*Chapel of St Ignatius, p. 44;
Bloch Building, p. 64*
450 West 31st Street, 11th floor
New York, New York 10001, USA
nyc@stevenholl.com

1 Xiangheyuan Road, Wanguocheng
Building 1-106, Dongcheng District
Beijing 100028, China
beijing@stevenholl.com
www.stevenholl.com

Jensen & Skodvin
Mortensrud Church, p. 164
Fredensborgveien 11
0177 Oslo, Norway
office@jsa.no
http://jsa.no

Fay Jones
*Thorncrown Chapel, p. 140; Mildred
B. Cooper Memorial Chapel, p. 144*
www.fayjones.org

Rem Koolhaas
Dutch Embassy, p. 76
Office for Metropolitan Architecture
Heer Bokelweg 149
3032 AD Rotterdam, Netherlands

B2905 Office Tower B
Jianwai SOHO
39 Dongsanhuan Zhonglu
Chaoyang District
Beijing 100022, China

180 Varick Street, Suite 1328
New York, New York 10014, USA
office@oma.com
www.oma.eu

Henning Larsen Architects
Enghøj Church, p. 194
Vesterbrogade 76
1620 Copenhagen V, Denmark
mail@henninglarsen.com
www.hlt.dk

Legorreta + Legorreta
Bel Air House, p. 200
Palacio de Versalles 285-A
Lomas de Reforma 11020, México
info@lmasl.com.mx
www.legorretalegorreta.com

Juha Leiviskä
*Myyrmäki Church, p. 30; Männistö
Church, p. 34*
Ratakatu 1 b A 12
Helsinki, Finland

Fumihiko Maki
TEPIA, p. 120
Maki & Associates
Hillside West-C, 13–4 Hachiyamacho
Shibuya, Tokyo 150-0035, Japan
www.maki-and-associates.co.jp

Mansilla + Tuñón
*León Municipal Auditorium, p. 68;
Zamora Archaeological Museum,
p. 176*
C/Artistas 59
Madrid, Spain
www.mansilla-tunon.com

Richard Meier
*Barcelona Museum of Contemporary
Art, p. 172*
Richard Meier & Partners Architects
475 Tenth Avenue, 6th Floor

New York, New York 10018, USA
mail@richardmeier.com

1001 Gayley Avenue
Los Angeles, California 90024, USA
mail@rmpla.com
www.richardmeier.com

Rafael Moneo
Pilar and Joan Miró Foundation,
p. 72; Kursaal Auditorium and
Congress Centre, p. 104; Lady of the
Angels Cathedral, p. 230
C/Cinca 5
28002 Madrid, Spain

Jean Nouvel
Galeries Lafayette, p. 90; Institut du
Monde Arabe, p. 126; Culture and
Congress Centre, p. 130
10 Cité d'Angoulême
75011 Paris, France
info@jeannouvel.fr
www.jeannouvel.com

Riepl Riepl Architekten
St Francis Church, p. 234
OK-Platz 1A, Dametzstraße, 38
4020 Linz. Austria
arch@rieplriepl.com
www.rieplriepl.com

SANAA
Glass Pavilion, p. 94
Kazuyo Sejima and Ryue Nishizawa
sanaa@sanaa.co.jp
www.sanaa.co.jp

Schultes Frank Architekten
Baumschulenweg Crematorium,
p. 196
Lützowplatz 7
10785 Berlin, Germany
office@schultesfrankarchitekten.de
www.schultes-architekten.de

Álvaro Siza
Galician Centre of Contemporary Art,
p. 208; Santa Maria Church, p. 212
Porto, Portugal

Heinz Tesar
Donau City Church, p. 138
Monbijouplatz 2
Berlin, Germany
mail@ateliertesar.com

Esteplatz 6/7
Vienna, Austria
atelier.tesar@eunet.at

Hans van der Laan
St Benedictusberg Abbey, p. 186
Van der Laan Stichting
Kerkplein 14
6578 An Leuth, Netherlands
vanderlaanstichting@planet.nl
www.vanderlaanstichting.nl

Meinhard von Gerkan
Christus Pavilion, p. 100
Architekten von Gerkan, Marg
und Partner
Elbchaussee 139
22763 Hamburg, Germany
www.gmp-architekten.de

Wandel Hoefer Lorch + Hirsch
Dresden Synagogue, p. 204
Dolomitenweg 19
66119 Saarbrücken, Germany
info@wandel-hoefer-lorch.de
www.wandel-hoefer-lorch.de

Shoei Yoh + Architects
Light-Lattice House, p. 28
12–30 Heiwa, Minami-ku
Fukuoka-shi
Fukuoka 815-0071, Japan
shoeiyoh.plus.architects@galaxy.dti.
ne.jp

Peter Zumthor
Therme Vals, p. 60; Kunsthaus
Bregenz, p. 108; Caplutta Sogn
Benedetg, p. 240
Süesswinggel 20
7023 Haldenstein, Switzerland
arch@zumthor.ch

PICTURE CREDITS

ACKNOWLEDGMENTS

This book could not have been written nor its photography undertaken without the generous support of many institutions and people.

The Graham Foundation for Advanced Studies in the Fine Arts provided the initial fellowship in 1976 for my study of light phenomena in architecture, followed by later grants in 1983 and 2005 to examine emerging work with light throughout Europe. With the aid of a fellowship from the Gladys Krieble Delmas Foundation in 1984, I was able to discover the Venetian light of Carlo Scarpa. The 1991 Lawrence B. Anderson award from MIT made possible a lengthy visit to Japan to study light in contemporary as well as traditional architecture, and a 1996 travel grant from the American–Scandinavian Foundation allowed me to explore the bewitching effects of northern light in Finnish architecture. A series of grants from the Campus Research Board at the University of Illinois sustained much of the other international travel required for this book, and the prolonged observation and unhurried photography of a wide range of buildings and building cultures. In additional to sabbatical leaves, several awards at critical moments from the University of Illinois provided what was most essential – opportunities for concentrated thought and writing free of teaching responsibilities: an appointment in 2005 as Associate of the Center for Advanced Study, and in 2007 an Arnold O. Beckman Award and Humanities Release–Time Award.

Among the individuals who made this book possible, I would like to first give thanks to Lucas Dietrich at Thames & Hudson, who not only responded with enthusiasm to this project from the outset, but also helped shape its development from inception to publication with unwavering encouragement, repeated insights, and sound advice. My deep appreciation goes as well to my editor Elain McAlpine, who brought an expert eye to editing the text and overseeing the book throughout its production, and to Claas Möller for the simple eloquence of his book design. And I wish to acknowledge a cumulative debt to my old friend and editor at *a+u*, Toshio Nakamura, who seemed always to appear at the right moment and nurtured much of my earlier work.

As the research for this book extends back over several decades, I am glad to thank many colleagues, past and present, who wrote generous letters in support of grants, fellowships, and leaves of absence: Jack Baker, Botond Bognar, Mohamed Boubekri, David Chasco, Joseph Esherick, Alan Forrester, Fay Jones, Alejandro Lapunzina, Donlyn Lyndon, Bea Nettles, Juhani Pallasmaa, Richard Peters, Robert Riley, Maurice Smith, Richard Williams, and for earlier grants that lay the groundwork for this project: Wayne Andersen, Stanford Anderson, Walter Creese, Jonathan Green, Gyorgy Kepes, Kevin Lynch, Henry Millon, and Minor White. The Director of the School of Architecture at the University of Illinois, David Chasco, was unstintingly supportive of my research efforts, and making possible leaves of absence at busy times.

The architects whose work is included in this volume were not only subjects of study, but also assisted my project in countless ways – making suggestions about and helping me gain access to buildings, in some cases accompanying me on visits, devoting time for interviews to discuss their ideas about light and design, and, finally, providing sketches and drawings. I would like to convey my gratitude to: Allmann Sattler Wappner, Tadao Ando, BAAS, Baumschlager & Eberle, Gunnar Birkerts, Brückner & Brückner, Alberto Campo Baeza, James Carpenter, Cheret + Bozic, Manuel Clavel Rojo, Joseph Esherick, Sverre Fehn, Carlos Ferrater, Norman Foster, Frank Gehry, Meinhard von Gerkan, Gigon & Guyer, Hiroshi Hara, Itsuko Hasegawa, Heikkinen & Komonen, Herman Hertzberger, Herzog & de Meuron, Steven Holl, Toyo Ito, Jensen & Skodvin, Fay Jones, Rem Koolhaas/OMA, Lapeña & Torres, Henning Larsen, Legorreta + Legorreta, Juha Leiviskä, Fumihiko Maki, Mansilla + Tuñón, Richard Meier, Rafael Moneo, Jean Nouvel, Juhani Pallasmaa, Paredes Pedrosa, Renzo Piano, Carme Pinós, Reipl Riepl, Schultes & Frank, Sejima & Nishizawa/SANAA, Claudio Silvestrin, Álvaro Siza, Maurice Smith, Ryoji Suzuki, Heinz Tesar, William Turnbull, Jørn Utzon, Wandel Hoefer Lorch + Hirsch, Shoei Yoh, Peter Zumthor.

My deepest gratitude goes to my wife Patty, who accompanied me and played a pivotal role in three decades of travel undertaken for this book. She brought to these often tiring expeditions a profound sense of freshness and joy, and stores of energy as well as patience at exhausting moments, but also a keen eye and sharp mind that helped shaped the ideas underpinning this book.